Science Exhibitions
Communication and Evaluation

Science Exhibitions

Communication and Evaluation

Anastasia Filippoupoliti

Contents

PART 4: AN EPISODE FROM THE PAST

Introduction

Anastasia Filippoupoliti

Democritus University of Thrace, Greece

Playful, inspirational, performative, recreational, interactive, discursive, engaging, conceptual... Attracting new audiences and exploring effective communication strategies is a primary concern of museum professionals as well as a key subject in the literature of museum studies.[1] A wealth of activities – in addition to the exhibition – aim to make the museum visit a memorable experience. Primarily social, a museum visit should be both a learning process and an enjoyable journey through objects and ideas.[2]

The present collection of articles focuses on science exhibitions and the successes and pitfalls of narrating science within three-dimensional environments. Interdisciplinary in its approach, this volume has brought together international case studies, which confront the practical aspects of setting up a science exhibition and tackle the challenges of evaluating the processes involved. The reader may find a mosaic of scientific themes unfolding – a sort of a directory of ideas – from mathematics and natural sciences, via biology and palaeontology, to cutting-edge research on the technology of networks and engineering.

Structurally, the book exposes the case studies and gradually weaves around them some of the most seminal arguments that illuminate issues of evaluation. What the essays have in common is that they envision the exhibition setting as an open space, a kind of forum where visitors should be invited to interact with the information being presented. In particular, the final section serves as a kind of thematic index, providing an insight into the behind-the-scenes processes

of conceiving an exhibition plan and overcoming potential difficulties.

Curating this volume's essays enabled three elemental subjects to emerge: first, engaging new museum audiences; then, defining and creating the science exhibit; and, finally, activating evaluation tactics.

First, engaging new museum audiences. Locating "best practices" for broader community involvement and developing sustainability is an ongoing issue for museum professionals. What role can innovative tools play in attracting visitors back to the museum? Gillian Thomas' essay, *Crossing the Threshold: Design to Engage*, seeks out strategic approaches which science centres could adopt as a way of increasing visitation and establishing best practice. Focusing on the Miami Science Museum, Thomas examines the concept of crossing a threshold and considers the different needs and practices of museums as a means to reduce barriers to learning and communication. The issue of how to create sustainable relationships between museums and their communities is further investigated by Dhikshana Turakhia's contribution *Communities are for Life, Not Just for Christmas*. Taking as a case study the Science Museum in London, the author addresses the issue by proposing that science centres may be leading the way on the future of museum education and community involvement. Then, Silvia Casini in *Art in Science Centres: A Challenge to Visitors and Evaluators* discusses the kind of challenges and opportunities the use of art poses for visitors and evaluators. She presents alternative tools that can be used,

such as video-based multi-modal analysis of behaviour, to understand visitors' engagement with art-science displays.

Then, defining and creating the science exhibition. The next group of essays explores the multidimensionality of the science exhibit. Few studies in recent literature deal with the theoretical context that lies behind the design of scientific exhibitions. In their article, *A Social Semiotic Framework for the Analysis of Science Exhibits*, Glykeria Anyfandi, Vasilis Koulaidis and Kostas Dimopoulos set out a theoretical approach to the subject. The authors seek to understand the potential of the interactive science exhibit as a conveyor of pedagogic messages. By analyzing a series of case studies, they underline the pedagogic practices involved and the possible implications depending on visiting methods and types of visitor groups. Another team of researchers from Plymouth City Museum (UK) puts theory into practice, discussing the process of developing a natural science exhibition. Jan Freedman, Helen Fothergill and Rob Longworth in *Taxing Taxonomy, Scary Systematics and Confusing Classification: Interactive Activities to Make Scientific Jargon More Accessible* explore the methods employed by several partners, during National Science and Engineering Week, to engage and inspire learners of different ages - and communicate why and how all organisms are named and classified, their relevance to society and their importance to their lives.

Extending this line of argument, Sue Dale Tunnicliffe and Annette Scheersoi question the role of dioramas in communicating biology. There has actually been little

research undertaken into this type of misunderstood exhibit. Dioramas are usually criticised as an old-fashioned approach. Yet the authors, in their paper *Natural History Dioramas: Dusty Relics or Essential Tools for Biology Learning?*, confront this attitude by arguing for the learning potential of dioramas and the multi-layered approach to the sciences that they can provide. Warwick Frost explores the links between museums and popular films as a means of communicating scientific facts. In his article, *Jurassic Park and Visitor Interpretation for Museum Dinosaur Exhibits*, he analyses how elements from *Jurassic Park*, the popular Hollywood film, have been incorporated into exhibitions as a way of interpreting paleontological theories. He argues that museums need to balance the knowledge and enthusiasm generated by such films, with their own scientific and learning objectives.

Eric Siegel and Stephen Miles Uzzo discuss the making of an exhibition on the subject of networks, held at the New York Hall of Science. *Connections: The Nature of Networks - Communicating Complex and Emerging Science* recounts the stages of that work and how it was continuously reshaped by front-end evaluation assessing visitors' perceptions and misconceptions. And finally in this section, Franz Klingender's article, *Science and Technology Exhibits: The Use of Interactives*, offers another perspective on the curator's task of creating an effective exhibit. The exhibition *Food 4 Health* at the Canada Agriculture Museum involves the transformation of complex nutritional information into engaging material for families and school groups. The author examines the

stages of translating research material into physical form.

And then, activating evaluation tactics. This cluster of essays presents a wealth of media along with evaluation strategies employed by exhibition teams to create powerful and meaningful experiences for museum audiences. Karina White in *Beautiful Science: Ideas that Changed the World* discusses the making of a permanent natural sciences exhibition at the Huntington Library, Art Collections and Botanical Gardens in San Marino, California. The author addresses issues of content development, evaluation and design of an exhibition which was eventually awarded the 2009 American Association of Museums *Excellence in Exhibition* award. Then, Kitty Connolly in her paper, *From Setting to Subject: Plants are up to Something*, discusses another award-winning permanent exhibition at the Huntington Botanical Gardens. In this case, the exhibition was conceived as a synthesis of a traditional conservatory and an interactive science center which approached visitors in an engaging way.

Kathy Fox and Kate Phillips in *Redeveloping the Science and Life Gallery at Melbourne Museum* also present design challenges. The authors explore how they tackled the communication of ideas such as time, biodiversity, evolution and earth in the redevelopment of four exhibitions within the Science and Life Gallery. A mix of interpretive media and contemporary design are discussed, which produced engaging, relevant experiences. Then, Jane Magill in *Chips for Everyone: Exploring Engineering Engagement through Practical Interactive Simulation* presents a multi-faceted approach to

communicating engineering. The particular example in this case is semiconductor technology, whose products are in daily use in most Western societies, whilst their design and function is both largely hidden and not well understood.

The following two contributions deal with Charles Darwin. On the occasion of the 2009 bicentenary of the scientist's birth and the 150th anniversary of the publication of *The Origins of Species* a number of events and exhibitions took place in the UK. In *Dealing with Darwin*, Henry McGhie, Pete Brown and Jeff Horsley discuss the concept and gradual development of the Manchester Museum's Darwin exhibition programme. Then, Jenny Cousins in *Science in a Historic House: Presenting Charles Darwin's Work in his Home* offers an insight into how Darwin's residence, Down House, has been used as the ideal setting to interpret the life and work of the scientist, blending together new media and authentic objects.

Next, Ana Delicado questions why - although innovative in its museological approach - the exhibition *Butterflies throughout the times*, held at the Portuguese National Museum of Natural History in 2008, was not a success. In *Between Environment and Science: An Exhibition about Butterflies* she analyses the exhibition content and interviews the curators of the exhibition. Cary Sneider in *Critical Listening: An Essential Element in Exhibit Design* is concerned with the importance of critical listening in exhibition making and evaluation: as experienced in two projects at the Lawrence Hall of Science in Berkeley, California, and a long-term exhibit at the Museum of Science in Boston.

The last two essays in this section deal with the communication of mathematics and economics. George Hart, Cindy Lawrence, Tim Nissen and Glen Whitney demonstrate the value of creating a museum dedicated to mathematics. In *Forming a Museum of Mathematics* the authors explore the design of an exhibition space that aims to manifest in an innovative way the colorful and poetic nature of the subject. Then, Silvia Singer and Carmen Villasenor describe the process of creating the *Market Simulator*, an award-winning exhibit at the Interactive Museum of Economics in Mexico City. In *Market Simulation at the Interactive Museum of Economics* the authors detail the process of making this exhibit, a game that allows twenty visitors to interact and learn. The final article illustrates an episode from the history of science exhibitions. Written by the present editor, *Collected in one View* discusses a seminal international science exhibition held in London in 1876 and reflects on some early concerns about the presention of science and its history.

The book is a thematic companion to *Science Exhibitions: Curation and Design*. Intellectually, it follows the arguments raised in that volume. The museum professional will find in the present volume the practicalities involved in communicating and evaluating a science exhibition. Most of the case studies can be read as memoirs of curatorial practice and experience. The museum theorist will find theoretical perspectives involved in the design of exhibitions. Both, however, will hopefully enjoy the fascinating subject of pondering on and – eventually – creating a science exhibition.

Notes

1 *See for example Black G. 2005. The Engaging Museum: Developing Museum for Visitor Involvement. Routledge; Falk J. & L. Dierking. 2009. Identity and the Museum Visitor Experience. Left Coast Press; Lang C. et al. 2006. The Responsive Museum. Working with Audiences in the Twenty-First Century. Ashgate.*
2 *See for example the work of Falk J. & L. Dierking. 1998. Learning from Museums: Visitors Experiences and the Making of Meaning. Altamira Press; Hein G. 1998. Learning in the Museum. Routledge; Hooper-Greenhill. E. 2007. Museums and Education. Purpose, Pedagogy, Performance. Routledge.*

Acknowledgements

I offer my sincere thanks to Graeme Farnell and all the authors who responded positively to my call for papers and collaborated with me in the transformation of an idea into a publication.

COMMUNICATION AND EVALUATION

1.
ENGAGING
NEW AUDIENCES

Crossing the Threshold: Design To Engage

GILLIAN THOMAS

Miami Science Museum

Since their inception in the mid 20th century, science centers have had an uncomfortable relationship with architecture. Seeking to distinguish themselves from the temples of science represented by the established object-oriented science museums, they frequently inhabited existing buildings, refurbished industrial spaces, and graduated from small shop fronts to warehouse type buildings. Traditional science museums meanwhile gradually adopted science center approaches and the distinction somewhat disappeared as science centers became more established features of the cultural landscape. The last two decades have brought a wave of new science centers and museums worldwide, but few were by notable architects. In the 2004 *Phaidon Atlas of Contemporary World Architecture*[1], 1052 buildings by 656 architects are listed. Sixty nine of these are museums, and only five of these are science centers or museums. None are Children's Museums, aquaria or zoos. More factories are listed than science centers. Two further projects, botanical gardens, are included as Glasshouses and one science center as a cultural center. One of those listed, the Eden Project, an extremely ambitious undertaking adapting a china clay mine, has been very successful, far exceeding visitor predictions. A second, COSI Columbus, Ohio (USA) had difficulty initially in achieving a viable operation, caused in part by the grandness of the architectural vision. It could be postulated therefore that science centers and museums are wary of architecture and do not conceive it as being an important component of their work.

This discussion is not limited to science centers and museums: in the UK's *Sunday Times*[2] recently, Hugh Pearman stated "You know them when you see them, the great public buildings. It's all to do with unshakable confidence." While many major art institutions cited, such as the Guggenheim in New York, the Pompidou Center in Paris and the Guggenheim in Bilbao, Spain have demonstrated how architecture can bring in the crowds, many other signature buildings have been less successful. And Mr Pearman concedes that, "in the jargon of the tourism business, the *experience* is what counts." Ignoring the visitor in the pursuit of architectural brilliance may not be a track to follow.

Similarly, in the *New York Times*[3], architectural columnist Nicolai Ouroussoff recently questioned, "Why is it so difficult to design a great contemporary art museum?" However, art museums do at least have a substantial track record in design buildings which have had a wide appeal to the public and increased visitor numbers. Architecture is seen as a valid expression of and partner to the art within.

The museum building's exterior is the museum's face to the world and its surroundings outside create the social environment for the visit. It should offer the invitation and also express the function of the building, equally important for science as for art. Getting people to step over that threshold will be significantly impacted by the message the building gives to the street about science and the welcome it infers.

Entering a science museum or science center represents both a physical, social and intellectual step for potential

visitors. It is a step into a building, but it is also a commitment to beginning a visit, which is intrinsically a social and cultural activity, and also an indication of being willing to explore science and technology as at least nominally part of that visit. Potential visitors that do not take that first step may be inhibited by a wide variety of reasons. As museums are increasingly aware of their social, as well as educational and cultural responsibilities, the need to integrate an appropriate welcome for all is essential.

To get people into museums or other cultural activities, they need to get across a threshold, either physical (Is this building inviting?), or intellectual and cultural (Am I interested in this? Does that look like something for me?). Developing interest is what draws people into informal learning. As defined by Hidi and Renniger[4], this is typically sparked by environmental features which convey incongruous and surprising information or personal relevance.

This essay explores the environmental aspects of a museum/science center threshold and strategies for encouraging people to step over it. This is not about charged or free museums or great or pedestrian architecture: those are different issues, although great architects should enable us to solve the problems well. It is an attempt to identify some of the factors which make a building welcoming and inviting to a wide variety of people. It is largely influenced by personal experience of working in different countries, with different types and sizes of museums, each with their own individual challenges. The difficulties that our institutions present to many people are varied and wide-

ranging. By exploring existing strategies and some examples, we may be able to better understand how to make our museums welcoming to more.

Location and master-planning

Museum Boards choose locations for a variety of reasons: an available building, opportunity to be part of a cultural quarter, site close to public transport or part of an urban regeneration scheme. Rarely do they have the choice outside of a specific urban district or region. Often the drive of available funding to kick start a local economy is the deciding factor, even when there is no local constraint. The broad demographics of science centers and Children's Museums, along with Aquaria, have made them a favorite for urban regeneration. However, creating a museum as a centerpiece of a development may not function, if the challenges are too great in term of changing people's attitudes, or the surrounding investment is too low or inadequate to change people's experience and sense of security in approaching the site. The relationship of the building to its access is key. In this sense, the threshold begins even before the building curtilege, it's part of the approach from the surrounding area on foot, by public transport or by car.

Master-planning the site can be a contentious process and it is rarely the occasion that the museum is the only player involved, holding all the cards. Frequently the land is a gift from a local authority and commercial and political interests can inhibit sound planning. Other major institutions are

frequently partners, often vying for a perceived "best place" in the development. Three key factors are visibility, security and providing ease of access, especially for families and school groups, the two core audiences. In the US in particular, after many decades of people and housing fleeing the urban core, it is a substantial challenge to invite people back to a previously semi-abandoned district and give a sense of security.

Choosing a location within a developing plan requires an ability to look beyond the immediate museum to the ensemble of the development and the future potential for additional partners. Working together to create that destination is often a challenge due to different sensibilities, a wide range of supporters groups and other agencies or advocates who may initially appear opposed. A social entrepreneurship approach is necessary, to envision the greater good of the whole and to develop a framework within which all can benefit. The creation of a destination is paramount to creating an environment where visitors will feel welcomed and the ancillary services will be adequate. Without that overall sense of security, visitors will come, but not linger and return less frequently. This may well take a decade or more beyond the initial investment of one or two cultural buildings and the surrounding areas, often designated as potential for commercial development, can remain semi-deserted, abandoned and threatening in appearance.

Sometimes, a small gesture from planning authorities can make a big difference and can significantly change how a science center is connected into a community and the

speed with which the urban fabric can be constructed. This is particularly important when planning large scale urban redevelopments where science centers are frequently the major draw and the largest visitor attracting institution.

At-Bristol (UK)

The At-Bristol project, opening in 2000, was part of a large scale urban redevelopment, part of a 55 acre inner urban waterfront site, with 11 acres for At-Bristol, comprising a science center, an environment center (now an aquarium), open squares and spaces and underground parking. The remainder of the site was zoned for mixed use. The site had previously been abandoned for several decades, had one large commercial office building adjacent and frequently was used in the evening by local youth for illegally racing cars. The overall 55 acre Harbourside area was a public private partnership, a determined effort between the Bristol City Council, the Bristol Chamber of Commerce and local landowners and developers to use the opportunity of available funding for cultural institutions as the means to generate momentum and create the infrastructure to initiate the overall redevelopment. This was a substantial challenge as the site had been derelict for over 30 years and numerous attempts to get redevelopment going had only moved forward in very small areas. While within walking distance of the City Cathedral and of a well used city center, this corner of the city was considered dangerous and avoided by people, especially at night. The challenge was to create an environment which

would be welcoming to pedestrians and perceived as safe.

Bristol in the West of England, has a wet though relatively mild climate. One of the planning requirements established for all buildings in the 55 acre site was the need for public covered walkways. All buildings, whether public or private, had to create these, externally or through the interior, with the intent of enabling pedestrians to be able to explore the whole 55 acres, passing from building to building, without needing to be long exposed to the weather.

This requirement had a very beneficial impact on bringing people into the area. Each building as it was developed effectively had a visible link to another and provided a series or arcades or walkways throughout the site. The two main At-Bristol buildings had different architects and different approaches. Wilkinson Eyre for Explore-at-Bristol created a walkway on two sides of the building, one towards Wildwalk-at-Bristol and one fronting on to the main square. Visitors emerging from the parking could quickly be undercover and also see the exhibitions inside. For Wildwalk, Hopkins provided a covered walkway through the interior, linking an existing listed building to the new building. This walkway led from an entry to the site, through to one of the squares. Pedestrians could also use this walkway to access the cafe or simply to regain their cars. This waterfront district of Bristol also has numerous bars and clubs and at night time, a not infrequent question within the walkway was whether this was in fact the night club. This porosity of the buildings and the interconnectedness of the public and private buildings

greatly enhances the ability to attract a wider public and lower the sense of threshold to be crossed.

Similar approaches have been used by other science centers, perhaps most notably recently by Zaha Hadid at the Phaeno Science Center in Wolfsburg, Germany. In an inner urban setting, near twin train tracks, the center integrates and includes this urban circulation pattern within it. The dramatic concrete shell of the building sits on large cones, allowing pedestrian traffic to flow underneath. Visitors are invited through the building as well as in, enabling them to participate without having to commit to enter. The cones themselves are part of the museum services, housing the entrance, bookstore and ways into the conference center and theater. Pavements ramp up to meet the bookstore or dip down to lead to an open plaza under the building. A blue strip leads visitors from the plaza to cross the canal. The *New York Times*[2] described visitors as being "lured from the surrounding street grid to the building's underbelly, pedestrians enter what feels like a secret underground world – a compressed pocket of energy amid the grayness of everyday life." The intermingling of public communal spaces of the city with the ticketed spaces of the museum reduces apprehension and familiarizes visitors.

Inside from outside

The exterior of buildings gives a distinct message about the availability of its contents. The nineteenth century model of temple or cathedral of science talked of authority, but also

respect, aspiration. They tended to keep science at a distance, to be worshipped. At the time that museums were building these temples, the commercial world was beginning to turn the insides out, with the development of department stores and their extensive external windows opening up the available goods to all, whether or not they could be afforded. Controversial at their inception, they featured elaborate architecture with imposing atriums inside with goods displayed in glass cases. The sales people, originally mainly male, rapidly became mostly female. With more focus on mass produced goods, these commercial "palaces" enticed their customers to buy. This was criticized by left and right, either as destroying the livelihood of the artisan, or inciting women to over-spend, with a negative impact on their families. In a short period of time, however, these stores expanded their market to the lower classes, not just the middle class, as rising aspirations and salaries coincided with a wider range of cheaper mass produced goods. Enhanced social equity and access developed from a model with a commercial goal.

The analogy with museums is interesting. It has taken almost an additional century before museums became equally confident about their mission to widen their audiences and use similar approaches to department stores.

Children's museums and a few science centers have either started or currently exist in malls. Generally seen by developers in the same category as art installations or charity stores, i.e. not as good as a commercial tenant, but better than an empty space, a few have made the mall their

permanent location, for example, Petrosians in Malaysia. This reflects the importance of the mall in developing countries: without a cultural quarter, the mall is the air conditioned space available for congregating, the commons for the people. It represents a determined effort to present science as something for everyone and part of everyday life.

Working in Trinidad in 2002 with Dr Sally Duensing, at the invitation of NIHERST (National Institute of Higher Education, Research, Science and Technology), a feasibility study for a science center was undertaken. To better define a building brief, a short study was carried out, showing books of images of museums around the world were shown to a wide range of people. These ranged from government officials, to science center staff, to teachers and visitors to the existing science center. The study was in two stages: interviewees were given sticky markers to attach to pages they found appealing or interesting. In a second stage, they were asked to explain their choices. The aim was to identify any local requirements for external appeal or types of spaces which could be part of the architectural brief.

Given the proximity of South America, the emergence of the kind of modern museum which has become a trend was anticipated: large geometric shaped volumes, sunny colors, possibly tiled finishes. On the contrary, this did not appear at all in choices. There were two main types of buildings chosen: fractured exteriors, and glass and mirror finishes.

Gehry buildings with their intriguing and broken exteriors and Foster buildings with their extensive use of

glass were often chosen. On probing the reasons for choice, the broken exterior generally elicited a response that it looks more inviting, provided lots of ways on, would be easier to get into and out of. The glass and mirror was seen as a way of bringing the outside in, of staying in the sunshine, being outside, enjoying the light. Respondents frequently noted that Trinidadians did not like the dark, they liked to be in the bright light. The importance of external spaces, of places where large family groups could gather and enjoy social events such as picnics, as well as experience some aspect of science and technology was stressed as important.

Undertaking a similar process in Miami in 2003-4, before beginning to write a brief for a new science museum, a different process was undertaken. The Exhibition team, led by Vice President for Exhibitions and Programs, Sean Duran and with Carlos Plaza as interpreter, created an exhibition of approximately 400 images taken from architectural magazines. These were arranged in themes (exterior, interiors, features,) and covered in sheets of Perspex. Each visitor was offered five adhesive dots, to be attached to favored images. Children were offered different colors from adults. At the end of each week, the dots were counted and removed. A computer survey of visitors' preferences for overall buildings was carried out in parallel.

Apart from odd weekends, for example when a Lloyd Wright fan group appeared to be visiting, overall, visitors showed a surprising consistency. Some of the key features which visitors enjoyed were:

- spaces filled with daylight;
- surreal spaces and unusual juxtapositions;
- buildings decorated with colored lighting schemes received widespread approval;
- major features such as parade staircases.

A small but significant subset of visitors chose traditional museum exteriors: flights of stairs plus columns.

The most frequently selected building was not in fact one that existed: a computer-generated image of the Coliseum at Rome, with half the walls replaced by palm trees and a tropical environment. The data for children was not consistent, as there was some color mixing, only a slight indication of increased enjoyment of unusual juxtapositions. Overall, the museum visitors could be said to enjoy being in daylight, seeing unusual and striking features, intrigued by unexpected events and seeking opportunities for appearing, seeing, occasions.

This insistence on the importance of recognition and clear architectural components that people can see themselves in was reinforced during the *Titanic* exhibition in 2006. While the current Museum building is not large enough to house a facsimile of the Titanic staircase, an image, almost full scale, was included. In spite of a range of photogenic objects, many visitors were seen to photograph themselves standing as if on the staircase, a recognizable feature from the film.

Far from a systematic study, these observations indicate that the overall building perception may not be as obvious as is frequently imagined. More ground breaking designs may

well be appealing, if they also correspond to visitors' needs to feel welcomed, easy to access, visible inside etc. For each Museum project, developing a brief which integrates local visitors' sensibilities may well lead to a more welcoming and appealing building.

Connectivity and visibility

A museum building in an urban environment does not just present its exterior to the world, it also provides information about its contents and broadcasts its presence. Working cooperatively to integrate the museums into overall signage strategies for a district gives a stronger identity. The City for Science and Industry in Paris is perhaps one of the better examples of this. As part of the large urban redevelopment project of la Villette, the overall park signage was developed as a strong identity with subsets for each of the individual components of science music and the green spaces, each with a different color and different geometric shape. Since opening in 1986, this overall signage has persisted and the *la Villette* name is often used indiscriminately for both the whole, i.e. the park and its constituent elements of science center, music conservatory, rock concert hall, temporary exhibition space etc, and sometimes as the name of one component. The science center is frequently referred to as *la Villette*, generally by science center professionals, for whom this is the key component of the overall development. For the general visitor, the mix of different cultural facilities and the creation of a destination has increased the accessibility of

science and technology.

Many museums have attempted to stretch out into the communities with installations beyond their boundaries. Several museums have installed objects such as planets at distances representing their relative distances and sizes from the sun. A more interesting strategy is the creation of a family of characters which identify a museum and introducing the public to these outside the museum. Of course, this has been done by Disney for decades, but an individual museum has a brand identity to establish without the major resources of a multinational company. Nevertheless it is a strategy which helps creates a bridge into the museum. One of the earliest and well articulated examples of this is the Museo de los Niños in Caracas, Venezuela. Its small and colorful sculptures of children running towards the Museum from the city environment signal its target market, its refreshing approach to learning and a strong sense of anticipation and enjoyment. A similar strategy was employed by Eureka! The National Museum for Children in Halifax, England, with a family of characters that reflect the audience and can be seen before arrival and continue throughout in the graphics.

Most museums' threshold convention remains that there is a clearly defined ticket barrier, easy to control. Even free museums have a clear entrance procedure and may check visitors' bags. For potential visitors unfamiliar with museums, they may get no further than the free and familiar services before the ticket barrier. Expanding the uses of the museum can expand the demographics of visitors.

At the current Miami Science Museum has a goal to act as a community meeting place, which is an important social focus in a diverse community. As a result, currently 25% of visitors come for something other than a regular ticketed admission. Some of these are free admissions for public meetings held by the City or the County, such as mayoral debates. Others are activities of a wide range of community groups. It is also used as a location for voting (but these visitors are not counted.) Many of these people would not tend to come to the Museum as a visitor, but this type of activity breaks down the barriers and encourages return, although evidence is anecdotal at present.

Conclusion

Visiting a museum is a social activity. Most people come in a group: family, school, friends, colleagues. Individual visitors are rarely a significant proportion of the total visitor numbers and even these do not expect to pass the visit entirely alone. Different groups of people have preferred ways of exploring, from being in large family groups, to wanting a more show oriented approach, or preferring workshop type activities to break that first barrier. These are different issues which merit further exploration in the context of how they could influence museum building design. Getting people over the threshold is however the first step and one which merits substantial consideration in the overall design of museum and science center buildings. Without that first symbolic step into a different world, a wealth of experiences will remain out of

reach. How much we consider visitors' perceptions strongly impacts how successful we will be.

References

Pearman, H. "Recession, what recession? The cultural-buildings juggernaut rolls on". An expanded and updated version of article first published in The Sunday Times, London (January 3, 2010) as "The landmark buildings shaping the next decade". http://www.hughpearman.com/2010/01.html

Phaidon Editors. *Phaidon Atlas of Contemporary World Architecture*, Phaidon Press Ltd, London, 2004.

Ourossoff, N. "Matching Architecture to Art in a new Miami Art Museum". New York Times Architecture Review November 23, 2009.

Hidi, S. and Renniger, K. A. (2006). "The four phase model of interest development". Educational Psychologist 41(2) 111-127.

Communities are for Life, Not Just for Christmas

DHIKSHANA TURAKHIA

Science Museum, London

Is *community* even the best way of describing what we are trying to do?[1]

The question above explores the crucial idea of definition. Trying to define the complex sociological term *community* will lead us to many meanings, but the process in itself of trying to define it – and the trouble it gives us – in fact informs us more than we realize. While at points it may seem that a sound definition of community has been reached, we must comprehend that society is constantly changing, and as these changes occur, our definition loses validity.[2] G.A. Hillery determined in the 1950s that there were fifty-five definitions of community in sociological literature.[3] While we can certainly state there must be many more definitions in 2010, it is clear that the meaning of the term "community" changes with the context in which it is placed. Instead of settling on one term, we must address the diversity, complexity and various characteristics of communities in order to fully understand them.

D.C. Stam asserts that as museums re-address themselves and the diverse communities they seek to serve, we have seen the rise of New Museology.[4] Old Museology was about collections, documentation, and interpretation of objects, while New Museology is about community focus, with the emphasis on community needs.[5] G. Deanty dispels the myths surrounding the meaning of community, and asserts that the word "community" is like a chameleon: changing its colours as it changes its context.[6] He acknowledges the variety of foundations communities can be based on beyond

ethnicity and religion, which has traditionally been the basis of government and museum policy. Communities in a slack physical sense are made up of people, and it is these people who bring meaning to the term. Just because someone is part of a community, their voice is not solely that of the collective, but also of an individual.[7] Museums are slowly realising that communities are not isolated, and that their audiences can belong to a variety of communities simultaneously. Furthermore, governments and museums use broad definitions such as the "Muslim community", "Irish community" or "elderly community", but these only address one aspect of a community group. While someone may consider themselves to be part of one community, they are not excluded from being part of another community, and this is where definitions of "community" become even more technical.[8] Museums must be able to cater for the individual and the many collectives that they are part of.

In this paper, I will be addressing the barriers that all museums face in their desire to work with community groups. While I have briefly tried to outline the complex nature of the term "community" in this introduction, my use of it in this paper is in relation to museums trying to engage with a community group or organization that is not visiting their institution. By no means am I asserting that the approaches discussed are the only ways to target community organizations, but I will be using the London Science Museum as a case study through which to examine the nature of community relationships with museums. The

Science Museum is a national museum, part of an umbrella organisation called the National Museum of Science and Industry (NMSI). The Science Museum has developed from being a museum reflecting the principles of the Enlightenment thinking of the late 19th century, to becoming a museum that wants to exemplify the advancing world of science. I analysed the Museum's audience research and conducted my own research on outreach community engagement during my masters in 2008, and am now employed in the Schools and Community Outreach Team.

Community engagement is one part of the audience development programmes that all museums have in place. I will be discussing the work that the Science Museum's Audience Research Team conducts, alongside the work of its Outreach Teams, but the crucial point is that the success of community and museum cohesion requires a holistic approach from the museum and the community together. I am going to examine the nature of the relationship that is required from both sides.

Breaking down barriers, building up relationships

The concept of barriers is important to understanding how museums and communities must work together to eradicate the past and present inequalities of access and build a new culture of inclusion.[9] The deconstruction of barriers has recently gained increasing importance and emphasis in museum policy.[10] Barriers exist throughout society, and the crucial factor museums need to realize is that they cannot

just deal with one barrier at a time, nor can they deal with barriers by themselves. Both museums and communities need to work together to dismantle barriers for there to be a sound and solid relationship between them.

There are a great number of barriers present between museums and communities, and these barriers lie internally and externally to the museum. When museums decide to deal with the barriers between them and the communities they wish to work with, "the engaging museum removes all barriers, not just one".[11] For a museum to be successful in breaking these barriers would require it to deal with all the barriers present. This means that a museum would have to change as much internally as they would externally. Internal barriers can include factors such as on-going fears of alienating existing audiences, a lack of resources, a lack of confidence (or at least uncertainty), a fear of the unknown, and support from management.[12] Staff must actively work with and represent the communities the museum wants to build a relationship with, and communities need to see themselves as part of the museum's working life to fully feel that they belong there.[13] External barriers can be physical, emotional, intellectual, social, or geographical, all in relation to a potential visitor.[14] Together these barriers have a dramatically demotivating effect on both sides. The solutions to the barriers and the creation of sustainable lasting relationships between museums and communities are not easy and not universal. Museums have to understand both communities and themselves, but also realize that this

knowledge is subject to change.

Museum staff have a tough, everlasting fight on their hands for barriers to be deconstructed, while communities perhaps feel that nothing is actively being done to include them, or that all efforts are merely tokenistic. The process seems never-ending.[15] Both museums and communities need to look at their potential relationship not in an isolated fashion but in the context of relationships in general. The very concept of building a relationship in life requires effort and time to be committed, and as new challenges are faced, both parties have to be willing to pull together and deal with them efficiently and persistently.

In 2007, the Department of Culture, Media, and Sport (DCMS) produced a report entitled *Inspiration, Identity, and Learning: The Value of Museums Second Study.* This report outlines that community work instigated by museums is relatively new in the United Kingdom.[16] However, the report does acknowledge that some museums in the UK are actively and successfully engaging with communities. The report compares a community group with a school group, both of children visiting the same museum. The results show that the children who came with a community group achieved higher and more positive learning outcomes than the children who came with their school.[17] This example shows that school visits to a museum entail a certain atmosphere, and that the whole experience is affected by the expectations of the children. Visiting as part of a community group, with friends and family, changes the atmosphere and expectations.

Museums need to realize that they have the potential to change perceptions of museums in young visitors' minds, possibly making them life-long museum visitors. [18]

Many national museums over the last twelve years under the Labour Government have begun to give education more importance. The Science Museum is no exception – education is very much at the heart of its offer to its visitors. This can be seen from the importance given to the learning unit teams in the Museum's organizational structure, and the employment of staff from within the learning unit at high levels of management in not only the Science Museum but also NMSI as a whole. Since the Museum receives public funding, it needs to prove its active role in society and its aims to continue to develop sustainable relationships and partnerships. [19]

The Science Museum is not just beginning to think about diversity, but is endeavouring to further its diversity both internally and externally. The Museum has in place a Diversity Panel that advises the Director of NMSI on making the Museum more accessible and appealing to diverse audiences. The Museum employs two full-time staff members to focus on the issue of diversifying internally and externally, as well as training all staff on the issues of diversity. Furthermore, the Museum's Audience Research Team conducts a variety of research and consultation into access and inclusion for the Museum both on and off site. Finally, the Museum has an Outreach Team, one of its principle goals being to increase access and engagement with the Museum's resources and collections, not only in London but also nationally and abroad.

The museum experience

Falk and Dierking have written extensively about museum barriers. They allege that there are four pre-museum visit barriers, which will affect a visitor's choice to enter a museum. The first is personal interest and desires. Cost is the second, be this money spent, or the cost of time spent. Convenience is the third, which brings up a whole plethora of questions from how easy it is to get to the museum, to where the visitor will eat and drink, to how many other people will be at the museum. Finally, we have the barrier of benefit. Visitors will ask themselves if a trip to the museum will benefit their lives in any way, and whether they feel comfortable in a museum both physically and emotionally.[20] As Black asserts, when a museum chooses to break the barriers that stand between them and their communities, they are in effect choosing to change human behaviour.[21]

'Different kinds of museums will attract different kinds of people'.[22] Falk and Dierking use socio-economic brackets to differentiate who museum visitors are and what type of museum they may frequent – with obvious but not necessarily accurate conclusions. Museums are primarily places of learning. Visitors in our multicultural society may not hold certain class status, but their levels of education and cultural understanding can still be high, and of course, this model can be applied in reverse. The use of socio-economic data by museums when trying to target communities needs to change. It is time for museums to focus on the communities themselves: what they are, who they are, why they exist, what

they know and want to know. This interest in communities in a personal context rather than a demographic context will be far more informing about visitors. It also in a large part demonstrates their interests and expectations, and whether the community actually want to be part of a museum-community relationship. On some occasions, rejection will have to be accepted on both sides.[23]

Barriers cannot be built on their own. For barriers to be present, they must have been raised. It would be easy to suggest that museums are responsible for the presence of barriers between themselves and communities they seek to build relationships with, but as Bennet affirms, this is an unfair demonization of the museum. This negative attitude towards the presence of barriers and their connection to museums should be avoided. Museums are constantly under fire, even though they are actively trying to change their practices.[24] Bennet advocates that communities are subject to the effects of government, thus changes have to occur at government level before changes can take place between museums and communities themselves. Witcomb claims that Bennet's model romanticizes the whole debate of community, museum, and government relations.[25] I thoroughly agree with Witcomb's argument – while it is easy to see the great importance government plays in museum-community relations, Bennett suggests that the sole power lies in the government's lap, and this is not wholly true.

Clifford's model asserts that museums should themselves be viewed as a community that is trying to find their own

cultural values and conventions. Witcomb endorses Clifford's model as a more realistic and successful argument for the creation of sustainable relations between museums and communities. Additionally, Clifford's theory supports my argument that museums are non-static, constantly changing, and re-evaluating entities. Museums do have a certain power, but they are still unstable and constantly struggling to get to grips with themselves.[26] Neither should try to work alone in the building of their relationship and neither should take all their leads from government policies. Bennett and Clifford's models together would create the most productive and to some degree holistic solution to the deconstruction of barriers and lasting, sustainable relations between museums and communities.

Museums are reaching out in new ways to local audiences of all kinds with specific posts and programmes.[27] I believe that museums can account for the lack of integration with communities with two major factors. The first factor is that a community does not see themselves represented within the museum, and feels that the collections are isolated from them. To break this first barrier down, museums now collaborate with communities to make links to their collections and create special exhibitions or events relating to them. The second factor is a museum's inability to draw communities in, and communities not wanting to visit a museum for a variety of reasons. The rest of this paper will tackle these two factors in detail.

Factor one: communities inside museums

The Science Museum's Audience Research Department (in conjunction with the Museum's Dana Centre) have conducted in-depth research and produced events in partnership with a variety of communities that are underrepresented at the Museum. I want to discuss the research and events created with the Chinese community through an audience-led process, as this particular study has produced many valuable lessons. Members of the target audience were invited to identify the theme of a specific topic or event, then to address the barriers that were present for their communities both attending the event in question and concerning the institution as a whole. This research was conducted before, during, and after the event development.[28] This style of research is particularly useful to the Science Museum's active understanding of communities. The Museum's impetus to identify the needs and opinions of communities shows that they are not only responding to Government pressures, but also reacting to London's diverse population and their connection to the museum.

The Museum's decision to focus on building a sustainable relationship with the Chinese community had three major motives. The under representation in itself of the Chinese community at the Science Museum; the fact that previous work had been undertaken with the Chinese community and had not created a lasting relationship; and in 2006 the London Mayor's Office putting the Chinese community at the forefront of cultural targeting, through the *China-in-*

London initiative.[29] Government pressure clearly played a part here, but it is positive that the Museum took initiative from its previous efforts with the community, which had not followed through as successfully as had been hoped. The Museum did not accept defeat, nor repeat the same technique of connecting to the community. Instead, they approached it from a new and unique angle, advocating that the work they were to conduct with the Chinese community was not tokenistic, but a measure that they wanted to push to its fullest potential.

Simonsson comments that the Science Museum quickly became aware that the Chinese community in London was itself very diverse.[30] Communities are far more complex than they appear, and so to actively work with a specific community, museums need to understand the community group's make-up. The Chinese community is made up of everyone from professionals to asylum seekers, thus while relationships can be built with each sub community, the breaking down of initial barriers must be individually tailored. For example, the British-Chinese members of the community – the members born and brought up in Britain – would not have barriers such as language blocking their visit to the museum. Instead, the barriers that would affect them would be the same as those, which impede all young Londoners – barriers such as time and options to participate in other leisure activities.[31] Meanwhile, new immigrant members of the Chinese community would face barriers such as language, and may feel that the Science Museum is not intended for them. Simonsson states that the

Museum can solve this by being clear who they are targeting within the community, and most certainly cannot target the whole community in one go.[32]

During 2006, the Science Museum conducted research into the creation of an event on Chinese Medicine with a focus group made up of gatekeepers of the London–Chinese community.[33] Communities in today's world are very wary of being chosen for tokenistic reasons and can be untrustworthy of large institutions like museums. The presence of a gatekeeper that the community trusts enables museums to gain the confidence of the community as a whole far more quickly. The Science Museum's consultation was used to understand the Chinese community and their presence in London society.[34] The focus group felt they were a silent community, focused on family and working hard, and was established as a strong ethnic community in London. They also felt however that their community had negative representation, and that other Londoners perceived them to be entirely made up of asylum seekers, illegal immigrants, and Chinese takeaway owners. They wanted to dispel this myth, and felt that the Science Museum could assist them in this goal.[35] The Museum was enabling the Chinese Community to gain a self-defined outcome from the final event. The Museum showed the community that their assistance in the development of the event was not only for the benefit of the Museum. The Museum used the consultation not only for gaining information for their own research and events, but also to better understand the community they wanted

to build a relationship with – as with any relationship in any context, both parties firstly have to get to know each other.

The theme of the Chinese Medicine event was considered interesting and relevant to the community members involved. The consultation determined that Chinese Medicine should be exhibited in the context of tradition, culture, heritage, and identity. They wanted reference made to the idea that leaving China and immigrating abroad meant that traditional remedies were slowly being lost. Furthermore, they wanted to see how Chinese medicine was now complementing and having some presence in Western medicine. They did not however want it to be a debate about which was superior, nor did they want to promote Chinese stereotypes.[36]

From this consultation, two events were created: *Being Chinese: East – West Matters*, and *Being Chinese: Eat Your Way to Health*. The focus group insisted that *Being Chinese* as a title would alienate British-Chinese members of the community who identify themselves with both nations, and so the final title became *Chinese Traditions*.[37]

The marketing for the event was key. The focus group specified that the images used in promotional material should be non-stereotypical, exciting, and unique. The final promotional leaflets were distributed by marketing company London Calling, targeting the Chinese Embassy; Chinese restaurants; Chinese health clinics; and an advert was placed on a Chinese website. The Museum was advised that word of mouth carried a lot of weight, and so specific members of the focus group targeted community organizations that they were

affiliated with. Meanwhile, Science Museum staff targeted the Camden Chinese Centre; the Chinese National Centre for Healthy Living; and the Institute of Chinese Medicine, as well as Chinese newspapers; Chinese network agencies; Chinese student union societies and Chinese television.[38] The Museum took a unique and very personal approach to the marketing of this event, dismantling the barrier of informing a potential audience. The final event was a success and brought in visitors of other cultural and ethnic backgrounds as well as the London Chinese community. The Museum through its initiative with the Chinese community adheres to the International Community of Museums statement that, museums have become forums for the encouragement of community interaction and concord. [39]

The Museum conducted a follow-up with the focus group after the events. The group felt overall that their views and ideas had been taken into consideration, and that the event was unique, relevant, and interesting, with most members feeling that they had learned something new. As with any event or exhibition, there was of course some constructive criticism. The community wanted a bigger connection to their everyday lives, and information about Chinese medicine on the high street – this would have created further connections specifically to the London-Chinese community.[40] The Museum's follow-up consultation demonstrated to the Chinese community that they were making the first step and truly indicating an interest in building a lasting relationship.

Factor two: communities outside the museum

Communities may decide for a variety of reasons that they do not want to visit a museum. To dismantle this barrier, museums are now taking their collections to the community in outreach programmes. This concept is not new or unique, but most museums' outreach departments are sidelined in favour of traditional methods of in-house education initiatives, and do not fulfil their true potential. Although the outreach approach is beginning to show excellent results in some museums, Black warns that outreach work should not be an add-on, but instead an integral part of the education department and its output.[41]

Many outreach teams focus on schools, with communities as an afterthought. Communities have to feel that the reason for a museum placing so much effort on working with them results from the museum's desire, not outside pressure or a governmental priority list. In a perfect world, community and schools outreach would each have their own team – a community team could then be dedicated to dismantling every barrier possible between the museum and communities. A team dedicated to community outreach can develop tailor made events; take the collections to the community; work with them on developing exhibitions in and outside the museum; and collaborate with other museums and their community teams and groups. This way there would be a more holistic approach to museums interacting and working together, as well as with communities. However, due to museums constantly being financially constrained,

it is unlikely for a museum to have two separate outreach teams. In addition to the current financial climate creating limitations on museums' own budgets, work being proposed with communities is being hit by reduced sponsorship and potential policy change at national and local government level.[42] It is therefore essential that in teams that target both schools and communities, managers and staff ensure that they fully invest time and resources in connecting with community groups.

Science museum outreach

The Science Museum Outreach Team has developed over a period of about ten years. At first, it was outreach in its simplest form, with shows being delivered in and around London. Its initial success led to external funding and the chance for the Team to develop and broaden its remit. As the Team's popularity grew and external funding ended, the sustainability of the outreach offer was only possible by charging schools. The Museum's Outreach service grew and was split into two teams – one for schools and one for communities. These teams later merged to make one united Schools and Community Outreach Team. This may be considered a step backwards, but while having two separate outreach teams is an ideal scenario, museums are always low on funds, so measures like this can often be necessary to maintain the best possible education offer.

The Science Museum has been and continues to be unique in its approach to education, and the Outreach Team plays

a big part in the Museum connecting with audiences that would not otherwise visit. The Team as a whole is committed to furthering access to the Museum, as well as spreading best practice to other organizations. The Outreach Team is not one body, but is made up of a collective of teams that all have different goals, enabling the Museum to be taken out beyond its four walls and many mezzanine levels. For this paper, I will be focusing on the success of the Creative Canal Outreach Project and the Schools and Community Outreach Team.

The Creative Canal project

The Creative Canal Project (CCP) was an outreach project that was jointly funded by the Department for Culture, Media, and Sport and the Department for Children, Schools and Families. It was part of the Strategic Commissioning Programme for Museum and Gallery Education, and ran from November 2003 until March 2009.[43] During the Project, the team worked with 72 community groups based near the Regents Canal in London, that had not previously been reached by the Museum. CCP involved sessions in a floating classroom on the London canal network that took schools and communities on science-based trips along the canals, along with planned visits to the Science Museum and visits by the CCP team to the groups' schools or community centres. Here the Museum achieved the foundations of a relationship with specific community groups. The idea was to give them not just one event and point of contact, but three, after which a group will perhaps feel that they want to visit the Science Museum of their own accord.

CCP established that communities go through a process of acceptance with museums. Community groups stayed in touch after the completion of events, coming to the Museum for further visits and inviting outreach staff to their own events. Group leaders passed the Outreach Team's contacts on to other community organisations, showing the value that group leaders saw in the Project. Participant numbers grew as the project went on – a clear indication of success and the trust that the communities felt in the project. Community groups' perceptions of the Science Museum and local smaller museums appeared to change, and some group members commented that they had never studied science as children but enjoyed the Project and exposure to new scientific words and concepts.[44]

The Science Museum gives careful consideration as to how to use its funding, in the most positive and unique way, to continuously engage new audiences – in some ways they have little choice as they are nationally funded, but at heart they are eager to engage people; promote the full potential of science; and reach the most diverse audiences possible. CCP is an example of a brilliant, successful and unique community initiative, and was a success due to its funding and the commitment and skills of its staff. The end of the Project did not see the end of unique community initiatives from the Outreach Team – it has led directly to an exciting new outreach project called Collecting Stories (CS).

Collecting stories

Collecting Stories: How collections of any kind can support the study and understanding of science, technology, engineering, maths, and the creative industries.[45] The focus of this outreach project is on assisting other regional museums in creating more accessible education resources, to share the best practice that the Science Museum and its Outreach Team is famed for. The Project will run for two years, with the first year culminating in a series of launch events held at the regional museums and their local museums, involving scientists and local Key Stage Three schoolchildren. These events will display the work undertaken on the project and inspire the museums to embed this way of working into their programming. In the second year of the project, the CS Team will invite all first year regional museums to skill-share with two new satellite museums in their regions. Although this project is currently timed at two years, the aim is to build and embed skills in museums permanently.[46] The Science Museum Outreach Team is considering how it can broaden its community remit beyond London, and how all museums can become more successful in their endeavour to engage with communities in and outside the museum building.

Schools and community outreach

This team consists of five Outreach Officers, who take the interactive, hands-on nature of the Museum's galleries and shows to schools and communities across the country and abroad. The Team has a variety of shows and workshops

aimed at children from Foundation Stage to Key Stage Four. The Team also develops new shows and workshops, and each officer takes on personal projects, such as collating statistics or furthering Special Educational Needs provision.[47]

The Schools and Community Outreach Team (S&C Team) is heavily in demand from schools, but wants to further progress its community relations. Unlike some organizations that consider schools and communities to be one entity, the Team targets schools and communities as separate bodies, and has very different approaches to dealing with each. The Team has made the first steps towards being more flexible for communities – both schools and communities are charged for the delivery of outreach sessions, but community groups are given reduced rates. In addition, schools must book a term in advance for the Team to visit their school due to high demand, but a community group can book at any time.

Before September 2008, the S&C Team had a community strategy that saw each of the five members researching and contacting local community groups that had been addressed by the Audience Research Team in their previous research. In early community strategies it is clear that a differentiation had been made between schools and communities, and that the Team was being as active as possible in targeting underrepresented communities. The issue that arose from this strategy was that the time required for success with this approach was not available – the Team did and still does deliver outreach sessions four days a week, leaving very little time to research and contact community groups.

The community strategy that I developed was based on qualitative research that I conducted for my masters dissertation in the summer of 2008 for the S&C Team.[48] I have since become a member of the Team and have been able to begin implementing and building on my recommendations for community engagement. The strategy is by no means complete – as I have reiterated throughout this paper, working with communities is an incessant process, involving acceptance of continuous change and adaptation. The strategy that I developed saw me researching and planning a list of community groups for each of the designated communities that were addressed by the Audience Research Team as underrepresented in the Museum. Each of the five members then took charge of one of the five lists. Community groups like constants and familiarity – they are often apprehensive of large organizations approaching them. Having one team member constantly in contact from the initial query through to delivery of the session and beyond would see the Team become successful in building lasting relationships with communities. While the communities that the Team target are outlined by the Museum's Audience Research Team, the internal support from managers and the Team's interest and dedication to furthering their community interaction is a key part in its immediate and future success. The Group for Education in Museums held a conference in Birmingham in 2009 discussing community initiatives within the museum sector, at which John Reeve – editor of the *Journal of Education in Museums* – commented that prolonged good practice across

the museum sector is reliant on inspirational and determined leaders.[49] The managers of the Outreach Team are fully committed to pursuing communities because of the benefit to the communities and the Museum. They ingrain this rhetoric within staff – managers do not merely preach the possible benefits, but include community interaction as a major objective in the job descriptions of the S&C Team Officers.

As part of my initiative, the S&C Team prepared an information pack to send out to community organizations. The Team advertises its learning offer in the Science Museum's *What's On* Guide. These were sent out with personal letters to community leaders indicating which sessions would be suitable for their community group. The S&C Team sent these packs out, and then called community leaders two weeks later. Cold calling and reeling off information at a community leader would be futile, whilst discussing options would be easier if community leaders had information packs in front of them. I did realize that just one phone call would not see groups booking us – each member in fact spent the best part of an academic year chasing their respective communities.

After a year of this strategy, it became obvious that even beginning to build the foundations of a relationship with these newly targeted communities was not effective, and there were some clear indications why. A number of community groups did ask why we were targeting them and what relevance we had for their members. This was due to the S&C Team's education offer being predominantly youth based, although a lot of the workshops and shows work well

with audiences with wide age-ranges, due to their interactive nature. The contacted groups were however more interested in in-house tailored events or tours by curatorial staff. Communities are not shy in asking for what they want – they know that museums may want to work with them, but are also under pressure to do so. Although their requests were out of the remit of the S&C Team, the Team did not give up their goal of interacting and building relationships with their desired communities. Lessons were learnt from the strategy, and a new approach that is even more honed and detailed has been produced for the S&C Team.

Using local council documents that outline where the majority of youth community groups for our selected communities in the London boroughs are based, I have been able to break down whom we should be targeting. I have spoken to education liaison managers in these London boroughs, and gained a unit list – a registered list of youth groups. The Team members are still in charge of a list of community groups, not only because this was one piece of the positive feedback we had, but also because all Team members liked this personal approach and the link they made to a community. A crucial point that emerged from my initial research and the Team's continuing interaction with new community groups is that once we work with a community, they come to trust our service, and they value the relationship that is blossoming and book us again. The Team could be content with the community groups they already work with on a regular basis, but the decision to further their

community links is a benefit for the Museum as a whole. As well as addressing the communities that have been identified by the Audience Research Team, they are looking to become pioneers in museum community relations, as exemplified by their recent outreach session at HM Prison Holloway, a women's prison in London.

Solutions and conclusions

The process of creating solutions to barriers and building sustainable relationships is not going to happen quickly or in isolation. Museums have to acknowledge that working together is the key – this is as crucial internally as it is externally. It must be acknowledged that outreach and audience development agendas are crucial elements in building community relations, but that they are only part of the solution.[50] The success of community engagement programmes relies on a more museum-wide interaction that goes beyond the learning and audience research department. During the process they must not take their existing visiting communities for granted – the changes they make for certain community groups do after all have the potential to be a benefit for all visitors alike.[51]

Stephen Weil states that at some point forty to fifty years into the 21st century, the relative position of the museum and public will have revolved 180 degrees.[52] Museums will emerge with a new relationship with the public, which will see the public holding the power. The museum as we know it, one of mystery, will become one of service.[53] Museums in their

long history have shown us how they can change, adjust, and on some occasions revert to previous traditional ways of working. A return to traditional museum thinking is not as negative as it may sound, as at the birth of museums two hundred years ago in Europe, the position of the museum in society was one of superiority, but museums were also central to community.[54] The shift will perhaps then be 360 degrees rather than 180. However museums change, the constant is that they are continually shifting. There is no one-size-fits-all solution and there most certainly is not an end to the argument. Change, adaptation, and adjustment are the three qualities for museums and communities to embrace in order to succeed when building sustainable relationships.

The answer in some cases is to tailor packages specifically to a community group, as was conducted by the Audience Research Team at the Science Museum and the London Chinese community. In fact, many museums in the United Kingdom's diverse society are now creating events aimed at specific communities, including for example events for Black History Month, Diwali and Gay Pride. Showing initiative by creating these events is all very well, but they need to integrate them into their day-to-day education offer, to prove that they are not merely following government policy or succumbing to tokenism. Making tailor-made packages is not always an option, so there are many other courses of action that can taken. The Science Museum Outreach Team has and continues to build sustainable relationships, by making connections with a community, and working slowly and flexibly with

them over a period of time.

Communities will feel disappointed if they realize that a museum has purely targeted them because of government or funding pressure, and they are likely to terminate any partnership being established and become distrustful of museums as a whole. While museums cannot eliminate the pressure placed on them by government or management bodies to target certain communities, they must make every effort to show their commitment in the end. Museums need to learn the fine art of balance: drawing in new communities without excluding old communities, whilst constantly working to build lasting relationships with all communities.[55] The only real solution is to be actively involved with communities and support them in their decision to either become part of a museum partnership, or – as will occur in some cases – reject the museum partnership altogether. Communities are precarious and fluctuating entities that people can choose to be part of; to not be a part of; and in some cases to leave, according to other variables in their lives. Museums are going to have to learn to accept that they will never fully understand every community, as they are unstable, adaptable, and changeable entities. The key is to enjoy and gain all the experiences possible from relationships while they last.

Notes

1 John Reeve, (2009). Editorial: Engaging Diverse Communities. Journal of Education in Museums. Group for Education in Museums, pp. 4

2 Elizabeth Crooke, Museums and Communities - Ideas, Issues and Challenges. (London: Routledge, 2007), 2

3 Elizabeth Crooke, Museums and Communities - Ideas, Issues and Challenges. (London: Routledge, 2007), 29

4 Deirdre Stam, "The Informed Museum: The Implications of The New Museology for Museum Practice," in Heritage, Museums and Galleries - An Introductory Reader, edited by Graham Corsane, (London: Routledge, 2006), 43

5 Sheila Watson, Museums and Their Communities. (London: Routledge, 2007), 13

6 Elizabeth Crooke, Museums and Communities - Ideas, Issues and Challenges. (London: Routledge, 2007), 30

7 Ivan Karp, Museums and Communities: The Politics of Public Culture (Washington and London: Smithsonian Institution Press, 1992) 12

8 Ivan Karp, Museums and Communities: The Politics of Public Culture (Washington and London: Smithsonian Institution Press, 1992) 4

9 Graham Black, The Engaging Museum. (London: Routledge, 2007), 54

10 Jocelyn Dodd and Richard Sandall, Including Museums - Perspectives on Museums, Galleries, and Social Inclusion (University of Leicester: Research Center for Museums and Galleries, 2001), IV

11 Graham Black, The Engaging Museum. (London: Routledge, 2007), 64

12 Graham Black, The Engaging Museum. (London: Routledge, 2007), 54

13 Sheila Watson, Museums and Their Communities (London: Routledge, 2007), 17

14 Graham Black, The Engaging Museum. (London: Routledge, 2007), 47

15 Graham Black, The Engaging Museum. (London: Routledge, 2007), 54

16 Department for Culture, Media and Sport. (2007). Inspiration, Identity, and Learning: The Value of Museums Second Study. University of Leicester:

Research Center for Museums and Galleries, 38

17 Department for Culture, Media and Sport. (2007). Inspiration, Identity, and Learning: The Value of Museums Second Study. University of Leicester: Research Center for Museums and Galleries,38

18 Department for Culture, Media and Sport. (2007). Inspiration, Identity, and Learning: The Value of Museums Second Study. University of Leicester: Research Center for Museums and Galleries, 38

19 Jocelyn Dodd and Richard Sandall, Including Museums - Perspectives on Museums, Galleries, and Social Inclusion (University of Leicester: Research Center for Museums and Galleries, 2001), IV

20 Lynn Dierking, and John H Falk. The Museum Experience (Washington: Whalesback Books, 1997), 13

21 Graham Black, The Engaging Museum. (London: Routledge, 2007), 61

22 Lynn Dierking, and John H Falk. The Museum Experience (Washington: Whalesback Books, 1997), 22

23 Lynn Dierking, and John H Falk. The Museum Experience (Washington: Whalesback Books, 1997), 24

24 Andrea Witcomb, Re-imagining the Museum - Beyond the Mausoleum. (London: Routledge, 2003), 81

25 Andrea Witcomb, Re-imagining the Museum - Beyond the Mausoleum. (London: Routledge, 2003), 8199

26 Andrea Witcomb, Re-imagining the Museum - Beyond the Mausoleum. (London: Routledge, 2003), 8189

27 John Reeve, "Editorial: Engaging Diverse Communities," Journal of Education in Museums 30 (2009): 3

28 Science Museum - Evaluation Seminar (London: Science Museum, 2007) 4

29 Science Museum - Evaluation Seminar (London: Science Museum, 2007) 4

30 Science Museum - Evaluation Seminar (London: Science Museum, 2007) 2

31 *Science Museum - Evaluation Seminar (London: Science Museum, 2007) 4*

32 *Science Museum - Evaluation Seminar (London: Science Museum, 2007) 2*

33 *Science Museum - Evaluation Seminar (London: Science Museum, 2007) 4*

34 *Science Museum - Evaluation Seminar (London: Science Museum, 2007) 7*

35 *Science Museum - Evaluation Seminar (London: Science Museum, 2007) 7*

36 *Science Museum - Evaluation Seminar (London: Science Museum, 2007) 7 - 8*

37 *Science Museum - Evaluation Seminar (London: Science Museum, 2007) 9*

38 *Science Museum - Evaluation Seminar (London: Science Museum, 2007) 8*

39 *Elizabeth Crooke, Museums and Communities - Ideas, Issues and Challenges. (London: Routledge, 2007), 133*

40 *Science Museum - Evaluation Seminar (London: Science Museum, 2007) 11*

41 *Graham Black, The Engaging Museum. (London: Routledge, 2007), 65*

42 *John Reeve, "Editorial: Engaging Diverse Communities," Journal of Education in Museums 30 (2009): 5*

43 *Kate Kuechel. The Creative Canal Project - Project report 2003 - 2009. Science Museum Learning. 2009, 3*

44 *Kate Kuechel. The Creative Canal Project - Project report 2003 - 2009. Science Museum Learning. 2009, 17*

45 *National Museum of Science and Industry; SM/NRM Strategic Commissioning Proposal 2009 - 2011.*

46 *National Museum of Science and Industry; SM/NRM Strategic Commissioning Proposal 2009 - 2011.*

47 *National Museum of Science and Industry; SM/NRM Strategic Commissioning Proposal 2009 - 2011.*

48 *Dhikshana Turakhia, "Communities are for Life, Not Just for Christmas: The History and Meaning of Community, the Barriers that Stand Between Communities and Museums, and the Potential for Sustainable Lasting Relationships" (MA diss, Institute of Education, London, 2008), 32 - 45.*

49 John Reeve, 'Editorial: Engaging Diverse Communities,' *Journal of Education in Museums* 30 (2009):1

50 Ian Blackwell, "Community Engagement: Why are community voices still unheard?" *Journal for Museums in Education* 30 (2009): 31

51 Graham Black, *The Engaging Museum.* (London: Routledge, 2007), 65

52 Stephen Weil, *the museum and their public* in *Museums and Their Communities* (London: Routledge, 2007), 31

53 Sheila Watson, *Museums and Their Communities* (London: Routledge, 2007), 33

54 Dhikshana Turakhia, "Communities are for Life, Not Just for Christmas: The History and Meaning of Community, the Barriers that Stand Between Communities and Museums, and the Potential for Sustainable Lasting Relationships" (MA diss, Institute of Education, London, 2008), 10

55 Sheila Watson, *Museums and Their Communities* (London: Routledge, 2007), 17.

References

Black, Graham. *The Engaging Museum*. London: Routledge, 2007.

Blackwell, Ian. 'Community Engagement: Why are community voices still unheard?' *Journal for Museums in Education* (2009): 31 – 36.

Crooke, Elizabeth. *Museums and Communities - Ideas, Issues and Challenges*. London: Routledge, 2007

Department for Culture, Media and Sport. *Inspiration, Identity, and Learning: The Value of Museums Second Study*. University of Leicester: Research Center for Museums and Galleries, 2007

Dierking, L.D., and John H Falk. *The Museum Experience*. Washington: Whalesback Books, 1997.

Dodd, Jocelyn, and Sandell, Richard. *Including Museums - Perspectives on Museums, Galleries, and Social Inclusion*. University of Leicester: Research Center for Museums and Galleries, 2001.

Karp, Ivan. *Introduction to Museums and Communities: The Politics of Public Culture*. Washington and London: Smithsonian Institution Press, 1992.

Kuechel, Kate. *The Creative Canal Project - Project report 2003 -2009*. Science Museum Learning. 2009.

National Museum of Science and Industry. *SM/NRM Strategic Commissioning Proposal 2009 -2011*.

Reeve, John. (2009). Editorial: Engaging Diverse Communities. *Journal of Education in Museums*. Group for Education in Museums, 1 – 8.

Science Museum. *Evaluation Seminar.* London: Science
 Museum. (2007)

Stam, Deirdre. 'The Informed Museum: The Implications of
 The New Museology for Museum Practice,' in *Heritage,
 Museums and Galleries – An Introductory Reader*, edited by
 Graham Corsane, 54 -70. London: Routledge, 2006

Turakhia, Dhikshana. *Communities are for Life, Not Just for
 Christmas: The History and Meaning of Community, the
 Barriers that Stand Between Communities and Museums, and
 the Potential for Sustainable Lasting Relationships* (MA diss,
 Institute of Education, London, 2008)

Watson, Sheila. *Museums and Their Communities.* London:
 Routledge, 2007

Weil, Stephen. 'The Museum and the Public,' in *Museums
 and Their Communities*, edited by Sheila Watson, 31 - 46.
 London: Routledge, 2007

Witcomb, Andrea. *Re-imagining the Museum – Beyond the
 Mausoleum.* London: Routledge, 2003.

Art in Science Centres:
A Challenge to Visitors and Evaluators

Observa – Science in Society

Vicenza, Italy

Neuroscientist Steven Rose claims that an instrument itself, such as a scientific tool – shapes, and sometimes reduces, the world it depicts and our perception of it. Thus, when we hold a hammer, everything will appear more or less as a nail (Rose 2005). But what would happen if the same instrument were taken out of its original context and employed in an alternative way? This simple question has grounded not only much of the contemporary research both in the sciences and the arts, but also the encounters between the two.

The past decade has seen a proliferation of science-art exhibitions and festivals, drawing public attention to cross-fertilisation between techno-science and art and to the artefacts produced within artist-in-the-lab projects. Border traffic between art and science has become an important feature of various innovative, late twentieth-century research practices such as genomic and brain research.

The initiatives show how art is an important mediator between science and the lay public and, conversely, how science activities are increasingly characterised by aesthetic and perceptual concerns. Science centres and museums promote and support the collaboration between science and art as a means of engaging with visitors. Science centres, in fact, show an increasing commitment to devoting resources to develop art-science exhibits and collaborative projects.

This paper discusses the kind of challenges the use of art in science centres poses to visitors and evaluators. My contribution will be twofold: first, I examine the potentialities that art as medium offers to science centres in reaching new

and broader audiences. I argue that the use of art in science centres can foster a more participatory and affective way of engaging with science, introducing notions of contingency and temporality. Adapting Stafford's (2007) perspective to science centres: what makes visitors look, pause, use and especially come back?

Second, I present readers with the challenges faced by museums when it comes to evaluating art-science projects. How can evaluators assess visitors' feedback and measure the impact of art-science exhibits? Are traditional surveys and focus groups still enough when art enters science centres and museums? I argue that alternative evaluation approaches relying on video-based multi-modal analysis of users' behaviour in front of the exhibits (Heath and vom Lehn 2008) might offer a better response to the kind of engagement promoted by art-science exhibits.

The theoretical framework of the chapter is informed by the critical apparatus of social studies of science applied to museums integrated by recent debates in aesthetics and the philosophy of the image (Elkins 2008; Rancière 2004; Stafford 2007). The examples discussed come from known art-science exhibits as well as from my experience as a researcher involved in monitoring a number of EU-funded projects using artistic means to engage audiences with science. As these projects are still in progress, the analysis is exploratory rather than normative, seeking to open up the debate and envisaging ways of dealing with the challenges encountered.

Art and science encounters in the museum

The existence of a relationship between art and science and the use of scientific instruments by artists is neither surprising nor a unique feature of our contemporary age despite the scepticism of those who considered humanities and sciences two separate domains (Snow 1998). From the nineteenth century onwards science and art have become autonomous. Before that time the fields shared the same epistemological horizon: science was not a finite body of knowledge but natural philosophy. Theories and practices in anatomy such as Vesalius' *De humanis corporis fabrica* (1543) clearly show art was embedded in natural philosophy. In the Renaissance, artists such as Filippo Brunelleschi, Leonardo da Vinci and Leon Battista Alberti were systematically confronted with science and with a science of vision, as testified by their use of perspective and machines for vision.

In 1998 the UK government created the National Endowment for Science, Technology and the Arts (NESTA). The 2001 report *Imagination and Understanding* published by the Council of Science and Technology (CST) further fostered the development of collaborations between scientists and artists. The report points out that divisions between arts, sciences and education are a cause of economic deceleration necessitating the creation of innovative outcomes from collaborative projects among artists, scientists and universities. Additionally, prestigious funding bodies such as the Arts and Humanities Research Council (AHRC), the Gulbenkian Foundation and the Wellcome Trust fund

projects at the interface of science and art in the belief that those actions can successfully tackle educational and social issues related to our contemporary techno-scientific world.

Although the gap between the natural sciences and the humanities identified by Snow in 1959 has not been superseded, artists are closer to scientists and *vice versa* on two main concerns. First, both scientists and artists are together in the quest for visualising unseen phenomena and properties of materials: in this search, artists make use of cutting-edge scientific instrumentation and scientists adopt aesthetically-charged ways of visualising their object of study. Second, artists are increasingly willing to tackle in their art work the socio-cultural-ethical issues raised by scientific research; scientists are becoming more aware of the importance of communicating their research findings not only in peer-reviewed journals but also in the public arena. Today, scientists and artists need each other as the art historian James Elkins (2001) pointed out: "artists are no longer making the majority of the world's most interesting images; and scientists are not getting any closer to being able to interpret the things they've been creating".[1]

The concern for promoting public understanding, engagement and participation in the hottest topics and conundrums posed by scientific research brings into the arena science museums and science centres for they are the concrete spaces where the lay public can meet technoscience.[2] At first, science centres and museums took on the role of mediators between science and the lay public, a role that

academic institutions do not embrace, for their audience is often the narrower community of researchers and students. Science museums carried out this mediating role and with it other propositions: first, the belief that scientists should not care about communication but only about conducting research and experiments; second, the consequent need for a professional mediator and an institutionally recognised space (the museum) to communicate science; third, the belief that once well informed, the attitude of the public towards techno-scientific issues would be one of trust if not acceptance (Bucchi 2004).

The main goal of science museums was to educate the public to science, to translate scientific knowledge accumulated in laboratories to the public (especially children and families) by means of engaging them with hands-on activities and exhibits. Since their first foundation (the Exploratorium in San Francisco, California was founded in 1969), however, science centres and museums have had to face an increasingly complex scenario in the relationship between science and the public. It is one where different actors and stakeholders interact, sometimes openly debating controversial issues. Thus, science museums have equipped themselves with new theoretical and practical tools for keeping up not only with the pace of scientific research but also with the pace of society (new technologies often mean an easier and quicker way to access information). Ethical issues and personal values, which were seldom part of science museums exhibits (Bell 2008, 388), are now increasingly incorporated in science

exhibitions and programs.

Today visitors to science museums and science centres enter a space where no definite answers are provided, rather questions are continually raised. In this scenario, the theoretical models underpinning the projects of public understanding of science have shifted from bridging the knowledge gap between scientists and the lay public to focusing on participation and engagement. The first model is commonly called a deficit model: communication is understood as a one-way process in which information is passed on (translated) from sender to receiver with the goal to increase scientific literacy. The second is called the public engagement model: communication is conceived as a set of strategies and activities to stimulate participation by active citizens with emphasis on process rather than on specific content, subsequently knowledge is produced and shared. With both models what seems to be distinct in theory is most of the times blurred in practice (Brossard and Lewenstein 2010).[3] In the daily practice of science museums and centres, these models are both present. Preference, however, is given to the second model with the consequence of exhibits and communication activities designed to respond to the needs of participatory forms of engagement.

This has been particularly true for science centres and new generation museums rather than traditional science museums focusing on the history of science. In the past decades science centres have slowly substituted the traditional science museum through a constant re-thinking and experiment of

curatorial and didactic practices: the result is a wide range of exhibits where visitors can experience science "hands-on" and learn by doing. In dismissing the word "museum" from their denomination, science centres have stressed their departure from the classical etymology of "museum" which refers both to the site where the Muses, protectors of arts and sciences, dwell (literally or metaphorically), and to a physical place, the library of Alexandria founded in Egypt at the beginning of the 3rd century BC.

In recent times, as the 2009 Ecsite conference in Milan has testified, there has been increasing attention paid to art inside science centres and museums as a means of engaging new audiences and experimenting with emotionally-charged forms of engagement with science. The formula "hands-on" is now increasingly substituted by "hands- and hearts-on" to highlight the emotional aspect of engaging with science. This is where art (not only design) finds its way through science centres and museums. I use the word *art* referring to Jacques Rancière's notion of aesthetics as "distribution of the sensible", as "a mode of articulation between ways of doing and making, their corresponding forms of visibility, and possible ways of thinking about their relationship" (Rancière 2004, 10). By this concept Rancière is referring to the way in which modes of production, action, and perception are articulated in a common social world (in this paper, that of the science museum). In Rancière's terms, art practices do not differ from other practices such as scientific ones; rather, they reconfigure the distribution of the elements

of those practices. An aesthetic engagement with scientific exhibits gives visitors the possibility to see in the particular configuration of the exhibit's elements a horizon of meaning that was previously unseen.

The cross-fertilization of science and art can take place thanks to three main reasons. First, large parts of science are visual and scientific findings come in the form of visualisations of data. The quest for visualising the unseen or for trying to understand what the world looks like is an aesthetic question (in the sense of aesthesis, that is, of perception). Second, artists have not only been interested in appropriating scientific tools and images but have attempted to highlight the aesthetic, social and emotional aspects raised by many techno-scientific issues. Third, scientists can find in the arts new methods for visualizing data in a way suitable for communication both to the scientific community and to the public, thus spreading their research to a wider public.

The introduction of art into science centres and museums did not happen at the same moment for each of them: from the beginning. The Exploratorium, the two new departments of London's Science Museum (the Wellcome Wing with its long tradition of connecting medical research to the arts, and the Dana Centre, a venue for discussing contemporary technoscience), and the Deutsches Hygiene Museum in Dresden, have promoted exhibitions inspired by art and science believing that the cross-fertilization between the two would improve communication with and engagement of the public. Other science centres and museums have started only

recently to work on the border between the two disciplines (Città della Scienza in Naples); others (the Science Gallery in Dublin, Ars Electronica in Linz, the Laboratoire in Paris) have opened as hybrid spaces hosting art-science exhibits and collaborations.

Art has proved suitable for addressing scientific topics that have to do with the human body such as the neurosciences and the working of the brain and genomics. In tune with the traditional closeness between anatomy and figurative art (the *Anatomical Atlas* by Vesalius or, in our contemporary age, the Visible Human Project which inspired artists to use cutting-edge medical imaging techniques), scientific research related to human identity such as genomic and brain research seems to be particularly suitable for being presented to the public in the form of art-science exhibits where art embodies (more or less metaphorically) the questions and attitudes that society has towards science.

Traditionally, the focus of visitor studies in science museums was the number of visitors and not the quality of the visit (Hooper-Greenhill 1993). The latter type of study has increased in the past decade. Yet there are no scholarly studies that assess the added value of art inside science centres and museums applying quantitative and qualitative methodologies to a satisfactory number of case-studies. There are only reports prepared by single museums and science centres, such as the one by the Exploratorium (*A vision of art at the Exploratorium. A plan for programs, research, and the creation of new work, 2007-2012*). Paying attention to the current trends

of science centres and museums and bearing in mind the reflections of the 2009 Ecsite conference, science centres and museums use art-science exhibits and projects for at least two different objectives: first, to target new audiences such as youngsters, adults aged 20-40 and professionals. To do this they have created hands-on approaches and learn-through-play exhibits but have only succeeded in involving children, schools and families, neglecting other important segments of the public. Second, to retain existing visitors who would return to a science centre if stimulated by exhibitions that are less reading-intensive and more emotionally-charged, as I will explain below.

Art historian Barbara Maria Stafford points out that one of the problems currently faced by curators is to attract and hold the attention of visitors, affecting their cognitive behaviours (Stafford 2008). Vision is not a passive recording on our retina of an image of the world, but an active and dynamic process in which the brain filters and selects information, confronting it with the information already stored. Stafford remarks how only 10% of our brain is focused on the outside world, the brain being an autopoietic system more internally focused, a fact that poses the following problem: how do we instruct the remaining 10%, that is, how do curators and educators capture what is still receptive to external stimuli (Stafford 2008)?

Evaluating art-science: case studies and methods
I believe Stafford's reflections are valid for art and science

museums, and for hybrid spaces which strive to enhance visitors' experience, stimulating their senses and their minds. However, it remains unclear whether the visitor brings cognitive and emotional enrichment back home after the visit or just gadgets. Purely quantitative studies and customer satisfaction surveys are not suitable indicators for an evaluation program aimed at assessing the cognitive impact of the museum *tout court* on visitors (Bucchi and Neresini 2002). The evaluation problem is even more urgent when art enters science centres, for it stimulates visitors to come to terms with puzzling images and phenomena.

Traditional tightly controlled narrative models of exhibition become impossible when art and science touch each other. The introduction of art into science museums entails the introduction of subjective, not only chronological time. Science museums often present a section or a collection dedicated to the history of science and technology by exhibiting objects and machines of different ages, allowing viewers to trace a linear history of progressive development. The science centre is mostly focused on the present (one uses the hands-on exhibit here-and-now), promoting an experience which concludes as one leaves the museum. The same does not happen when art is introduced: art generates emotional experiences that re-activate memories. The museum becomes an intimate place of projections and illusions, closer to the cinema. Like the visual arts and cinema, the museum generates an experience for the viewer that is largely illusory (Bruno 2003, 231-260). The mnemonic landscape activated by

art in the museum, allows the creation of mental images, chance recollection, the re-presentation of an experience.

Art complicates the simplistic formula "hands-on, minds-on and hearts-on", transforming the science museum into a place to wander (and wonder). Thanks to art, the images, the objects in the form of exhibits to see and interact with cannot be read too easily; sometimes they cannot be read at all, only seen. The non-verbal aspect of the image is highly regarded when art comes into play: through images (they can be also tactile, acoustic, tasteful, not necessarily visual as in the exhibition at the Laboratories, *Le Whiff*) art incites us to dream and daydream. Many purely scientific exhibits, on the contrary, disregard the non-verbal side of the image in favour of tasks to perform with instructions and guidelines. Having considered the importance of images and vision, evaluators should be able to verify and understand more precisely what happens in front of an exhibit (be it a single image or a more complex ensemble of objects, images and interactive mechanisms).

To assess what the visitor has learnt from the visit or, to put it more concretely, what the visitor takes back home not only in terms of learning, but also of stimuli, should be the question museum professionals and evaluators seek to answer (Bucchi and Neresini 2002). Cognition is context-based (what were the motives for the visit, was it a group visit, etc.), it depends on a number of variables (social context of origin, educational level, etc.) and, ultimately, it is related to emotional elements, ethical and personal values. In order to

assess the emotional and cognitive impact of a visit, one has to observe and analyse what happens in front of an exhibit, the kind of interaction developed among participants/users and what emotional response has been activated.

This detailed reading, conducted by video recording and conversation analysis, is called multi-modal analysis. The practice shifts from a logocentric to a multi-modal approach to science, opening up possibilities for new understandings of communication, but also triggering new methodological and practical issues. It focuses on the quest for in-depth analyses of the complex social practices of meaning-making through linguistic and non-linguistic semiotic resources (conversational fragments, bodily gestures, bodily movement in the environment), whereby meaning is constructed (Kress and Van Leeuwen 2001).

Science museum visits are often made by groups rather than by single individuals. But most exhibits seem to address a single visitor who is asked to perform a series of tasks in a highly controlled fashion. As Heath and vom Lehn (2008) explain, the user of the exhibit is typically presented with a problem/question. The possible ways of answering and coping with that issue are provided by the system (often a computer-based one) which gives a score after the user's performance. Multi-modal analysis of video recordings of behaviour in front of an exhibit have demonstrated how supposedly "interactive" exhibits do not foster collaboration and co-participation (Heath and vom Lehn 2008). Does art help to improve socialization in the museum visit? Art alone

can stimulate discussion among participants interacting in front of and with an exhibit, something that even interactive exhibits cannot promote.

How can art be introduced into science centres? In at least in three ways.

The first scenario foresees existing artworks that are brought into the museum space, or artists that are appointed to contribute to a science exhibition by creating works of art which respond to certain techno-scientific issues and themes. This option adds a more contemplative experience to the one normally proposed by the science exhibition.

The second possibility is to develop exhibits and collaborations between artists and scientists. These have been very popular in the last decade and strive to bridge the gap between art and science by means of creating a third culture. Although traditional science museums promote those collaborations, two relatively new spaces best embody this approach, which can open up unforeseen possibilities for the public.

The third scenario is to have a range of traditional activities and objects where art plays a role, as is the case with a number of EU-funded projects on science communication and engagement. This scenario offers the possibility of experimenting with different evaluation methods.

In what follows I shall provide some examples to illustrate these three scenarios. All challenge both visitors and evaluators, offering insights for reflecting on the impact of art in science exhibitions, insights that might be worth being

developed further.

The first scenario has been embraced by various institutions, including the Wellcome Trust, the Hygiene Museum and the Exploratorium. In view of the role played by vision in attracting and holding visitors' attention, it might be worthwhile going back to the "old" painting on the wall (clearly, it could also be a sculpture or another type of art installation) to provide an immersive experience for science museum visitors, who are often distracted by too many stimuli, pressing buttons or performing tasks. Art becomes a moment of pause and reflection in the context of the science exhibit, a moment to take breath and look again.

Although this seems to be the easiest approach, I believe quite the opposite is true: to let art and science speak their own languages providing them with a common arena in which they can exist without attempting to blend the two into a hybrid which is neither sufficiently artistic nor scientific (Elkins 2008, 18). Recalling the deficit model of science communication mentioned earlier, this approach does not attempt to bridge the gap between art and science. Similar to Elkins' attempt to place one close to the other, the two languages of art and science share a common space in order to enrich public perception and awareness, rather than to forge a third language.

When it comes to evaluating this scenario, even the simple juxtaposition between a work of art and a scientific exhibit is worth evaluation. To give an example, one could confront the way visitors make sense of a scientific concept,

of a controversial scientific issue, or of a technology, by taking into account two variables: first, the cognitive impact generated in the presence of the scientific exhibit alone; second, the cognitive impact generated in the presence of the same exhibit and of a work of art related (or not) to it.

The second scenario is best illustrated by the Science Gallery in Dublin and the Laboratoire in Paris, two new generation science centres inspired by the Exploratorium. These develop highly experimental exhibitions resulting from collaborations between artists and scientists where the focus is on the cognitive processes shared by science and art: to observe, investigate and create. Both spaces are hybrid, being open to experimentation between science and art.

The Science Gallery in Dublin, located in a strategic area close to the city centre (business), the pubs (social life) and Trinity College (education), is a *particle accelerator for ideas*, as Director Michael John Gorman calls it (Gorman 2009). The aim is to conduct scientific research providing visitors with an artistic experience in a public space accessible by everyone for free. Each exhibition is organised by a team comprising artists, scientists and designers, set up thanks to open calls for ideas from professionals and the general public. The space is not only expository but functions as a scientific laboratory where experiments are led and visitors can sometimes participate as experimental subjects, as scientists or as artist-scientists. The Science Gallery is a porous place open to the public: people stepping inside can take the lift, propose their idea for an art-science exhibition and stop to discuss it with

their peers and see whether their idea can become a concrete exhibition. Inside the gallery people can interact and discuss issues with real scientists and artists. Virtual visitors are also a target group, thanks to the use of social networks such as Twitter and Facebook. The exhibitions taking place there do not propose any fixed model for the interaction of art and science: art enters the Science Gallery not in the form of works of art but rather as a creative platform for generating ideas in between science and art. A main weakness, however, is that these art-science experiments may not be capable of involving groups that are less socially integrated.

The Laboratoire in Paris, close to the Louvre, is a mix of curiosity cabinet and laboratory where ideas are created and then disseminated, sometimes even in the form of patented, commercial products. The Science Gallery left behind any connotation of museum, but the accent is still on science despite the focus on art-science cross-fertilization. The Laboratoire in Paris has dispensed with the word *science* as well, to highlight that it is not a place to learn about science: the ambition is to throw ideas together and see how they react and mingle. Artists, scientists and the public do not have fixed identities but are participants in the experiment. The divide is not between experts and the lay public but between those who are innovators and those who are not. The model of the Laboratoire is that of a *catalyst of ideas* (Edwards 2008), a place for youngsters and adults rather than for children, a place for young professionals who are excellent in their profession or field (be it science or art) and who dare to pursue an idea, to go

back to education, to experiment. Unlike the Science Gallery, the Laboratoire is not particularly good as a meeting space: there are no bright lights, no colourful spaces, not even many people. Although the Laboratoire as a whole does not seem to have any explicit educational role for society at large, it offers a place and methodology for fostering creative thinking encouraging visitors to critically reflect on how to create art-science concretely.

The exhibition *Le Whiff* exemplifies the Laboratoire's approach. Displayed on shelves, books, test tubes, the materials of various kinds look like *objects trouvées*. These objects are lifeless as the Laboratoire is not a laboratory where actual professionals work together experimenting. The real *laboratoire* exists elsewhere and is virtually reconstructed through the narratives provided for visitors on an iPod. After entry, visitors follow their own path among the different shelves, looking from the perspective of a scientist, artist, or entrepreneur. Although there is no hands-on approach here, visitors are challenged to use their own imagination to reconstruct the process that led from the original idea to the final product. However, the only feedback tool available in the iPod program is a Yes/No button to express appreciation for the exhibition. In this second scenario, evaluators should be able to focus on the process rather than on the final output of the art-science collaboration – as happens in ethnographic research through the key figure of the attached observer.

The introduction of a third agent beyond the artist and the scientist has the merit of focusing attention on the

collaboration not only retrospectively, but as the project unfolds. Consequently, the key words are *process* – not output – and *interaction* between the people involved. The attached observer acts as an observer and sometimes even as a participant within the project, triggering questions, facilitating and questioning the interaction itself, exploring possibilities that might provide new directions of research for the artist and the scientist individually, even after the specific collaboration has ended (Mandelbrojt 1994). As social anthropologist James Leach puts it: "those new directions, perhaps more than any finished physical output, are a genuinely collaborative product, unimaginable without the particular relationships between those involved" (Leach 2006, 449).

The multi-modal analysis of visitors' behaviour and interaction in front of an exhibit is certainly important in a space such as the Science Gallery where the gallery itself fosters interaction and exchange between visitors, but it can also be useful when the exhibit is an art-science "experiment" pursued outside the gallery premises as in the case of the Laboratoire.

The last scenario can be illustrated by referring to the ongoing project *Time for Nano*, one of four projects communicating nanotechnology and nanoscience (N&N) funded by the European Commission within the 7th Framework Program. The aim of the project is to engage youngsters of various European countries in dialogue and discussion about N&N using creative and artistic communication tools. The project is run by a consortium

including science centres and museums, artists, network organizations and a research centre specialising in monitoring and evaluating SiS (Science in Society) projects. Over two years from October 2009 to May 2011 several "Nano days" are taking place in science centres and schools including demonstrations and experiments, forums and events with scientists and researchers; and a web-based video contest for teenagers will ask them to respond to actual dilemmas posed by N&N. The dilemmas are divided into categories: impacts on environment, safety and privacy, nanodivide, nanomedicine and health, and human enhancement. To support and inspire the contestants, science centres and museums provide their education and communication expertise, including a Nano kit with experiments on N&N and the card game *Play Decide* already tested for a project on biotechnologies. The science centres aim at reaching youngsters directly through the web, and at providing them with the tools to develop and sustain their learning of N&N.

The goal of the competition is to produce the most creative, thought provoking and scientifically sound video on any of the dilemmas posed by N&N. This project has two main objectives: first, to engage youngsters in N&N; second, to understand what youngsters' perception of N&N is and their priorities. In what sense does art play a role in achieving those goals? The web-based video competition promises to be an innovative way of addressing a scientific topic by artistic means with the collaboration of the Slovenian-based artist collective BridA. The web-based video competition offers

several challenges: first, the possibility to use the web to ensure the participation of a wider number of different segments of the public besides those who have the chance to attend a Nano day or school labs on N&N. Second, the video competition calls for a product which will probably be made by a group rather than by a single person. Their creativity is stimulated and they are asked to make the creative effort to translate N&N into a visible product.

The innovative approach of *Time for Nano* is not the presence of the Nano kit, rather the possibility given to youngsters to participate in a video competition using science centres (physical space) and the web platform (virtual space) as training tools and art as a means of expression. As evaluators of the project, our aim is tackling the following questions: what do visitors/participants learn (cognitive aspect)? Does the project influence what they think of science in general and of N&N in particular (attitudinal aspect)? How do youngsters attempt to engage creatively with N&N (creative choices/ scientifically-sound content)? To answer these questions, we have designed a series of evaluation and feedback tools such as pre- and post-visit questionnaires, semi-structured interviews, observation charts and simple web tracking tools. All these methods present some advantages and disadvantages. For example, questionnaires distributed to the public attending the Nano day in a science centre allow us to collect quantitative data which can be easily inserted in a matrix for statistical purposes. However, the traditional questionnaire cannot assess the cognitive impact of the visit

on a medium-to-long timeline. Interviews with a sample of participants and winners allow a more in-depth analysis of personal attitudes and motivations but they do not provide data that can be treated in a statistical way.

The possibility of combining different evaluation tools helps overcome the limits each of them has. Furthermore, these are among the most easily manageable tools considering the limited resources generally given for the monitoring and evaluation of EU projects. However, they do not explicitly address the impact of art (in this case, the video competition) in achieving the goals set by the project. Moreover, they cannot survey the virtual visitors who can take part in the competition without attending any of the activities in science centres. The fact that the video competition is web-based challenges evaluators to collect feedback and impact from virtual visitors. The "average user" cannot be identified due to privacy concerns, rendering evaluation impossible and ineffectively assessing who is doing what.[4]

Multi-modal analysis of visitors' behaviour in front of an exhibit, could be implemented in projects such as *Time for Nano*. The interaction promoted by this project is not only computer-oriented (the web-based competition) but much more bodily oriented: the card game *Play Decide*, the series of activities of the Nano kit to be done in science centres, the creation of a video which often requires consultation and collaboration with others are all activities that could be studied by adopting a multi-modal analysis based on video recordings. Social interaction is something different from

interactivity (Heath and vom Lehn 2008). What are people doing? How do they move? What kind of utterances do they make when they are doing experiments with the Nano-kit or when they are arguing during the card game? The observational charts might not always work well, considering that moderators during *Play Decide* have to be able to observe, write down impressions and then summarise their findings in a brief report. In this respect, having video-recordings available might facilitate the moderators' and evaluators' task.

The possibility of engaging creatively with N&N, proivided by the video competition, introduces an element of contingency into the activities designed by the project, an element which is not plan-based nor always goal-oriented. As Heath and vom Lehn well argue:

> *"there are relatively few studies that examine the action and interaction that arises at the exhibit face. There are, of course, a growing number of studies using surveys, interviews, focus groups, and so on, to assess the effectiveness of exhibits (...) but, like other forms of variable analysis, they tell us little about the quality of action that arise at exhibits and the forms of participation that they engender, facilitate or occasion"* (2008, 86).

Art introduces emotive responses and contingency in the science exhibition, thus enriching the formula "hands-on, hearts-on": multi-modal analysis conducted alongside traditional evaluation tools such as interviews

and questionnaires might enable evaluators to tackle the art-science exhibition giving more space to what actually happens during a museum visit. Multi-modal analysis, in the end, safeguards the element of performativity which characterises art-science exhibits and projects.

COMMUNICATION AND EVALUATION

2.
DEFINING
AND CREATING
THE SCIENCE
EXHIBIT

A Social Semiotic Framework for the Analysis of Science Exhibits

GLYKERIA ANYFANDI

Eugenides Foundation, Athens

VASILIS KOULAIDIS &

KOSTAS DIMOPOULOS

University of Peloponnese

The institution of the science museum is traditionally connected with pedagogical objectives, addressing major parts of society and especially children. This article presents a theoretical language to describe the pedagogic practices embodied in the science exhibit, in its conceptual, structural and operational features. Social semiotic and socio-epistemic approaches are combined in this context. The science exhibit is approached as a pedagogic "text" applying concepts from social semiotics and particularly from the multi-modal analytical framework. Basil Bernstein's theory of cultural codes and his concepts of classification and framing, as well as the notion of formality from Halliday's systemic functional linguistics, provide the theoretical basis for the analysis of the science exhibit as a pedagogic text. What is explored is the relation between the scientific knowledge embodied in the exhibit, the knowledge produced in the techno-scientific community, and social structure. Further, our study focuses on the construction of the visitor as a social subject and as a learner.

We argue that study of the museum exhibit benefits from the import of a socio-epistemic agenda into the socio-semiotic conceptual frame and its promising methodological toolbox: this agenda is derived from Bernstein's sociological theory of cultural codes, into the socio-semiotic conceptual frame. Other fields with a similar pedagogic function can be expected to benefit from this approach: these include museum education and curating, user-centred development of science exhibits as well as other educational materials

based on language, on visual, or other semiotic systems.

This article has three overarching aims. The first is to illustrate the need for the proposed theoretical language of description: this is done on the basis of a review of museum research related to the science exhibit. The majority of studies seem to evaluate exhibits either for achieving practical objectives of the museum or with a focus on learning associated with the science exhibit and the museum environment. These mostly empirical studies offer useful insights into what makes an exhibit "successful", or "effective" in museum practice; they also highlight critical exhibit design features and parameters of the museum environment. However, the science exhibit is usually viewed as a neutral means deployed in order to fulfil communication and pedagogic objectives in the science museum. What then becomes apparent is the scarcity of studies that approach the exhibit as a pedagogic text, discernible by means of a social grammar and with a socio-epistemic emphasis.

The second aim is to conceptualise the science exhibit as a text, as a multi-semiotic representation with a conventional character and signification qualities. The signification function of the exhibit is seen as an interplay between its expressive potential and its semantic/discursive dimension. This part highlights the advantage of social semiotics for better understanding new and complex forms of texts other than oral and written language in use, as is the case with the science exhibit. These efforts are associated with concepts and methodological elements from the work of Gunther Kress

and Theo van Leeuwen (Kress and van Leeuwen 1996; 2001). In this respect, social semiotics offers descriptive instruments that facilitate understanding of the semiotics of the science exhibit, in relation to two particular features – namely, its multi-modality and materiality. The socio-epistemic agenda stemming from Bernstein's sociological theory of cultural codes is considered to be relevant to the museum study, especially when combined with the socio-semiotic conceptual frame and methodological innovations. The proposed frame for the pedagogic analysis of the science exhibit is theoretically grounded on the concepts of classification and framing, as well as the notion of formality from Halliday's systemic functional linguistics.

The third aim of the article is to illustrate the application of the proposed descriptive frame to selected science exhibits. The analysis relates classification, framing and formality with conceptual and technical specifications of the science exhibit which are considered to be critical for the construction of the pedagogic discourse. The reading of these characteristics draws on the methodological work of social semiotics as applied to visual and multi-modal representations. Conclusions are drawn from the type of pedagogic practices that may be realised by the selected exhibits, according to the pedagogic and social characteristics of the visitor. An operational translation of this frame will enable the development of a theory-informed, practical and easily applicable instrument for the pedagogic assessment of a science exhibit.

Legitimizing the necessity for a socio-semiotic frame of analysis for the science exhibit

Within the frame of museum[1] research, the science exhibit has been approached as a medium to convey to non-expert publics various concepts, ideal-type examples of everyday phenomena, or scientific models referring to an idea, object, event, system or process from the techno-scientific world (Gilbert and Stocklmayer 2001; 2002). Additionally, the science exhibit has been examined as a means to trigger learning processes in the context of the museum visit.

A number of underlying assumptions can be identified in the literature: that the science exhibit is a neutral medium, a vessel filled with science content, which is more or less a mirror image of the natural and social world; that there is a passive receiver of this message; that museum science is a simplified form of the corresponding scientific knowledge to which science exhibits refer. So, what is left is to detect the suitable exhibit that could "pass the message" in the best possible way. The influence of the transaction model, still persuasive in its conceptual minimalism, seems to remain quite strong while the social semiotic dimension of the science exhibit has not attracted much attention. According to Bud, "much effort has been directed towards more effectively communicating messages in museums. Far less attention has been given to re-examining the messages themselves" (Bud 1995, 1).

In museum research the science exhibit is usually evaluated in terms of success or effectiveness in communicating

concepts, ideas and phenomena from the world of science and technology to non-expert publics, and in triggering learning processes within the context of a museum visit. Specifically, an exhibit is considered effective and successful when it passes the message, informs, educates, encourages targeted actions, attracts more visitors, and even entertains (Knutson 1954; Perry 1992).

It is often argued that a successful exhibit should be able to strengthen self-confidence while being challenging (Perry 1992), generate curiosity (Perry 1992; Shettel 1973), and encourage communication with the visitor (Perry 1992; Rennie and McClafferty 1996; Griffin 1999). Empirical research suggests that successful exhibits are indeed associated with qualities such as liveliness in presenting the subject, comprehensibility of the exhibit's content, accuracy of information presented, perceived objectivity, relevance to all age-groups, memorability, user-centeredness, open-endedness[2] and technological novelty (Shettel 1973; Alt and Shaw 1984; Wagensberg 1992, Sandifer 2003).

A substantial body of empirical studies was conducted as early as the 1920s (Roberts 1997; Screven 1993; Bitgood 2002) investigating various design features of the exhibit, as well as the setting or environmental factors thought to be critical for the development of successful and effective science exhibits. These studies of pre-existing exhibits and museum environments are known as summative evaluation studies; they have allowed museum administrators to make better use of financial resources, improve the services provided,

attract new visitors, satisfy wider audiences, and finally achieve financial sustainability (Shettel 1973; Peart 1984; Screven 1993; Roberts 1997). Gradually, interest has moved to formative evaluation, studies conducted during the process of exhibit or exhibition development, and even further to front-end evaluation aimed at setting the ground for exhibition development still in the planning phase (Rennie and Stocklmayer 2003).

The usual outcome measures of exhibit effectiveness are attracting power,[3] holding power (Shettel 1973; Peart 1984; Boisvert and Slez 1995; Sandifer 2003),[4] opting to interact with a certain exhibit (Alt and Shaw 1984; Peart 1984; Boisvert and Slez 1995; Sandifer 2003), reading time which is related to holding power (Bitgood 2003), the number of exhibit elements that attract visitor attention (Bitgood, Serrell and Thompson 1994), communication power assessed by knowledge gain, memory, reasoning, and/or attitudes (Bitgood 2003), and collateral visitor behaviours, such as pointing at and touching an exhibit and social interaction (Sandifer 1997; Rennie and Stocklmayer 2003; Bitgood 2003).

Through this type of research, more concrete exhibit characteristics have been highlighted as crucial for the development of an effective exhibit; these include colour, light, contrasts, sensory stimulation and use of communication techniques such as sound, movement, presentations, films, control upon the interaction, three-dimensionality of the exhibit, combination of exhibit with key-objects, and finally label comprehensibility (Shettel 1973; Peart 1984; Perry 1992;

Wagensberg 1992; Sandifer 2003).

Evaluation studies have offered valuable insights but they have also been criticized as not having been able to offer adequate explanation about visitor behaviour (Roberts 1997), or to lead to exhibits with the potential to transform visit attitudes (Peart 1984). Additionally, empirical evaluation studies are considered to test hypotheses in artificial experimental situations, distancing the museum experience from its wider social and cultural context (Schauble, Leinhardt and Martin 1997; Rennie and McClafferty 1996). Last but not least, evaluation studies demonstrate neither conceptual cohesion, a coherent terminology, nor even a common point of research reference. It might even be suggested that much of the research on learning in museums has been atheoretical (Falk and Storksdieck 2005). Therefore, there is no common measure with which to assess the findings of each study (Shettel 1973).

Since the 1980s, museum research has realigned its focus by placing the visitor more intensely in the spotlight, with obvious influences from cognitive approaches to learning. As learning in non-formal environments has increasingly gained more attention from researchers (Gerber, Marek and Cavallo 2001), a new trend in studies is to examine the science exhibit and its environment for the possible impact on the visitor – be it social, economic, political or personal. In fact, individual learning experiences make up a good part of this trend of empirical research (Garnett 2001). A number of these empirical studies concentrate on exhibit characteristics such

as exhibit size, types of interaction and related activities, choices in and control of interaction, exhibit subject and content cohesion and comprehensibility (Falk and Dierking 1992; Falk 1993; Boisvert and Slez 1995; Borun and Dritsas 1997; Falk 1997; Falk and Dierking 1997; Bitgood 2002; Bitgood 2003; Sandifer 2003; Pedretti 2004; Allen 2004; Martin 2004; Falk and Storksdieck 2005; Jarvis and Pell 2005). These features are correlated with attracting and holding visitor attention, comprehension, the degree of interaction with the visitor and the type of learning processes they encourage.

Much of the early research led to real progress in the field of museum studies and has offered valuable insights. However, empirical museum research has been criticised on various levels and from different points of view:

On the level of epistemological background, for being informed by a range of different disciplines and perspectives, using different terminology and methodologies, diverse research experience, culture and values, and eventually yielding non-comparable findings.

On the level of theory, for suffering from insufficient theoretical foundations, and a lack of internal cohesion (Shettel 1973; Falk and Storksdieck 2005). Evaluation studies can claim a mostly descriptive value without being able to offer sufficient explanation about the visitor's behaviour (Roberts 1997). Much of the research on learning has focused on identifying, measuring and assessing learning effects as the immediate outcome of a museum visit or interacting with exhibits. Meanwhile, scarce attention has been paid to the fact

that both the interaction with the exhibit and the museum visit have a personal meaning for each visitor and they form only a part of a long process of consolidation and development of new ideas (Falk and Dierking 1992; Rennie and McClafferty 1996; Griffin 1999; Burns, O'Connor and Stocklmayer 2003).

On the level of methodology, for testing hypotheses in artificial experimental situations, thus decontextualizing the museum experience from a wider social and cultural environment (Schauble, Leinhardt and Martin 1997). Part of the learning impact studies investigate learning in school using laboratory methods that cannot be successfully transplanted to non-formal research fields and the museum environment, where the individual is presented with different challenges and opportunities (Schauble, Leinhardt and Martin 1997; Rennie and Stocklmayer 2003; Dierking, Ellenbogen and Falk 2004; Rahm 2004).

On the level of empirical outcome, for not offering concrete and solid advice on how to transform visitor attitudes (Peart 1984).

Developing common criteria and methodology for evaluating the effectiveness of the exhibits, both on the theoretical/methodological and the empirical planes, is becoming a new quest encouraged by the demand by museums for improvements in exhibition organisation and exhibit production (Smithsonian Institution 2002; Lindauer 2005).

Since the 1990s, a strand of museum research has adopted a more theoretical orientation questioning learning and

meaning in the museum, under constructivist influence and within a socio-cultural conceptual frame, and using methodological tools from hermeneutics (Rennie and Stocklmayer 2003; Rennie and McClafferty 1996; Schauble, Leinhardt and Martin 1997; Schauble 1997; Logan 2001; Martin 2004). These theoretical developments have revived interest in studying the construction of meaning from the point of view of the visitor (Hooper-Greenhill 1999). Gradually, it has come to be recognized that the construction of meaning emerges from interaction between actors in social settings and various facilitating factors – the latter includes tools, speech, signs and symbolic systems.

Conceptualizing the science exhibit as a semiotic resource

In this section, we concentrate on drawing the science exhibits out of their neutrality, out of their status as "invisible and faithful tools" (Latour 1996, 235). An object, as silent spectator of human action "...is impossible to engage in detail in the construction of society" (ibid.). Therefore, the aim now is to conceptualise the science exhibit as a product of human activity, to highlight its representational character and textual function as supported by a social semiotic approach.

The representational function of the science exhibit is exemplified in reference to different types of science exhibits. According to the typology developed by Gilbert and Stocklmayer (2002), there are two main types of interactive exhibits: the "exemplars of phenomena" and

the "analogy-based exhibits" (or teaching models). The first
type is "an idealized example of a real-world phenomenon"
and "its purpose is to provide direct experience with the
phenomenon" (Afonso and Gilbert 2007, 968). This type of
exhibit demonstrates characteristic behaviours of living
and inanimate entities "in the most efficient and effective
manner". Into this category fall exhibits such as a colony
of bees, a hot house containing tropical species, as well as
exhibits that demonstrate the behaviour of materials, e.g.
of polarized light. For this latter exhibit, as Gilbert and
Stocklmayer explain "visitors are invited to place a polarizer
in front of a beam of white light and to observe the colour
effects produced when stressed translucent materials – for
example, plastic spoons and rulers – are viewed through it"
(Gilbert and Stocklmayer 2002, 839).

The second type of interactive exhibit is an analogical
representation "of a real-world phenomenon, or of a consensus
model (one approved by scientific society) of a phenomenon, or
of a technological product" (Gilbert and Stocklmayer 2001, 43).
Analogical representation is a model formed "by considering
that which is to be represented (the target) analogically in
the light of the entities and structures of something, which
it is thought to be, like (a source)" (ibid.). Examples of the
analogical type are the exhibit *Bat* (a model for representing
a bat's ability to locate sounds) and the exhibit *Visible effects
of the invisible*, a model which demonstrates the behaviour of
liquids. In the analogical representation, the two domains
(source and target) "may be alike in respect of entities, in

their relational structure, or in both" (Afonso and Gilbert 2007, 969).

In either of the aforementioned exhibit types, the exemplar and the analogical, the science exhibit refers to something other than itself, which is perceived as significant. This other is the conceptual and material products of the techno-scientific world. This representational quality imbues the science exhibit with its social and worth-communicating value. Even those exhibits that appear unproblematic and simple, with prominent iconic features (e.g. *the hot house*, or any diorama) retain their relational function. Functioning as exemplars they clearly refer to something other than themselves, to entities from the real world (i.e. a phenomenon), from the extra-semiotic environment.

Understanding the science exhibit as a social product, as a form of social action, means developing awareness of the fact that the exhibit embodies a selection made, or better, successive selections made, in reference to a range of issues. These could include the subject of the exhibit, the pedagogical aims, its structural setup, the materials, the type of interaction and the foreseen uses, the interface enabling the exhibit-visitor relation, and the interpretive environment, inter alia.

Even a science exhibit recognised as part of scientific historical heritage, drawing its value mainly from its authenticity, is still a product of selection. An important authentic exhibit does not naturally occupy a place in a certain exhibition, unless the museum curator (or the

equivalent for each institution) picks it up out of a range of possibilities (paradigmatic plane), in order to realize the interpretative plan of a certain exhibition, providing that it fits the intended message of the exhibition (syntagmatic plane). For example, an original steam-engine of the 18th century may be the signifier of a great invention as part of an historical exhibition presenting the industrial evolution as an important step in the evolution of humanity, and could be hosted in a museum of science and industry. Alternatively, it could be an object of national pride as part of an exhibition focusing on the contribution of Britain to world technical and scientific heritage. Or, it could be an object-as-testimony of local history, placed in its original environment. This is the case for the oldest steam engine still in its original engine house and "still capable of doing the job for which it was installed", that is the 1812 Boulton and Watt engine, at the Crofton Pumping Station.[5] Finally, an exhibit –especially a massive one – could be presented as a stand-alone exhibit, as an attraction pole at the entrance of a museum or a themed exhibition. Such an exhibit "...not being embedded in a social or intellectual context, may require... a great deal more interpretation" (Gilbert and Stocklmayer 2002, 838).

In any of these cases where the content tends to be perceived as real or natural, codes of realism are being utilized (Chandler 1994). Even realistic ways of representation are historically and culturally conditioned and subject to (more or less conscious) learning, even though they become transparent and obvious through experience. According to

Fiske, convention is necessary for interpreting any sign, no matter how iconic or indexical this may be. It standardizes the appropriate uses and reactions to a sign (Fiske 1982). The materiality of the exhibit and its three-dimensionality contribute to its natural reading (Kress and van Leeuwen 1996). The sense of depth, the abundance in quality and quantity details, the natural shadowing, the multisided arrangement, bring the three-dimensional object closer to codes of realism (ibid.). The greater the sophistication and sensory stimulation (movement, colours, sound etc), the higher the truth value of the text[6] (ibid.).

It has been argued so far that the science exhibit performs consciously, or not, a semiotic function, and observes implicit (or not) conventions by which its messages are constructed, become encoded and decoded. This signification function can be illustrated in the following diagram, inspired by the Saussurian model of the sign. The science exhibit can be conceptualised as bearing:

- an expressive dimension, where expressive means: material elements, semiotic rules and communicative conventions, organized in a systematic way, enable signification.
- a content dimension, which refers to the object represented by the exhibit.

The signification function of the exhibit is seen as interplay between the expressive potential and the semantic/discursive dimension (Fig. 1).

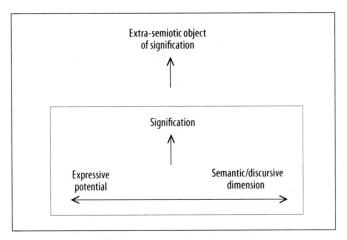

Figure 1: The multi-semiotic exhibit

In museum practice, the science exhibit draws its expressive potential from a range of semiotic modes (printed text, visual representations, sound, moving image, etc.) and expressive means (labeling, architectural structures, information material, interpretative intervention of museum personnel and any other object, action or event with a possible interpretative result).[7]

The conceptualisation of the science exhibit as a semiotic structure draws upon theoretical concepts originating from the tradition of Critical Linguistics as merged with Michael Halliday's systemic functional grammar where language is viewed as a mode of social action (Halliday 1978). In Halliday's systemic functional linguistic theory, text is anything "…that is said or written in an operational context, as distinct from a citational context like that of words listed in a dictionary" (Halliday 1978, 108). This theoretical integration evolved into

social semiotics, whereby text was termed any instance of a semiotic system, in use (visual representation, visual art and sculpture, sound, music). Social semiotics produced then an instrument for social critique by means of any semiotic system, preserving the systemic-relational element of Hallidayan conception (Hodge and Kress 1988; Kress and van Leeuwen 1996, Iedema 2003).

It has been recognized that social semiotics has improved understanding of new and complex forms of texts, especially the study on multi-modality which focuses on representational modes other than speech or writing and how they work together in meaning making (Hodge and Kress 1988; Kress and van Leeuwen 1996; Kress and van Leeuwen 2001; Iedema 2003).[8] This framework is applied to a variety of multi-modal texts, such as school textbooks, mass media content, advertisements, works of art and other cultural artifacts, sculpture, and even children's toys and everyday objects etc. (Hodge and Kress 1988; Kress and van Leeuwen 1996; van Leeuwen 1999; Kress and van Leeuwen 2001; Koulaidis, Dimopoulos, Sklaveniti, Christidou 2001; Koulaidis, Dimopoulos and Sklaveniti 2001; Dimopoulos, Matiatos and Koulaidis 2002; Koulaidis and Dimopoulos 2003; Dimopoulos and Koulaidis 2002; Dimopoulos, Koulaidis and Sklaveniti 2003; Harrison 2003; Dimopoulos, Koulaidis and Sklaveniti 2005). The recognition of new kinds of texts followed the development of new forms and practices of visual expression ('visualization' of information) (Kress and van Leeuwen 1996) associated with the dominance first

of television and advertisement, and later with the Internet (Cook 1998; Lemke 2006). The efforts in the social semiotic field are based on the assumption that a systematic relation exists between the content and formal characteristics of a semiotic system, and its social context and instance of use. A second assumption is that a semiotic system encodes social experience and structure (Halliday 1978; Hodge and Kress 1988; Iedema 2003).

The concepts and instruments developed by social semiotics could facilitate a better understanding of the science exhibit as a meaning making resource.[9] An example is the analytical framework proposed by Kress and van Leeuwen (1996; 2001) for two-dimensional visual representations and their efforts to apply some of these notions to multi-modal texts. The agenda has recently included the analysis of three-dimensional visual representations, even though it is still under development (Kress and van Leeuwen 1996, 2001; Lemke 2006). At the same time, the multi-modal analysis seems to depart from a somehow too technical and context-bound conceptualization of semiotic instances, and to abandon a focus on a finalized semiotic product and the interest in here and now. Further, it seems to shift towards more generalisable aspects of multi-modality, related to practical processes of semiotic making. These evolutions promise to illuminate the social dynamics, the creative forces and the alternating of contexts of practice that underlie semiosis (Kress and van Leeuwen 2001; Iedema 2003).[10] This is especially so in reference to the materiality of the science exhibit, an aspect which is

usually left out for not being socially relevant. However, materiality is not a mere servant to our wishes and meaning making needs. It captivates in an enduring mode, what is at stake in human interaction. It embodies goals, intentions, and concerns, something that cannot be achieved by symbols and symbolism alone (Law and Mol 1995; Latour 1996). Objects shape the frame of interaction. Along with the practical activities, they are essential for "manufacturing the social link" (Latour 1996, 236).

It has been clear so far that the science exhibit does not own its meaning, which cannot be taken for granted. Equally, meaning is not imposed on the reader. The exhibit, as any text, acquires its meaning potential according to how it is constructed, what social agents do with it, how it enables different interpretations and how it becomes the field for processes of negotiation, construction and change of social experience (Halliday 1978; Hodge and Kress 1988; Kress and van Leeuwen 2001; Halliday and Martin 2004; Vannini 2007). In this sense, the exhibit is not only a carrier of intended and unintended meanings, but a field where conflicting discourses struggle to prevail. If we consider the exhibit as a pedagogic text, which constructs the reader, the conditions of reading and the pedagogic relation, then it might be worthwhile to address openly the link with society and investigate by which practices and resources this link is realized in the museum context. This implies importing into the museum research agenda a more pronounced socio-epistemic orientation. In particular, it is suggested that Basil Bernstein's sociological

theory of cultural codes could enhance our understanding of the museum and particularly of the discursive and constructive character of the science exhibit, in relation to questions of power, discourse and identity.

Bernstein studied a variety of message systems, such as school curricula, pedagogy and evaluation, and distinct types of pedagogic practice with important effects on the distribution and exertion of power among the participants (Sadovnik 2001). Bernstein (1971) believed that "[h]ow a society selects, classifies, transmits and evaluates the educational knowledge it considers to be public, reflects both the distribution of power and the principles of social control" (Fyfe 1998, 328).

His concern was about issues such as the structure of authority/power which runs through the process of transmission of knowledge in pedagogical contexts, the form this transmission takes, the structuring of the identity of participants involved, the theory of pedagogy applied in the professional and other types of relationship between instructors and those instructed, etc. (Bernstein 1991). We can benefit from Bernstein's study of formal education system which he considered "a vital regulator of the structure of experience" (Bernstein 1991). As Fyfe suggests, "Schools and museums exercise pedagogic functions, museums have been agencies of mass education, their histories sometimes overlap as ones of shared symbolic control whilst school and museum continue to have symbiotic associations" (Fyfe 1998, 328).

Bernstein's theory of cultural codes is a theoretical

instrument used to analyze aspects of social experience at different levels, such as institutions, social practices and fields of social action (languages, consciousness/ideology, family, formal education, labour/production, division of labour etc.) (Bernstein 1991). The codes are considered "culturally specified mechanisms of positioning", which position unequally the subjects within social relations. They are taken up by the subjects tacitly and regulate their behaviour and consciousness. Codes are normative principles that constitute the basis for selection and clustering of messages, the forms for their realization and their related contexts. In these normative principles are encoded the class-determined relations of power and norms of social control (Bernstein 1991; Koulaidis and Tsatsaroni 1996).

For Fyfe, Bernstein's theoretical framework has a lot to offer to museum study, also because Bernstein "...is alert to materiality and objects (Bernstein 1975, 151-6), to the spatial and architectural aspects of power and knowledge and to the way in which the priorities of a social structure may be realized in physical settings" (Fyfe 1998, 329).

Taking the example of the exhibit as an instance of discourse, and particularly as a pedagogic text, Bernstein provides a theoretical framework that will allow an analysis of the science exhibit reinstating the link with the social. The science content of the exhibit should not be considered as merely a simplified form of the scientific knowledge to which the science exhibit refers. Bernstein distinguishes between the scientific knowledge produced by and within the scientific

community (primary context) and scientific knowledge which is reproduced within other (secondary) contexts. Through this process, which he terms "recontextualization", the original scientific knowledge is transformed so as to become compatible with the established social order and the dominant ideologies and practices of the new context (Koulaidis and Tsatsaroni 1996; Koulaidis, Dimopoulos, Sklaveniti and Hristidou 2001).

The process of recontextualization of knowledge applies to various intellectual fields, including that of the museum. According to Fyfe, in regard to art museums, "museums recontextualize things which have other lives – in junk shops, art dealers' showrooms, exhibitions and other places in the cultural field" (Fyfe 1998, 329).

Recontextualization takes place with the intervening of a third context that enables the relocation of scientific texts and practices from the primary context of discourse production to the secondary context of its reproduction. We assume, then, that the science museum discourse becomes enabled via the embedding of a scientific discourse (concepts, conventions and practices developed within the scientific community and considered valid and worth promoting) in a discourse of everyday, lifeworld knowledge available in the community. Such a claim is supported by previous work analyzing teaching activity as a process involving three cognitive frames – the frame of scientific knowledge, the frame of the everyday, lifeworld knowledge and that of school knowledge (Koulaidis and Tsatsaroni 1996). Thus, the science exhibit

is not a prepackaged body of scientific knowledge designed to be conveyed unproblematically to visitors. Rather, it is a different construction, which requires an acting visitor. More than this, it actually constructs subject positions, roles, identities and social relations, and distributes practices in the museum.

Applying the framework of analysis on the science exhibit as an instance of pedagogic text

For analysis of the science exhibit as an instance of discourse that reproduces scientific knowledge, three notions will be used: classification and framing (Bernstein 1996), and formality (Halliday 1996). These analytical dimensions correspond to the following definitions:

Classification: The degree of specialization of the techno-scientific knowledge promoted by the science exhibit, in relation to the everyday, practical and experiential knowledge of the non-expert, and to other knowledge systems such as religion, politics, ethics etc. This dimension reflects the positioning of the visitor to the body of techno-scientific knowledge (Koulaidis and Dimopoulos 2003, 3265).

Whenever the exhibit content promotes a sharp differentiation between techno-scientific and practical-experiential knowledge, then the classification is strong. If the boundaries between the two forms of knowledge are blurred, then the classification is weak. It is not unusual that a science centre uses elements of practical-experiential knowledge to guide the attention of the visitor to a certain

activity; subsequently, the content becomes more specialized in order to explain a phenomenon, or to present the scientific foundation of a familiar technological application which is common knowledge for non-experts.

Framing: The regulation of control (who controls whom) over norms that moderate the communication of knowledge, paying particular attention to the social positioning developing between the visitor and the exhibit. The stronger the classification and the framing, the more hierarchical and ritualistic the educational relation tends to be. The learner tends to be considered uninformed, with limited status and rights and access to hierarchically structured knowledge is conquered gradually, functioning as a constant motivation. The weaker the classification and the framing, the more undermined become the current authority structures and the jurisdiction of the instructor. The rights of the learner are increased, the content of learning is defined in cooperation between instructors and learners. The pedagogic focus is transferred from the acquiring of defined knowledge to the ways of acquiring it, and evaluation takes more into consideration personality characteristics of the evaluated (Bernstein, 1991).

In the context of the science museum, framing is related to the control of norms that regulate the conditions of communication between the museum/exhibition and the visitor who interacts with the exhibits (Dimopoulos, Matiatos and Koulaidis, 2002). Thus, strong framing means that the visitor retains limited control upon the norms that regulate his/her relation with the

exhibit, its environment or any other element that conditions this relation. On the contrary, weak framing means that the visitor is considered an interlocutor of equal standing, that he/she has a range of options as far as concerns the negotiation of conditions of interaction with the exhibits, and access to different parts of the science museum (ibid).

Formality: The degree of elaboration of the semiotic code (e.g. scientific or everyday language). Formality is related to the degree of abstraction, elaboration and specialization of the expression codes used for the construction of the exhibit message (Halliday and Martin 1996; Koulaidis and Dimopoulos 2001). Low formality refers to codes that resemble everyday ways of expression and contribute to an everyday, realistic representation of things. High formality refers to specialized codes, which present the object of reference in high abstraction and focus on regularities, where general morphological characteristics are promoted rather than details of appearance. These dimensions will be used to configure different domains which will be used to retrieve the type of pedagogic practices enabled by the science exhibit.

The combination of classification and formality defines the degree to which a text introduces the reader to the norms, codes and practices of the scientific community, which condition knowledge construction, validation, and expression, by use of specialized and elaborated expressive codes. This combination produces four different domains of pedagogic practice: the esoteric, the metaphorical, the public and the mythical. (Fig.2)

	Strong classification	Weak classification
High formality	Esoteric domain	Mythical domain
Low formality	Metaphorical domain	Public domain

(Koulaidis and Tsatsaroni 1996, 63).

Figure 2: The domains of pedagogic practice

In turn, these domains will be exemplified below, using a set of selected science exhibits from the permanent exhibitions of the Eugenides Foundation. What is claimed here is that an exhibit implies – in a more or less conspicuous way – a tendency to enable practices associated with one of the above-mentioned domains. However, this cannot be sustained absolutely. The exhibit is a combination of semiotic elements that can be associated with certain semiotic systems, which do not necessarily combine cohesively into meaning making. Rather, as the reader will find out in the following decoding of the exemplifying exhibits that follow, particular exhibit elements may actually compete with each other in meaning making.

The esoteric domain: The esoteric domain of an exhibit refers to discursive types that are realised by means of highly elaborated forms of expression (high formality), and draw on scientifically specialized knowledge (strong classification). The following example (Fig. 3) refers to an exhibit titled *Family photos*, which is part of the thematic exhibition *Biotechnology*.

This exhibit presents hereditary and genetic transmission

Figure 3: The *Family Photos* exhibit

of individual traits (eye colour, blood group etc.) across generations. They depend on the genes carried by chromosomal DNA. In each cell, the pairs of chromosomes are made up of a paternal and a maternal set. So genes are present in two copies and these copies take different forms called alleles.

The scenario of exhibit use foresees that visitors examine the paths of heredity by means of an interactive genealogical tree showing four generations and three types of transmission – recessive, dominant and gender-related. Visitors stand in front of a display representing a family tree and choose one out of three ancestor couples at the origin of the transmission of a genetic disease: Huntington chorea (carried by chromosome 4), colour blindness (carried by the sex chromosome X), or beta (carried by chromosome 4), thalassemia (carried by

chromosome 16).

Even though the field of application of this exhibit is close to everyday experience, the knowledge basis of this three-dimensional representational is ontologically distant from everyday experience, strengthening the classification (Koulaidis, Dimopoulos, Sklaveniti, Hristidou 2001). The prominent visual representation of the genealogical tree plays an important role for the construction of the exhibit message. This genealogical tree is a visual representation with a classificational function (Kress and van Leeuwen 1996) which is considered closer to the conceptual, as opposed to action (ibid). Therefore, this visual representation is considered as associated with codes of high elaboration. The same impression is accentuated by use of ample techno-scientific terminology (DNA, cell, chromosomes, genes, recessive, dominant and gender-related transmission, Huntington's chorea, colour blindness, beta thalassaemia etc).

The exhibit is thus associated with the esoteric domain, due to its high scientific specialisation (genetic transmission of traits and hereditary diseases).

The relatively low contrast of colours and the lack of a distinct title for the exhibit strengthen its framing, as they do not encourage interaction and actually preclude any negotiation of meanings with the visitor. On the contrary, the interactivity elements first provide the visitor with some degrees of freedom concerning the access modes of the exhibit (view the external shell of the exhibit, observe the visual representation, read the labels and finally interact with the

tree structure) and secondly the depth of interaction (explore one, or more options presenting the transmission of a genetic disease fully the foreseen scenario of use). Additionally, the main element of interaction (the tree) and the labels are within the viewing cone of the visitor. All these elements weaken framing since they construct a powerful visitor with considerable rights in the relationship with the exhibit.

The metaphorical domain: The metaphorical domain refers to exhibit discourses which combine expressive means of low elaboration resembling the codes of everyday experience (weak formality) and scientifically specialized content (strong classification). In this case, scientific knowledge is communicated without the usual impediments posed by codes of high elaboration, usually deployed in the techno-scientific domain.

The following example (Fig.4) refers to an exhibit entitled *Volume and Mass*, which is part of the thematic exhibition *Matter and Materials*.

The exhibit provides opportunities for exploration, distinction and understanding of the concepts of volume, mass and matter, gravity and density. According to the scenario of exhibit use, visitors experiment by picking up objects of different sizes that weigh the same (1 kg). Their senses are misled as they have the impression that it requires more effort to lift objects smaller in volume. The weights can be checked on a scale. Eight materials can be tested, of varying density: steel, aluminium, glass, granite, wood, Rohacell polymer, rubber, and pumice stone.

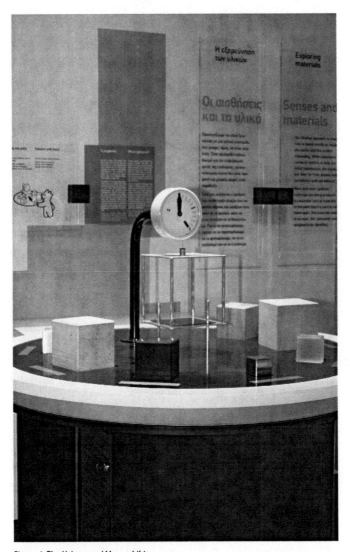

Figure 4: The *Volume and Mass* exhibit

The knowledge subject of this three-dimensional representational is ontologically distant from everyday experience, strengthening the classification (Koulaidis, Dimopoulos, Sklaveniti, Hristidou, 2001). However, the expression plane is based upon hands-on experimentation. The understanding of the scientific concepts is facilitated by use of simple, concrete objects (cube, scale), by materials that look and feel familiar (wood, glass, aluminium, rubber, etc.). Therefore, the representation is associated with codes resembling everyday life experience. The same impression is accentuated by use of ample techno-scientific terminology.

The high contrasts and use of warm colours encourage the exchange with the visitor, thus weakening the framing of the exhibit. So does the invitation for experimentation which seems to be attended to the visitor, who is invited to a hands-on approach, by the concrete objects obviously waiting to be tested on the scale. There is also the possibility for more than one visitor to interact simultaneously with the exhibit, enhancing the social experience of the interaction, empowering the visitor, and further weakening framing.

The public domain: the public domain refers to exhibit discourses which present knowledge of low specialization (weak classification) by expressive means of low elaboration (weak formality). A related example follows (Fig.5), based on the exhibit entitled *Director of Photography*, which is part of the thematic exhibition *Communication: Image and Sound*. The exhibit explores the pivotal role of lighting in performance arts, creating the right ambience in

Figure 5: The *Director of Photography* exhibit

theatre and cinema. The various lighting techniques are largely based on the conventions of traditional photography. In order to create the desired atmosphere, the director of photography has to highlight the appropriate details of the scene.

According to the scenario of exhibit use, each visitor acts as a director of photography, being able to experiment with lighting on a virtual cinema set. The installation includes a model street scene with a number of characters (on the street and in the buildings), a camera, a multimedia touch screen interface featuring an overhead view of the model to turn spotlights on or off, and a feedback monitor to see the impact

of the lighting on the model. Visitors are first introduced to the basics of lighting simulation in a street scene, by means of a prerecorded audio message. The story is based on a fifties film noir scenario. Visitors are invited to choose from three different types of lighting.

Even though the exhibit is based on trial and experimentation, the theme of the exhibit is of low specialization (weak classification), since it refers to concepts linked to everyday practice (street scene, ordinary people as characters, cinema, mood and atmosphere etc). On the contrary, on the expression plane, the interaction is based on aesthetic codes, a fact that weakens on the significance of tools originating from the province of technology (monitor, camera, multimedia interface etc), but are integrated into everyday use. The constructed visitor here is considered to be familiar with applied technology. What is implied is that the visitor is associated with societal segments that have access to this type of technology. This is an example of how the social is encoded in the specifications of the exhibit.

In circumstances where the visitor has limited access to multimedia technology of everyday use (e.g. those from less privileged social strata), he or she would be highly unlikely to feel familiar with manipulating this type of technology and would even develop technophobic tendencies. When the visitor is asked to interact with a technology-demanding exhibit, he or she might even feel estranged from the whole process. Such an exhibit would then be of high formality and would be characterized by practices in the mythical domain

Figure 6: The *Thousand Copies* exhibit

(weak classification, high formality).

The fact that the visitor cannot easily grasp the main concept of the exhibit, just by looking at it, combined with the lack of a visible exhibit title, weaken the power of the visitor over the conditions of interaction. On the other hand, the moderate height of the installation, making the equipment easily manipulable, the hands-on approach and the experimental character of the installation weaken the framing and empower the visitor.[11]

The mythical domain: The mythical domain refers to practices that combine content of low specialization (weak classification) and elaborated codes of expression (high formality). An example is based on the exhibit *One thousand copies*, which is part of the thematic exhibition *Biotechnology* (Fig.6).

The exhibit refers to the genetic diversity and related variability among individuals and populations within the human species. Each individual has a vast number of genes (around 100,000) that produce individual traits and uniqueness. Genetic diversity, a very important asset for human heritage, also manifests itself in the fact that populations from different parts of the world have specific characteristics such as skin colour, height and the presence or absence of certain enzymes. However, there are some populations that live very far from one another yet share a good number of common traits.

The external side of the exhibit includes two surfaces covered with photographs of individuals with visible variations. Inside the exhibit, there is a giant kaleidoscope made of three mirrors. Visitors walk into the kaleidoscope and see themselves reflected to infinity. Outside, they view a series of pictures of faces showing human genetic diversity. The aim of the exhibit is to raise questions about *What would happen if we were all alike?*, to explore issues of identity, implying a positive thinking about diversity. This exhibit presents issues encountered in the realm of everyday life which are distinctive of a social and even moral orientation rather than a techno-scientific questioning (low classification).

The expressive means of this content draw on a minimalist style of presentation (using picture frames of the same dimensions, repetition of motives, colour likeness, minor colour differences expressed in shades of grey), in order to present in a stylistically similar way a range of visibly different

human faces. In other words, the expressive means impose interpretations on the visitor, thus increasing both formality and framing. In the internal part of the exhibit (the visitors view their image in the mirror in eternity) the expressive means tend to provoke more reflection than action, thus increasing formality. The combination of low classification and high formality imply practices of the mythical domain.

The imposing message of the exhibit tends to strengthen formality, even though a surface reading might point to a user-centredness of the theme, an element that would empower the visitor. However, it would be misleading to equate the statement "the human being as the centre of attention" to "the visitor is the centre of attention": the first refers to *humanity*, which is ontologically a different entity to that of the individual *visitor*.

Conclusion

This article presented some new possibilities for exploring in a more systematic way the pedagogical potential of the science exhibit, examining conceptual, structural and operational features in practice. The proposed theoretical language combines concepts and methodology from social semiotic and particularly multi-modal analysis, along with the socio-epistemic concerns of Bernstein's theory of cultural codes.

The concepts of classification, framing and formality are employed in order to analyse the science exhibit as an instance of recontextualized scientific knowledge. The concepts

correspond respectively to the degree of specialization of the techno-scientific knowledge promoted by the science exhibit, in relation to the everyday, experiential knowledge, the regulation of control over norms that moderate the communication of knowledge, and the degree of elaboration of the semiotic code used to express the exhibit content. The combination of the values of classification and formality produce four domains of practice (esoteric, metaphorical, public, mythical), which – complemented by the dimension of framing – describe the applied pedagogic discourses enabled by the science exhibit.

The theoretical framework described in this article allows the exploration, in a systematic way, of issues such as the way scientific knowledge is recontextualized into science exhibit knowledge, the pedagogic relation constructed between the science exhibit and the visitor, and the type of reader constructed by the science exhibit.

These domains are exemplified with selected science exhibits. As the analysis of the examples reveals, more often than not the science exhibit is not a cohesive pedagogic text. Rather, it is the field for competing discourses and practices exerting their tensions and limitations onto the pedagogic interaction with the visitor.

Along these methodological lines, an operational translation of this framework will produce an even more systematic instrument for the analysis of the pedagogic practices implied by the exhibit. Such an effort is expected to facilitate targeted development of pedagogical material, that

would respect pedagogical specifications and communicative conventions, and, more significantly, that would take into consideration the social characteristics and pedagogical needs of the visitor.

Notes

1. *Unless otherwise indicated, the term 'museum' is used to refer to any type of non-formal learning environment (including science centres) open to the public, that offers exhibits as a way of communicating techno-scientific subject matter to the public and makes use of interactive means to that end.*

2. *An exhibit is considered to be open-ended if it meets at least one of the following criteria: 1. The exhibit allows for the achievement of multiple visitor-set goals; 2. The exhibit allows for one goal to be achieved in multiple ways.*

3. *Attracting power is usually defined as the percentage of visitors who stop at a given exhibit for a minimum amount of time.*

4. *Holding power is usually defined as the ratio of time spent by the visitor at an exhibit to the minimum time necessary to examine key objects, read labels, etc. According to Knutson (1954), only a limited number of visitors stop for more than a moment before any exhibit, unless the exhibit is particularly successful in holding attention.*

5. *See http://www.croftonbeamengines.org/about.html*

6. *The concept of 'truth value' is linked to that of modality, which refers to "the status, authority and reliability of a message, to its ontological status, or to its value as truth or fact" and further that "all utterances, all texts, given their social provenance, will always bear signs of modality" (Hodge and Kress 1988, 124).*

7. *Another interesting issue would be to discuss the conventionality and the semiotic nature of particular exhibit features, those parts that form the exhibit as a whole, e.g. a visual representation, a label, a peripheral object, a panel, a hand-guided mechanism, a monitor, a video, etc. Those features are not used in a contingent mode. Paraphrasing Halliday, in order to understand the 'language' in use of the science exhibit, we should start examining what each exhibit part 'says' against the background of what it might have 'said' but did not. The use*

of a form of semiosis means 'making choices in the environment of other choices'
(Halliday, 1978, 52). In other words, we could try to deconstruct the semiotic
whole of each exhibit and discover its constitutive parts.

8. *Any text is considered multi-modal (Iedema, 2003).*

9. *One could raise many interesting points for consideration, to name a few:*
If an exhibit tells a 'story', the same 'story' could probably be 'narrated' in
more than one way, using different codification, material and technological
apparatuses. We can explore how and why one semiotic system is chosen over
another and what might be the consequences for the 'content' of the message.
The cohesion of the multi-semiotic exhibit as a meaningful whole cannot be
taken for granted. The semiotic systems may complement or compete with each
other in meaning making process (Iedema, 2003).

10. *Compatible with this line of thinking is the concept of 'resemiotization' of*
Rick Iedema (2003). Resemiotization is about 'how meaning making shifts from
context to context, from practice to practice, or from one stage of a practice to
the next'.

11. *What is interesting here is to see the twofold interpretation of technology in*
the semiotic reading. For a visitor familiar with current audiovisual technology
of everyday use, technology enhances interactivity (its modes and depth)
with the exhibit. For a visitor deprived of access to this type of commodities,
technology may disempower the visitor.

References

Afonso, A. S. and Gilbert J. K. 2007. Educational Value of Different Types of Exhibits in an Interactive Science and Technology Centre, *Science Education* 91, 967 – 987.

Allen, S. 2004. Designs for Learning: Studying Science Museum Exhibits That Do More Than Entertain, *Science Education* 88 (Suppl. 1), 17– 33.

Alt, M.B. and Shaw K.M. 1984. Characteristics of ideal museum exhibits, British Journal of Psychology 75, 25-36.

Bernstein, B. 1991. *Pedagogikoi Kanones kai Koinonikos Eleghos*, Introduction, translation, notes: Joseph Solomon, Athens: Alexandria [in Greek].

Bernstein, B. 1996. *Pedagogy, Symbolic Control and Identity: Theory, Research Critique*. London: Taylor and Francis.

Bitgood, S. 2002. Environmental psychology in museums, zoos, and other exhibition centres. In *The Environmental Psychology Handbook* (2nd ed.), R. Bechtel and A. Churchman (eds) pp. 461-480, New York: John Wiley and Sons.

Bitgood, S. 2003. The role of attention in designing effective interpretive labels, *The Journal of Interpretation Research* 5, 2, 31-45.

Bitgood S, Serrell, B. and Thompson, D. 1994. The impact of informal science education on visitors to museums. In *Informal science learning: What research says about television, science museums, and community based projects*, V. Crane, H. Nicholson, M. Chen, and S. Bitgood (eds) pp. 61-106, Dedham, MA: Research Communications.

Boisvert, D. L. and Slez, B. J. 1995. The relationship between

exhibit characteristics and learning-associated behaviours in a science museum discovery space, *Science Education* 79, 5, 31-45.

Borun, M, and Dritsas, J. 1997. Developing Family-Friendly Exhibits, *Curator* 40, 3, 178–196.

Bud, R. 1995. Science, Meaning and Myth in the Museum, *Public Understanding of Science* 4, 1-16.

Burns, T. W., O'Connor, J. D. and Stocklmayer S. M. 2003. Science communication: a contemporary definition, *Public Understanding of Science* 12, 183–202.

Chandler, D. 1994. *Semiotics for Beginners*. University of Aberystwyth. [http://www.aber.ac.uk/media/Documents/S4B/semiotic.html]

Cook, R. G. 1998. Semiotics in Technology, Learning, and Culture, Bulletin of Science, *Technology and Society* 18, 3, 174-179.

Dierking. L., Ellenbogen K. M. and Falk J. 2004. In Principle, In Practice: Perspectives on a Decade of Museum Learning Research (1994-2004), *Science Education* 88 (Suppl. 1), S1-S3.

Dimopoulos K. and Koulaidis V. 2002. The socio-epistemic constitution of science and technology in the Greek press: An analysis of its presentation, *Public Understanding of Science* 11, 225-241.

Dimopoulos, K., Matiatos S. and Koulaidis V. 2002. Science and Technology Centers as 'texts'. In *Learning for the Future: Proceedings of the Learning Conference*, B. Cope and M. Kalantzis (eds), Sydney: Common Ground Publishing.

Dimopoulos K., Koulaidis V. and Sklaveniti S. 2003. Towards an Analysis of Visual Images in School Science Textbooks and Press Articles about Science and Technology, *Research in Science Education* 33, 189-216.

Dimopoulos K., Koulaidis V. and Sklaveniti S. 2005. Towards a framework of socio-linguistic analysis of science textbooks: the Greek case, *Research in Science Education* 35, 2, 173-195.

Falk, J. H. 1993. Assessing the Impact of Exhibit Arrangement on Visitor Behavior and Learning, *Curator* 36, 2, 133-146.

Falk, J. H. 1997. Testing a Museum Exhibition Design Assumption: Effect of Explicit Labelling of Exhibit Clusters on Visitor Concept development, *Science Education* 81, 679–687.

Falk, J. H. and Dierking, L. 1992. *The Museum Experience.* Washington, DC: Whalesback Books.

Falk, J. H. and Dierking, L. 1997. School Field Trips: Assessing Their Long Term Impact, *Curator* 40, 3, 211-218.

Falk, J. H. and Storksdieck M. 2005. Using the Contextual Model of Learning to Understand Visitor Learning from a Science Centre Exhibition, *Science Education* 89, 1–35.

Fiske, J. 1988. *Introduction to Communication Studies.* London: Routledge.

Fyfe, G. J. 1998. On the Relevance of Basil Bernstein's Theory of Codes To the Sociology of Art Museums, *Journal of Material Culture* 1998, 3, 325- 354.

Garnett, R. 2001. *The Impact of Science Centres/Museums on their Surrounding Communities: Summary Report*, Questacon,

Australia. [http://www.ecsite.net/epos/public/homepage. htm]

Gerber, B. L., Marek, E. A. and Cavallo, A. M.L. 2001. Development of an informal learning opportunities Assay, *International Journal of Science Education* 23, 6, 569- 583.

Gilbert, J. K. and Stocklmayer, S. 2001. Design of Interactive Exhibits to Promote the Making of Meaning, *Museum Management and Curatorship* 19, 1, 41-50.

Gilbert, J. K. and Stocklmayer, S. 2002. New experiences and old knowledge: towards a model for the personal awareness of science and technology, *International Journal of Science Education* 24, 8, 835-858.

Griffin, J. 1999. Finding evidence of learning in museum settings. In E. Scanlon, E. Whitelegg and S. Yates (eds), *Communicating Science.* pp. 63 – 93. London: Routledge.

Halliday, M. A.K. 1978. *Language as Social Semiotic.* London: Edward Arnold.

Halliday, M. A.K. 1996. On the Language of Physical Science. In M.A.K. Halliday and J. R. Martin (eds), *Writing Science: Literacy and Discursive Power*, pp. 54-68. London: The Falmer Press.

Halliday, M. A.K. and Hassan, R. 1989. *Language, Context and text: aspects of language in a social-semiotic perspective.* Oxford: Oxford University Press.

Halliday, M. A.K. and Martin J. R. (eds) 1996. *Writing Science: Literacy and Discursive Power.* London: The Falmer Press.

Halliday, M. A.K. and Martin, J. R. 2004. *H glossa tis epistimis.* Athens: Metehmio [in Greek].

Harrison, C. 2003. Visual Social Semiotics: Understanding How Still Images Make Meaning, *Technical Communication* 50, 1, 46.

Hodge, R. and Kress, G. R. 1988. *Social Semiotics*. Cambridge: Polity Press.

Hooper-Greenhill, E. (ed.). 1999. *The Educational Role of the Museum* (2nd ed). New York : Routledge.

Iedema, R. A.M. 2003. Multimodality, resemiotization: extending the analysis of discourse as multi-semiotic practice, *Visual Communication* 2, 1, 29–57.

Jarvis, T. and Pell, A. 2005. Factors Influencing Elementary School Children's Attitudes toward Science before, during, and after a Visit to the UK National Space Centre, *Journal of Research in Science Teaching* 42, 1, 53-83.

Koulaidis, V., and Dimopoulos, K. 2003. Science Education in Primary and Secondary Level: An analysis of the discursive transitions across different fields of the pedagogic discourse, *International Journal of Learning* 10, 3263-3274.

Koulaidis, V., Dimopoulos, K. and Sklaveniti, S. 2001. Analysing the Texts of Science and Technology: School Science Textbooks and Daily Press Articles in the Public Domain. In *Learning for the Future: Proceedings of the Learning Conference*, B. Cope and M. Kalantzis (eds). Sydney: Common Ground Publishing.

Koulaidis, V., Dimopoulos, K., Sklaveniti, S. and Hristidou, V. 2001. *Ta kimena tis techno-epistimis sto dimosio horo.* Athens: Metehmio [in Greek].

Koulaidis, V. and Tsatsaroni, A. 1996. A Pedagogical Analysis of Science Textbooks: How can we proceed?, *Research in Science Education* 26, 55-71.

Knutson, A. 1954. Evaluating Exhibits, *Health Education Journal* 12, 28.

Kress, G. and van Leeuwen, T. 1996. *Reading Images: The grammar of visual design*. London: UK, Routledge.

Kress, G. and van Leeuwen, T. 2001. *Multi-modal discourse: The modes and media of contemporary communication*. London: Arnold.

Latour, B. 1996. *On Interobjectivity, Mind, Culture and Activity* 3, 4, 228 – 245.

Law, J. and Mol, A. 1995. Notes on Materiality and Sociality, *The Sociological Review*, 43, 274–94.

Lindauer, M. 2005. What to ask and how to answer: a comparative analysis of methodologies and philosophies of summative exhibit evaluation, *Museum and Society* 3, 3, 137-152.

Logan, R. A. 2001. Science Mass Communication. Its Conceptual History, *Science Communication* 23, 2, 135-163.

Martin, L. M.W. 2004. An Emerging Research Framework for Studying Informal Learning and Schools, *Science Education* 88 (Suppl. 1), S71 -S82.

Peart, B. 1984. Impact of Exhibit Type on Knowledge Gain, Attitudes, and Behavior, *Curator*. 27, 3, 220-237.

Pedretti, E. G. 2004. Perspectives on Learning through Research on Critical Issues-Based Science Centre Exhibitions, *Science Education* 88, 1, S34– S47.

Perry, D. L. 1992. Designing exhibits that motivate, *ASTC Newsletter* 20, 2, 9-10.

Rahm, J. 2004. Multiple Modes of Meaning-Making in a Science Centre, *Science Education* 88, 2, 223-247.

Rennie, L. J. and McClafferty T. 1999. Science centres and science learning. In Scanlon E., Whitelegg E. and Yates, S. (eds) *Communicating Science*, pp. 63 – 93. London: Routledge.

Rennie, L. J. and Stocklmayer S. 2003. The communication of science and technology: past, present and future agendas, *International Journal of Science Education* 25, 6, 759-773.

Roberts, L. C. 1997. *From Knowledge to Narrative: educators and the changing museum*. Washington: Smithsonian Institution.

Sadovnik, A. R. 2001. Basil Bernstein (1924–2000). In *Prospects: the quarterly review of comparative education*, pp. 687-703. Paris: UNESCO: International Bureau of Education XXXI, 4.

Sandifer, C. 1997. Time-Based Behaviors at an Interactive Science Museum: Exploring the Differences between Weekday/Weekend and Family/Non family Visitors, *Science Education* 81, 6, 689-701.

Sandifer, C. 2003. Technological Novelty and Open-endedness: Two Characteristics of Interactive Exhibits That Contribute to the Holding of Visitor Attention in a Science Museum, Journal of Research in *Science Teaching* 40, 2, 121–137.

Screven, C.G. 1993. Visitors, *Museum International* XLV, 178, 2.

Schauble, L., Leinhardt, G. and Martin, L. 1997. A framework

for organizing a cumulative research agenda in informal learning contexts, *Journal of Museum Education* 22, 2 /3, 3-8.

Shettel, H. H. 1973. Exhibits: Art from or educational medium?, *Museum News* 52, 1, 32-41.

Smithsonian Institution. 2002. *Exhibition Standards.* Washington, DC, Smithsonian Institution Press, Office of Policy and Analysis.

Van Leeuwen, T. 1999. *Speech, Music, Sound.* London: Macmillan.

Vannini, P. 2007. Social Semiotics and Fieldwork: Method and Analytics, *Qualitative Inquiry* 13, 1, 113.

Wagensberg, J. 1992. Public Understanding in a Science Centre, *Public Understanding of Science* 1, 31-35.

Taxing Taxonomy, Scary Systematics and Confusing Classification: Interactive Activities to Make Scientific Jargon More Accessible

JAN FREEDMAN, CLARE BUCKLAND,

HELEN FOTHERGILL, ROB LONGWORTH,

PETER SMITHERS, ELAINE FILEMAN

& JODIE FISHER

Plymouth City Museum & Art Gallery,

Plymouth Marine Laboratory,

Sir Alistair Hardy Foundation for Ocean Science

& University of Plymouth

Latin. The ancient language used by the Roman Empire. Ancient, maybe; unpronounceable, perhaps; but not extinct. Scientists use Latin (and Greek) words to name new organisms they discover, to demonstrate the planet's great biodiversity and to build the Tree of Life that Charles Darwin first pondered and scribbled in one of his early notebooks. But who can say if *Vampyroteurhis infernalis* does share any of the feeding habits of *Desmodus rotundus?*[1] What does it mean when scientists talk about *Lepas anatifera* belonging to the order Pedunculata, in the phylum Arthropoda, sharing a very distant phylogeny with the phylum Mollusca?[2]

Naming animals, plants and other organisms (taxonomy), sorting them into groups (classification) and working out their relationship between other organisms (systematics) is the foundation of the biological sciences. All disciplines in biology are underpinned by identification and classification of animals and plants, including; understanding ecological changes; conservation methods for the protection of endangered species; examining the distribution of species; responding to climate change; studying biodiversity and the diversity of life (Tilling, 1987, 87; Cracraft, 2002, 127; Lyal, 2005, 65; Public Service).

Scientists, both professional and amateur, have discovered and named approximately 1.5 million species to date (Wheeler, 2008, 2), with an estimated 3 – 100 million species still to be found, described and published (Cracraft, 2002, 127; Lyal, 2005, 65). Recently, however, there has been a decline in taxonomists and systematists in the UK (Heyer, 2008, 17;

Public Service), and a reduction in new studies relating to the form and structure of organisms (morphological studies), which is resulting in leaving existing identifications untested, many of which may be incorrect (Wheeler, 2008, 2). It may be thought that taxonomy is a dead science, but with the current alarmingly high rate of extinctions the work of taxonomists has never been more vital (Wheeler, 2008, 2). Without knowing what species are there we will never know what has been lost and we will never have known, nor fully appreciate, the full biodiversity, and beauty, of life on our planet.

The school curriculum has failed to inspire people to pursue careers in taxonomy and systematics. The House of Lords Science and Technology Committee, Third Report in 2002 (HoL, Third Report) acknowledges a shortage in teaching taxonomy and systematics in schools and universities and admits there needs to be a greater emphasis on the importance of these subjects. A decline in taxonomic teaching in both schools and universities in the UK has also been noticed (Tilling, 1987, 87), and biology has been reported by students as being "dull" (Lock, 1998, 25) and "boring" (Tranter, 2004, 104), with interest in the subject generally decreasing as a child gets older (Tunnicliffe, et al. 2007, 36).

This paper explores the methods used by several partners in the City of Plymouth, during National Science and Engineering Week, to engage and inspire learners of different ages about why and how all organisms are named and classified, its relevance to society and importance to their lives.

National Science and Engineering Week

Founded on 27 September 1831, in York, the British Science Association (subsequently the British Association for the Advancement of Science, and more recently the BA), was originally set up, as outlined on the website, with the following aims (British Science Association, About Us):

· To give a stronger impulse and a more systematic direction to scientific enquiry;

· To promote the intercourse of those who cultivate science in different parts of the British Empire with one another and with foreign philosophers;

· To obtain more general attention for the objects of science and the removal of any disadvantages of a public kind that may impede its progress.

After 170 years, the main aims of the British Science Association are still very much the same; making science accessible to everyone. A nationwide initiative, National Science and Engineering Week (NSEW), was set up in 1994 and supported by the Government (British Science Association, History). The "week" takes place over ten days and promotes science and engineering, the importance of these subjects and how they relate to everyday lives.[3] Many organisations across the United Kingdom participate in events during NSEW which vary from *Green Explorers*, where children design and create buildings from recycled material (British Science Association, North East), to *Inner-space*, where members of the public can explore the human body (British Science Association, East).[4]

The partnership

The City of Plymouth has several scientific organisations, which are actively promoting science to the public and offer significant schools' outreach and engagement programmes. In 2006, four of these organisations joined together to organise an event for NSEW; Plymouth City Museum and Art Gallery (PGMAG), the University of Plymouth (UoP), the Sir Alistair Hardy Foundation for Ocean Science (SAHFOS) and Plymouth Marine Laboratory (PML).

After discussion, the partnership decided to theme the NSEW event around taxonomy, systematics and classification, entitled *Naming Nature*. All partners have hosted science events and activities at their respective organisations, and found that this area, that is essential to the study of biology, is one of the least understood by members of the public. The partners have witnessed confusion and lack of interest from the public and school groups when encountering the scientific terminology and the Latin/Greek words used in the fundamental rules of naming and describing all organisms (living and extinct) on the planet.

Planning the event involved creating themed activity tables for each of the partners and an introductory area (described below). Pull up banners for each table were written and checked by each partner to ensure readability and consistency. From the first meeting, the marketing plan for NSEW involved all the partners, including the British Science Association logo (which provided funding to support the event) on any press release and publicity (Runyard and

French, 1999, 55). The event combined each others' expertise, knowledge, practical materials and specimens to help with the event, benefiting and raising the public awareness of all organisations (Runyard and French, 1999, 104). PCMAG hosted the event in one of the larger galleries.

Naming Nature ran for booked school groups from Tuesday to Friday during NSEW, and was open to the public on Saturday. The weekday school sessions ran for one and a half hours for each school, allowing approximately 12 minutes for the pupils to spend on each of the six interactive tables. The sessions ended with a competition, where the pupils created their own animal or plant and gave it a Latin name (see Evaluation for further details).

The week long event was supported by members of staff and volunteers from each organisation. Student volunteers from the UoP assisted throughout the week. The keen and enthusiastic students acted as role models and were closer to the age of the visitors than the general age of the staff; this aided in breaking down the stereotype of scientists as old eccentric men with great beards. *Naming Nature* also provided the students with an opportunity to get involved in science communication and gain experience for their CVs. The students, and the staff, were the specialists for the week (and will be referred to as such throughout this paper), explaining the apparent complexity of scientific jargon in everyday terms.

The words *taxonomy* and *systematics* were used on all the activity tables, as well as other scientific terms. The specialists

used these terms and then explained what they meant, how they relate to the organism and why they are used. This allowed the visitors to understand why scientists used these seemingly strange words. The visitors could then use the terms when they identified different organisms throughout the event.

Naming Nature

The introduction table used information posters and specimens from PCMAG's natural history collections, to describe how:

- organisms are named (*classification*);
- organisms are different from each other (*taxonomy*);
- classification and taxonomy can illustrate the diversity of organisms on Earth and their relationships to each other on the "tree of life" (*systematics*).

Carl Linnaeus (also known as Carolus Linnaeus, or Carl von Linné) (1708-1778) was a Swedish natural philosopher who wanted to make a catalogue of all animals and plants on Earth (Ruse and Travis, 2009, 686); even today this is nowhere near complete. In doing so, Linnaeus has standardised the system for naming all organisms to this day. He organised organisms into hierarchies, using Latin, with similar organisms placed closely on the hierarchy (Fig. 1).

The beauty and simplicity of this system is that Latin is an ancient language, no longer used for verbal communication, so the words have not changed. Latinising names allows someone

Kingdom	Phylum	Class	Order	Family	Genus/Species	Simple name
Plantae	Magnoliophyta	Magnoliopsida	Rosales	Urticaceae	*Urtica doica*	Stinging Nettle
Animalia	Invertebrata	Insecta	Lepidoptera	Nymphalidae	*Vanessa atlanta*	Red Admiral Butterfly
Animalia	Chordata	Mammalia	Primates	Hominade	*Homo sapiens*	Human
Animalia	Chordata	Aves	Piciformes	Picidae	*Picus viridis*	Green Woodpecker
Animalia	Chordata	Reptilia	Saurischia	Tyrannosauridae	*Tyrannosaurus rex*	—

Figure 1: An example of a few organisms named through the Linnaeus classification system (omitting the sub-families, sub-orders, super orders, etc).

in China, for instance, to know what animal they are looking at without the confusion of different local names used by someone in, say, England. This system of classification can also demonstrate the close similarity of animals and plants, inferring their close evolutionary relationship, although Linnaeus had no belief in evolution (Ruse and Travis, 2009, 687).

There are rules which apply when naming new species, which were also outlined on this introductory table. In order to name a new species, it has to be scientifically described and published in a scientific journal. Comparisons with similar organisms must be shown clearly, leading to what order, family and/or genus the organism belongs. The name given must be in Latin (or Greek) and follow gender assignments for the ends of genus and species names. Finally, a species can be named after someone else, but not after yourself!

Mini-beasts

Arachnida, Hexapoda and *Myriapoda* are just a selection of invertebrates, that can be called mini-beasts, but how can someone make sense out of that list? The UoP created an activity using a simple key and a myriad of plastic mini-beasts for visitors to group together (Fig. 2). Explaining the differences between groups of mini-beasts, such as number of legs, the different antenna and the wing shape, allowed the school groups, and the public, to group these scaled-up mini-beasts into the correct bucket (labelled with a scientific name).

Live mini-beasts were on display to examine the different

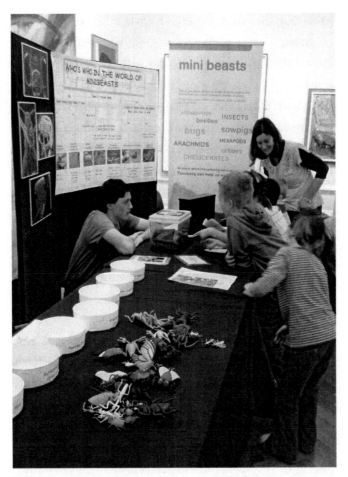

Figure 2: The UoP stand, with the plastic mini-beasts, and named buckets for sorting in the foreground, and the pupils looking at live mini-beasts. The pull up banner and the posters in the background provide additional information for the groups.

parts that separate one species from another in more detail, including hissing cockroaches, giant land snails and giant stick insects. These activities allowed the visitors to look at mini-beasts in a way they never have before; as scientists.

Scientific names were used and explained by the specialists to demonstrate the importance of why Latin/Greek is employed. For example, the Greek coining of Hexapoda can be translated into English; *Hex* means *six* and *pod* means *foot*, so Hexapoda means six-legged (and includes all the six-legged mini-beasts, such as flies, beetles and moths, for example). Another example, Myriapoda, can be translated into English; *Myria* means *many* and *pod* means *foot*, so Myriapoda means *many feet* (and includes centipedes and millipedes).

Feathered friends

PCMAG developed an activity using mounted bird specimens from the natural history collections. Examples of different orders of birds were used with a bird key to examine the different features, including beak shape, feet, and feathers. The specimens used were from several different families, including birds of prey (Falconiformes), owls (Strigiformes), perchers (Piciformes and Columbiformes), waders (Charadriliformes) and divers (Gaviformes).

The specialists began each session with an explanation of the terms used and what makes them different from each other (Fig. 3). For example Falconiformes can be translated into English; *falx* means *sickle* and *formes* means *shape*. The visitors then had to use the key and the specimens to identify

Figure 3: The interactive bird taxonomy table, with specimens handled by the specialists, but close for the pupils to see the features of the animals.

the different group and describe why they thought it was from that group. Although some of the visitors immediately tried to guess the birds which were familiar to them, the specialists focused their attention on the things that makes them different from other specimens. This method of grouping and sorting reinforced the morphological basis of much of the history of taxonomy and classification.

Life beneath the waves

The miniature world of the oceans was investigated by SAHFOS, using live specimens under a microscope and models of phytoplankton (plants) and zooplankton (animals) (Fig. 4). Often, early scientists named these microscopic

Figure 4: The marine stand showing the children working on the zooplankton match. To the left of the picture is a microscope with live samples collected by SAHFOS.

organisms based on their appearance, the zone in which they lived and how they moved. For example, the phytoplankton diatom *Gyrosigma* was so called because scientists thought the cell looked like a *rounded S shape* which is what *Gyrosigma* is translated to in English; *Gyro* means *round* and *sigma* means *sigmoid* or *s-shaped*. Another example would be the Copepod, so called because of the way it moves its legs and swims; *Cope* means *paddle or oar* and *pod* means *foot*.

This activity allowed the visitors to carefully study the shape of these microscopic organisms to work out their names. They were given the names of the organisms and had to match them to models of the microscopic creatures, using the appearance of the organisms.

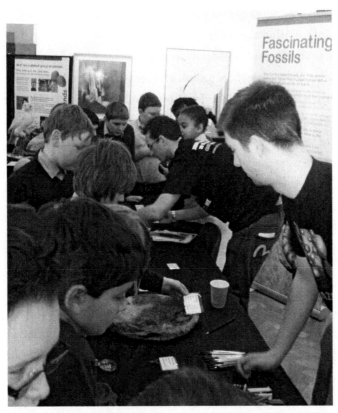

Figure 5: The interactive hands on geology stand, using real fossils from the UoP and PCMAG for the pupils to handle and examine.

Fascinating fossils

Taxonomy and classification is not just limited to the living world, but also extends back millions of years into the geological past. Scientists who study ancient life in the rocks (palaeontologists) have classified long dead species and ancestors of the animals and plants we see today, for hundreds of years. By studying the remains that are found in rocks

and sediments globally we can determine a huge amount of information about life in the geological past.

To illustrate how palaeontologists analyse fossils and classify them, school groups and the public were asked to use their knowledge of modern animals and plants to undertake two tasks (Fig. 5). Firstly they were asked to match a selection of fossils to their names. Names were given in simple terms, such as *mammoth tooth* and *ichthyosaur paddle*, along with their Latin names and age. By assessing size, shape and the form of the fossils visitors were able to match the names to the fossils by learning how the different shapes and sizes help classify the different species. Secondly they were then asked to undertake a short quiz about the different fossils. This quiz aimed to get the school pupils and public to think more about the animals and plants that the fossils once were. By asking them to determine what the once living animal or plant specimen looked like, they begin to make links with the modern world. The visitors can then discover more about the fossils, relating them to living organisms, similar to those we see on Earth today.

The future

Molecular techniques and modern deoxyribonucleic acid (DNA) fingerprinting can be used to assist in species identification. To demonstrate this, PML developed an interactive activity based on simple DNA sequences of several organisms. A model was used to explain what DNA actually is, and to determine how parts on the model (genes)

DNA barcode segment	Common name	Scientific name	Interesting facts
CAG CCG GGC AAT GAT	Sea cucumber	*Bohadschia argus*	Phylum Echinodermata (spiny skin) along with brittle stars, sea urchins and starfish.
CAG CCG GGC AAT GAT	Common starfish	*Asterias rubens*	Phylum Echinodermata (spiny skin) along with brittle stars, sea urchins and sea cucumbers.
ACA CTT AAC TAA TGG	Blue whale	*Balaenoptera musculus*	The Blue Whale is usually classified as one of seven species of whale in the genus *Balaenoptera*; however, DNA sequencing analysis indicates that Blue Whales are phylogenetically closer to the Humpback (*Megaptera*) and the Gray Whale (*Eschrichtius*) than to other *Balaenoptera* species.
ACC CTT AAC TAA TGG	Harbour porpoise	*Phocoena phocoena*	Porpoises, along with whales and dolphins, are descendants of land-living mammals and are related to hoofed animals. They entered the water roughly 50 million years ago.

Figure 6: Examples of the DNA segments the pupils had to match up to find the correct organism on *The Future* table.

relate to eye colour and hair colour. Visitors were then given the opportunity to match cards with segments of DNA (barcodes) to different organisms using a tabulated library of DNA segments, which listed the different species that the DNA belonged to (see Fig. 6). After the visitors matched their cards to the information library, they could then compare the DNA of the different organisms. (The DNA segments used were just examples, and designed to illustrate the similarity of DNA between organisms and how closely related all life on Earth is.) The future of taxonomy using DNA barcodes was discussed with school pupils and the public. This illustrated how the advances in technology, combined with working closely with taxonomists, can potentially assist in the identification of different species.

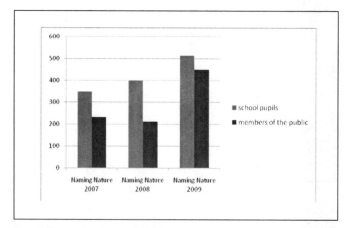

Figure 7: The attendance figures of school pupils and members of the public for the *Naming Nature* events from 2007 – 2009.

Evaluation

Naming Nature ran for three successive years, from 2007-2009. The attendance at the event by school pupils and the general public can be seen in Fig. 7. Over the three consecutive years, the number of school pupils has increased. The fall in attendance of the public in 2008 may be attributed to the fact that *Naming Nature* was held at a different venue and not in the museum.

Feedback was provided by the school groups and the members of the public. The feedback from the teachers who organised the school sessions was very positive (Figs. 8a, 8b), illustrated by the following quotes:

- "We have attended in previous years. This year was the best yet! Well organised with a perfect blend of listening and activities"
- "The activities enthralled and excited the children and were inclusive. Their relevance and the enthusiasm and expertise of the adults ensured the children participated fully. It was wonderful to see experts on the floor working with the children right to the end. Such enthusiasm is inspirational for young people."
- "These activities worked very well with our work for Key Stage 2 Science."

The last day of the event was open to the public, and evaluation was also carried out (Fig. 9). The ages of the attendees who filled in the questionnaires ranged from 6 to 26 years old, with two responses not stating their age. The feedback was

	Very	Fairly	No view	Not very	Not at all
How would you rate the following aspects of this event/activity?					
Interesting	25	1	0	0	0
Enjoyable	23	3	0	0	0
Topical	17	10	0	0	0
Educational	23	4	0	0	0

Figure 8a: Evaluation from teachers who attended the Tuesday to Friday sessions (2007).

positive, with many children enjoying the interactive parts of the event, in particular the live mini-beasts and the real specimens from the museum collections.

The competition entries (Figs. 10-12) also allowed evaluation of the younger visitors' understanding of taxonomy and classification. The competition was designed to be completed after time spent on the activity tables. They had to use what they had learnt at the different activity tables to create an animal or plant, and then name it in Latin. (Some descriptive Latin words were translated into English on the back of the competition sheet). The creativity and enthusiasm shown by the pupils, and later, by the members of the public, displayed clear understanding of naming organisms. The prizes for the competition winners and runners up varied for each year, ranging from microscope kits to CD Encyclopaedias, and each year's winner was invited for a special behind the scenes tour to view PCMAG's natural history collections with their class.

	Very	Fairly	No view	Not very	Not at all
To what extent do you agree with the following statements about this activity?					
The event/ activity was well structured	15	4	0	0	0
There was enough time for discussion and/ or activities	12	13	0	1	0
I understood the majority of issues raised and this event gave me the opportunity to explore issues and concepts	18	6	1	0	0
I am likely to tell my friends/ colleagues/ families about what I discovered in this event	18	7	1	1	0
Taking part in this event/ activity has made me want to find out more about science and engineering	12	7	5	0	1

Figure 8b: Evaluation from teachers who attended the Tuesday to Friday sessions (2007).

Did you learn anything new at this event? What did you learn?	"Learnt fossils and some names." "Yes. Found out what it is like to hold a cockroach." "Bugs/insects."
What did you and your family enjoy and why?	"Enjoyed looking at the different things that you don't get a chance to see normally." "Staff knew loads." "All of it."
What did you and your family not enjoy and why?	"Not really." "Would have enjoyed more stuff."
Is there anything we can do to make it better for next time?	"Something for smaller, 2 and under, to keep them amused while other children learn and enjoy." "More creatures to hold."

Figure 9: A selection of responses from the evaluation by the general public (2009).

Discussion

The House of Lords Science and Technology Committee focused on the decline of professional systematists and taxonomists in the UK in two reports; the Third Report in 2002, (HoL, Third Report) and the Fifth Report in 2008 (HoL, Fifth Report). The Third Report recognised that there is a need to take action to improve systematic biology in the UK, and recommends that institutions need to promote the subject to increase awareness. The report also acknowledges a deficiency in teaching taxonomy and systematics at schools and universities and that there needs to be a greater emphasis in the curriculum on the importance of taxonomy. The Fifth Report recognises that there is an urgent need for taxonomists, as the majority of those currently in professional positions are

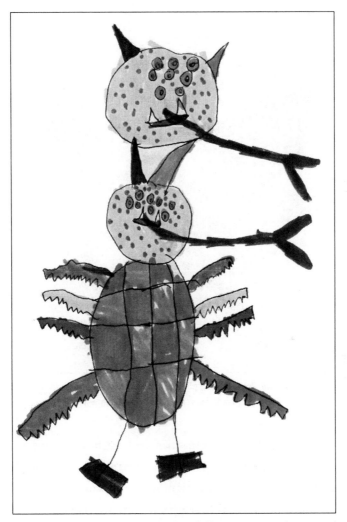

Figure 10: Competition entry by a school pupil. The creature created was named
Bicephalodentapod (translated as "two headed teeth foot" creature)

Figure 11: One of the competition entries which was given a genus and species name of *Dentpterapod trigranulata* (translated as "Triangluar shaped tooth-wing-foot" creature).

over 40, with many close to retirement age. It also recognises the importance of regional museums to inspire young people about the importance and significance of taxonomy.

Museum natural history collections have been, and remain, vital for taxonomy and systematics (Suarez and Tsutsui, 2004, 66). Natural history collections are rich in a wide variety of specimens, from pinned insects to spirit preserved marine life. These specimens can be used by

Figure 12: Another example of the creativity and imagination of the young visitors, this creature was named *Rubraptera polypod* (translated as "red winged many legs").

schools to provide evidence to support the theory the pupils are learning in the classroom (Braund, et al. 2008, 28). Real specimens are available to look at, even handle, and the museum itself offers a learning environment that is new, exciting, comfortable and outside the classroom (Braund, et al. 2008, 28).

One of the simplest ways for museums, and other organisations, to assist with promoting taxonomy, and other science subjects, is through clear communication. The two types of communication used in museums are mass communication, through labels with objects and specimens, and face-to-face communication through talks and interactive events. Both these methods of communication were used in *Naming Nature*.

One of the main disadvantages of mass communication is that the message of the label, or banner, can be misinterpreted

(Bucchi, 2004, 269). However, the benefit of having specialists (a mixture of staff and volunteers) at each activity in *Naming Nature* meant that the posters and banners (mass communication) were not misunderstood by the visitors.

The varying age range of the specialists allowed them to be approachable and inspiring, as one teacher comments: "...It was wonderful to see experts on the floor working with the children right to the end. Such enthusiasm is inspirational for young people." The specialists were on hand to have conversations, and sometimes debates, with pupils about topics they may feel uncomfortable discussing with their teachers. It has been reported (Dunkerton, 2007, 102), that pupils do not engage with their teachers about scientific discussions, and this was apparent during *Naming Nature*; teachers have commented verbally to the specialists "Bob is so quiet in school" and "it is great to get the children to think about things in more detail. They are asking so many questions!"

Children of different ages have different levels of understanding and different learning styles (Crowley and Siegler, 1999, 304), which was the more challenging part of *Naming Nature*. The age groups ranged from 4 year-olds to 14 year-olds. The specialists were briefed on how to pitch their levels of detail to different audiences, not dumb down their activities, but to make them relevant; to engage an audience by (1) knowing their interests (what do they like?), (2) setting goals (what will they get from this?) and (3) motivation (are they bored yet?) are essential for learning (Hidi and

Harackiewicz, 2000, 151). Scientific terms were used and explained for each age, and in the case of the younger age ranges (4 years to 9 years old), they were asked to repeat these words out loud together. They themselves were sometimes given as an example of taxonomy; we belong to the genus and species *Homo sapiens*. This demonstrated that big scientific words are not scary, nor confusing, and are meaningful to them.

The background and interest of any teacher, in particular primary school teachers who have to cover all subjects from science to art, will subconsciously dictate the detail in which a subject is covered (Watters and Ginns, 1995, 22). Teachers may brush over scientific words, as they themselves may not be comfortable with their meaning (Watters and Ginns, 1995, 22). The evaluation from the teachers signified the relevance of *Naming Nature* to subjects on the curriculum. The presence of specialists, and the out-of-classroom learning, allowed the teachers to stand back if they were not comfortable, or join in with the specialists if they were familiar with the subject. On several occasions teachers were even joining in with the pupils, asking the specialists questions, which turned the teachers into the "taught". This was interesting to observe at the event.

Some competition entries demonstrated contextual awareness of the creatures and plants they created; for example big teeth for eating other animals, or wings for flying. This demonstrates the child's "systems thinking", which is used to describe how well children understand the

interactions of ecosystems, and environmental interactions (Hipkins, et al, 2008, 73). They clearly finished their day with understanding how different animals and plants are named, many based on the features they possess, and creating some fascinating names that may boggle even the most confident taxonomist (Fig. 13).

The partnership worked extremely well, because all partners wanted the same outcome; to create a fun, interactive and engaging event to promote taxonomy and systematics. School pupils learn by doing (Campbell, 2003, 897), and the interactive thinking and planning of *Naming Nature* allowed a seemingly difficult subject riddled with scientific jargon, to be broken down, explaining the how and the why. *Naming Nature* was successful because it drew in the audience and tickled their curiosity. The event was also manned by extremely keen, enthusiastic and well informed staff and volunteers who interacted with the public, and proved science is not dull or boring.

The final day of the event on Saturday was open to members of the public; mainly family groups who had made a special visit for the event, and a few independent museum visitors who had found the event during their trip to the museum. The public day of NSEW was very different and interesting, in particular in observing the family groups. One study (Crowley, et al. 2001, 712) looks at how parents assists their child's learning by leading the interaction with an instrument and looking at how it works (evidence) and changing how they now understand that instrument to work (theory) to match

Latin name	Translation	School	Age
Polymaxima chromispod	Many large colourful feet creature	Thornbury Primary	5
Tetraptera polypoda	Four winged many feet creature	Victoria Road Primary	8
Chromismaxima robustaspinus	Large colourful think spiny creature	Thornbury Primary	5
Oceania polycerasspinus	Many horns and spiny creature of the ocean	Prince Rock Primary	8
Minimaicthys maritima	Small fish of the ocean	Marlborough Primary	10
Maxima unilolorceras	Large one horned creature	Thornbury Primary	9
Petra chromis	Colourful wing	Compton Primary	7
Pelagicahirsta bichromis	Hairy swimming two coloured creature	Oreston Community Primary	7
Minimaptera chromis	Small winged colourful creature	Beechwood Primary	8

Figure 13: A selection of examples of the competition entries of creatures scientifically named by school pupils.

the new evidence they have discovered. Many children, and adults, have preconceived theories about different subjects in science, and these theories can change when they are shown new evidence (Crowley, et al. 2001, 712). This study only focused on an independent interactive object, with no staff assisting them in the interpretation.

Many of the children had visited *Naming Nature* during the week with their school and had come back with their parents. These children (8 and upwards) were discovering for themselves with more confidence, and then explaining to their parents what they had learnt. Real scientists were on

hand to answer questions and help guide the children with the activities, using evidence, to reach the correct theory. In this case the scientists took over from the role of the parents by explaining about identifying, generating and interpreting the evidence. To younger children (7 years and under), the parent would often repeat what the scientist had described. By explaining and describing the different structures in organisms and asking the right questions, the specialists helped the children to reach the right answer.

Conclusion

To address the problem of declining taxonomists and systematists, one author (Lyal, 2005, 65) suggests we need better field guides, more environmental and taxonomic centres set up, clear communication with taxonomists and finally resources available for schools. All of these suggestions are important, especially for engaging with amateur taxonomists, who are becoming the dominant group in the taxonomic world and are responsible for the main bulk of taxonomic identifications throughout the UK. *Naming Nature*, we hope, will demonstrate that communicating clearly and inspiring children with hands-on activities and specialists, is an important method to engage and encourage the next generation of scientists.

The endless variety in morphology and other characteristics in organisms can draw many students to study the beauty of the natural world (Wheeler, 2008, 2). The role of museums and other science organisations is to

communicate science in a clear and approachable way for those people who do not see that immediate beauty, and for everyone to be able to understand and become inspired by science. Taxonomy isn't taxing, systematics can be clear and simple and classification just needs a little common sense. Naming and identifying organisms is the way to understand the biodiversity of the planet, and discover first hand what Darwin (1905, 441) intended when he wrote "endless forms most beautiful and most wonderful have been, and are being, evolved."

Notes

1. *Vampyroteurhis infernalis literally translates as the 'vampire squid from hell', based solely on it's appearance. It eats prawns and jellyfish. Desmodus rotundus however, is the Common Vampire Bat, which feeds solely on blood.*

2 . *Lepas anatifera is the scientific name for the Goose Barnacle. It is classified in the order Pedunculata, because it shares many similarities with other barnacles in this order. The order Pedunculata is classified in the phylum Arthropoda, because barnacles are in fact more closely related to crabs and lobsters, than clams or oysters [which are both in the order Mollusca]. The two groups, Arthropoda and Mollusca, share a common ancestor around 520 million years ago [phylogeny examines the history of groups of animals as they change through time].*

3. *National Science and Engineering Week was originally set up as National Science Week in 1994. Engineering was added to the title in 2006.*

4. *Further information about the British Science Association and National Science and Engineering Week can be found on www.britishscienceassociation.org*

Acknowledgements

The events could not have taken place without the dedication and enthusiasm of the student volunteers from the University of Plymouth, to whom, we are indebted. Thank you to all the members of staff at all the partner organisations for their assistance and support with the project. Thank you to the British Science Association for their funding and support for the three years the Naming Nature event ran. Finally, a big thank you to all the pupils at the schools who booked a session in the museum.

References

Braund, M., et al. 2008. New Scientists. *Museums Journal*. 108 (5) pp.28-31.

British Science Association, *About Us*: http://www. britishscienceassociation.org/web/AoutUs/OurHistory/ index.htm Accessed on 24th December 2009.

British Science Association, *East*: http://www. britishscienceassociation.org/NR/rdonlyres/67FCCFD9-7485-45AA-BF2A-A2858212C3DF/0/Eastern.pdf Page 8. Accessed on 24th December 2009.

British Science Association, *History*: http://www. britishscienceassociation.org/web/nsew/NSEW_arcive/ NSEWHistory.htm Accessed on 24th December 2009.

British Science Association, *North East*: http://www. britishscienceassociation.org/NR/rdonlyres/592F7BAD-D62F-4D7B-8859-1F422D4AADED/0/BANSWNorthEast.pdf Page 7. Accessed on 24th December 2009.

Bucchi, M. 2004. Can Genetics help us rethink communication? Public Communication of science as a 'double helix'. *New Genetics and Society*. 23 (3) pp.269-286.

Campbell, R. 2003. Preparing the Next Generation of Scientists: The Social Process of Managing Students. *Social Studies of Science*. 33 (6) pp. 897-972.

Cracraft, J. 2002. The Seven Great Questions of Systematic Biology; An Essential Foundation for Conservation and the Sustainable use of Biodiversity. *Annals of the Missouri Botanical Garden*. 89 (2) pp.127-144.

Crowley, K. and Siegler, R. S. 1999. Explanation and

Generalisation in Young Children's Strategy Learning. *Child Development.* 70 (2) pp.304-316.

Crowley, K., et al. 2001. Shared Scientific Thinking in Everyday Parent-Child Acivity. *Science Education.* 85 (6) pp.712-732.

Darwin, C. 1905. *On the Origin of Species by means of Natural Selection.* R & R Clarke, Edinburgh. Fifth Impression. p. 441.

Dunkerton, J. 2007. Biology Outside the Classroom; the SNAB visit/issue report. *Journal of Biological Education.* 41 (3) pp.102-106.

Heyer, W. R. 2008. Can Long Established Scientific Societies Survive the Digital Age? *Washington Academy of Sciences.* 94 (2) pp.17-32.

Hidi, S. and Harackiewicz, J. M. 2000. Monitoring the Academically Unmotivated; A Critical Issue for the 21st Century. *Review of Educational Research.* 70 pp.151-179.

Hipkins, R., et al. 2008. The interplay of concepts in Primary School Children's Systems Thinking. *Educational Research.* 42 (2) pp.73-77.

HoL, Fifth Report: *House of Lords, Science and Technology Committee, Third Report* http://www.parliament.the-staionary-office.co.uk/pa/1d200708/1dsctech/162/16206.htm Accessed on 5th December 2009.

HoL, Third Report: *House of Lords, Science and Technology Committee, Third Report* http://www.publications.parliament.uk/pa/1dsctech/118/11807.htm Accessed on 5th December 2009.

Lock, R. 1998. Advanced Level Biology-Is there a Problem?

School Science Review. 80 (290) pp.25-28.

Lyal, C. H. C. 2005. Crumbling Foundations: the erosion of the taxonomic base of biology. *School Science Review.* 87 (319) pp.65-74.

Public Service web: *Picture continues to be bleak for systematics and taxonomy:* http://www.publicservice.co.uk/feature_story.asp?id=10260 Accessed on 23rd December 2009.

Runyard, S. and French, Y. 1999. *Marketing and Public Relations Handbook for Museums, Galleries and Heritage Attractions.* The Stationery Office. p.55., p.104.

Ruse, M. and Travis, J. (Eds) 2009. *Evolution: The First Four Billion Years.* The Belknap Press of Harvard University Press. p. 686, 687.

Suarez, A. V. and Tsutsui, N. D. 2004. The Value of Museum Collections for Research and Society. *Bioscience.* 54 (1) pp.66-74.

Tilling, S. M. 1987. Education and Taxonomy: the role of the Field Studies Council and AIDGAP. *Biological Journal of the Linnean Society.* 32 (1) pp.87-96.

Tranter, J. 2004. Dull, Lifeless and Boring? *Journal of Biological Education.* 38 pp.104-105.

Tunnicliffe, S., et al. 2007. Is Biology Boring? Students Attitudes Towards Biology. *Journal of Biological Education.* 42 (1) pp.36-39.

Watters, J. J. and Ginns, I. S. 1995. *Origins of and changes in preservice teachers' science teaching self-efficiency.* Presented at the Annual Meeting of National Association for Research in Science and Teaching. April 22-25. 1995. San

Francisco, CA.

Wheeler, Q. D. 2008. Undisciplined Thinking; Morphology and Henning's Unfinished Revolution. *Systematic Entomology.* 33. pp.2-7.

Natural History Dioramas: Dusty Relics or Essential Tools for Biology Learning?

SUE DALE TUNNICLIFFE

Institute of Education, University of London

ANNETTE SCHEERSOI

Frankfurt University

Natural history dioramas typically combine preserved organisms and painted or modelled landscapes. They were historically designed to evoke feelings and to promote an ethic for the preservation of species and their habitats (Insley 2007). Collections of exotic animals were established for the satisfaction of a curious public and the edification of scientists. Karen Wonders conducted the most comprehensive study of dioramas for her PhD study, which was published as a book. Her work is summarised (Wonders 1989).

Natural History Dioramas had their hey-day in the late eighteenth and early nineteenth and have nowadays often been derided as old fashioned and as low technical exhibits unworthy in a computer focused, push button age. Interactive museum exhibits, designed by a new generation of designers and marketing professionals, have captivated museum directors. Yet, after a several decades of push button and hands-on exhibits, computers are now commonplace. Visitors are overheard urging children to look at "the real things" of whatever subjects, cultural or biological, because they can "... do computer things at home".

The natural history diorama as a unique genre of reality exhibit is emerging as a key tool in biological and conservation education. The Carl Ackley dioramas of the American Museum of Natural History in New York for example are still a tremendous visitor attraction. A number of museums in the USA have recently extended their dioramas (e.g. Denver, University of Nebraska, Lincoln, and Boston), and new dioramas have been constructed worldwide (e.g. in the

Natural History Museum in Malta, the Museum of Scotland in Edinburgh, Museum of Natural History [Ottoneum] in Kassel, Germany, and different museums in China). Dioramas can provide the whole picture of a given habitat and biome. They reflect or construct reality.

Dioramas as useful tools?

Our particular interest is in dioramas not only on the story they tell but also the story and inquiry they can stimulate. Dioramas have a tremendous educational potential and can be used to communicate science to a wide audience. Nevertheless, the educational literature on dioramas is still small, and dioramas do not feature in major texts on museum learning. Existing literature considers that dioramas draw visitors and have a high intrinsic value (e.g. Breslof 2001). By their stillness, they offer visitors the opportunity to stand and stare (Tomkins and Tunnicliffe 2001) and stimulate narratives (Reiss and Tunnicliffe 2007). All kinds of dioramas provide emotional access to topics (Insley 2007), and, as depictions of reality, contrived and authentic replication (Tunnicliffe 2005), they are valuable records of the animals (and plants) on the site on which the diorama is based (Quinn 2006).

Natural history dioramas are increasingly appreciated as valuable genre of museum exhibit and their key role is more and more recognised by the museum professionals with a developing appreciation of the importance of such exhibits, albeit some from over a century old, in contributing to visitor's understandings of their work and that of conservation

188 · NATURAL HISTORY DIORAMAS

and taxonomic biology. Using natural history dioramas to develop and communicate aspects of biological education and inquiry science is an innovative concept, which has arisen from research into the content of spontaneous conversations of visitors at natural history dioramas (e.g. Tunnicliffe 2009, Scheersoi 2009). Researching such communications, the visitor's behaviour and interpretations are developing into an important aspect of the biological education work of natural history museums and is now being developed by more researchers. Examples of research findings on the educational value of Natural History dioramas will be given below.

Background: museum learning

When people look at exhibits, be they in a science museum, botanic garden or zoo or specimens on a field trip, they construct meaning from what they see, what so ever it is, animal, vegetable or mineral or constructed artefact. As a museum audience, visitors interpret exhibitions using a variety of personal and cultural influences views (Scott 2005). Animals as exhibits, as well as those of the farm or living the wild, have an apparent fascination for human beings who watch and interpret animals for themselves (Kellert and Westervelt 1982; Eagles and Muffitt 1990). However, attitudes and emotions are not intransigent. Bitgood (1992) points out that exhibits reshape visitor attitudes through the thinking that they stimulate in the visitor, and both Alt (1980) and Stevenson (1991) show that the viewing of exhibits by visitors and their interactions with them are coloured by

feelings of enjoyment or emotional involvement, as well as an inherent predisposition to them. Visitors have the potential to react with exhibits in a number of ways through which they become engaged in a mental process. Visitors can explore the exhibit, using both their own personal context and the information provided by the institution. However, the type of the exhibit guides a visitor in the form of mental interaction available with it and such interactions range from observation and discussion to visitors constructing new meaning and acquiring further understanding which they are able to relay to their group and in turn teach other individuals.

A successful exhibit, from the museum's perspective, is one which entertains and educates (Screven 1986), yet transmits a message that is both received and comprehended by the visitors. If the visitors talk about the exhibits, the museum may judge them to be successful in terms of purveying their message but what level of education is this? Is the message really received? Visitors do not always abstract the message from an exhibit which the designers envisaged because of a number of factors. Firstly the perceptual processes of visitors act as filters which act to reduce the fidelity of the exhibit message to the visitor. These perceptual filters do this by forming either a complete barrier which effectively prevents the message getting through or distorts its meaning (McManus 1987). Secondly, people tend to look at and note that with which they are familiar and often ignore phenomena which do not connect to what they hold in their minds (e.g. Scheersoi 2009).

The skill of the museum as a communicating institution, through its interpretative techniques, is to link what the visitor already knows and feels with the information which the institution possesses about its exhibits. In this way, a meaningful museum experience is created for the visitor in terms both of personal context, enjoyment and the acquisition of information. The museum experience is discussed further by Falk and Dierking (1992) and Hein (1998) amongst other authors.

Whilst visitors may acquire new knowledge during their visit, they will build on what they already know. Museum educators should remember however, that the word *learning* is used synonymously with associated terms such as *education* by many institutions (Falk and Dierking 1992) and in fact people, in our educational experience, find things out during museum visits but real learning occurs much more rarely, the fact being forgotten shortly after the visit unless further consolidation and discussion occurs. It is important to realise the distinction between a transfer of facts and learning. The term education has been used by museums to refer to the provision of information, rather as a recipe provides information to cooks but does not seek to educate them, merely inform. However, if education, meaning communicating, discovery and knowledge acquisition, or learning, in terms of constructing understanding, is to occur at exhibits, learners must be able to place the exhibit in a conceptual framework which is meaningful to themselves and it is important to understand ways in which existing concepts may be altered

through interaction with an exhibit.

It is important for educators and curators to understand both, that which catches the attention of visitors, and how they make sense of what they see, so that relevant strategies can be provided to assist them in learning more about the topic displayed.

Educational research and natural history dioramas

The dioramas were originally designed to carry both scientific and contextual messages but what are the messages received by the wide museum audience e.g. school children, who are conscript visitors (Tunnicliffe 1998) brought by schools for curricular purposes, children brought with other adults for their own objectives, social leisure or educational, adults who choose to attend, and older visitors, what sense do they make of these messages?

There are various ways of finding out the impact of the exhibits on the visitor and their interpretation of them. One can listen, record and analyse spontaneous conversations, one can question an interview, visitors can be questioned and interviewed after seeing the dioramas, and drawings of the dioramas can be used as will be shown below.

What the diorama means to the visitors can be elicited at least in part by asking them to tell the story of the dioramas, what is it all about. The following responses are of such an interview:

An eight-year-old boy was asked to tell the story of the diorama he was at (three Kodiak Bears). He moved the

conversation to another nearby diorama and then another and then closed the dialogue by saying he was going to look at his favourite dioramas:

Boy: *I see a bear. (Identity)*

Researcher (R): *Anything else?*

Boy: *No.*

R : *What time of year do you think it is?*

Boy: *Well, fall because there are no leaves. (identity with justification). Let me show you the one that I like. (activity justification)*

They moved to the Dall Sheep.

R : *Why do you like this one?*

Boy: *I like the goats (nearest fit identity) because they live on these rocks and have big horns. (justification form of habitat behaviour and diagnostic feature). I have a second favourite; let me show you which one it is.*

They moved to the Bobcat.

R : *Why do you like this one?*

Boy: *I like him because he is eating the bird and walking in snow. (behaviour observations and aesthetic justification for his choice)*

The child shows knowledge by identifying the main animal and other artefacts and bio facts. He then draws on the evidence from what he sees to postulate about the possible temperature, making an evidence-based statement about the weather and explaining the behaviours shown. He shows his preference for some dioramas and the fact that he had been visiting the museum before.

Before we continue to illustrate the visitors' way of interpreting the scenes presented in Natural History dioramas, some specific characteristics of this kind of museum exhibit will be depicted.

Natural history dioramas: seminal characteristics

Natural history dioramas have several seminal characteristics of design: Firstly, the correct species of animals and plants are shown together, this is in geographical terms as well as natural relationships, particularly of feeding. Dioramas thereby overcome the barrier of exhibiting plant and animals, both predator and prey, in realistic situations together. Secondly, animals are usually depicted doing something interesting, which is not, necessarily the case when making first hand in situ wild life observations. Thirdly, dioramas of museum animals have a distinctive calm and stillness about them. Fourthly, even though they may depict acts of predation, natural history dioramas often have a Garden of Eden feel to them. There is no disease or malnutrition – animals are inevitably shown in the prime of health and physical fitness. This ideal world phenomenon has been noted elsewhere in children's drawings (Reiss et al. 2007) and this reflects an idealistic view of reality a view of "what should be" rather than the "what is". Fifthly, dioramas combine different disciplines within a single exhibit: they display biological, geological, meteorological, ecology and cultural concepts, whilst also providing an aesthetic experience. They provide a context for the animal and communicate messages from a

variety of areas. Indeed the backdrops have been utilized to help pupils understand the weather, for instance in a NOAA project at the American Museum of Natural History (Holmes 2009).

By these specific characteristics, Natural History dioramas are, at their best, superb exhibits and one of the most powerful techniques for emotional access and potentially effective biology learning.

Visitor's conversations at dioramas

The conversations generated and the stories told at dioramas can be used as source of our understanding of the responses of visitors to these exhibits and the messages as information bytes which are embedded in the exhibits.

There are three main ways of analysing pupil conversations, which apply to any visitors at exhibits, have been identified (Tunnicliffe and Reiss 1999). Using a systemic network to approach the content of a conversation in terms of the context in which the exhibit is shown and a description of and identification of the object, its behaviour and the feelings elicited by the object in visitors as well as their statements of knowledge can be identified effectively changing qualitative conversations to quantifiable data (Tunnicliffe 1995). Secondly, Bloom (1992) described what he termed contexts of meaning. In conversations the talker makes a description of expression based on personal experience, which gives, rise to episodic knowledge statements or expressions of emotion, the use of metaphors and similes or displaying interpretive

frameworks such as "That worm's a boy because it's fatter." Lastly, Cosgrove and Schaverien (1996) identified the processes of science occurring in the conversations of children when engaged in science work. They subdivided the types of conversations into descriptive, factual and explanative conversations to peers or teacher about an investigation. The type of conversations moved through asking why and how questions, often associated with episodic memories, to conversations, which raised and tested hypothesises to lastly philosophical conversations. When visitors look at exhibits, especially dioramas, these varied types of conversations are present.

Research (Scheersoi and Tunnicliffe 2009) observed behaviour of visitors, and their spontaneous conversations were recorded and analyzed. The data indicate, that visitors act just like at other museum exhibits (Tunnicliffe et al. 1996). Initially they identify the specimen and name it and often comment on a salient feature or structure. At dioramas, they also describe behaviours and make affective comments. If their interest is caught, they start interpreting the scenes presented, mostly in anthropomorphic terms, seeking to relate the subject to what they know and understand. Visitors rarely read the information provided by the museum (texts) and interpret at the level of their biological knowledge, which is generally basic. They may raise questions about the subject, ask why, how and what and construct hypotheses. In most cases, this typical biological dioramas interaction sequence occurs: identify – interest – interpret – investigate (Fig. 1).

However, the order of these four typical activities may vary.

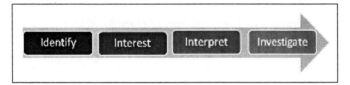

Figure 1: The "four I's-sequence" at natural history dioramas.

Identify

Visitors recognise salient features of animals or plants presented in dioramas and match them to an existing mental model thus recognising a type of animal or plant. They use the name of "nearest fit" when they cannot recall or find the correct name for an organism, a way of maximising similarity between category members (Markman 1989). They are creating an artificial category depending on their previous knowledge but the category of nearest fit provides a starting point to develop further narrative or interpretation. For example, visitors recognise black on white stripes as belonging to species of zebra, animals with hair, horn and hooves are goats or antelope, birds with pink feathers and long legs are species of flamingo. The context (habitat, different species of animals and plants, interrelationships, cultural artefacts ...) helps them to create meaning from what they see. The following spontaneous conversation at a beaver diorama illustrates this phenomenon (data generated at the Academy of Natural Science Philadelphia, USA):

Girl: Look chipmunk, lake, and look at birds in the tree.

Mom: What else? I think the beaver ate the tree. Where do they take the wood?

Girl (pointed): It's called a dam. Chipmunk.

Mom: We get chipmunks in our yard sometimes, haven't you seen them?

This conversation also shows that even though children may have a wilderness deficit (Louv 2005) they are in touch with their everyday nature (Tunnicliffe, in press) but not in an overall comprehensive way.

Interest

The role of interest in holding attention and encouraging learning has been mentioned from different authors (e.g. summarized by Krapp 1999). An interest-based action has the quality of intrinsic motivation and provides a positive emotional experience. Visitors have a limited knowledge of the complex fields of biology and educators need to introduce them step by step to the issues. Such efforts are more effective if the visitors' interests are engaged and developed. Studies in different museums have been conducted to find out which specific features in natural history dioramas support the development of interest by attracting visitors and encouraging focused observations and continued curiosity (e.g. Scheersoi 2009). Analysis of the data indicates that interest is engendered by recognising either the familiar, seeing young or big or dangerous animals, or by the unexpected (e.g., human traces in the wildlife scenes, such as a beer bottle in an elk diorama at Senckenberg Museum in Frankfurt). Visitors spontaneously

name certain specimens and scenes, comment about that to which they relate personally or start questioning phenomena that do not fit with their existing ideas. They show emotional reactions concerning the animals presented (=> affective), the diorama design and arrangement (=> aesthetical) and historical aspects or human traces presented in the diorama (=> cultural, experiential).

In conversations of primary children at the late dioramas in the Natural History Museum London, affective comments were heard more often in conversations than they were heard in the zoo (Tunnicliffe 1995). An eight-year-old girl said at the Water hole diorama, "It's beautiful." In contrast, a five-year-old girl interpreted the dioramas by announcing "These things are all dead, the giraffe and its baby", and promptly began to cry. This is a very unusual comment but illustrates the spectrum of emotions generated at dioramas. Hence, looking at dioramas elicits not only intellectual but also to emotional responses.

Diorama drawings made by children record selective features, those which they find most relevant. These are, in general, connected with their personal experiences, including every day observations of animals around (pets, farm animals, local wild animals), media representations and narratives. These features vary strongly between the individual children.

We conclude that dioramas stimulate interest if they evoke emotional responses and provide different anchor points which enable visitors with varying individual background

to relate previous experiences to the scenes or artefacts presented. Interactions with this sort of dioramas result in visitors' feelings of enjoyment, involvement, and stimulation which are the most typical emotional aspects of an interest-based activity.

Interpret

Visitors come to the diorama on their visits with some knowledge relevant to the content in most cases. In their view their knowledge is pertinent to the exhibit and they often use this and only this on their interpretation of what they see. What the visitor hold in their mind is their mental model. What they saw or draw about the exhibit is their expressed model (Buckley et al. 1997), which calls on information held within their mental model.

The knowledge and understanding which visitors bring to the exhibits influences both what they observe and how they interpret it. Such information obtained enables museums to understand their visitors are becoming more and more a feature of museum work.

Studies have been conducted to assess the prior understanding of children of local endemic wildlife and then eliciting any increase in understanding and knowledge through analysis of drawings after a visit to the natural history dioramas (Mifsud 2009). In the following conversation at a diorama in the USA, the two seven year old boys are interpreting that which they see, naming organisms to the nearest fit, a name they know of a specimen that has the

diagnostic features of the type with which they are familiar. They interpret the animals' behaviour referring to their previous knowledge.

> Boy 1: *Looks like a party! Those boars [peccaries, a nearest fit naming] could be waiting for those animals [Desert Big Horn sheep] to pass by and jump out at them.*
>
> Boy 2: *Think they are mountain goats [identity, nearest fit] in sort of desert, they are just trying to walk by.*

This next conversation was held amongst a school group of nine-year-olds at a Puma diorama set in a local park. There was a puma on a rocky ledge below which were some deer. It is also an example of parallel conversations, the girl is looking at the features of the diorama whilst the boys focus on the action in the science:

> Boy 1: *No it's bigger, that's a puma.*
>
> Girl: *It looks like a puma trying to catch sheep. [behaviour, hypothesis from noting position of specimens and artefacts]*
>
> Boy 2: *When they get in front of the rock [the deer] he'll jump down and grab them [behaviour, hypothesis]. He's pretty much concealed from them.*
>
> Boy 1: *That's what bobcats do, they jump down. [explanation of behaviour from recall]*
>
> Girl: *Habitat, looks like a forest.*

Educators in museums have the important role of assisting visitors in interpreting the exhibits. Before strategies can be designed and implemented it is crucial to understand both what the visitors notice and what sense they make for

themselves of the exhibits in question.

We mentioned before that visitors interpret at the level of their biological knowledge, which is generally basic. To overcome the existing knowledge and understanding deficit (Fig. 2), visitors have to be assisted. Illustrating the salient diagnostic feature of the phyla, classes and species as represented by the specimens exhibited would help establish the taxonomic features, which could be employed by educational, strategies to establish fundamental principles of classification. For instant, whether birds have feather and mammals have some kind of hair covering, fur, and spines or hair as the case may be. Further information could explain the behaviours portrayed which again would confirm or extend the ideas which the children raise from their observations. Furthermore, interpretation of some form could establish the habitat features and the interrelations of the specimens to the habitat features portrayed.

Assisting the visitors in interpreting the (biological) information presented should not be a didactic experience though, a transmission of facts by educators, in the English sense, including the worksheet, teacher, and chaperone accompanying groups. A museum visit is a social nurturing experience and should be focused on talk, for talking is the initial stage in literacy. A dialogic talking style is that usually employed with very young children, starting with labeling (naming). Research conducted by the authors reveals that a great deal of museum talk is of this nature. Such talk is developed into dialogic talking by the adult or peer once a

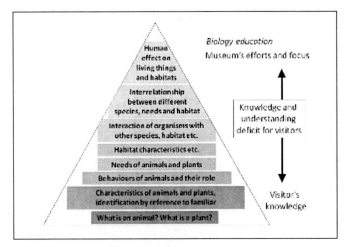

Figure 2: Biology education triangle of concepts illustrated in dioramas

label has been established, asking for justification of ascribing that name to that object or phenomenon. The facilitators act as the significant other in Vygotskian terms.

The three following conversations from family groups and a school group with their teacher illustrate typical styles of conversation at dioramas (data generated at the Academy of Natural Science in the USA):

At the Desert diorama

Girl: Is that a porcupine or hedgehog over there?

Mom: What kind of habitat?

Girl: Desert.

Mom: Look at the curly horns almost on to their back.

Girl: Yes.

Mom: What are these?

Girl: Buffalo we saw at farm, two of them. I think that's two

sisters and that's Mom and baby.
Mom: Do they all have horns? I wonder what they feel like?
Girl: Woolly.
Mom: Do you remember touching an alpaca?

At the Polar Bear
Mom: What do you like?
Girl: Polar Bear.
Mom: What colour is his coat?
Girl: White.

At the diorama of a polar bear on an ice flow with a seal kill
Boy 1: A Polar Bear. [identity, previous knowledge]
Boy 2: The seal is dead. [interpretation, previous knowledge]
Boy 1: The polar bear is killing it. [behaviour description]
They are all stuffed. [information from knowledge] That's
our favourite animal at the zoo. [personal affective comment,
interest]
Teacher: That's a Northern Fur Seal [text echoing – observed
reading from label]. That's what happens in nature, they have
to eat. [teaching point re predator prey]
Boy 1: That's Walrus blood – that's seal's blood. [hypothesis,
explanation]
Boy 2: Kevin, he has got big teeth. [diagnostic observation
about polar bear]

Programs have been conducted and evaluated in the Denver
Museum of Natural Sciences (DMNS) using enactors to talk

to visitors in front of dioramas and to discuss the phenomena presented (Tinworth 2009). These programs were very successful and helped to enrich the visitors' understanding of the themes, concepts, and content of the dioramas and of the Museum.

The natural history museum is often deemed an informal learning environment. In the case of school children and other learners it is effectively a learning place outside the base classroom. Such extension learning sites have an important role to play in engaging the learner's intellect in finding their own best pathway to learning. In using natural history dioramas the educator can encourage the learners to take more than a quick look at exhibits but to look with meaning and construct deeper understanding linking with their existing knowledge.

Investigate

Governments worldwide require, through their national curricula or standards that pupils learn not only facts but also skills and processes, with emphasis on science method, which is often referred to as science inquiry, the scientific method. The fundamental starting point is observation, pupils have it be guided into looking with meaning and rather than just seeing or imagining what they see based on mental models already held (Tunnicliffe and Litson 2002). Careful observation, identifying common features and seeing patterns, is the mainstay of basic biological studies at both the macro and micro level. Dioramas have been however

neglected by educationalists but, through looking with meaning at natural history dioramas, learners of all ages can learn to observe carefully, notice and seek further details of patterns, detect sequences of events, notice similarities and differences, interpret behaviour shown by the position of the animals, plants and artefacts and make connections with the understanding with which they, the observer, comes to view the dioramas. As mentioned above, dioramas offer by their stillness opportunities to "stand and stare" – to observe carefully. Dioramas are indeed snapshots, thus they are a moment frozen in action, so visitors can view and ponder and look again, unlike live animal exhibits in zoos, which perform a different function for their visitors. Moreover, in contrast with the single taxidermically prepared animal, the specimens in natural history dioramas are shown in their natural context and many messages are there for visitors to interpret. If visitors look with meaning they may develop acute and accurate observational skills.

Dioramas stimulate narratives, and studies have shown that children's narratives and explanations often develop into inquiry science: They observe, ask questions, formulate hypotheses which they try to corroborate by comparing scenes presented in the diorama with their own experiences and previous knowledge (Tunnicliffe 2007). Other research (e.g. Gatt et al. 2007; Tunnicliffe and Reiss 1999) finds that knowledge is acquired also from amongst other things, television, children's books.

The following conversation was held between three nine

year old school children looking at a diorama of Caribou at the Academy of Natural Science Philadelphia, USA. It shows another example of parallel conversations, one between the two boys as they note diagnostic features and then postulate on the gender of the specimens. And a separate line of thought spoken by the girl:

Boy 1: No horns, biggest horns and big horns.

Girl: This glass is really clear.

Boy 2: Looks like a female (identify, hypothesis) – really he's the · leader (big horns) you tell that's the female by the expression and no horns (identity, justification).

Inquiry is both the art and science of asking questions about a phenomenon, in this case natural history dioramas portraying the natural world, and finding answers to those questions. It involves careful observations and measurements, hypothesizing, with reasons, interpreting and theorizing. Indeed, inquiry-based learning is a way of acquiring further knowledge and understanding through the very process of questioning. Learners may raise the questions themselves spontaneously from their own first hand observations connected with their mental model of the subject of the dioramas. Alternatively, the question may be put to them by an educator to scaffold their thinking and develop concepts required by curricula.

Inquiry based science can be encouraged and developed in natural history museums particularly at dioramas with an emphasis on observations and constructing meaning

from them linked with the mental models of the phenomena observed which the planners already have. Prominent signage, or other forms of interpretation, such as explainers, or well-briefed teachers and chaperones, at various locations, would provide information for children or general visitors to establish the enemas of the specimens and the aspects of the location. Such signage would verify the observations and hypotheses, which the visitors engender through their observations and could lead to more careful observations.

Conclusion and implications for biology educators

Museum visitors, be they school attendees or lifelong learners, vary in their learning styles, academic and artistic strengths. Thus scientific instruction needs to be flexible enough to accommodate the cognitive differences amongst the range of visitors. Natural history dioramas attract visitors and can provide ideal initial conditions for teaching biological science in an out-of-school setting for all categories of learners – dioramas can be accessed and interpreted in different ways according to the highly variable scientific knowledge, interests and experiences of the visitors.

These exhibits, depictions of reality, poses a high intrinsic value alone by their being there to be looked at, without any other interpretation other than the understanding visitors bring and observations they make. However, museum educators could respond to the highly variable scientific knowledge of the visitors which is revealed by analysis of responses at given dioramas through making use of the various

responses. Various strategies could be provided focusing on the varied content of the dioramas making them accessible for direct interpretation by the visitor. The focus of intervention initiatives should be on accurate minds-on observation rather than physical hands-on manipulation of objects and invite questions from the observer. A useful perspective can be to see dioramas as storytellers. Visitors respond well to stories, and bring their own experiences, hopes and fears to them, but to maximise the educational impact of dioramas, the stories needs to be read with some care (Reiss and Tunnicliffe 2007). Visitors construct meaningful narratives at dioramas, which can provide a starting point in discussion and development of the science process. However, some of the visitors do begin to raise questions, construct hypotheses and explain in their terms. When such questions and hypotheses are heard this is the ideal time for an intervention, which could scaffold the visitor's thinking and help construct further concepts. Schools could use the observations and discussion of their pupils as a starting point for developing inquiry science.

Museum learning should be collaborative and should be a social experience and be multisensory. There is a spectrum of genres of exhibits. A live animal exhibit is totally different from a cultural artifact. We should not use one-size-fits-all in our approach to museum discovery encounters but assess the role of education and educators and change from using teaching to finding out with significant other. At any exhibit there is an experiential zone in which the viewer and the exhibit occupy a space and in this something or someone,

label or person or interpretation, can act as a significant other in this zone of potential development. Through dialogic talk, to the self or to a person, a visitor may link existing concepts to something they know and increase their cognitive development in the area. Analysis of their personal narrative at exhibits can reveal such accommodation and development. A cue sheet might aid in part dialogue of the self with the exhibit. Challenge the almost mandatory use of worksheets and tick boxes as the perceived mainstay of museum education. Such provide documentary evidence, usually of collaboration amongst peers and adults, but the value to pupils of this written task oriented visit, is questionable. Reading and writing is a Western curriculum fixation. Oracy, talking and listening, are two of the four equally important strands of literacy, and dioramas provide a stimulus for these aspects of literacy to develop extremely effectively.

Discovery Learning begins with talking about what is observed and the sense the lookers makes of the images they view, be they two or three dimensional, reduced, enlarged or life size. Observations may lead the observers to ask interesting questions. Posing such questions may lead the person questioned to consider important science issues that are meaningful to them and about which they are willing to tussle mentally to find the answer. Talking is the precursor of reading and writing. Why do some museum educators strive arrogantly to make their visitors learn? Let us work to encouraging observations and narratives through the stimulating environments – of museums, finding out, so

visitors talk, and, if museum staff, teachers, chaperones or parents, feel the need to cue the visitors, do it in dialogic manner. Let the visitors draw, record electronically if they are comfortable with that, that which interests them. Write if they want to a keyword as an *aide memoire* for further research to extend the information, but above all look, think and say!

The natural history diorama is recognised by many museum educators and educational researchers as possessing a powerful potential for science education in terms of processes and skills as well as knowledge and furthermore offer a unique interest to humans who have the need to interact with the rest of the living world. They are an exceptionally effective medium for learners to acquire elements of biodiversity information such as habitats of particular animals and interrelationships of organisms. Dioramas of the natural world are a vital part of portraying the natural world to people, adults and children. They should be cherished and used in effective educational strategies, which assist in an individual's science education.

Bibliography

Alt, M. 1980. Four years of visitor surveys at the British Museum (Natural History) 1976-79. *Museums Journal* 83: 145-148.

Bitgood, S. 1992. The Anatomy of an Exhibit. *Visitor Behaviour* VII (4): 4-14

Bloom, J.W. 1992. The development of scientific knowledge in elementary school children: a context of meaning perspective. *Science Education* 76: 399-413.

Breslof, L. 2001. Observing dioramas. *Musings*, Spring 2001, American Museum of Natural History [http://www.amnh.org/learn/musings/SP01/h_hw.htm]

Buckley, B., Boulter, C. and J. Gilbert. 1997. Towards a typology of models for science education. In *Exploring Models and Modelling in Science and Technology Education*, edited by J. Gilbert, 90-105. Reading: University of Reading.

Cosgrove, M. and L. Schaverien. 1996. Children's conversations and learning science and technology. *International Journal of Science Education*, 18: 105-116.

Eagles, P. and S. Muffitt. 1990. An analysis of children's attitudes toward animals. *Journal of Environmental Education* 21(3): 41-44.

Falk, J. H. and L. Dierking. 1992. *The Museum Experience*. Washington, DC: Whalesback Books.

Gatt, S., Tunnicliffe, S.D., Borg, K. and K. Lautier (2007) Young Maltese children's ideas about plants. *Journal of Biological Education* 41(3): 117-121.

Hein, G. 1998. *Learning in the Museum* (Museum Meanings).

London: Routledge.

Holmes, J. 2009. "Cloud observation expedition" at dioramas. In The Important Role of Natural History Dioramas in Biological Learning, edited by S.D. Tunnicliffe and A. Scheersoi. *ICOM Natural History Committee Newsletter*, 29: 15-16.

Insley, J. 2007. Setting the scene. *Museums Journal* (2): 33-35.

Kellert, S. R. and M.O. Westervelt. 1982. *Children's Attitudes, Knowledge and Behavior toward Animals.* Washington DC: United States Government Printing Office.

Krapp, A. 1999. Interest, motivation and learning: An educational-psychological perspective. *European Journal of Psychology of Education*, Vol. XIV(1): 23-40.

Louv, R. 2006. *Last Child in the Woods. Saving our Children from Nature-Deficit Disorder.* Chapel Hill, USA: Alonquin Books of Chapel Hill.

Markman, E. 1989. *Categorization and Naming in Children: Problems of Induction.* Cambridge, Mass.: The MIT Press.

McManus, P. M. 1987. *Communications With And Between Visitors To A Science Museum.* Unpublished Ph.D. thesis, Chelsea College, University of London.

Mifsud, E. 2009. Wildlife dioramas from Malta. In The Important Role Of Natural History Dioramas In Biological Learning, edited by S.D. Tunnicliffe and A. Scheersoi. *ICOM Natural History Committee Newsletter*, 29: 7-10.

Quinn, S. 2006. *The Great Habitat Dioramas of the American Museum of Natural History.* New York: The American Museum of Natural History, in partnership with Harry

N. Abrams, Inc.

Reiss, M.J., Boulter, C. and S. D. Tunnicliffe. 2007. Seeing the natural world: a tension between pupils' diverse conceptions as revealed by their visual representations and monolithic science lessons. *Visual Communication* 6: 99-114

Reiss, M.J. and S.D. Tunnicliffe. 2007. *Dioramas As Depictions Of Reality And Opportunities For Learning In Biology.* Talk given at NARST, April 2007, New Orleans.

Scheersoi, A. 2009. Biological interest development at natural history dioramas. In The Important Role Of Natural History Dioramas In Biological Learning, edited by S.D. Tunnicliffe and A. Scheersoi. *ICOM Natural History Committee Newsletter*, 29: 10-13.

Scheersoi, A. and S.D. Tunnicliffe. 2009. *Stop, look, learn – Biological interest development at Natural History dioramas.* Talk given at the 7th ESERA Conference, 31.8.-4.9.09, Istanbul, Turkey.

Scott, M. 2005. Writing the History of Humanity: The Role of Museums in Defining Origins and Ancestors in a Transnational World. *Curator* 48(1): 74-89.

Screven, C.G. 1986. Exhibitions and information centres: Some principles and approaches. *Curator* 29 (2): 109-138.

Stevenson, J. 1991. The long term impact of interactive exhibits. *International Journal of Science Education* 13 (5): 520-532.

Tinworth, K. 2009. Creating a unique visitor experience through enactors. In The Important Role Of Natural History Dioramas In Biological Learning, edited by

S.D. Tunnicliffe and A. Scheersoi. *ICOM Natural History Committee Newsletter*, 29: 21-25.

Tomkins, S. and S.D. Tunnicliffe. 2001. Looking for ideas: observations, interpretation and hypothesis-making by 12-year-old pupils undertaking science investigations. *International Journal of Science Education* 23(8): 791-813.

Tunnicliffe S.D. 1995. *Talking About Animals: Studies Of Young Children Visiting Zoos, A Museum And A Farm*. Unpublished PhD thesis, King's College, London.

Tunnicliffe S.D. 1998. Boy Talk: Girl Talk - Is it the same at animal exhibits? *International Journal of Science Education* 20 (7): 795-811.

Tunnicliffe, S.D. 2005. What do Dioramas Tell Visitors? A Study of the history of Wildlife Diorama at the Museum Of Scotland. Current Trends in Audience Research and Evaluation. Volume 18. *CARE*. AAM, Washington D.C.: 23-31.

Tunnicliffe, S.D. 2007. The Role of Natural History Dioramas in Science Education. *Informal Learning* (87): 11-14.

Tunnicliffe, S.D. 2009. Inquiry at Natural History dioramas – useful resource in science education. In The Important Role Of Natural History Dioramas In Biological Learning, edited by S.D. Tunnicliffe and A. Scheersoi. *ICOM Natural History Committee Newsletter*, 29: 16-20.

Tunnicliffe, S.D. *First Engagement with the Environment. People and Science*. March 2010. The British Association for Science: 25.

Tunnicliffe S.D., Lucas, A.M. and J.F. Osborne. 1997. School visits to zoos and museums: a missed educational

opportunity? *International Journal of Science Education* 19(9): 1039-1056.

Tunnicliffe, S.D. and M.J. Reiss. 1999. Talking about brine shrimps: three ways of analysing pupil conversations. *Research in Science and Technological Education.* 17 (2): 203-217.

Tunnicliffe, S.D. and S. Litson. 2002. Observation of Imagination? *Primary Science Review* (Jan/Feb.): 25-27.

Wonders, K. 1989. Exhibiting Fauna - From Spectacle to Habitat Group. *Curator* 32 (2): 131-155.

Jurassic Park and Visitor Interpretation for Museum Dinosaur Exhibits

WARWICK FROST

La Trobe University

Victoria, Australia

In 1995 Stephen Jay Gould reflected on the success of *Jurassic Park* and its influence on museums. There was a lot in the book and film which Gould enjoyed, some parts he dismissed as poorly done or bad science, but he concluded pessimistically about its effect on museums. He argued that in response to the success of the film most natural history museums had chosen to, "mount, at high and separate admission charges, special exhibits of colourful robotic dinosaurs that move and growl but (so far as I have been able to judge) teach nothing of scientific value about these animals".[1] Gould saw these separate exhibits as little more than theme parks, emphasising entertainment over education and doing little to encourage visitors to explore the other parts of these museums.[2]

It is now twenty years since the release of Michael Crichton's book *Jurassic Park*, and it is perhaps time to revisit Gould's comments and consider the longer term effects on dinosaur exhibits in museums. I want to go beyond Gould's criticisms of what has been termed "commodification", the "Experience Economy" or "Disneyfication" in museums, for there is an ample literature on these concerns.[3] Instead my interest is in how museums deal with revisions in scientific knowledge about dinosaurs and how they adapt interpretation to match changing visitor expectations. *Jurassic Park* provides an intriguing lens for considering this issue for it is an exceptional example of a popular culture production which incorporated new scientific knowledge and projected it to a wide audience.

As an example of this popular culture/scientific knowledge

nexus, consider this quote from a recent work on dinosaurs. To introduce Raptors it immediately recalls movies it assumes its readers have seen:

> No dinosaur has better captured the gothic side of human imagination than the cunning raptors depicted in the Jurassic Park movies. Rather than presenting us with slow, dull-witted lizards as in the early Hollywood classics such as Cooper and Schoedsack's King Kong, director Steven Spielberg's raptors depicted dinosaurs in a new and disturbing image. With the power of hundreds of scientific experts restoring them, and embellished with the imaginations of Hollywood scriptwriters, the Jurassic Park raptors come across as fast, agile and highly intelligent predators.[4]

This combination of new scientific knowledge and heightened expectations amongst visitors provides exciting challenges for exhibition and interpretation designers at museums. Over half a century ago Tilden argued that good interpretation needed to be provocative and stimulating. In recent years a growing literature on interpretation has followed his lead, arguing that visitors are seeking "mindful" experiences, which stimulate and actively involve them. Possible means of achieving this, it has been argued, include interactive displays and thematic interpretation (which provides a message rather than basic facts). Some have argued that techniques from popular culture may be used for successful interpretation, providing examples of theatrical and musical performance as effective means of communicating meaning

and understanding.[5]

There is also an increasing recognition that visitors are not merely passive receivers of interpretation and that the content is just as important as the method of presenting interpretation. Rather than just blindly accepting what is presented, visitors co-construct interpretation by blending their own previous knowledge and views with what is provided by guides and other interpretive media. In some cases there may be multiple competing interpretations of meaning and significance. This provides challenges for interpretation designers as they struggle to decide how to present it. They may be tempted to choose just one as the "right" interpretation or try to juggle a number of conflicting views and hope the visitor understands. Such conflicts are common for cultural heritage museums, faced with, for example, issues of how to represent ethnic minorities. However, they can also apply for scientific issues. For example, in Australia there is a long history of debate over how rainforests should be defined (given urgency as such definitions will affect decisions to log or protect particular forests).[6]

The aim of this chapter is to examine these issues of visitor interpretation at museum dinosaur exhibits. A comparative approach is taken using five exhibitions, three from the USA, one from the UK and one from Australia. These only represent a small fraction of the museums worldwide which feature dinosaur exhibits. Nor are they necessarily representative, for the five chosen all have reputations for being innovative in their approach. Indeed, my concern was to consider museums

which were seen to be leaders in the field and examine how they were adapting in constructing interpretation against a background of changing scientific interpretations.[7]

This research initially began with the US museums. The Rocky Mountains of the western USA contain a large number of extensive dinosaur fossil sites and a number of dinosaur-themed exhibits have been established in this region. Montana, for example, contains fifteen dinosaur museums, field stations and interpretive centres, cooperatively marketed as the Montana Dinosaur Trail with funding from the state government accommodation tax. Following fieldwork in the USA, this research was extended to two large museums located in major tourist cities. The five dinosaur museum exhibits considered are:

1. The Siebel Dinosaur Complex, Museum of the Rockies in Bozeman, Montana, USA (www.museumoftherockies.org).
2. The Wyoming Dinosaur Center in Themopolis, Wyoming USA (www.wyodino.org).
3. Dinosaur National Monument in Utah, USA (www.nps.gov/dino).
4. The Dinosaur Gallery, the Natural History Museum, London, UK (www.nhm.ac.uk).
5. The Dinosaurs Exhibition, the Australian Museum, Sydney, Australia (www.australianmuseum.net.au).

Jurassic Park and the reimagining of dinosaurs

Jurassic Park (1990) hinges on the science fiction concept that

DNA extracted from dinosaur fossils could allow modern day clones to be created. As imagined by Michael Crichton, entrepreneur John Hammond uses this technology to create a theme park. Hammond, a Walt Disney style character, locates his theme park on an island off Costa Rica (in order to escape US government regulation) and invests heavily in automation in order to reduce labour hassles. Predictably the computers fail and the dinosaurs escape. Crichton thus revisits issues of theme park authenticity and safety which he also explored in *Westworld* (1973) and *Timelines* (1999). A bestseller, the novel was filmed by Steven Spielberg (1993). A huge commercial success it was followed by two sequels (1997 and 2001). Following on from these fiction films, the BBC had great success with its nature documentary series *Walking with Dinosaurs* (1999).[8]

Crichton's novel explores a range of scientific themes. However most of these were jettisoned for the films (his subplots involving computers were almost immediately out of date). The primary focus of the films became the reanimation of dinosaurs. What particularly caught the public's imagination was how well the dinosaurs were represented. In the first film this was originally intended to be achieved through the combination of highly realistic puppets and back projections. However, rapid advances in computer generated effects forced Spielberg to use these for some scenes, lest his film be quickly seen as dated.[9] The combination of puppets and computer generated dinosaurs was perfected in *Walking with Dinosaurs* and was used to great effect in the two film

sequels. For the first time, dinosaurs could be realistically represented on film.

What also caught the attention of viewers was the skilful presentation of a number of revolutionary theories about dinosaurs. These included:

1. Dinosaurs were warm-blooded, closely related to birds.
2. They were much more agile than previously thought. Their tails, for example, did not drag along the ground.
3. Some were highly intelligent, especially the Raptors – human sized predators.
4. Many dinosaurs had highly complex social arrangements, including being attentive parents.
5. Some dinosaurs were small, apart from Raptors the films featured the relatively unknown *Compys* and *Dilophosaurus*[10]. In contrast, the third film introduced *Spinosaurus*, a predator larger than *T-Rex*.

Such theories had been debated by palaeontologists for decades. However, the novel and films drew these dramatically to the attention of the public. Accordingly dinosaur exhibits had to incorporate *Jurassic Park* into their interpretation. They needed to include the theories popularised in the film, plus others not used on the screen (for example, that some male dinosaurs were highly coloured – as in birds). Exhibits had to balance the knowledge and enthusiasm generated by the films, with their scientific and educational objectives.

They could use connections to the films, for example having exhibits designed by scientific advisors to the films, but also needed to keep some distance from what is science fiction. The exhibits discussed in this chapter each followed different paths in dealing with these challenges.

The Siebel Dinosaur Complex, Museum of the Rockies

Completed in 2007, this wing was financed by a donation of $US2 million from businessman Thomas Siebel. Its main focus is on dinosaurs from Montana, a region particularly rich in a wide variety of fossils. The Museum of the Rockies serves as the cornerstone of the 15 site Montana Dinosaur Trail and is located on Interstate Highway 90 (the main highway in Montana) near the turnoff for Yellowstone National Park.

The Siebel Dinosaur Complex has strong links with *Jurassic Park*. Its curator Jack Horner was the consultant to the movies and a partial basis for the character of the paleontologist Allan Grant. Much of the interpretation makes specific reference to the films, particularly the excavations in Montana which feature in the beginning of the first film. There is a strong emphasis on Raptors, as well as *Tyrannosaurus* and *Triceratops*. In addition, whether intentionally or not, the external structure of the complex bears a striking similarity to a cinema multiplex.

The entry portal to the museum has been designed to provoke and challenge visitors. Outside the museum stands a full size replica of the skeleton of a *T-Rex*, posed aggressively as in the films. Contrasting with this conventional exhibit,

the next display – after the entry doors – is of what appears
to be a modern water fowl. Positioning it in such a key
position invites the visitor to look more closely. What is such
a ordinary looking bird doing in such a prime location? An
interpretive label explains that it is indeed prehistoric and
suggests we look closer for how it differs from its modern
descendant. Closer examination provides a revelation, its
beak has teeth!

Moving further into the exhibit come a number of
interpretive panels. The first explains that this museum
subscribes to a number of new and contested theories about
dinosaurs and that we need to revise our views of prehistory.
The second is a general explanation of how scientists develop
hypotheses, test them and evolve theories, which may be
hotly debated within the scientific community. Accordingly,
it argues, all scientific interpretation has an element of
subjectivity, nothing in the biological sciences can be said
to be absolutely true, though if enough scientists agree their
consensus may be viewed as truth. It is an intriguing and bold
statement, I am not aware of any other museums making such
a declaration."

All this prepares the visitor for the next panel. It simply
proclaims that *Dinosaurs Are the Ancestors of Birds*. Listing eight
shared characteristics the panel presents the following:

> *Birds share more characteristics with Dromaeosaurid and
> Troodontid dinosaurs (a group named Deinonychosauria), than
> with any other group of animals. Therefore we can hypothesize
> that birds evolved from this group of dinosaurs. This means*

that birds are actually a group of reptiles, rather than a distinct group unto themselves. Birds are living dinosaurs. Until someone can demonstrate that another group of animals shares more characteristics with birds than do dinosaurs, the theory is considered to be strong, and therefore, scientifically true... BIRDS ARE AVIAN DINOSAURS – BIRDS ARE LIVING DINOSAURS!

The two entrance displays then take on a special meaning. The toothed waterbird in the foyer is as much a dinosaur as the *T-Rex* outside. This theme of dinosaurs and birds being linked is continued throughout the exhibition. Interpretation emphasises the modern theories that dinosaurs were warm-blooded and agile. Most significantly these theories are not presented as radical or extreme, but consistent with the declaration at the entrance, as widely accepted truths. The link with birds is most strongly emphasised in an extensive display of *Deinonychus* (one of the Raptors excavated in Montana). Life size models show them as hunters and in social groups. The interpretation discusses them as having many features we normally associate with birds and presents a theory that they were probably brightly coloured like modern birds. Indeed the males in the display models are very brightly coloured. And here there is interpretation discussing the Raptors in *Jurassic Park*, explaining that in the films they were made larger for dramatic effect, while the bright colouring was discarded as being too extreme for audiences.

The Wyoming Dinosaur Center

This museum is located in a small town, well away from any Interstate Highways or major tourist routes. Nor has it benefited from a major benefactor. Instead it functions as a good example of a small community-based museum, with a small staff supplemented by volunteers and relying on limited funding. Accordingly even though it has the same exhibition space as the Siebel Dinosaur Complex (about 12,000 square feet) it cannot afford the same production values. This is most apparent in the interpretation in its entrance portal, which provides a general geological history of the earth. In sharp contrast to the Siebel Complex, it provides a great deal of text without conveying any specific themes. Instead of being provocative or challenging, it provides an essentially factual, even pedestrian introduction. This is further evident with a display of *Archaeopteryx*, where the interpretation states that birds are dinosaurs. However, unlike its Montana counterpart this statement is hidden in the fine print of the text rather than being highlighted.

The bulk of the exhibition consists of reproductions of the skeletons of large dinosaurs. There is a strong emphasis on various *Ceratops* (*Triceratops* is Wyoming's state dinosaur). Dominating the exhibition is a 30 metre long replica of *Jimbo*, a *Supersaurus*, one of the largest dinosaurs ever found, which was recently excavated by the Museum. The replica was initially constructed for the 2006 *Great Dinosaurs* Expo in Japan, where it was viewed by over one million visitors. After that exhibition it was placed on permanent display at

the Wyoming Dinosaur Center.

It is this emphasis on local finds and fieldwork that allows the museum to overcome its lesser expenditure on interpretation. As with the Siebel Complex, visitors are able to observe curators at work through large windows. However, at Wyoming, the curatorial staff also come out from behind the glass, providing impromptu question and answer sessions with visitors. In such cases they bring out real fossils for visitors to handle, for example, children were allowed to hold a large *Stegasuraus* bone weighing a number of kilograms. Research on visitor interpretation indicates that allowing the visitors to handle unusual objects is an effective way of stimulating their interest and increasing their satisfaction.[12] Wyoming's policy is also effective in reinforcing the authenticity of their displays and the visitor experience.

Dinosaur National Monument

Established in 1915, Dinosaur National Monument is operated by the US National Parks Service. Located in a remote part of Utah, the site comprises large numbers of fossils, an estimated 400 individual animals, in a relatively small area. The high concentration suggests that large numbers of dinosaurs were drowned by floods or crossing a swollen river and their remains deposited against a sandbar. Geological folding means that these fossil bearing strata are now tilted at a 45 degrees angle. These circumstances allowed for an unusual design when the visitor centre was built in 1958.

Enclosed within the visitors centre is a large sandstone rock face. Originally this rock face contained a few visible fossils which could be viewed from an observation deck. Between 1958 and 1991 staff continued to work on the wall, exposing more fossils. Visitors could both see an increasing number of fossils in situ and observe paleontologists at work. When in 1991 the rock wall had become played out, over 1,600 fossil bones could be seen from the observation deck.[13]

Unfortunately, the visitor centre was built on unstable ground and there were increasing problems with cracking of its foundations. In 2006 it was declared unsafe on occupational health and safety grounds and closed. In 2009 it was finally decided to demolish the structure and replace it.

The closure of such a high-profile visitor centre forced the National Parks Service to adopt new strategies to cater for visitors. A temporary visitor centre was constructed, containing a limited number of fossils. Conscious of its diminished appeal, it was decided to remove the visitor entry fee for the site. This resulted in what we might term a decommodification. National Parks and Monuments in the USA charge entry fees, often resulting in the unsatisfactory situation where visitor interaction with park rangers is limited solely to a commercial transaction and management becomes overly concerned with providing car parks and other facilities to justify the charge. At Dinosaur National Monument, with no revenue collection duties, staff came out from behind their desk and talked to visitors about the displays and history of the National Monument.[14]

In addition a Fossil Discovery Hike was promoted for visitors who wished to see fossils in situ. This trail had been developed before the closure of the visitors centre, but had now become a substitute for it. Covering about two kilometres it took visitors to another rock wall where they could see and touch fossils. Unlike the original visitors centre, these fossils were not enclosed, there was no observation deck, no interpretive panels and the pathway was rough. However, it provided a highly satisfactory experience for visitors who were prepared to forsake comfort.

Dinosaur Gallery, Natural History Museum

The Dinosaur Gallery occupies a wing of one of the world's most famous and popular scientific museums. On two levels it provides a mass visitor experience, often crowded and noisy. Unlike the other museums considered in this chapter, it charges no admission fee. This is due to a policy of the UK government to encourage access to museums and similar institutions.

Dominating the Dinosaur Gallery is a full scale animatronic reproduction. Initially this was a diorama of a group of *Velociraptors* in Central Asia's Gobi Desert. However, this was changed to a full scale *T-Rex*, roaring and glowering and visitors on the raised observation decks. This is a good example of Gould's criticisms of the effects of *Jurassic Park* on museum exhibits. There is little interpretation, the visitor experience is one of taking photos and enjoying the squeals of mock terror from young children. In a darkened room, it

is highly reminiscent of an amusement park Ghost Train. Elsewhere, animatronic Raptors inhabit the corners of the exhibition, but without interpretation or context.

The more conventional displays are drawn from around the world, though there is a strong local theme. A number of fossils are drawn from England, particularly the Jurassic Coast World Heritage Area. Hidden away amongst various displays is the fossil tooth of an *Iguanadon*, discovered by Gideon Mantell in 1822. It was this and other discoveries of the early nineteenth century which eventually led Richard Owen to advance the hypothesis of a class of prehistoric animals he termed dinosaurs.

The Dinosaur Gallery contains a wide range of displays. Some advance recent theories and argue that researchers are continually revising their theories. Others, such as the animatronic figures are incongruously divorced from any educational content. *Jurassic Park* makes an appearance in an entertaining video display which demonstrates how human perceptions of dinosaurs have changed over time. Images from *King Kong*, *The Lost World*, *One Million Years BC* and the *Flintstones* represent older misconceptions, whereas *Jurassic Park* is lauded as showing more modern interpretations.

Dinosaurs Exhibition, Australian Museum

For a long period Australia seemingly had very few dinosaurs. However, in recent years there have been quite a number of discoveries of species endemic to Australia. With strange names derived from Aboriginal place names or helpful

sponsors, they include *Minmi*, *Muttaburrasaurus*, *Qantassaurus* and *Atlascopcosaurus*.[15] Recent interest has particularly focussed in the polar dinosaurs, adapted to thrive in cold conditions with long winter nights.

The Australian Museum is Australia's oldest science museum. Despite its name, it is a state rather than a national institution. Like the Natural History Museum it is located in a major city, which is both a popular tourist destination and has a large domestic population. The Dinosaurs Exhibition is a recent addition, developed specifically for a long established museum faced with declining visitor numbers. Its focus is strongly on indigenous dinosaurs, which is both an opportunity, but also a challenge, as visitors may have little knowledge of these new discoveries.

Like the Natural History Museum, the Australian Museum is housed in a classic Victorian public building. However, whereas the Natural History Museum houses its dinosaur exhibits in darkened rooms, with two levels squeezed into what was originally one, the Australian Museum has taken the opposite approach. Its exhibition space is filled with light and the high ceilings have remained. Two walls are used for the projection of films. One is an animated reconstruction of a dinosaur stampede at a water hole, of which the tracks have been discovered in Outback Queensland. To heighten visitor interest, the film is not on a continuous loop, but is shown at advertised periods during the day. The second shows a Wollemi Pine forest, presenting this as a typical ecosystem inhabited by Australian dinosaurs. The Wollemi

Pine is a "living fossil", rediscovered by chance in 1994 in a barely accessible gorge in the nearby Blue Mountains.[16] While now cloned and commercially available, the Wollemi Pine is still little known and only a handful of specialists have ever seen a mature specimen. Both films are designed to overcome deficiencies in the displays, particularly the limited number of charismatic replicas. It is intriguing that this is the only one of the museums considered that uses large scale projections.

The Australian Museum also stages another event each day, when a life-size realistic puppet dinosaur is walked through the displays by its keeper. Aimed squarely at children, it is based on similar walks experiences undertaken by many zoos. The realism of the dinosaur puppet allows it to work and the puppet is mobbed by children asking questions of its keeper. As with the projected films, this experience is designed to supplement the otherwise static displays and make up for the limited number of large and impressive exhibits.

Discussion

Directly after the release of the first *Jurassic Park* film, Stephen Jay Gould was worried that it would tip the balance in science exhibitions in favour of entertainment rather than education. The blockbuster film led to blockbuster exhibitions, but their show was heavy on special effects and light on meaningful and effective interpretation. Now, fifteen years after Gould warned of such dangers, we can see a maturing of dinosaur exhibitions. Thankfully, museums have moved on, designing

permanent exhibitions which generally aim for a strong emphasis on interpretation.

However, *Jurassic Park* has changed the context for dinosaur exhibits. It has made museum curators more conscious of the concept of co-construction of interpretation. The contemporary museum visitor is likely to have seen *Jurassic Park* and/or *Walking with Dinosaurs*. This pre-existing experience is likely to have two strong influences upon visitor expectations. The first is visual, the public now have a very definite image of how dinosaurs looked, moved and behaved. Gould's worry was that this would lead to an over-reliance on spectacular animatronics, though that does not seem to have been the case, for only one of the five exhibits considered here used robot representations. Instead they tended to opt for better quality interpretation, utilising modern concepts that interpretation is more effective if it is mindful, challenging, thematic and interactive.

The second influence is that *Jurassic Park* has made the public aware that there has been a revolution in how science understands dinosaurs. The lay public knows that there are debates over whether or not they were warm-blooded. They understand the relationship to birds, that they were more agile than we previously thought and that there is an ever-growing number of new dinosaurs of various sizes and functions being discovered. The modern museum goer is not a passive receiver of information, rather they devour new information about dinosaurs from a range of media and they expect museums to be up-to-date with these changes.

The five exhibits considered in this chapter all sought to grapple with this issue. They all took different paths and they had varying levels of comfort in dealing with new theories. At one extreme, the Siebel Dinosaur Complex embraced the new, making clear and bold statements that birds were dinosaurs and that dinosaurs were warm-blooded. The others tended to present this more as a debate, setting out the two sides of the argument, but hanging back from giving a definitive answer.

A final observation is that all five exhibits chose to emphasise local dinosaur finds. This in some ways mirrors developments in zoos, where some have chosen to take a bioregional approach. For dinosaur exhibits this is an intriguing decision, it suggests a rejection of the blockbuster approach and an acute understanding that the visitor is already well educated in dinosaurs. Rather than the biggest and the most ferocious, the visitor is looking for a type of authenticity, the point of difference in the local prehistory that makes a particular area special and its museum worth experiencing.

ABOVE: Model T Rex at the entrance to the Museum of the Rockies, Bozeman. Note the posture: head low, tail well off ground. [Photo Stephen Frost]

BELOW: Gould's Nightmare - Animatronic T Rex in the Natural History Museum, London. [Photo Warwick Frost]

Notes

1. Stephen Jay Gould, Dinosaur in a Haystack: Reflections in Natural History (New York: Harmony, 1995) 235.

2. Ibid. 236.

3. The term 'Experience Economy' was termed a few years after Gould wrote, though it provides a good description of the processes he was worried about. It describes the design of enhanced experiences for consumers, such as special shows and exhibition, at a higher price than previously charged. See Joseph Pine and James Gilmore, The Experience Economy: Work is Theater & Every Business a Stage (Boston: Harvard Business School Press, 1999). For a critique of this concept and its application to visitor attractions see Warwick Frost and Jennifer Laing, "Up Close and Personal: Zoos and the Experience Economy," in Zoos and Tourism: Conservation, Education, Entertainment?, edited by Warwick Frost (Clevedon: Channel View, forthcoming 2010). See also A.Beardsworth and A. Bryman "The Wild Animal in Late Modernity: the Case of the Disneyfication of Zoos," Tourist Studies 1 (2001) on these processes in zoos and Susan Pitchford, Identity Tourism: Imaging and Imagining the Nation (Bingle: Emerald, 2008) on this issue at the ill-fated Celtica Museum in Wales.

4. John Long and Peter Schouten, Feathered Dinosaurs: the Origins of Birds (Melbourne: CSIRO, 2008), 21.

5. Freeman Tilden, Interpreting our Heritage (Chapel Hill: University of North Carolina Press, 1957, 1977 ed); Gianna Moscardo, "Mindful Visitors: Heritage and Tourism." Annals of Tourism Research 23 (1996); Sam Ham and Betty Weiler, "Diffusion and Adoption of Thematic Interpretation at an Interpretative Historic Site." Annals of leisure research, 7 (2004); Jennifer Garton Smith, "Learning From Popular Culture: Interpretation, Visitors and Critique." International Journal of Heritage Studies 5 (1999).

6. Athinodoros Chronis, "Coconstructing Heritage at the Gettysburg

Storyscape." Annals of Tourism Research 32 (2005); John Tunbridge and Gregory Ashworth, Dissonant Heritage: the Management of the Past as a Resource in Conflict (Chichester: Wiley, 1996); Warwick Frost, "Making an Edgier Interpretation of the Gold Rushes: Contrasting Perspectives from Australia and New Zealand." International Journal of Heritage Studies 11 (2005); Pitchford, op cit. For the debate over the scientific definition of rainforests see Warwick Frost, "Rainforests." In Encyclopaedia of Ecotourism, edited by David Weaver, 193-204. (Oxford: CAB International, 2001).

7. Museums with old fashioned approaches to interpretation might be termed 'dinosaurs', though in the light of recent research the use of the term dinosaur for the slow and unchanging is no longer accurate or appropriate.

8. In my case I watched the BBC documentaries with my children first, which then stimulated us to seek out the films and then finally the novel.

9. Gould, op cit.

10. Whereas the films represented Velociraptors as bigger than they actually were, Dilophersaurus was shrunk, given a frill around the neck and the ability to spit poison.

11. For a discussion of the difficulties museums have with subjectivity, see Frost, op cit, 2005.

12. Moscardo, op cit; Ham and Weiler, op cit.

13. Linda West and Dan Chure, Dinosaur: the Dinosaur National Monument Quarry (Vernal: Dinosaur Nature Association, 2001), 10-17.

14. This is certainly a reversal of Pine and Gilmore's Experience Economy. A more interactive, arguably better, experience has been developed as a result of removing the charge.

15. In 1993 the Australian Post Office wanted to cash in on Jurassic Park through a special issue of stamps featuring Australian Dinosaurs. The resultant publicity led to the Australian Post Office becoming a key sponsor of dinosaur

exhibitions. See Thomas Rich and Patricia Vickers-Rich, Dinosaurs of Darkness
(Sydney: Allen & Unwin, 2001), 115-117.

16. *James Woodford, The Wollemi Pine: the Incredible Discovery of a Living*
Fossil from the Age of the Dinosaurs (Melbourne: Text, 2000). The Wollemi Pine
is from the family Araucariaceae, bit distinct from the other genera Araucaria
and Agathis.

Bibliography

Beardsworth, Alan and Bryman, Alan. "The Wild Animal in Late Modernity: the Case of the Disneyfication of Zoos." *Tourist Studies* 1 (2001): 83-104.

Chronis, Athinodoros. "Coconstructing Heritage at the Gettysburg Storyscape." *Annals of Tourism Research* 32 (2005): 386-406.

Frost, Warwick. "Rainforests." In *Encyclopaedia of Ecotourism*, edited by David Weaver, 193-204. Oxford: CAB International, 2001.

Frost, Warwick. "Making an Edgier Interpretation of the Gold Rushes: Contrasting Perspectives from Australia and New Zealand." *International Journal of Heritage Studies* 11 (2005): 235-250.

Frost, Warwick and Jennifer Laing. "Up Close and Personal: Zoos and the Experience Economy." In *Zoos and Tourism: Conservation, Education, Entertainment?*, edited by Warwick Frost. Clevedon: Channel View, (forthcoming) 2011.

Garton Smith, Jennifer. "Learning From Popular Culture: Interpretation, Visitors and Critique." *International Journal of Heritage Studies* 5 (1999): 135-148.

Gould, Stephen Jay. Dinosaur in a Haystack: Reflections in Natural History. New York: Harmony, 1995.

Ham, Sam and Betty Weiler. "Diffusion and Adoption of Thematic Interpretation at an Interpretative Historic Site." *Annals of Leisure Research*, 7 (2004): 1-18.

Long, John and Peter Schouten. *Feathered Dinosaurs: the Origins of Birds*. Melbourne: CSIRO, 2008.

Moscardo, Gianna. "Mindful Visitors: Heritage and Tourism." *Annals of Tourism Research* 23 (1996): 376-397.

Pine, Joseph and James Gilmore. *The Experience Economy: Work is Theater & Every Business a Stage*. Boston: Harvard Business School Press, 1999.

Pitchford, Susan. *Identity Tourism: Imaging and Imagining the Nation*. Bingle: Emerald, 2008.

Rich, Thomas and Patricia Vickers-Rich. *Dinosaurs of Darkness*. Sydney: Allen & Unwin, 2001.

Tilden, Freeman. *Interpreting our Heritage*. Chapel Hill: University of North Carolina Press, 1957, 1977ed.

Tunbridge, John and Gregory Ashworth. *Dissonant Heritage: the Management of the Past as a Resource in Conflict*. Chichester: Wiley, 1996.

West, Linda and Dan Chure. *Dinosaur: the Dinosaur National Monument Quarry*. Vernal UT: Dinosaur Nature Association, 2001.

Woodford, James. *The Wollemi Pine: the Incredible Discovery of a Living Fossil from the Age of the Dinosaurs*. Melbourne: Text, 2000).

Connections: The Nature of Networks Communicating Complex and Emerging Science

ERIC SIEGEL & STEPHEN MILES UZZO

New York Hall of Science

Hands-on science centers were born in the 1960s, a product of a confident culture of science and technology. The New York World's Fair in 1964 suggested that by building bigger rockets, faster computers and more powerful engines, science and technology would offer prosperity without limit. For the following two decades, science education, including the newly hatched science and technology centers, celebrated the unlimited potential of science as an explanatory paradigm and the unambiguous benefits offered through new technologies. By the 1990s the complexity of science exploded with complex and jargon filled areas of research such as chaos, emergence, genomics, string theory, ecosystems ecology that challenged public comprehension.

Even the watershed moment at the turn of the millennium when the human genome was decoded, the biological equivalent to the moon landing, opened vistas of new complexity. When the confetti settled to the floor, we realized that decoding the human genome raised more questions than it answered, as human biology could not be captured in a sequence of base pairs, no matter how extensive or accurate. Genomics, in fact, was an early window into the complexity of interconnected systems and provided an impetus for the development of a new science of networks.

So when it came time, also at the turn of the millennium, to put together a centerpiece exhibition on networks at the New York Hall of Science, it is not too surprising that the project ended up light years away from where it began.

CONNECTIONS
The Nature of Networks

Networks beyond the internet

In 2000, the big technology story was the internet, a computer networked designed to function differently from other technological networks such as the phone system and the highway system. The internet was growing geometrically and enabling new patterns of communication and commerce. Minor players such as Yahoo were gaining prominence and power through an organic process of accretion, individual web sites were going viral. There was an intuition among many technologists that the internet was different, and the science educators at the New York Hall of Science were curious to explore that difference.

The project began, as so many U.S. science center projects do, with a grant proposal to the National Science Foundation. An early premonition about the difficulty of our approach was the fact that our peers turned down the proposal twice before

it was finally funded. As we refined the argument, we realized that this would not be another exhibition about the wonders of technology and the power of the internet. Such an exhibition had already been done, in fact, at the Museum of Science and Industry in Chicago, which explained HTTP, data packets, IP addresses, and routing. Our team had the insight that doing an exhibition about the marvels of internet technology for our young audience would be analogous to an exhibition about phone technology for their parents. It would feel old and irrelevant. So we described this exhibition as a way to use the internet to explore the fundamental and emerging science of networks, not only as it applied to communications, but also as it applied to biology and our social existence.

The science of networks

In 2002, Steve Uzzo wrote the following memo to the *Connections* team:

> *The Internet is rapidly becoming a metanarrative (a container, if you will) for all the ways in which people connect and perform day-to-day interactions in every conceivable way except face to face. There is a subtext in Internet business circles (much wishful thinking, a few working technologies) that all forms of communication are converging on the Internet (or the metanarrative it represents). This has spilled over into World-Fairsian thinking on the part of the public. But this increasing technocentricity misses the greater movement in understanding that is taking place: that of the network as the paradigm of organization, structure, and function in Nature. It is becoming*

increasingly evident that networks are likely Nature's way of getting everything to work together. Whether it is atomic/ molecular, intra/inter-cellular, ant colonies, flocks of starlings, human communities (including the Internet), ecosystems, the biosphere... Heisenberg suggested that "the world appears a complicated tissue of events in which connections of different kinds alternate or overlap to combine and thereby determine the texture of the whole." With the emergence of complexity theory, cybernetics, and systems thinking in the latter half of the last century comes the suggestion that it is the connections that are important, not the things. If we do a mind experiment and dwell down through the levels mentioned above in reverse (biosphere to atomic, sort of like the "Powers of Ten") only the connections matter. At each level when we get to the "thing," the "thing" is not a thing at all, but another set of relationships. This is the crux of why getting lay people to understand networks is important. They (networks) may in fact be all there is. We have an obligation to further the understanding of networks because it helps us understand ourselves, and how we fit in the big picture. It will be important for the visitor experience to communicate this powerful notion. Our next brainstorming session needs to connect the big idea with the excellent little ideas that have come out already, and hopefully tease out others while eliciting some new perspectives on the existing ones we have already discussed. If we can accomplish this, it would have to be labelled a success."

This insight was supported by a new book by Albert-László

Barabási entitled *Linked: The New Science of Networks* in which Dr. Barabási shares his research that there are patterns of connections that characterize phenomena as distant as the functioning of proteins in a cell, and the accretion of connections on the internet. His research suggested a common mathematical structure for these networks, and he posited that this structure might well be a fundamental characteristic of the natural and social world.

Serendipitously, an explosion of interest in complex networks among the research community was just beginning to hit the scientific presses and network science was becoming an important new locus of research. Network science was escaping from its original technical moorings (in math and game theory), and propagating into fields as varied as Sociology, Cell Biology, Ecology, Neuroscience and beyond. This revolution, captured in groundbreaking work such as László Barabási's book transformed our thinking about the exhibition even as it was being conceived. An exhibition originally imagined as a way of explaining communication networks and how they functioned now needed to consider a broader topic: "How Everything is Connected to Everything Else" in Dr. Barabásis words.

New research suggested that the internet was a complex network with some unexpected characteristics. Since it lacks central control, it behaves more like emergent networks found in nature more than human-engineered networks. All networks include fundamental characteristic components of hubs, nodes, and links, but these components are arranged

differently in "designed" networks than in "emergent" networks. This cluster of ideas formed the organizing principle of the exhibition. To reflect this evolution, the name of the exhibition changed from *Connections: a World of Networks*, to *Connections: the Nature of Networks*.

Exhibition prototyping

The exhibition team, which by now included the authors and the exhibition design firm Jeff Kennedy Associates, started by going through the time tested standard process of developing an exhibition. We hired an evaluator to help with front-end research that suggested a widespread familiarity with networks in three contexts in order of awareness:

1. Office computing ("I can't print because the network is down").
2. Telecommunications ("the television networks").
3. With some prompting, the term "social network" registered modest familiarity.

People were lukewarm in their interest about telecommunications networks, but warmed up a bit when they considered exploring their social networks. Not for the first or last time, we found out from our peers and our audience that the word "network" was closely bound with technology. But the spark of interest around the concept of social network encouraged us not to limit our exploration to technological networks.

Reflecting our desire to place networks in a larger, non-

A view of *Connections*: the large, tiled mobile-like structure suspended above the space is entitled *Float* by Tim Prentice.

technological, context we were concerned not to make the exhibition itself conspicuously "technological." We wanted to go beyond the computer screen, beyond the mouse and trackball, and create experiences in which the technology was embedded, but the interface was physical. This interest was

fostered through a visit to the MIT Media Lab, where tangible computing modalities were pioneered.

In all of this, we confronted the challenge of all exhibitions that attempt to address cutting-edge technology and science, the challenge of sustainability. When you focus on the latest technology, the most current science, you run the risk of rapid irrelevance as the cutting-edge moves more rapidly than does fundamental science, and state of the art technology quickly obsolesces itself.

Our first prototypes did focus on network technology, but with an eye toward demonstrating the social empowerment of networks. We envisioned a room in which one wall was a video window to a distant locale. Visitors would walk into the room and interact with their counterpart across the country or across the world. But what would they do with their new friend? Wave hello? Play a game together? Make a drawing together? Through brainstorming, we connected this idea with the idea of "telehaptics" in which touch is transmitted at a distance. We talked about internet see-saws, rope pulls, arm wrestling, something to promote the kind of beyond-the-computer interaction we were looking for.

We began design on a proof of concept for this approach through a year-long struggle to create an internet tug-of-war, in which one group of students would compete with another group at a distance over the internet. As this idea percolated through the institution, the administration and Board became excited about it and asked if we could create the internet tug-of-war in time for the ground breaking ceremony

Near simulates the dynamics of social networks using nearest neighbor algorithms.

for a major new expansion of the museum in October of 2001. Working with programmers, engineers, and robotics vendors, and armed with a profound ignorance of the difficulty of the undertaking, we created a prototype pneumatic internet tug-of-war for the Hall of Science within days of the big event. NASA agreed to host a group of students at JPL, and we would host another group at the Hall of Science to the sounds of pile drivers putting in the foundations of the new building.

But then a couple of things happened. The first was September 11. As we stood in awe at the huge clouds of smoke billowing out of lower Manhattan, about 10 miles away from the museum, the whole undertaking was cast in doubt as the entire city was shut down. Within days of the demo, there were still major problems yet to be solved, not least was that NASA was in lockdown and could not be used as the site for the other

end of the rope pull. But as the city pulled together in the aftermath, an alternate site blocks from Ground Zero in lower Manhattan became available. To the crude sucking, grinding and chirping sounds of the two prototype pneumatic rope pull apparatuses, the sound of cheering youngsters swelled and the groundbreaking as well as the network rope pull was a resounding success, as evinced by a *New York Times* article featuring this new application of the internet.

The prototype demonstrated that the social interaction made possible by the network appliance we had built was of much more interest than the underlying technology. While the internet tug-of-war was transformed into an internet arm wrestle for the final exhibition, this fundamental insight continued to guide the development of *Connections*.

What's the big idea?

For several years, there has emerged an orthodoxy among science museum exhibition developers that efficient and effective development starts with a consensus-crafted *Big Idea* which can be summarized in a sentence or two. This Big Idea is intended to provide a framework for exhibition developers, functioning as a filter to keep exhibition experiences focused and meet pedagogical goals. As Beverly Serrell writes in *Exhibit Labels: An Interpretive Approach* the Big Idea will: "… clarify, limit and focus the nature and scope of an exhibition and provide a well-defined goal against which to rate its success."

Based upon the success of the Big Idea approach at

Ropes and Pulleys conveys the complexity and dynamics of networks. Visitors turn the wheels to change the topology of the pulleys and ropes creating clusters and isolated nodes.

exhibitions at the New York Hall of Science and throughout the country, the development team set about trying to identify a singular summary conception that is a "statement of one sentence with a subject, an action, and a consequence. It is one big idea, not four." (Serrell). This effort led to much

discussion and not a little conflict among the team. Should the exhibition be about the internet, as it had started? Should it be about networks in nature? Should it be about the processes that form networks in nature, and their underlying characteristics? Should it be about the shared characteristics of all networks?

The team considered all of these ideas, but the authors felt that there was a fundamental gap in the process. How does this prescribed construct of Big Idea relate to the visitors experience within the exhibition? Our intuition and previous work led us to believe that visitors valued experiences more than intellectual frameworks. We were concerned that a singular controlling idea for the exhibition would diminish the creativity of the experiences that we could identify or develop around a broader conception of the topic. In addition to this concern, we recognized the broad gulf between visitors' pre-existing knowledge of the subject and the complexity of the topics we proposed to introduce.

We were able to articulate a set of conceptual goals for the exhibition, which while not quite as stringent as the Big Idea approach, did serve as a useful guide for the experiences we developed. This set of ideas was:

1. A network is a complex, interconnected system.
2. Networks have components – hubs, links, and nodes – and shapes resulting from the configuration of these components are important to their function.
3. There are planned networks (or "man-made networks") and emergent networks (or "natural networks."). The

internet is distinctive in that it is a planned network with emergent characteristics.

As these are sequential ideas, leading from the most basic to the most complex conception of the topic of the exhibition, they suggested a sequential organization through which we would introduce first network definitions, then network topology, then the forces that shape networks in different contexts. Of course, we recognized that visitors do not experience science center exhibitions sequentially, but this approach offered a fundamental shape for *Connections: the Nature of Networks.*

At the same time, the design team recognized that our primary goal was to create memorable and evocative experiences within this framework, and if that resulted in some loose conceptual threads, we were willing to take that risk. Again, the rationale is that visitors remember experiences more than conceptual structures.

Exhibition design: artists in the science center

Connections was developed to live in a dramatic new building at the New York Hall of Science. Designed by Polshek Partners, the new wing features a forty-foot ceiling, and is clad in a translucent coating that diffuses light throughout the interior. The skin of the building is defined by a close grid, and the infrastructure, both structural and mechanical, is exposed. It is a dramatic, light-filled, visually complicated space.

So, combined with the intellectual ambition of the topic, we were challenged to create experiences that hold their own in this powerful space. Through a year long search, we found artists and technologists who responded to this challenge with enthusiasm and imagination. The Jeff Kennedy design team came up with an overall exhibition design that responded creatively to both the topic and to the space.

Collaborating with artists was one of the highlights of the process of creating *Connections*. People who create art do not design to a specification, they frequently do not design for explicit pedagogical intent. Therefore, incorporating artwork into an exhibition with explicit learning goals is a negotiation between the artist's vision and the developer's understanding of the content and of the audience. It requires flexibility and an appetite for creative tension, along with the willingness to live with uncertainty, as artwork is by definition at least partially untried. Incorporating artwork into a science center exhibition also requires flexibility in pedagogical outcomes, as the process of creating artwork is not as susceptible to the kind of iterative prototyping that characterizes the development of standard interactive museum exhibitions. The payoff is that the audience experiences some of the beauty, ambiguity, and delight of a successful interactive artwork.

Three artists contributed major works to *Connections*. Scott Snibbe, a California artist who has considerable experience working in science centers, created two pieces, You are Here and Near. Tim Prentice contributed a beautiful installation entitled *Float* in which several hundred plastic tiles float

above the exhibition space, demonstrating the interactive and evolving quality of networks. Perhaps most adventurously, we commissioned a work from an in-house exhibition technician, Kyle Dries, called *Ropes and Pulleys*. Although Kyle was a kinetic artist and had done installations in public spaces, he had not done a piece of this scale and level of interactivity before, and his piece was one of the highlights of the exhibition.

Impact of Connections

The Hall of Science has consistently worked to address challenging topics on the exhibition floor, from the quantum model of the atom to molecular biology to evolution. We undertake these challenges both as part of our institutional identity and as a way of contributing knowledge and experience to the field of informal science. We are always interested in discerning and analyzing the effect of these exhibitions on our visiting public, through evaluation, through visitor surveys, and through in-house documentation.

Connections was funded through grants from the National Science Foundation and several private foundations, so we had a particular responsibility to document the impact of the exhibition on our visitors. To that end, we hired People, Places, and Design Research to conduct an evaluation shortly after the opening of the exhibition. The purpose of the evaluation was two-fold. First, we wanted to understand what visitors gained from the exhibition; second, we wanted to learn what kind of adaptations would help the exhibition experience for visitors.

As is frequently the case with visitor evaluations, the outcomes were both surprising and useful. The design of the exhibition within the space presented challenges to visitors, as it was directly adjacent to a popular exhibition about the science of sports. Young visitors who experienced that exhibition first had a hard time understanding the transition from the hyper-kinetic sports exhibition to *Connections* with its more contemplative experiential vocabulary. Second, the variety of experiences within *Connections* was successful in triggering an open-ended inquiry into the relationship among the various experiences. Focused interviews with young visitors using visual cues elicited responses about the common themes among the disparate elements, including "things are all connected", "people can be connected like ants and the telephone", along with a predictable amount of free association among the elements of the exhibition. Visitors agreed upon the favorite experiences, which included the artists pieces described above, the internet arm wrestle, a large display of golden orb weaver spiders, and a colony of leaf cutter ants. Based upon this evaluation, we changed signage to facilitate visitor learning, but otherwise did not make major changes in the exhibition.

The second tier of evaluation was among the Hall of Science's on floor staff of Explainers. These high school and college students are the public face of the museum for visitors, and serve as paid employees of the Hall of Science. As they stay at the Hall for an average of two years, they represent an experienced and expert window on the visitor experience.

Here the news was not so good. Explainers clearly had a hard time with *Connections*. Several rounds of training did not change the fundamental perception among the Explainers that, with the exception of a few specific exhibit elements, *Connections* was a difficult exhibition to interpret. We have continued to work on this with some success, and now see examples of effective interpretation across the different components of the exhibition. We are particularly encouraged by the recent successes of Explainers in working with social network interpretation and with elements of emergent behavior.

However, from the opening of *Connections* it became clear that among a certain group of visitors, the exhibition rang a deep and satisfying chord. We would get emails from colleagues and visitors expressing admiration and interest, and this perception led to the joke that *Connections* is the most popular exhibition among PhDs who visit the Hall ("both of them really like it!"). However, this wry insight led to a very surprising and important development when Steve Uzzo completed his dissertation in network science and began to work actively with the scholarly community engaged in this field. As a result of this work, a whole community of researchers, artists, and scientists has coalesced around *Connections* and built momentum about the topic. The Hall of Science has hosted several international conferences and planning meetings related to network science and visualization. We have also been invited to speak and give papers on these themes at conferences around the world,

and even helped to foster an Australian documentary on the science of networks that showed on public television in the United States.

There is intense interest in how the Hall of Science teaches complex and contemporary themes of science to the general public. We hope taking on these challenges will help demonstrate that complex and salient themes in science research can be the topic of exhibitions and programs at science centers. It is essential that the public grapple with contemporary science in order to participate in the critical decisions that confront us individually and collectively. Complex and emergent systems are at the center of fields ranging from climate studies to genomics, which have immediate impact on the public. Understanding the underlying technology of networks, and the way in which this technology mirrors natural systems has fostered new areas of research in national security, in biomimetics, and a host of other technologies. We believe that science centers must engage with contemporary science, and that new strategies are urgently needed for engaging the public in these complex and urgent topics.

Bibliography

Barabási, Albert-László and Bonabeau, Eric. (2003) "Scale-Free Networks." *Scientific American*, Vol. 288 No. 5. New York: Scientific American. 50.

Barabási, Albert-László. (2002) *Linked: The New Science of Networks*. New York: Perseus Books.

Bonabeau, Eric and Théraulaz, Guy. (2000) "Swarm Smarts." Scientific American, Vol. 282, No. 3 New York: *Scientific American*. 72.

Camazine, Scott, Jean-Louis Deoubourg, Nigel R. Franks, James Sneyd, Guy Théraulaz & Eric Bonabeau. (2001). *Princeton Studies in Complexity: Self-Organization in Biological Systems*. Princeton: Princeton University Press

Hardy, Christine. (2001) Self-Organization, Self-reference and Inter-influences in Multilevel webs: Beyond Causality and Determinism. Cybernetics and Human Knowing 8, No. 3. Charlottesville: Imprint Academic. 35.

Laszlo, Ervin (2002). "The New Holism: The Grand Prospect for Science and Society." *World Futures: The journal of General Evolution* 58, Mo. 2-3. Taylor and Francis. 137.

Prigogine, Ilya and Stengers, Isabelle. (1984) *Order out of Chaos*. New York: Bantam Books.

Serrell, Beverly. (1996, second printing 1998) *Exhibit Labels: An Interpretive Approach*. Walnut Creek: AltaMira Press.

Strogatz, Steven.(2004) *Sync: How Order Emerges From Chaos In the Universe, Nature, and Daily Life*. New York: Hyperion.

Waldrop, Mitchell. (1992) *Complexity: The Emerging Science at the Edge of Order and Chaos*. New York: Touchstone Books.

Watts, Duncan. (2004) *Six Degrees: The Science of a Connected Age*. New York: W.W. Norton.

Wolfram, Stephen.(2002) *A New Kind of Science*. Champaign: Wolfram Media.

Science and Technology Exhibits:
The Use of Interactives

FRANZ KLINGENDER

Canada Science & Technology Museum Corporation

For the past ten years the use of interactives in museums of science and technology has been the source of much ink. For many observers they epitomize all that is wrong with contemporary museums and provide yet another example of their dumbing down. For the more vocal adult museum-goers they provide the rationale for never crossing the threshold of a museum of science and technology. Both parties characterize interactives as the source of an insufferable level of noise that they would argue can never be associated with serious learning. For them, interactives consist of little more than knobs, dials and handles to be quickly manipulated before running off to do the same thing elsewhere on the museum floor. These pundits seemingly long for a past wherein one found cases full of artifacts of technology each with a little descriptive tag hanging around its neck. In this milieu the museum's curatorial staff was expected to produce artifact texts to inform the reader about everything of importance regarding the artifacts on display. There was also expected to be a reverential silence in the exhibit hall, learning of course being a silent and serious engagement.

Some of the blame for the current situation can be laid at the feet of science centres. In North America at least, there is considerable confusion between science centres and museums of science and technology. This is not made any clearer by the fact that many museums of science and technology, looking enviously at science centres' attendance numbers, have gone on to adopt their interpretive tools. The most favoured of these tools has been the interactive.

Background

To understand this situation, it is essential to examine the type of artifacts that were on display in 19th and early 20th century museums of science and technology. They can be best characterized as being largely mechanical with most of their workings visible to the careful viewer. Often as not they were patent models or builder's models, which by their very nature were intended to show how a process occurred or a piece of technology functioned. In large part many consisted of what we would currently refer to as simple machines. If one compares the complexity of a Watt pit engine with that of even the simplest of internal combustion car engine this point becomes clear. If the museum visitor took the time to read the descriptive artifact caption and to study the item it would have been possible to comprehend the operation of the technology. If the viewer were lucky enough to encounter a working model, the learning process was made that much easier.

Another important factor to consider is the mandate and focus of the pre-interactive museums of science and technology. These institutions were founded in 18th and 19th century North America by wealthy members of society and were intended to allow them to exhibit what for the period was the latest technological innovation. The audience was initially made up of their friends, though eventually the working classes were allowed entrance with the hope that a visit might further their education. Although children may have been present it was expected that the audience would be mostly made up of adults. The tone of the presentation

was the glorification of science and technology and how it might be called upon to solve all of modern society's woes. It is also important to understand that although it was hoped these museums of science and technology might help in the education of the working classes they were in no way associated with the formal system of education.

Interactives today

A great deal has changed since the time of the early museums of science and technology. The science and technology associated with everyday life has become increasingly complex. More and more of it has come under the control of proprietary limits to information. Through unfortunate experience society has come to no longer view science and technology as the unquestionable force for good that it once was. Most importantly, all writers now agree that the degree of science and technology literacy that we once possessed has long since evaporated. For many museum-goers, issues in contemporary science, although definitely of interest, are very hard to fathom. Mass media sources are of little assistance in gaining an understanding as they most often either over-simplify the issue or – due to their sources – exhibit a strong bias. In the eyes of most Canadians, museums are a trusted source of unbiased information. Therefore, if museums are to remain relevant they need to assume an active role in interpreting and often demystifying modern science and technology.

Museums' role in society has also undergone profound changes. Whereas once they were sources of learning unto

themselves, they now have become an integral part of the larger box of tools available to educators. As a result North American museums of science and technology must look to the school curriculum when they are designing new exhibits and programmes. If a museum's school programme is to receive any enrolment there must be a straightforward justification of its links with curriculum outcomes. Museums also now rely on school-aged visitors for a significant portion of their annual visitation. Due to the many other sources of information and entertainment competing for the attention of their audiences, if a publicly-funded museum of science and technology is to remain financially viable it has no choice but to incorporate techniques of learning that meet the needs of the young visitor. Because these visitors bring no prior knowledge with them when first encountering science and technology, designers of exhibits and programmes must approach the challenge in a radically different fashion than for a largely adult audience. The days of cases of static dusty artifacts have long since passed into the historiography of museums.

The discussion about the use of interactives has not been limited to observers outside the walls of the museum. The issue has provided much fodder for sessions involving curators and programming staff at professional museum associations. The argument usually goes something along the lines of the curators questioning how all the results of their material culture research will be imparted if text is reduced in favour of the use of interactives. The programming staff-person then points out that their exit surveys have shown

that the majority of museum visitors read only a portion of the available exhibit text. This exchange goes to the heart of the methods of disseminating information in museums. Traditionally curators have felt it their duty to provide the visiting public with all their findings on a particular topic. At its most extreme, this has resulted in book-on-the-wall exhibits where the visitor is bombarded with words – and in programming staff faced with visitors who complain loudly that the exhibit is boring.

Recently the problem has begun to be resolved. Historically, curators have controlled how information was provided, reinforced by the fact that many of them were the only museum staff with advanced academic degrees. Programming staff were relegated to the secondary role of mouthpiece. In North America since the 1980s there has come to be a more balanced relationship between these two key players. Curators and programming staff are much more equal partners in the development of exhibits. The membership of exhibit development teams is now made up of both working collaboratively as equals. Although curators continue to serve as the institutional content experts, the expertise of the programmer in the transfer of information has gained a great deal of credence. One of the many things these professionals have pointed out is that a significant proportion of their clientele is more engaged by interactives than text. Given that the mission of both parties is the successful imparting of information, both have come to rely on the other's expertise.

Another development that has affected museums of science and technology is the findings of the extensive research of the past thirty years, the focus of which has been on the different learning styles exhibited by museum-goers. This body of work has provided irrefutable evidence that a significant number of our visitors learn best by doing. No matter the number of times the person reads about the process or technique, they only truly comprehend as a result of what has come to be called hands-on-learning. In theory at least for this portion of our museum clientele, interactives provide the key ingredient to the success of their learning. This same research has also shown that pacing the experience within exhibits also helps to reduce visitor fatigue. Although interactives have a much greater value than to simply serve as diversions, they undoubtedly do provide a more relaxed learning experience in combination with panels of text and cases of artifacts.

Unfortunately, in addition to being a common complaint among curators, it has been confirmed by observation that there is a fair degree of truth in the assertion that the majority of contemporary museum-goers are at best information browsers. Put more simply, although they may wish to learn, they don't really want to read all the exhibit text in order to do so. The solution most commonly used is to include interactives designed to engage those visitors and thereby hopefully to help them learn. The associated risks are that the interactive becomes no more than a source of entertainment (the bells and buzzers syndrome), or that it is too complex

and does not aid the learning process or that due to the level of technology used it is prone to malfunction.

What is an interactive?

Interactives range in complexity from simple mechanical devices consisting of ropes and pulleys designed to teach about the function of simple machines to electronic units incorporating computer screens that are very much akin to the current generation of popular computer games. The principle common to all is that they move the experience from passivity to activity. By doing something it is hoped the participant will learn something.

A pitfall common to many museums is insufficient thought being given to the type of interactive in relation to its educational task, or the learning outcome anticipated from its use. This is often evidenced in the use of a complex and often expensive interactive where a much less expensive and simpler mechanical one would suit just fine.

Testing

After years of involvement with exhibits, most museum staff will agree that despite their best intentions in the writing of text and design of exhibits, unfortunately visitors do not always "get it". This problem arises because the exhibit team either does not understand or takes for granted the level of knowledge of their visitors. Since most major exhibits require several years of preparation, staff tend to assume that what for them has become common knowledge is understood

equally well by the visitor. The same holds true for the design of interactives: we assume that their use will ensure that they will understand. This problem arises for three primary reasons. It is complex to explain a concept using only artifacts, words and images and so out of desperation a decision may be made to include an interactive. Interactives have incorrectly been imbued with the ability to serve as a fail-safe panacea for interpretive issues. Finally, and likely most importantly, there has been no testing undertaken to ensure the interactive is designed to properly serve the educational need. In an effort to save time and have the project completed on schedule, the decision is made to forego interactive testing. For an interactive to serve its purpose, before undertaking its design the exhibit team needs to agree on learning objectives. Only after setting the level of the bar to be used in measuring its success can the interactive be mocked up and tested with the public. If, as a result of testing, it becomes clear that an interactive has failed to meet its objectives, it must be redesigned or even eliminated.

Food for Health

In 2006, the Canada Agriculture Museum and four partners whose mandate was food production and public health, opened a 140 square metre travelling exhibit called *Food for Health*. The big ideas of the exhibit were to examine Canadians' food choices, food safety, how their food is produced, how methods of food production have changed through history and to provide them with information about the role food

plays in ensuring good health. The exhibit was designed to meet the needs of school groups and families with children. It consists of text panels, cases containing artifacts and props and six interactives. The content was selected, text written and exhibit design approved by a team made up of museum staff and partner representatives. Although providing a solid historical context it was agreed that the exhibit's primary focus would be the contemporary Canadian situation.

As the exhibit was intended to travel – and thus the positioning of components was subject to the requirements of the host venue – it was clear that a linear arrangement of content was not feasible. Rather the exhibit was planned so visitors could graze their way through its content based on their particular interests or age level.

Front-end evaluation undertaken with members of the audience demographic was very helpful in refining the exhibit's focus. We found that most Canadians have little knowledge about how and where their food is produced and processed and from their responses it was clear that they felt media coverage of the topic only served to induce fear and scepticism. A common response was confusion arising from seemingly constantly changing and conflicting findings that appear in the popular media regarding nutrition. From their perspective the public saw the safety and nutritional value of particular foods changing on a weekly basis. Another focus of their concern was the organic, genetically-modified and conventional agriculture controversy. Since there continues to be a lack of impartial sound scientific research about

nutritional benefits, it was decided to include interviews with three farmers in which each explained why they had chosen their particular method of agricultural production.

One of the challenges faced by the curator was taking the wealth of complex scientific and nutritional information provided by the scientific community and making it engaging for a family audience. The scientists' lack of experience with museum exhibits meant they felt the solution was to use lengthy panels of text. And since the food industry forms a strong lobby, as well as funding health research, it was also essential to ensure that whatever we presented had been impartially vetted.

Time Shopper

Over the course of the past one hundred and sixty years the availability and distribution of food available to Canadians has changed quite drastically. Although those changes were fairly consistent across the country there were some anomalies. In 1850 fresh lobster would not have been available in an inland city such as Toronto or Winnipeg, but in the coastal community of Halifax it was readily available. Due to the Canadian climate, many foods we now take for granted year-round could only be purchased in season. The development of a network of rail and later air services had a tremendous impact on what Canadians could and could not eat. We therefore set as our learning objective that at a minimum the visitor should be able to explain how factors of location and period affect the availability of food.

The challenges faced in transmitting this information were numerous. From interviews we learned that the public has no concept of these changes and often were not aware of how the oranges they ate in 2010 had made their way from the grove to the grocery. If we were to convey these concepts and to do so for five different communities across the breadth of Canada we needed a means of showing all the layers of information at one time. We also needed to provide the information in an engaging and understandable fashion. A decision was made to use the medium of a time travelling grocery cart full of the items we had selected. These items included foodstuffs that would have been produced by early pioneers as well as more exotic items such as oranges that are not grown in Canada.

It was decided to convey the information in the form of an electronic game where the players were challenged by a granny figure to assist her with shopping for items on a grocery list. Visitors are invited to select one of three periods, from three locations and a season and then were faced with deciding whether all the items on the list would have been available. Period images of the locations, showing systems of transportation and places of food retailing, were used to enhance the experience and to emphasize the changing technology. Players are also forced to make their decisions quickly as granny's voice lets them know her "time shopping grocery cart" is rapidly running out of power. If the player makes a mistake they are told so, if correct they are cheered on by granny and urged to move on down the list. The complexity

of language and concepts means this interactive is best suited to children older than twelve years of age or a bit younger if accompanied by an adult.

Initially we had selected five locations, four periods and six foodstuffs, but when we tested the concept using sheets of paper standing in for the various computer screens we found users either got lost or lost interest as they failed to find many of the foodstuffs. Although curatorial research had pointed to an interestingly complex game, it proved too complex for our visitors and therefore defeated any chance of our learning objectives being absorbed. As a result we reduced the number of locations and foodstuffs. When the final interactive was tested we found it remained sufficiently challenging and had not over-simplified the concept. In the proposed floor plan provided to host venues we recommend the interactive be situated near exhibit cases dealing with the history of food preservation and modern methods of food packaging designed to extend a foodstuff's shelf-life. As a result of the computer programming required for all the selections, locations and periods this was an expensive interactive to produce.

Bacteria in the Kitchen

Food poisoning is a quite common problem in Canadian households, and in many instances what actually is food poisoning is misidentified as a gastro-intestinal ailment. Although the cause is sometimes traced back to a problem somewhere in the food processing and packaging system, most commonly the error is on the part of the consumer.

In this era of highly mobile urban families the vehicles for transmission of conventional wisdom have been greatly reduced. The advice of seniors who have gained extensive knowledge from preparing and properly storing food is no longer readily available.

The team decided that this interactive would be aimed at the sizable cohort of pre-school aged children who spend time with one of their parents in the kitchen. This meant that text needed to be kept to a minimum and the interactive would rely on images as a means of imparting information. The interactive consists of a flat panel showing a kitchen interior with a number of problems or incorrect methods of food storage or preparation. These consist of easily found items such as a cat walking across the counter and a raw roast on the top shelf of a refrigerator dripping juices on foodstuffs on shelves below it. It also included raw meat and vegetables being cut on the same cutting board at the same time, a common cause of cross-contamination leading to food poisoning. The challenge for the young visitors is to find all the errors and to raise the flip-door to discover the proper method. Although the interactive design proved to be simple and relatively inexpensive, the background research and team around its messages became very complicated. Project partners with expertise in food safety were recommending a scenario that in the majority of homes would be completely unrealistic. If the interactive had incorporated the extremely diligent food safety practices that they were recommending it would have been seen as irrelevant by museum visitors. So the team came up solutions to the

problems that – although not quite as extreme – if followed would result in safe food preparation and storage practices.

The raw data for the interactive content had already been researched and assembled by a local civic health unit so any front-end evaluation was deemed unnecessary. This interactive has proven to be a popular venue for kindergarten groups visiting the exhibit. It has also resulted in some humorous interaction between child and parent as the former loudly announces the mistakes they notice the latter has been making in the home kitchen. It has been positioned in the centre of the exhibit layout and is surrounded by brightly coloured images of fruits and vegetables on the backs of adjoining text panels.

Burning Calories

Research undertaken by scientists and health professionals as background to the development of this exhibit repeatedly shows that Canadians have no notion of appropriate food portions and how much energy they need to expend to burn off the calories consumed as part of their daily diet. Although this might have been less of an issue when our lifestyle included more physical activity, as we become increasingly sedentary the effects are showing up in increasing obesity. This is even more of a concern as the numbers of these children and young people in that circumstance continue to rise.

The problem is exacerbated by the increasing quantity of snack foods in Canadians' diet. Unfortunately many people fail to realize the often disproportionally large calorific

content of small quantities of many familiar snack foods.

Early in the exhibit development process having agreed this was an issue with which the exhibit had to deal, the project team decided the only effective way to illustrate the concept was to have the visitor attempt to burn off some calories. In order both to make the point of hidden calorific content and to select a familiar food item, the team decided the goal would be to have them burn off the calories from one potato chip.

The interactive consists of a heavily modified exercise bicycle with an enclosed rear wheel connected to a device roughly measuring the energy expended by the person's pedalling and this data is transmitted to a computer housed inside a screen in front of the rider. As they pedal and expend energy, portions of the image of the chip in front of them disappear. In order to make the programming possible the "consumption" of the chip is broken into four pieces. The mock-up of this interactive required extensive testing to calibrate the measuring technology in order to provide an accurate result. Although we had wanted to encourage the rider to continue by having the chip nibbled, we found the additional programming costs could not be justified. We also found that even with the chips having to be consumed in four bites our test audience was still more than willing to continue the experience. Although the bicycle was sized for visitors from eight years of age upwards it has proven to be equally popular with adults. Because it was anticipated, indeed hoped, that this interactive would draw a group of visitors to cheer on one of their number, it was recommended that it not be placed

in a confined location. After the exhibit had opened at the Canada Agriculture Museum the team was pleased to notice how effective this interactive was in highlighting the energy required to burn off the calories from what for most is a very small proportion of the snack food eaten in one sitting. Its design and the necessity of making sure the mechanics were robust meant this was a moderately expensive interactive.

The Usual Suspects

The Canadian Public Health Agency estimates there are around twelve million cases of food-borne illness annually in this country. In North America at least there has been extensive press coverage of those instances where agricultural practices or lack of hygienic food processing has contributed to consumers becoming ill. This has resulted in a situation where consumers are quick to accuse agriculture of causing the illness but are unwilling to admit to their own culpability. In fact, when statistics were produced that pinpointed the causes of food-borne illness a much greater percentage could be attributed to consumer error than to problems in the food supply system. Front-end interviews also showed that among our visitor demographic there was widespread ignorance as to the types and causes of food-borne illness. There was also the mistaken belief that all types of food-borne illness were equally dangerous. The museum's interpretive representative on the team made it clear that although the topic was of importance if it was not properly handled we were at risk of boring our visitors. From visitor research in other exhibit

projects we knew there was a significant interest in actually being able to see the microscopic organisms. The curatorial representative on the team recommended this as an instance where comparing and contrasting with the historical context would be effective. Researchers associated with the Canadian federal government's food protection agency recommended the interactive include the six most common microbes. They also suggested we make use of extant time lapse photography to show how quickly a single microbe can into thousands.

The interactive consists of a large text panel featuring historic images dealing with instances of food-borne illness such as contaminated water and testing milk samples in an early public health laboratory. A small computer screen in the lower quadrant of the panel shows a film loop of *E Coli* reproducing itself. The interactive focus is a custom-built microscope through which one can view electron microscope images of the six microbes. The premise is the visitor is helping to identify suspects accused of causing food-borne illness. A flipbook containing the scientific name for each microbe, its cartoon image, a copy of the microscopic image, a description of its *modus operandi* and symptoms for each is placed alongside the microscope. Around the microscope are six enlarged cartoon representations of the microbes each with a name such as *Eager Ernie*. As the microbes are not indentified on the slides, the visitor is presented with the challenge of matching the flipbook data with what they see through the lens. When we undertook front end testing of this interactive those visitors shown only the cartoon images said they would

also prefer to see what the microbe really looked like and those only shown the microscopic images showed little interest in continuing on to learn more about the microbe, which of course was the interactive's ultimate goal.

The selection of the content for this interactive was a topic of much heated discussion among team members. Those involved with public health were concerned the inclusion of historical content would dilute the messages regarding the severity of food-borne illness and the often very simple procedures to prevent its onset. The curatorial representative was concerned that without that context food-borne illness might seem to be only a contemporary issue and so the interactive risked becoming little more than a health advisory pamphlet. The research scientists we asked to approve the text expressed the concern that the cartoon images trivialized what can often be a very serious illness. This proved to be an interactive where all parties needed to compromise in the creation of a final product. In the recommended floor plan this interactive is placed in close proximity to two large cases of artifacts highlighting historic food preservation and the development of food safety regulations. Although this interactive is fairly simple, due to its content the design process moved quite slowly.

Look at the Labels

From interviews with our audience demographic it was obvious that we needed to find some means to deal with ingredient lists on packages of commercially-made food. Interviewees made reference to concerns about their families

consuming foods containing ingredients with scientific names that they could not pronounce, and that they didn't understand the significance of the order of ingredients. Many people also admitted to being unable to use the label to discern whether a foodstuff contained an ingredient to which they were allergic or one the consumption of which they had received medical advice to reduce. This was another instance where it was obvious that the method selected to present the information had to be carefully considered. We were faced with several concepts that on the surface seemed straightforward but that our interviews had proven was far from the case. We were convinced that panels of text describing how to read a label were doomed to remain unread too. Experience had also shown that this sort of information is best absorbed by our audience if faced with a challenge. Our goal was to have them actively participate in the learning process. Exhibit observation exercises also showed this technique often leads to intergenerational participation amongst visitors.

It was decided to select four scenarios, each representing a different part of our audience. In one, an elderly lady was trying to increase the amount of fibre in her diet and was faced with making her selection based on reading the labels of a loaf of wholewheat and a loaf of light rye bread. On one of the labels-fibre rich wholewheat flour and bran was much closer to the top of the list than the other, meaning in that product it was present in a larger percentage than the other. In another a young woman was trying choose between a package of dried cream of asparagus or mushroom soup mix to suit

her vegetarian diet. Due to his snack food addiction a high school student was faced with reducing the amount of salt he consumed daily. In each instance the visitor was faced with helping the person choose between two similar products on the basis of the ingredients or the product labels. Once they had read the person's dietary requirement and the two product labels visitors were asked to push one of two buttons to make their selection. If their answer was correct they heard a cheer and if incorrect a sound to indicate they were wrong. This was a very simple interactive to design, the most complex part being its graphic design. Since it consisted of little more than a normal exhibit panel fitted with six push buttons it was also comparatively inexpensive.

This interactive is situated at right angles to a panel making reference to tidbits of information about Canadians' food. The information is presented in the form of highly edited news items on a mobile communication device. Unfortunately despite the partners' best intentions, this material has been of little interest to the visiting public. We are left with a situation where despite the partners feeling the public should know, they have expressed no interest in knowing. Whether proximity to this panel has been the problem, the label reading interactive has been equally under-used. Tracking results for the exhibit have shown that numerous visitors glance at it, but then immediately pass onto another component of the exhibit.

Feed the Alien

In 2006 when *Food for Health* launched, childhood obesity was

a serious concern amongst public policy-makers. Diabetes was on the rise within this group and despite public education campaigns the problem showed no signs of abating. Four years on and childhood obesity continues to be an issue with some researchers suggesting that many of these children will die at a younger age than their parents. The same researchers point out that these children are not slightly over their recommended Body Mass Index, more and more of them are being diagnosed by their paediatricians as being morbidly obese. In North America, dealing with the issue of obesity among children is complicated by media representations of the ideal body image. Models and actors in television series are very slim, often bordering on an anorexic appearance. Product advertising tells young girls that their appearance is a key measure of their success. In television programmes young males that are only slightly over-weight are portrayed with some degree of ridicule and their characters are certainly destined to never succeed with the opposite sex. Therefore although everyone around the table felt the issue warranted inclusion, there was concern about how to deal with it in order not exacerbate the problem.

In North America there is a highly popular computer game where the player's avatar is chased by a monster and must make its way through a maze to a safe refuge avoiding getting caught. As the young demographic that plays this game is the same as that which is of concern to health professionals it was felt for this interactive a game approach would meet wit the greatest success. Partners involved with youth health

promotion argued that despite the goal of the interactive being to show young people the results of not eating a balanced diet, our protagonist could not look human. It was decided instead to use an alien who had just arrived on our planet and therefore is unaware of the effects of "earth food". The player is expected to guide the alien through the maze and to select food for it that will provide a properly balanced diet. If fed too much snack food and too many soda drinks the alien becomes visibly fatter, cannot move as quickly and due to its girth cannot fit through the bridges on the short-cuts to the safe refuge at the end of the game. If on the other hand the alien is not fed at all, it withers in size and its speed through the maze is significantly reduced, making it an easy target for the monster. If the player offers the alien a proper diet and is adept at using the joystick to move it through the maze, getting to the safe refuge is a relatively easy task.

To take advantage of a pre-existing familiarity with the design of electronic games the production of this interactive was contracted to a firm that with proven expertise in that area. The exhibit team met with the two designers, one responsible for the graphics and the other for the game-play. They were provided with the variables, including food suitability, the potential of weight gain/loss, and game board hazards and short cuts. Based on their expertise an appropriate length of play time was selected after which the game resets. A decision was made to keep the graphics relatively simple since unlike a commercial product, the look was of secondary importance and the team was aware that

graphics represented a significant portion of the total cost. It was decided that the game would be appropriate to the skill level of an eight- to twelve-year-old.

Once a beta version was available the game was set up on the floor of a sister museum of science and technology in Ottawa with a visitor demographic similar to that of the Canada Agriculture Museum. The results of those tests showed there were several serious problems with the interactive. Players of the target age range found its design and tone to be too childish and they lost interest well before play was complete. In order to keep their interest gore would have to have been incorporated into the game and its design would have had to have been much more complex. Simply put, their experience with electronic games meant they were too advanced an audience. On the other hand, the younger children for whom the tone and graphics were suitable did not have sufficient skills with electronic games to make it possible for them to play and win. This interactive also fell prey to the distraction of other components of the exhibit: whereas the length of game play would normally have held their attention till completion, other interactives such as the *Burning Calories* bicycle drew them away.

The game as incorporated into the exhibit was modified to suit the skill level of the younger children. This meant the complexity of the layout was simplified by eliminating a number of the hazards and dead-ends, making the route to the safe haven more obvious and lengthening the time before the game reset itself. Despite these changes, once incorporated

into the exhibit the game still failed to deliver its anticipated outcomes. One tracking study suggested that much of the audience simply did not find the game. This may have been because the screen formed part of an exhibit panel with the joystick projecting from the bottom. Even incorporating the alien as a screensaver many young visitors simply walked right past it. Given the time and funds spent in its design, testing and construction and particularly the importance of the subject, since it failed to engage the interests of the audience demographic this interactive unfortunately cannot be judged a success.

Conclusion

Museums of science and technology can no longer fill their exhibit halls with cases of artefacts and hope that their visitors will be able to make some meaning of them. Today's museum visitors enjoy a sense of discovery, but they also appreciate when clues are provided to assist in that process. The role of museums in society has changed, as have the expectations placed on them. Even if the suggestion that museums have become entertainment causes one to shudder, changes in their educational role alone require them to be using a very different kit of tools. The issue is for staff to agree about how to best balance their role as places of entertainment and enlightenment. Our visitors learn in different ways and if museums of science and technology are to remain relevant to a wide audience, we need to give some consideration to those learning styles. When used properly an interactive can

play a key role in meeting those needs. That said they can only reasonably be expected to play a supporting role to the more traditional exhibition tools of artifacts, images and text.

Like any of the other components that make up an exhibit careful research must go into their design and construction. Part of this research involves selecting the type of interactive that is best suited to the need. The exhibit team must work together to reach consensus on the use of interactives and the role they will play in exhibits. Part of this process is committing sufficient time to undertake the audience research to ensure the interactive meets the goals that have been set for it. At the Canada Agriculture Museum each interactive is backed by an information dossier that outlines the concept it is expected to interpret, how we see the visitor using the tool and specifically what that person will have learned. If, as was the case with several of the interactives planned for *Food for Health*, evaluation shows the interactive is not meeting those goals, it needs either to be altered or eliminated. If the team is not clear about a concept it is unrealistic to expect that an interactive will magically make everything clear. If we don't know what we are trying to say, that problem needs to be resolved before starting to design interactives. If one's visitor analysis shows the public is not interested in a proposed exhibit topic, interactives are not going to suddenly make the topic appealing. The expectations established for interactives therefore need to be realistic. If an exhibit starts out lacking content, no matter the number of interactives used, the absence will remain. Finally if a museum decides to incorporate

interactives into its exhibits purely for their entertainment value, they will quickly find that the interactive no match for the competition from other sources of entertainment outside the walls of the museum.

Recently in North America large new museum capital projects have opened with much fanfare – but their lustre is rapidly tarnished by a lack of operating funds. The same principle holds true for interactives – for them to serve their purpose they need to remain functional. There needs to be a budget line for interactive maintenance. When they don't function and visitor interaction cannot happen there is an inordinately large negative impact on public goodwill towards the rest of the exhibit.

This modified exercise bicycle allows museum-goers to experience burning off the calories in one potato chip.

Using a humorous tone adults and children alike are introduced to the microbes that lead to the more common food-borne illnesses.

Through role play, visitors are challenged to extract essential health information from packaged food labels.

This computer helps children learn the health risks associated with an unbalanced diet.

The Time Shopper introduces Canadians to how access to foodstuffs has changed over the past century.

3.
ACTIVATING
EVALUATION
TACTICS

Beautiful Science:
Ideas that Changed the World

KARINA WHITE

The Huntington Library, Art Collections

and Botanical Gardens

San Marino, USA

The Huntington Library, Art Collections, and Botanical Gardens, in San Marino, California, holds one of the best collections of history of science materials in the world. Spanning the 13th–20th centuries, this vast repository includes thousands of rare books and manuscripts: a literary record of human thought, questioning, and discovery. Works by thinkers such as Aristotle, Ptolemy, Vesalius, and Galileo reside alongside writings by Newton, Darwin, Einstein, and countless others. In 2006, the Huntington was given an important collection of works from the Burndy Library. The gift included some 67,000 rare books and reference volumes as well as a collection of scientific instruments. Given this extraordinary addition to the library, the Huntington was keen to build on recent efforts to provide the general public with innovative exhibitions highlighting the Huntington's emphasis on science. Just a few years ago, the Huntington opened a new botanical education center, bringing scientific inquiry into sharp relief.

In a time when "informal science education is often the only means for continuing science learning in the general public beyond the school years" (National Science Teachers Association Board of Directors, 1999), cultural institutions are uniquely positioned to provide authentic educational experiences related to the sciences. The Huntington's commitment to education led to the development of a new, permanent exhibition on the history of science: *Beautiful Science: Ideas that Changed the World. Beautiful Science.* It opened to the public in November 2008, and is a 2,500 square-foot

exhibition divided into four content areas – astronomy, natural history, medicine, light – and a reading room.

The challenge

The most significant challenge for this project was to communicate scientific concepts and their complex history to the general public. We were determined to create an exhibition that would be accessible and appealing to a lay audience, but where to begin? Sometimes it seems that exhibitions, like school textbooks, can drain all the joy and excitement out of topics such as history or science. Daniel Lewis, the Dibner Senior Curator of the History of Science and Technology, and I wanted to create a history of science exhibition that would excite people, even those who don't necessarily think of themselves as science geeks or history buffs. We were determined to design an exhibition that was engendered with wonder, moments of beauty, and an energy that was palpable. We sought to share some of the amazing ideas that have emerged out of scientific thought: the expanding universe, the workings of evolution, the harnessing of electricity – in ways that would be both engaging and accessible.

Casting one's eyes around the field of history, science, and library exhibitions can be a rather discouraging enterprise. All too many history exhibitions are dominated by confusing layers of stilted text and loosely related imagery. Science exhibitions rarely integrate rare or authentic objects, and while many are successful at engaging people with physical phenomena, the trajectory of ideas that informs

scientific understandings is seldom part of the story. Library exhibitions offer a series of precedents in which written works are displayed in large, isolating cases, with little thought to contextualizing the books or their ideas. Furthermore, interactives (in almost any kind of exhibition) are frequently designed only for children, thereby turning off adults who could benefit from multi-sensory methods of learning. Observation of these precedents stimulated our core exhibition development goals:

1. to focus the content in such a way as to make it accessible and exciting;
2. to make the ideas in our books and manuscripts the primary focus of the exhibition;
3. to design cases and an environment that would highlight the exhibit materials;
4. and to use graphics, text, interactives, and multimedia to reinforce the extraordinary ideas contained in the books.

The audience

The target audience for *Beautiful Science* consists of adults with no specialized knowledge of the sciences. The decision to create an exhibition for a general audience was a key one, and its consequences were felt throughout our development process. Targeting a lay audience required that we question our own assumptions about the knowledge and experience visitors bring with them to the museum. Through audience research and evaluation, we were able to check these

assumptions and review our decisions at a number of steps in our creative process.

Through demographic surveys, we know that a majority of visitors to the Huntington are educated adults. And, though many have not studied science at advanced levels, they likely share favorable impressions of science with the broader public:

> Americans like science. Overwhelming majorities say that science has had a positive effect on society and that science has made life easier for most people. (The Pew Research Center for the People and the Press, 2009)

> With few exceptions, science and technology enjoy a positive reputation throughout the world. Most people believe that science and technology play a key role in raising their standard of living and improving their quality of life... Despite their favorable attitudes, most people do not know a lot about science and technology. Many do not seem to have a firm understanding of basic scientific facts and concepts, knowledge that is necessary not only for an understanding of science and technology-related issues but also for good citizenship. (National Science Board, 2008)

Additional studies also point to the low level of science literacy among the general public:

> A majority of American adults do not know that humans evolved from animal species or that the Sun and Earth are in the Milky Way galaxy. And one-third think that humans and

dinosaurs existed at the same time, according to a... nationwide survey on scientific literacy among adults." (The New York Times, 1994)

With stagnant and/or declining science literacy in the general population, and an increase in political attacks on ideas endorsed by the scientific community, it seemed more urgent than ever to provide the public with safe places for learning, dialogue, and discussion. The centuries of scientific endeavor represented in the written works held by institutions like the Huntington must remain at the center of public dialogue about science and society. First editions of works like Charles Darwin's *On the Origin of the Species* (1859) and Galileo Galilei's *Sidereus nuncius* (1610) are humanity's legacy and our shared history. The long and rich past that informs our present knowledge is crucial to our understandings of our world and of ourselves.

Focusing the content: the big idea

As we began extensive content research: on scientists, their ideas, and their written works, we also worked to focus our overarching message. Given that the combination of science and history could leave some visitors bored and uncomprehending, the provocative notion of beauty in science became a guide for the entire exhibition. This idea did not come immediately, however, but after a series of brainstorms with the exhibition team, and after honing broader ideas about change, wonder, and discovery. Realizing

that the ideas in the exhibition's books and manuscripts mark huge leaps of imagination as well as documentation of careful study, we eventually arrived at our big idea: *Beautiful ideas in these books and manuscripts changed the way we understand the universe.* In the exhibition, beautiful ideas in science are defined as breakthroughs that shifted our understandings of the world and broadened our imagination. Evolution, gravity, the relationship between light and energy, the invention of vaccines – each of these ideas changed our concept of our world and ourselves. While beauty can be a slippery and subjective concept, we believe that science – asking questions about the world and discovering answers through observation and the gathering of evidence – has contributed to our collective knowledge in profound and beautiful ways. *Beautiful Science* invites visitors to examine trajectories in the history of scientific thought, to remember how many people have contributed to our current understandings, and to imagine what we have yet to learn.

Choosing a big idea helped to frame choices about what to include and what to say about each work, and each group of works within a content area. The focus on beauty and changing understandings allowed us to choose particular narratives from the vast possibilities present in the field of science history. Equally important, it freed us from feeling that we needed to be comprehensive in the telling of the history of science – an impossible goal in any case. The provocative notion of linking beauty and science was appealing to us; we also hoped that visitors would be intrigued by this pairing.

The subtitle, *Ideas that Changed the World* is also a compact: it is a promise that we will share and interpret these ideas with the visitors when they enter the exhibition.

Front-end research

Located in southern California, the Huntington is surrounded by resources relevant to the history of science. The California Institute of Technology (Caltech), where Einstein famously visited, is just down the street. The Mount Wilson Observatory is nearby, and the Observatory's papers and collections now form part of the Huntington's holdings. NASA's Jet Propulsion Laboratory (JPL) is also located nearby. Drawing on these resources, we solicited ideas from scientists and researchers as part of our front-end research. Seeking to bridge the excitement scientists feel about the content of the exhibition with the interests of a general public, we asked a group of local scientists about the beauty of science. It was crucial for us to think broadly about what makes science compelling, both today and throughout history. The responses we received were intriguing, and represent experiences from people working in scientific fields:

"[Science] allows a person to travel in time and space, to visit the small and the large... You can visit the world of an ant colony, or the world inside a computer chip, or the land of the stars. You can visit dinosaurs 70 million years ago or a billion years hence when the sun will die. You can see what is going on inside a star where the elements are forged. You can see inside the microscopic workings of the cells in your body."

(Paul Rothemund, Senior Research Fellow, Computation and Neural Systems Department, California Institute of Technology)

"There are only a few basic laws and fundamental particles. It's taken us a long time to discover them, and we still don't know how all this complexity came about, which means there's plenty more to discover." (Shanti Rao, Engineer, Jet Propulsion Laboratory)

These front-end interviews led us to think about a number of dimensions of science: the scale of its subjects, from microscopic to telescopic; the complexity of some ideas and the (seemingly) simple elegance of others; and, the wonder that is a common thread for all people who have sought answers to questions about their world. Combining these perspectives from the scientific field with data from our literature review on public attitudes and knowledge about science, we set out to infuse the exhibition with a scientist's passion and a generalist's curiosity.

Exhibit criteria

Throughout our exhibition development process, it was crucial to work back and forth between generating ideas internally, and testing them with visitors and peers. Acknowledging a widespread sense of intimidation many nonscientists feel about science topics, it was clear that the messages of the exhibition needed to be engaging and accessible. One strategy in vetting exhibit ideas was to establish a set of criteria to focus the objectives within each gallery. For example, one of

the criteria related to visitor experience was: *Exhibits will help to visually communicate scientific understandings in clear, direct ways*. A series of questions helped the development team to brainstorm and assess the best ways to bring a particular understanding to life:

- Is most of the information presented concrete instead of abstract?
- Are there illustrations or diagrams in the featured work that communicate this understanding?
- Can this particular concept be represented through objects, models, or interactive experiences? If not, how will it be displayed?

Using this set of parameters helped us to develop cohesive groups of works, related illustrations, and relevant interactives. For example, in the telescope section of the astronomy gallery, one of the featured works is Galileo's *Sidereus nuncius* (The Starry Messenger), a rare first edition of his 1610 book announcing the telescope. When Galileo turned the first telescope to the sky, he drew what he saw, a moon covered in mountains and craters, and through the printing of his drawings and observations, helped to overturn a classical model of the universe that had been based on perfect, smooth spheres. In deciding how to communicate the importance of *Sidereus nuncius* in the story of the telescope, we choose to install a replica of his telescope alongside the book that is open to show Galileo's own drawings of the moon. Visitors can look through this hand-made replica, aimed at an accurately-

scaled model of the moon, and can gain appreciation for the detail Galileo could see when he pointed his scope to the sky – and in the process, see something startlingly similar to what he himself saw.

Formative evaluation

After generating a number of plans and ideas for specific exhibits, we prototyped extensive sections of the exhibition. A group of advisors, including experts in the history of science, design, and informal education, joined us for an intense, three-day prototyping session. Each advisor was invited based on their expertise, their critical eye, and their insights into creating exhibitions for a general audience. Additionally, we invited members of our target audience to view collections materials, graphics, instruments, labels, and interactive prototypes and provide feedback. With both groups, information was collected systematically. We developed a series of questions and asked each reviewer to answer them in writing, repeating the set of questions for each of the content galleries:

1. What do you think the exhibits in this section are about?
2. What suggestions do you have for making them more user-friendly?
3. What improvements would you suggest in relation to content, materials, and/or communication strategies?
4. What edits or additions would you make to this area?

5. How do the exhibits in this section communicate as a group?

6. How does this section connect with your ideas about the exhibition as a whole?

7. How does this section connect to your ideas about the history of science?

Answers to these questions provided a strong critique of the exhibition prototypes from a number of perspectives. Crucially, our advisory team helped us to focus our big idea, and to reinforce it in the labels, wall texts, and graphics. They also made invaluable suggestions about orientation, emphasizing the importance of setting up a clear entry area and message in a foyer space, before visitors enter the astronomy gallery. Some content suggestions were very specific: "Move Galileo work [on the speed of light]." "Descartes label confusing." While others were overarching: "Let go of the rigid timeline in the light section and use groupings instead."

Members from our target audience were also crucial in testing many of the interactive components at this phase. By integrating the interactives with the books, we sought to directly link these experiences with the collections. In these prototyping sessions, we learned that some of our goals were being achieved: "I like the proximity of the experiments to the books." While other interactives were less successful: "I couldn't make out an image in the pinhole camera." Through testing each component we were able to identify areas of weakness

and receive suggestions on clarifying the relationship between interactive elements and the library works.

In summary, these prototyping sessions led to a honing of our main idea and to a tightening of relationships between objects, text, and interactives. The advisory group offered many suggestions for presenting a sequence of ideas in ways that did not emphasize a linear progression of ideas, but rather a series of discoveries astounding in their time. Our public visitors often echoed comments made by the advisory team, with many people encouraging a tightening of our message and more consistent information in labels, while also expressing their strong engagement with the exhibition objects and interactives.

Exhibition walk-through

One hundred books and manuscripts make up the heart of *Beautiful Science.*" These objects range from Isaac Newton's own annotated copy of his *Principia mathematica* to letters by Louis Pasteur and Nikola Tesla. Nearly 140 illustrations from the library collections are reproduced on the walls, each image part of a story in the history of science. Thirty-two interactive experiences are integrated throughout the exhibition, including audio stations, scientific tools, re-created experiments, digital books, and video animations.

Upon entering each gallery, visitors see beautifully lit books and manuscripts arranged in sinuous rows and punctuated with interactives. Objects such as telescopes in the astronomy gallery, microscopes in the natural history

gallery, and a camera obscura in the light gallery enliven the visitors' experience. Wall colors and illustrations energize each gallery with an unexpected richness. Text on the walls is large, clear, and succinct. Titles announce sections in language that immediately communicates each storyline. Visitors also quickly realize that there are timelines built into each sub-section of the exhibition, providing them with a predictable organizational structure.

Astronomy: The astronomy gallery has deep blue-black walls and illuminated images from the celestial zodiac in the coved ceiling. It feels like night. A hand-painted mural of the night sky, aglow with the Milky Way, announces the "naked eye" section. A large drawing of a telescope, taken from Isaac Newton's *Account of a new kind of telescope* is above Newton's seminal work of the same name. Wrapping the other walls of the gallery are a series of books and images communicating different stages in our understanding of our place in the universe. Highlights in the astronomy gallery include a censored copy of Nicolas Copernicus' *De revolutionibus*, his revolutionary book placing the Sun in the center of the solar system, and a letter of Einstein's in which he sketched light bending around the Sun.

Natural history: Turning the corner into the natural history gallery, visitors encounter deep orange walls covered in extraordinary images of plants and animals. This room is alive. Inspired by early curiosity cabinets, the "observation" section is a chronology in images, from the first known manuscript drawing of a pineapple to richly colored works

of Maria Sybilla Merian and John James Audubon. Half of the natural history room is devoted to evolution, arguably one of the most powerful ideas to emerge out of scientific thinking. Underscoring this importance, we chose to display more than 250 copies of Darwin's *On the Origin of Species*. Beginning with his first edition (1859) and moving chronologically through different editions and translations, the display of these books is a statement on the power of the printed word, and the persistence of a beautiful idea.

Medicine: The medicine gallery, in a deeply rich red to suggest the blood of life, features large and dramatic wall illustrations, setting off sections on structure, healing, and childbirth. The works featured include some of the highlights in humanity's quest to better understand and heal the body. William Harvey's book describing blood circulation is small and seemingly innocuous, but its impact was astounding. Before Harvey's experiments and discoveries, the role of the heart and lungs in circulation was a mystery. Large, illustrated works of anatomy trace a trajectory of increasingly accurate understandings of the human body. The color and drama of the books in this section resonate with the gallery walls and graphics, enclosing visitors in a space both intense and intriguing.

Light: The light gallery uses light itself as an exhibition element. Exhibit titles are projected onto white walls. A fiber optic sculpture hangs from the ceiling, filling the room with a glowing energy that emanates from delicate filaments. A display of antique light bulbs shines eerily within a nitrogen-

312 · BEAUTIFUL SCIENCE: IDEAS THAT CHANGED THE WORLD

filled case. A series of intriguing interactives is sprinkled between the books on display. A camera obscura is set up with views into the adjacent reading room. It sits between written works by Ibn al-Haytham and Johannes Kepler, two scientists who used the camera obscura in their quests to understand vision. Alongside Isaac Newton's own copy of his *Opticks*, is an interactive re-creating one of Newton's most famous experiments. Visitors rotate a prism, intercepting a path of white light. By shifting the prism in and out of its path, they can see the spectrum of the rainbow – light split into its constituent parts – and then recombine the light beam back into white light.

Reading room: The final room of *Beautiful Science* is the reading room. In this sun-filled room, comfortable chairs welcome visitors to sit and reflect. Bookshelves hold reference copies of the exhibition books, making them physically accessible to visitors. Two computer touch-screen stations have interactive timelines as well as video interviews with contemporary scientists and historians. The timelines are grouped by exhibit content areas, and feature information on many of the big ideas, people, and tools related to scientific thought from classical times to the present. Visitors can chose from nine videos of prominent scholars and practitioners discussing the beauty and history of science.

Interpretation

Entry points into content: In order to provide welcoming entry experiences into the content of the exhibition, compelling

and accessible storylines were chosen. Content that could easily have slipped into the inaccessibly cerebral (think of the laws of electrodynamics, the theory of relativity, biological classification systems) was framed instead in terms nonscientists would understand: light, energy, observation. Richly colored and illustrated rooms help to communicate the main theme of each space, with bold and clear titles to welcome visitors to each section. Intriguing tools, objects, and discovery drawers invite exploration. The label text and interactive experiences draw people's attention to what they can actually see in the featured works.

Organizational strategy: In countless exhibitions it is difficult to identify the big idea, or to understand how the exhibition is organized. By using large font sizes and headings that are informative and concise, visitors can quickly assess their options, and get a sense of the big ideas that the exhibition is presenting. While some visitors prefer sequential experiences and others are more free-form, "exhibitions that have a clear sequence or linear structure and also offer the option to skip around will satisfy the people who want a plan without annoying those who don't." (Serrell, 1996) Each sub-section of *Beautiful Science* is in a chronological order. Wall graphics reinforce this – sometimes with dates, other times through text and illustration that show ideas changing over time ("species are stable and unchanging" to "species change over time" in the evolution section, for example). Organizing the featured exhibition books, interactives, and the wall graphics in these chronologies allows a methodical viewer

to progress in a linear fashion, while giving a non-sequential viewer the tools (visual, auditory, tactile) to quickly gauge context as they move from one object to another.

A predictable hierarchy of information in an exhibition is crucial for visitor orientation and engagement. On the walls of each gallery, visitors see two levels of information: the overall title and description for the gallery, and titles and short descriptions for the sub-sections of the room. For example, in the natural history gallery, the title (*natural history*) is large, and easily seen from the entry door. Smaller titles announce the two sub-sections: *evolution*, and *observation*, and mark the start of each sequence. Wall graphics and illustrations reinforce each theme, so that visitors can quickly get the main ideas of each gallery.

"I think what intrigued me the most was the atmosphere created by the wall graphics... they engaged my curiosity and made me want to explore more deeply." (peer reviewer)

Integration of interactives: Throughout the exhibition, interactive experiences are designed to reinforce the ideas contained in the books. The interactives are not huge or dominating; the intent was not to upstage the books but rather help to bring the books to life. Each interactive experience is integrated in a particular relationship to the books adjacent to it, and each is designed to appeal to adults as well as children. In *Beautiful Science* we take the stance that adults want to be fully engaged while learning, and can gain a great deal from well-designed interactives.

Many of the exhibition interactives offer visitors direct

experiences with devices employed by early scientists. For example, in the natural history section one of the featured books is by Antoni van Leeuwenhoek, who made remarkable observations using a tiny, hand-held microscope. A replica of Leeuwenhoek's microscope sets next to his book, and visitors can pick it up to see the tiny hairs on an insect's wing. An adjacent audio station features an actor reading Leeuwenhoek's lively description of bacteria from his own mouth that he observed using one of his microscopes, delightfully referring to the bacteria as "little living animalcules, very prettily a-moving."

Touch-screen monitors featuring digitized pages are placed alongside their source books, allowing visitors to "leaf" through extraordinarily illustrated works such as Mark Catesby's *Natural history of Carolina*, and Bernard Albinus' *Tables of the skeletal and muscular structure of the human body*. The monitors we chose are deliberately smaller than the large illustrated works – they are quiet additions to the exhibition, offering visitors the chance to view multiple pages and magnified details of illustrations – not simply deployments of technology for its own sake.

Instruments and experiments are built into casework in ways that explicitly link the chronology and discoveries of scientists. In the Natural History section of the exhibition, nearly 100 images from five centuries cover two walls, detailing a rich span of scientific curiosity and observation. This timeline of images is echoed in the chronology of written works in cases that wrap these walls. Punctuating the cases

316 · BEAUTIFUL SCIENCE: IDEAS THAT CHANGED THE WORLD

COMMUNICATION AND EVALUATION

are some of the tools scientists used in their observations, including a beautiful, hand-made replica of one of the earliest microscopes. This microscope, similar to the one Robert Hooke used when compiling his *Micrographia*, the first printed work to include detailed drawings made using magnification, sets right next to our 1st edition copy of Hooke's famous seventeenth-century volume. *Micrographia* is open to the large, fold-out illustration of a flea. Visitors can gain a sense of the awe Hooke must have felt when he looked through a microscope to view a flea, with all of its hairs and body segments, visible under magnification. Each interactive experience in the exhibition was carefully considered and designed to contribute directly to visitor's understanding of the content contained in the books and manuscripts.

> *"The integration – and the variety – of the interpretive and educational activities was superb. First in the level of integration–rather than segregating educational activities into one or two sections of the show, you couldn't go two cases without having another interactive element. Secondly, the variety was great; the mix of hands-on pieces, replicas, and media interactives was extremely well done." (peer reviewer)*

Range of experiences: As visitors come to exhibits with a range of interests and constraints (some may have an hour, others five minutes; some may like to read, others to listen to audio), it is very helpful to design for a wide variety of experiences. The exhibition components in *Beautiful Science* were designed to be accessible for these kinds of temporal and sensory

KARINA WHITE · 317

ranges. Time commitments can range from brief encounters looking through a camera obscura, to the study of multiple pages of a digitized book. Visitors can pore over the hand-written manuscripts on display, or sit with a reference copy of a book in the reading room. In the medicine gallery, glass jars containing medicinal herbs can be opened and smelled. A tactile experience with a book from the 18th century awaits curious visitors who yearn to touch and smell the mustiness of an honest-to-goodness rare book. Throughout the exhibition, visitors can lift a headset to hear the words of the scientists themselves, relating their excitement at a new discovery. Visitors drawn to art can spend time with the beautifully illustrated anatomical atlases in the structure section of the medicine room, or delight in moving a magnifier over the detailed watercolors of a 19th century natural history work.

Design

Not lost on us is the expectation that an exhibition entitled *Beautiful Science* should be beautiful itself. Exhibitions are highly visual. They are experienced briefly – audience members will likely not spend more than an hour in an exhibition, and often spend less than a few minutes looking at any one exhibit (McLean, 1993). As exhibition practitioners, we believe that it is our job to inspire visitors: to pique their curiosity and to reward their efforts. These goals translated into a design emphasizing clarity to address the intellectual content, and lushness to address the affective desires of visitors.

"The design was stunning. Walking into that first room, all you do is stop, stare, and wish your apartment looked like that, or that you could live in the show." (peer reviewer)

Throughout the exhibition, the design establishes clear relationships between the books and the wall graphics that relate to them. Responding to the challenge of exhibiting books – showing only one page opening is necessary, but renders the books utterly unbook-like in the viewer's experience – we brainstormed a number of ways to bring the ideas of the books to life. Groups of illustrations trace trajectories of discovery represented in the written works. For example, in the *location* section of the astronomy gallery, a sequence of illustrations depicting an Earth-centered universe is positioned directly above works by astronomers whose observations supported an Earth-centered view. Above the next group of works, including those by Copernicus, Kepler, Galileo, and Newton, are a series of illustrations reflecting a Sun-centered view. Each set of images is labelled with a title emphasizing the major idea (*Earth is the center of the universe; Sun is the center of the universe*) and a concise description. Continuing along in the location sequence, visitors see works and images related to early concepts of our galaxy, then to multiple galaxies and an expanding universe. A subtly hand-painted star field forms a background to these series of images and suggests a trajectory of ideas that continues today.

Relationships between the wall text and images track the content in each section in a variety of formats to help prevent the fatigue that can accompany too much repetition. The text

is large, clear, and focused. Titles of each gallery and each section are designed to communicate quickly and directly–providing for many "I got it" moments, and setting people up to feel both comfortable and intrigued. Label and wall texts were written and continuously edited for clarity and brevity. The texts are succinct, and speak to what visitors can see. Moving away from an academically oriented writing style, the labels suggest a new model for library exhibitions – one that welcomes and rewards a curious general public.

"The very precise and limited use of text kept the messages focused and helped keep my attention on the exhibit." (peer reviewer) "It may be the first show in literally years where I really did read all the wall text, and moreover, the wall text was useful; it explained things well, and concisely, and completely." (peer reviewer)

Seeking to build exhibit furniture that would provide visitors with intimate experiences with the rare books and manuscripts, we designed custom casework featuring wells cut into the case decks. Custom-built acrylic cradles are set inside the wells, supporting the books and minimizing the profiles of the cases. Curving fiber optic lights within the vitrines are focused onto each book, creating an ideal viewing environment, with very little glare and few shadows. Object labels are placed within the vitrines at the head of the books. This positioning emphasizes the book as the main object of focus, and reduces that back-and-forth reading that is so common in exhibition casework and distracts focus from the real artifacts.

Furniture in each room is painted to match the walls of its section, and the cases are attached to the walls, leaving room for wheelchair accessibility as well as creating a look that is light in feel. Built-in touch-screens, interactives, and cabinet drawers are worked in throughout each gallery, providing a range of visual and experiential options to visitors.

Results

Shortly after opening, the Los Angeles chapter of *Excellent Judges (EJ)*, an exhibition professionals' critique group, was invited to review *Beautiful Science*. This group includes museum practitioners from art museums, natural history museums, and science centers, as well as independent exhibition designers and educators. The EJ group uses the Framework evaluation form developed by a team of museum professional supported by the National Science Foundation to "assess excellence in exhibitions from a visitor-centered perspective." The Framework criteria are: comfort, engagement, reinforcement, and meaning. Using a ranking system, *Beautiful Science* received *very good* to *excellent* scores in all four categories, a tough benchmark to achieve. Comments from the group reinforced the value of attempting to make science accessible to nonscientists: "It actually got me to want to go explore more science exhibits which I'm usually automatically turned off by, I guess when presented in such a poetic way it appealed to my sensibility." (EJ reviewer)

"Really, the exhibit is one of the best I've seen recently, and I'll admit to you that I plan to shamelessly steal inspiration

and ideas from it for all our upcoming shows." (EJ reviewer)

Additionally, in our summative evaluation process, we worked with evaluator Beverly Serrell to gather input from our target audience in order to assess cognitive and affective impacts of the exhibition. Tracking and timing studies and cued questionnaires were used with adult visitors to *Beautiful Science*. In the tracking and timing study, we looked to measure a number of indicators that provide data on visitor engagement: the amount of time spent in the exhibition, visitor behavior in the exhibition, and the percentage of elements viewed. The cued questionnaires helped us to gauge whether visitors understood the main messages, and what kinds of affective responses they had to the content and design. These summative studies helped us to identify changes that could improve the visitor experience, such as making the reading room more cozy and inviting, and adjusting our audio labels to add information on track lengths. We were also heartened to find that almost all visitors interviewed understood and were inspired by the main messages of the exhibition. All responses below are quotes from adult visitors:

[The main purpose of the displays in these galleries is to make people...] "...enjoy the wonder and beauty of the discovery of working knowledge of the earth, the skies, and humanity"; "...understand the significance of previous discoveries upon which our current science builds"

[I didn't know, or I never realized...] "...the significance of books in promoting scientists to search with better focus";

"...the history of astronomy and the arguments of the Earth-centered vs. Sun-centered solar system"; "...so many of these ideas have changed the world".

[It reminded me...] "...the value of interactive displays, especially for children and lay people"; "...that the magnitude of space/universe still overwhelms the imagination".

[Anything else?] "Beautiful exhibit. A great motivator to participate in science as opposed to just being exposed to it." "This exhibit is truly beautiful, and better still, engaging to my young ones – thank you."

Conclusion

Science exhibitions created for an adult audience are a rare species. Yet it is increasingly important that the general public have access to scientific content that can inform important daily decisions, as well as wider societal policies. The history of science is also extremely important to insert into our collective dialogues: our current scientific understandings rest on thousands of years of critical thought, observation, and synthesis. Informal institutions such as museums, science centers, and libraries can play an important role in engaging visitors with science concepts, history, and phenomena. Authentic objects and interactive experiences cannot be provided through nature magazines or the *Discovery Channel*. Well-designed exhibitions offer unique opportunities to share ideas in visually compelling and memorable ways.

References

American Association for the Advancement of Science (2008). *Benchmarks for Science Literacy.*

Celis, William (1994). Many Americans Flunk Pop Science Quiz. *The New York Times*, April 21, 1994.

Cyane, Valerie, Heather J. Nicholson, Milton Chen, and Stephen Bitgood (1994). *Informal Science Learning: What research says about television, science museums, and community-based projects*, Dedham, MA: Research Communications, Ltd.

George, Rani (2000). Measuring Change in Students' Attitudes toward Science Over Time: An Application of Latent Variable Growth Modeling. *Journal of Science Education and Technology*, 9(3): 213- 225.

Hein, George E. and Mary Alexander (1998). *Museums: Places of Learning*. American Association of Museums Education Committee.

Kirchhoff, Allison (2008). Weaving in the Story of Science: Incorporating the nature of science into the classroom through stories about scientists, discoveries, and events. *The Science Teacher:* 33-37.

McLean, Kathleen (1993). *Planning for People in Museum Exhibitions*. Association of Science-Technology Centers.

National Research Council (1996). *National Science Education Standards*. Washington, D.C.: National Academy Press.

National Science Board (2008). *Science and Technology: Public Attitudes and Understanding* (Science and Engineering Indicators: 7.1-7.43).

Nelson, George D (1999). Science Literacy for All in the 21st

Century. *Educational Leadership* 51(2): 14-17.

Pew Research Center for The People and The Press (2009). *Scientific Achievements Less Prominent Than a Decade Ago: Public Praises Science; Scientists Fault Public, Media.*

Reeves. Carolyn, Debby Chessin, and Martha Chambless (2007). Nurturing the Nature of Science: Integrating the nature of science into the existing curriculum. *The Science Teacher*: 31-35.

Rutherford, F. James and Andrew Ahlgren (1990). *Science for all Americans.* New York: Oxford University Press.

Serrell, Beverly (2006). *Judging Exhibitions: Assessing Excellence in Exhibitions from a Visitor-Centered Perspective.* Walnut Creek: Left Coast Press.

Serrell, Beverly (1996). *Exhibit Labels.* Walnut Creek, CA: Altamira Press.

Solomon, Joan, Jonathan Duveen, and Linda Scot (1992). Teaching About the Nature of Science through History: Action Research in the Classroom. *Journal of Research in Science Teaching*, Vol. 29, No. 4, pp. 409-421.

ABOVE: The medicine section is announced by its deep red color, dramatic wall illustrations, and clear title graphics.

BELOW: Visitors peer through a hand-made replica of Galileo's first telescope from 1609.

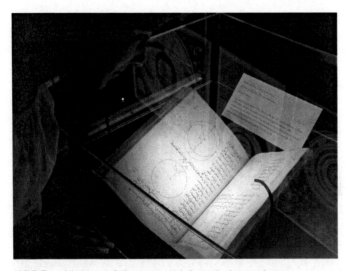

ABOVE: The exhibition case design encourages intimate viewing experiences.

BELOW: In the astronomy gallery, visitors are immersed in a dark room, full of glowing books, images, and clearly organized sections.

ABOVE: Alongside Robert Hooke's *Micrographia* (1665), one of the earliest printed books to document the microscope, is a beautifully crafted replica microscope of the era.

BELOW: In the light gallery, titles on the walls are projected in light, featured books glow in their cases, and a fiber optic light sculpture fills the room with energy.

From Setting to Subject: Plants are up to Something

KITTY CONNOLLY

The Huntington Library,

Art Collections and Botanical Gardens

San Marino, USA

Plants are up to Something motivates visitors of all ages to learn about spectacular plants from around the world. Conceived as a synthesis of a traditional conservatory and an interactive science center, this permanent exhibition is housed in a 16,000 square-foot steel and glass greenhouse. Its goal is to engage visitors in the process of science using weird and wonderful plants. With plants as the focus, not the background, this exhibition breaks new ground in botanical science exhibitions.

Institutional setting

The Huntington Library, Art Collections, and Botanical Gardens, in San Marino, California, is a collections-based research and educational institution established in 1919 by Henry and Arabella Huntington. Henry Huntington, a key figure in the development of Southern California in the early 20th century, was an active collector of rare books, manuscripts, artworks, and plants. By the time he founded the institution, he and his wife had amassed an extensive collection focusing on British and American history, literature, and art, as well as rare and fabulous plant specimens. Today, the Huntington has approximately 350 employees, 1,100 volunteers, and welcomes more than 550,000 visitors each year.

Permanent exhibitions include all three collection areas. The library exhibits outstanding rare books and manuscripts on American and British history, literature, art, and the history of science, medicine, and technology. Art exhibitions

The Victorian-era profile of the Rose Hills Foundation Conservatory for Botanical Science contrasts with its modern approach to informal science education. [Courtesy of The Huntington Botanical Gardens.]

include British and American art of the 17th to 20th centuries. The institution averages nine temporary exhibitions each year, ranging from 130 square-foot highlights from our permanent collections to 5,000 square-foot shows. But for decades, interpretation of the 120-acre gardens remained rudimentary. *Plants are up to Something* changed that by elevating the gardens from being chiefly a beautiful setting to a subject worthy of exhibition.

Exhibition overview

Opened in 2005, *Plants are up to Something* is divided into four galleries, each with a distinctive climate that supports a combination of existing collections and new acquisitions. Three of the galleries represent habitats: lowland tropical rain

forest, montane cloud forest, and temperate bog. Sixty-six exhibits, including 50 interactive stations, are integrated with approximately 1,600 plants. The collections are pantropical in the rain and cloud forests. The bog plants are from the Southeast United States. The collections in the fourth gallery, the *Plant Lab*, do not represent ecological assemblages, but rather are organized into thematic groups based on the parts of a plant. The climate in this wing is colder and drier than the habitat galleries, allowing for a higher density of exhibit equipment, including microscopes, videoscopes, and scientific meters.

Challenges

Setting out to create a botanical exhibition within a working greenhouse poses some obvious challenges. How would exhibits hold up under extreme humidity, harsh sunlight, and high temperatures? Would visitors be interested in expanding their appreciation of the beauty of plants to include a more scientific approach? What aspects of botanical life would be covered? Would encouraging visitors to interact with living plants endanger our collections? Major problems turned out to be, in reality, opportunities to forge new models.

Environment: Plants are up to Something is housed within a working greenhouse, so environmental conditions were a major concern during exhibition development. The climate in the conservatory is unforgiving: humidity ranges between 35% and 95%, temperatures from 50° at night to 95° during hot days, light is 50% of full sun, and everything is regularly

Summer afternoons in the lowland tropical *Rain Forest* Gallery are very hot and humid. Conditions are just right for plant growth, and equally challenging for exhibitry. [Courtesy of The Huntington Botanical Gardens.]

Tropical conditions were not a metaphor on this project. In addition to the overhead misting, exhibits are sometimes watered by stray hoses. [Courtesy of The Huntington Botanical Gardens.]

drenched with water. Stepping through the front doors into the central *Rain Forest* gallery, visitors are enveloped in thick, humid air. The distinct contrast from the usually arid

outdoors of Southern California is striking. Passing through the doors to the *Cloud Forest*, the air becomes cooler and mistier but beyond that the *Bog* gallery is warmer and drier. The drier, cooler air of the *Plant Lab* contrasts with the neighboring *Rain Forest*. One advantage of these discrete climatic zones is that visitors reported using humidity changes as a principle way-finding clue. Each gallery has a distinct feel.

All of the signage, furniture, and equipment had to withstand these trying conditions. Armoring the exhibits to withstand the environment took a great deal of planning, materials research, and specialized fabrication. Stainless steel and acrylic solved most of the rust issues while microscopes and video monitors turned out to be surprisingly robust. Compound and dissecting microscopes were encased in acrylic boxes which protected them from the elements while allowing access to fine focus knobs. Videoscopes are delicate, so armoring their stress points and shielding them from hoses was critical. We tried a wide assortment of hand tools before identifying a suite robust enough for everyday use. Labels made from UV- and water-resistant poly banner or vinyl hold up for six months or more before requiring replacement. And lamination has been a great help.

Setting versus subject: Once we made a commitment to creating an exhibition inside a botanical conservatory, the issue of our subject remained. Plants are not generally seen as very engaging objects for science exhibitions, even within gardens. Conservatories worldwide promote visiting works of art more than their own permanent collections. Beyond the world of

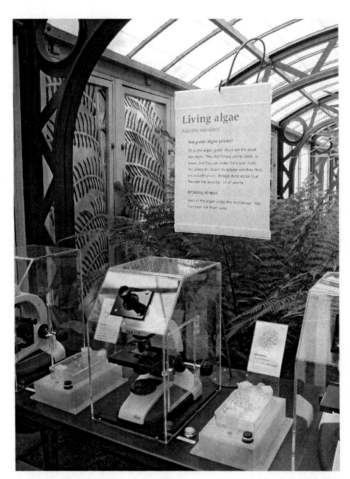

Acrylic cases protect the microscopes but allow visitors to view the working microscopes and adjust the focus. This exhibit shows three different types of algae. Slides are refreshed daily. [Courtesy of The Huntington Botanical Gardens.]

public gardens, people know very little about plants and commonly cease to notice them in daily life, despite their vital importance in the biosphere. "Plant blindness" is a

term coined by biological educators Wandersee and Schussler (1999, 2001) to describe this inability to appreciate the unique biological features of plants. Lacking hands-on experience in growing, observing, and identifying plants, people have few opportunities to become aware of basic plant science. *Plants are up to Something* was conceived as an inoculant against plant blindness and a commitment to bringing botany back into the garden.

While informal learning institutions, such as museums and science centers, play an increasingly important role in addressing science literacy (National Research Council 2009), most institutions either use plants as a backdrop for animals or omit them altogether. Institutions that do feature plants often lack adequate growing facilities so must rely on models and large-scale replicas to demonstrate biological concepts. Some botanical gardens are making serious efforts in this area, but they rarely integrate science activities with the living collections. There were few places to seek inspiration. Even the Huntington, a place of surpassing botanical beauty, previously devoted few resources to raising awareness of the complex world of plants. Although at least 70% of Huntington visitors come in order to visit the gardens, interpretation of the living collections was quite limited. Plant identification tags and the occasional descriptive sign were visitors' only access to information.

A few years ago, Huntington leadership decided to take a critical look at its botanical programs. As an estate garden, the Huntington had a strong tradition of display and horticulture,

with education playing a lesser role. Only two school programs used the gardens and no garden-related classes or exhibits were provided for the public. The institution came to realize that it was not taking full interpretive advantage of its collections. As a consequence of this realization, the Huntington launched an initiative which refocused the garden programs on education and generated serious consideration of our audiences. Until 2005, every one of the Huntington's permanent and temporary exhibitions was interpreted for adults, with ancillary family guides produced for some shows. *Plants are up to Something* was the institution's first exhibition designed for a family audience, and the first with permanent interactive elements. In addition, the project was also the first to receive support from the National Science Foundation.

Focusing the Topic: Once the decision was made to create an exhibition on plants, the question naturally arose, *What, exactly, about plants?* At the outset, the idea was to cover botanical processes comprehensively, in part to compensate for the lack of precedent found in other institutions and in part because each aspect of botany was viewed as crucial. Initial exhibit subjects included growth, development, nutrition, and reproduction. Photosynthesis, respiration, and transpiration were included, as were ecological functions and the evolution of plants. The exhibition was to be a veritable textbook of plant biology.

Narrowing the subject took a number of years, frank discussions with advisors and audience members, and many difficult decisions. We considered subject after subject.

SCIENCE EXHIBITIONS

What is life? was too esoteric. Understanding *The vital work of botanical gardens* was really not all that vital to visitors, although certainly important to staff. *Plants bring things to life* was too easily misconstrued to have a spiritual and not scientific context. Analogies with animals, such as *Plants breath just like you do* were proposed as a way to make plants more comprehensible and interesting to children, but we rejected it as fundamentally misleading. In critical ways, plants are unlike animals.

We needed to narrow the topic and decided to write a big idea. The big idea is a concept popularized in the influential book *Exhibit Labels: An Interpretive Approach* (Serrell 1996). The big idea is a clear, one-sentence statement of what an exhibition is about and why people should care. Without a strong big idea, every topic could potentially fit into the exhibition. With a big idea, the exhibition has focus and limits. *Everything about plants is important* may be true, but that approach would have left most of our visitors dismayed by overwhelming detail or baffled by the inclusion of seemingly random information that didn't add up to a meaningful whole. The big idea helped us to hone down the topic and so to reach visitors with limited interest and capacity to understand botany, those who are not subject-matter experts. Subject matter experts would understand the material anyway.

In the end, the filter which we clarified the subject was limiting exhibits to those involving visitors in direct observation using their scientific skills. The big idea we ultimately settled on was, *Use your scientific skills of observation,*

By approaching exhibit ideas with an eye to what visitors could do, we eliminated topics that were untranslatable to the exhibition floor and invited all visitors to engage directly with our subject: fantastic plants. [Courtesy of The Huntington Botanical Gardens.]

comparison, measurement, and analysis to understand the amazing things that plants do. This big idea served its purpose: it limited the exhibit to what visitors could do with plants, not what they could know about plants.

Scale - time and space: Perhaps one of the reasons exhibitions rarely feature live plants is the issue of scale. Structures of prime botanical interest tend to be either microscopic like chloroplasts, cell walls, and xylem tubes, or too large to be contained within a standard exhibit hall, such as entire ecosystems. Botanical processes likewise tend to be either too quick to readily perceive, like the explosive release of fern spores, or so slow as to be unobservable during one museum visit, like the rotational movement of a tendril as it reaches for support.

To translate plant processes and structures into perceptible scales many designers use representations, which certainly can have their place in botanical exhibitions. Models can make the transfer of pollen hard to miss even for young audiences when the "pollen" is the size of a grapefruit. Drawings and photographs can direct visitors' attention to key structures. Ecosystems can be represented in a diorama or computer animation more easily than they can be enclosed in an exhibit hall, but something essential is lost in this process of abstraction. Plants have qualities that cannot be reproduced and living collections exist to showcase these very qualities. Although certain scientific concepts can be learned more easily with the use of models and diagrams, perhaps these are the concepts that are best left to institutions that do not have

Videoscopes linked to monitors help people to discover and share the nuanced differences in leaf textures. Photo murals on the widows reinforce the message. [Courtesy of The Huntington Botanical Gardens.]

living collections. Using plants to their fullest interpretive potential was one goal of *Plants are up to Something.*

Magnification was one key technique we used for bringing plants to scale. We included hand lenses, compound and dissecting microscopes, and videoscopes with exhibits so visitors could examine living and preserved specimens. At each scope we placed photographs or drawings of what visitors could expect to see under magnification and whenever possible linked the scope to a monitor so visitors could share the view. For example, in an exhibit about the structure of xylem, we chose to show a translucent slice of wood under a dissecting scope rather than to create an expensive and

abstract model showing the flow of water through trees. Instead, visitor can see the actual holes in the wood where xylem cells conduct water and examine an adjacent section of a tree trunk.

We addressed time scale through enhancing some exhibits with time-lapse video. In addition to showing botanical processes at discernable speeds, videos made the concepts accessible for visually-oriented visitors. We licensed footage from the BBC's *Private Life of Plants* series to create short clips of plants in action. The footage includes the development of roots pushing through the soil, a field of dandelion seeds dispersing on the wind, and a flower maturing its male anthers one at a time followed by its female stigma opening. Shots of carnivores like a Venus flytrap capturing a beetle bring action to adjacent plants and illustrations. The scenes of leaves pulsing with sap as they unfurl and flowers following the sun are powerful reminders that plants are indeed up to something. Many of the videos are interspersed in the plantings (the monitors are waterproof and designed for bright light conditions), providing a surprising and rather beautiful mix of living plants and stunning photography.

Opportunities: While many of the challenges opened up new avenues of interpretation, certain project conditions were seen as clear opportunities from the start. Having a target audience of middle school children meant we could present fairly sophisticated material and design out of respect for their desire to be treated as adults. Visitors were already eager to visit: the arched dome and milky glass panels of the

conservatory generated interest as it was under construction. And since plants are physically rich subjects that beg for direct contact, we could approach the subject from a variety of cognitive and experiential angles.

Audience

The target audience for the exhibition is families with children between the ages of 9 and 13. By choosing this audience, we saw an opportunity to provide children with a positive experience with science and plants at a critical age. The age focus reflects both the United States National Science Education Standards (1996) emphasis in middle school on living systems and organisms, and the Science Content Standards for California Schools (1998) seventh grade focus on life sciences. Furthermore, research suggests that the middle school years are those during which a child makes the decision to either "like science" and take more science classes in school, or avoid it altogether (George 2000). Positive experiences with science-related activities such as those offered in the conservatory can build the confidence and skills a child needs to pursue an interest in science and conservation.

Choosing this target audience also opened up the opportunity to approach plants and science from an adult, rather than child-like, perspective. We found that students this age were eager to engage in grown-up activities. During formative evaluation, students tended to speak more enthusiastically and specifically about plants after using

The eagerness of students to measure the acidity of pitcher plant juice with a pH meter convinced us we were on the right track with our audience. [Courtesy of The Huntington Botanical Gardens.]

exhibit prototypes than they did before engaging with the activities (Randi Korn & Associates 2003). We found that children in particular appreciated being able to use real equipment, including microscopes, refractometers (used to measure the percentage of sugar in a liquid), acid and nutrient meters. This confirmed our commitment to integrating authentic materials into the exhibits, rather than models or replicas.

An approach that honored children's desire to be treated with respect for their capabilities led us to create exhibits that were also accessible to adults. We followed a strategy of designing small group, adult-oriented experiences that were cognitively accessible and aesthetically appealing to our target audience. Although adults knew the content and experience were designed for children, they felt very comfortable using

the exhibits. The level of the material was not off-putting to adults, perhaps because botany is not a subject they think about every day. Introductory or reinforcing material served as a reminder of how interesting plants can be: "It appealed both to the adults and the child... And everything's plain for the children... but it captivated me. I love to garden and there [were] a lot of things that you don't realize are going on right under your very nose." [51-year-old visitor]

Since more than 70% of visitors to public gardens are adults, interpretation that is effective with that audience is a valuable addition to gardens' informal educational portfolio. Many science intuitions discretely target adults and children; rather than creating separate interpretation for each audience segment, they could create interpretation that lets older children and adults both be adult.

Expectations

The conservatory setting created expectations of a different experience than in the gardens. While the gardens are generally viewed as places of beauty and sources of respite, the striking new conservatory (one visitor called it a "jewel box") promised something unusual, although perhaps not an unprecedented array of interactive exhibits. The Huntington is generally a hands-off place. It was important to let visitors know right away that this was going to be a more active experience. On the building's front doors, the title and main message of the exhibit greets visitors: *Plants are up to Something*. Through these doors, visitors enter directly into the *Rain Forest*, with

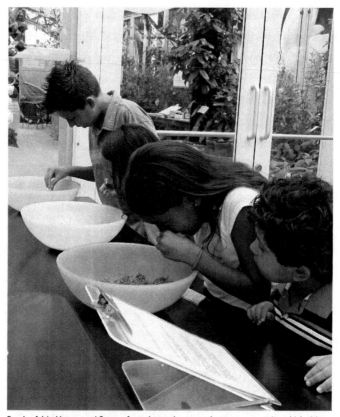

Bowls of dried leaves and flowers from the gardens provoke strong memories which visitors share with each other. [Courtesy of The Huntington Botanical Gardens.]

tall palms reaching into the rotunda dome and mist settling from above. Wanting to signal that this was an interactive space, we placed introductory experiences near the entrances. Kaleidoscopes and monitors featuring time-lapse videos introduce a different way of looking at plants. From the main overlook, visitors glimpse exhibits along with the transparent

acrylic wall of the cut-away pond. Many young visitors head right for the pond to see the lilies and fish within.

We wanted to fulfil visitors' expectations of beauty, as well. Conservatories tend to contain displays of lovely and exotic plants. Traditionally, their exhibits tend toward the aesthetic rather than emotional or didactic. We didn't want to confound those expectations. In the Huntington conservatory, the very first thing people encounter is an array of gorgeous hybrid orchids in bloom. It is a highly-prized spot for photography. The palms, vines, and hardwoods in the *Rain Forest* gallery are lush, diverse, and impressive. In the *Cloud Forest*, visitors are enveloped in mist and surrounded by tiny species orchids, spiky bromeliads, and strange carnivorous plants. The *Bog*, likewise, doesn't disappoint with its rich collection of carnivores: Venus flytraps, pitcher plants, and sundews. Even the more open *Plant Lab* is home to rampant flowering vines and plants with bizarrely shaped stems and leaves. The exotic and beautiful are there, but *Plants are up to Something* goes beyond that to engage visitors with the plants.

Entries

The exhibits were designed to be accessible at a variety of temporal, sensory, and cognitive levels. Time commitments can range from brief encounters with a kaleidoscope, to in-depth experiments that take up to five minutes. Those who prefer interactions with volunteers can participate in a facilitated flower dissection or trigger a Venus flytrap. *How sweet is it?* can involve visitors for three minutes or more in

measuring the sugar level in different flower nectars. There are exhibits to engage various senses, from plunging gloved hands into hot compost in *Layers of dead leaves* to smelling familiar seasonings in *Spices from the rainforest*. Hooking burs onto animal pelts makes seed dispersal prickly but concrete in *Seeds that travel with animals*.

Considerable thought went into the creation of different types of cognitive and emotional stimulation. Walk-by *Video plantings* and *Touch baskets of seeds* are two examples of exhibits that require no reading or instructions. *Leaf quilt* draws attention to often underappreciated variations in leaf shape without interjecting complex terminology into the experience. *Hundreds of greens* invites visitors to share their thoughts about plants. For those with an analytical bent, exhibits such as *Sphagnum soak* and *Roots and nutrients* offer the opportunity to measure and quantify experimental variables. The *Plant petting zoo* is located between more intellectually challenging exhibits on leaf stomata and fern spores. In this exhibit, different plants are positioned so that visitors can touch, smell, and compare them. This multi-sensory exhibit provides variety and a cognitive rest area for visitors as they move through the conservatory.

Even while the exhibition was designed to be visited in a non-linear fashion, thematic groupings were developed for each of the four conservatory galleries in order to help visitors build upon their everyday understanding of plants. In the *Plant Lab*, rather than focus on complex processes such as photosynthesis and pollination as organizers, we turned

Some of the exhibits emphasize the beauty of plants. This sorting exercise is also meant to be accessible to our youngest visitors. [Courtesy of The Huntington Botanical Gardens.]

to the parts of a plant. Knowing that virtually all visitors to the conservatory would understand that plants have different parts, we thought that exhibits on *flowers* or *leaves* would make an easy entry point for delving into what those flowers and leaves are doing.

In order to make the material approachable, we developed exhibit ideas based on things visitors could actually see or experience during their few moments at an exhibit. As one example, this approach led to the development of an exhibit on leaf stomata, *Leaves are full of holes*. When creating an exhibition on plant processes, museums feel compelled to include photosynthesis. In this exhibit, visitors view leaf pores as physical evidence of the gas exchange critical

to photosynthesis, rather than trying to communicate the more abstract aspects of this complex process. Science center exhibits on photosynthesis tend to either encase plants in sealed chambers or under water in order to control the measurement of gas produced. These exhibits do not bring visitors closer to plants but serve to make them more abstract and unapproachable. They can also take some time for results to be apparent. A leaf under a microscope and a plant on a table present immediate physical evidence of the botanical structures of photosynthesis, and they are beautiful as well.

Interpretative approach

Our interpretative strategy was informed by extensive formative evaluation. With few precedents, we needed to confirm that our approach to the subject was engaging and enlightening. Consequently, we spent two years on prototyping and evaluating with the help of Randi Korn & Associates. Printing out text and mocking up foam-core versions during the development process, we tested labels and exhibit components with school children, visitors to the Huntington, project advisors, and museum colleagues. Over the course of the project, we built prototypes for 62 exhibits, almost entirely in-house. We tested an exhaustive 133 versions of the prototypes with more than 250 people in eight intensive sessions. We dropped 17 exhibits. By the time we installed our final exhibits, we had prototyped 85% of them, making changes and improvements along the way. During the development and evaluation phases, we refined

our interpretive approach down to *real plants, real tools, real science* which in turn generated criteria through which we filtered the exhibits:

- Does the exhibit feature real plants? A working greenhouse all but required the use of living plants rather than models or simulations, and using living plants required the use technology to convert scales of time and size into meaningful experiences.
- What real tools will visitors use? The use of authentic scientific tools showed respect for the target audience but required extensive prototyping of equipment.
- Is the exhibit based on real science? Science means exhibits were focused on observable structures and phenomena. Exhibits aimed to provide visitors with the scientific skills of observation, comparison, measurement, and analysis they needed to continue learning on their own.

Real plants: This project takes unprecedented advantage of its greenhouse setting by making extensive use of real plants in exhibits, rather than models or other representations. We believe that real plants have the strongest possible cognitive and affective impact on visitors, and are the strongest antidote to plant blindness. Learning from the real thing is one of the major attributes that botanical gardens and other collections-based institutions have to offer. With this in mind, we limited ourselves to topics that visitors could observe directly from plants during their visit.

Our focus on real plants led to the creation of many exhibits that highlight visible plant structures or processes. For example, in *Leaf textures* visitors use a magnifying videoscope to examine the textures of different leaves, which range from fuzzy to bumpy to wrinkled. These close-up views allow visitors to see everyday plants in exquisite detail, while also shedding light on the function of some of these hairs, waxes, and other leaf textures: "Then you look at the leaf [with your eyes] its like nothing, but when you use that [videoscope] you see really amazing things." [Sixth grade student]

Real tools: During early testing with our target audience, we learned that children really liked using authentic scientific instruments. They were eager to spend long periods engaged in activities such as measuring the sugar concentration in nectar samples with a refractometer. Rather than becoming distracted by the tool, students reported that they were surprised to learn that flowers had different kinds of nectar. With minimal armoring, we were able to set up an exhibit consisting of simulated nectar samples, their corresponding flowers, tissues for cleaning, and tethered refractometers. *How sweet is it?* is one of our most successful exhibits with visitors spending a median of almost three minutes at the exhibit and expressing understanding of the main message: different pollinators prefer nectars of different sugar levels. "It was fun when you had to measure out the different liquids and use the [refractometer]. It made me feel like a scientist. It was cool." [Sixth grade student]

We were mindful that the exhibits should engage the

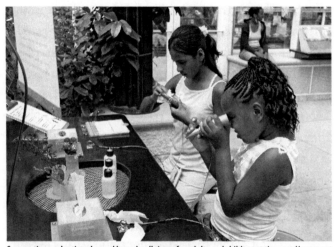

Summative evaluation showed long dwell times for adults and children at times at *How sweet is it?* [Courtesy of The Huntington Botanical Gardens.]

visitors primarily with the plants, rather than with the tools. During one evaluation session, we asked students to use and comment on an exhibit about flower parts. The prototype consisted of cut flowers in a vase, and labelled, scanned images of flowers. The activity was to identify and count the flower parts so they would learn about plant families. The students responded saying that it was "too much like school" and that they did not see the point in the activity. After adding a videoscope that visitors could use to create magnified images on a monitor, we tested it again. This time, students loved manipulating the videoscope, but were still not particularly interested in identifying flower parts. The exhibit was engaging, but our content was not being successfully communicated. At this point, we thought about

tools botanists and horticulturists use, and realized that they often use paintbrushes to hand pollinate plants. So, we added a dry paintbrush and asked the students to move the pollen from the anther to the stigma, to pollinate the flower just as it is done in the field and nursery. Suddenly, there was a reason to know what the reproductive parts of the flower were and how they worked – a motivation for visitors to seek out the parts, and a more compelling reason to use the videoscope. The tool engaged the public in closer observation of the plants.

Real science: In order to incorporate the practice of science into the exhibits, we asked ourselves what visitors could do at each exhibit, rather than what they could learn. This filter helped us to eliminate many ideas, and to focus on how to communicate content through meaningful activities and experiments. As a result, exhibits encourage visitors to engage in the practice of science – to touch, smell, observe, measure, and compare: "I think it's a really good way to learn for me and for [my daughter]... Being able to touch things, you learn much better that way. I think it makes things more interesting. You want to explore more." [42 year old visitor]

For each exhibit, we focused on particular skills that visitors could practice. Measurement is the main activity in *Sphagnum* moss exhibit called *How do bogs stay wet? Sphagnum* is the foundation plant for bogs and keeps bogs wet and acidic. Two lightweight plastic baskets hold five-gram samples of moss. The dry sample is sealed in a plastic bag to prevent it from taking on water. The wet sample is free to absorb water. The length of basket handle compensates for the slight

difference in weight between the samples. Visitors dip the wet sample in a basin of water and weigh it on a waterproof scale. They then compare the weight of wet sample to the dry one. In this way, visitors gather their own data from real plants. A close up image of *Sphagnum* cells on the label shows the hollow cells that give the moss its unique water-holding capacity.

Another exhibit employing visitors' science skills featured *Nepenthes* tropical carnivorous pitcher plants. With a large collection of these plants, we knew we wanted to highlight them in an exhibit. Initially we thought it might be interesting to emphasize their diversity by looking at hybridization. We chose plants that hybridize in the wild and asked visitors to look at a plant, and use their observation skills to identify which plants could be the parents. While kids and adults enjoyed this exhibit in our evaluation sessions, we ultimately changed it entirely. We realized we weren't telling the most compelling story about what these plants were doing (they are carnivorous after all), and we were encouraging faulty science (genetic characteristics don't always manifest in visible traits, so looking at parents and offspring of plants is just not good science). So, we came up with a new idea, designed to help visitors understand the plants' carnivorous strategy. In the new exhibit, *How do pitcher plants digest insects?* visitors compare the acid level in pitcher juice with that of purified water using pH meters. *Nepenthes* surround the exhibit. By examining real pitcher juice, complete with partially digested insects, visitors connect the carnivorous habits of the plant to the digestive juices in its pitchers.

Results

Summative evaluation provided evidence of overcoming the project's challenges and the success of our interpretive approach (Randi Korn & Associates 2006, 2009). In contrast with exhibitions at most science centers, *Plants are up to Something* works equally well with audiences of all ages, and showed significant positive impact on visitors' attitude toward and knowledge of the subject. Interactive exhibits engage visitors in the experience: observation showed that 86% of visitors interacted with exhibits and 72% discussed the content. Interviews revealed that the project's three primary objectives were met:

1. Increased visitors' understanding that plants are active: Results were statistically significant between people who visited the Conservatory and people who didn't with higher scores correlated with being a repeat visitor and visiting the Conservatory.

2. Improved visitors' knowledge of plants: Results were statistically significant between people who visited the Conservatory and people who didn't with higher scores correlated with visiting the Conservatory.

3. Improved visitor's attitude towards plants: Most visitors to the Huntington arrived with very positive attitudes toward plants, but higher scores on this objective were correlated with visiting in adult-only groups and visiting the Conservatory.

Taking a novel and risky approach to a rarely featured

subject paid off. We assumed that there were interesting and rewarding interactions people could have with plants and that our visitors would participate and understand those opportunities. Approaching both our subject and audience with respect means that our visitors are learning about plants in a way that we never afforded them before and is rarely afforded elsewhere. We continue to share our experiences through papers, talks, workshops, and a how-to book for creating the exhibits. But perhaps the most public sign of success came in 2007 when *Plants are up to Something* was awarded the grand prize in the 19th Annual Excellence in Exhibition Competition by the American Association of Museums (AAM).

After one workshop I was approached by a young educator who announced, "I didn't think there was anything interesting to do with plants." Hopefully, *Plants are up to Something* serves of a model for a few of the things science exhibitions can accomplish.

Notes

Key Huntington staff on the project were Jim Folsom, Principle Investigator and Director of the Gardens; Karina White, Exhibition Developer; Katura Reynolds, Exhibition Assistant and Illustrator; and myself as Co-Principle Investigator and Project Manager. The design firm was Gordon Chun Design. Ironwood Scenic was the fabricator. Landscape design was by Deneen Powell Atelier. Evaluation services were provided by Randi Korn & Associates, Inc.

This chapter is based in part on the Huntington's submittal to AAM for the Excellence in Exhibition competition. Karina White and Kitty Connolly coauthored that submittal.

References

California Department of Education. 1998. *Science Content Standards for California Schools: Kindergarten through Grade Twelve.* Sacramento, CA: CDE Press.

George, Rani. 2000. "Measuring Change in Students' Attitudes toward Science Over Time: An Application of Latent Variable Growth Modeling." *Journal of Science Education and Technology,* 9(3): 213-225.

National Research Council. 1996. *National Science Education Standards. National Committee on Science Education Standards and Assessment.* Washington, D.C.: National Academy Press.

National Research Council. 2009. *Learning Science in Informal Environments: People, Places, and Pursuits. Committee on Learning Science in Informal Environments.* Philip Bell, Bruce Lewenstein, Andrew W. Shouse, and Michael A. Feder, Editors. Board on Science Education, Center for Education. Division of Behavioral and Social Sciences and Education. Washington, DC: The National Academies Press.

Randi Korn & Associates, Inc. 2003. *Select Conservatory Exhibits: Formative Evaluation Round One.* Unpublished manuscript. San Marino, CA: The Huntington Botanical Gardens.

Randi Korn & Associates, Inc. 2006. *Summative Evaluation Conservatory for Botanical Science.* Unpublished manuscript. San Marino, CA: The Huntington Botanical Gardens.

Randi Korn & Associates, Inc. 2009. *Exhibition Evaluation: Summative Evaluation of Plants are up to Something.* Unpublished manuscript. San Marino, CA: The Huntington

Botanical Gardens.

Serrell, Beverly. 1996. *Exhibit Labels: An Interpretive Approach.* Walnut Creek: Altamira Press.

Wandersee, James H. and Elisabeth E. Schussler. 1999. "Preventing Plant Blindness." *The American Biology Teacher,* 61(2): 82-86.

Wandersee, James H. and Elisabeth E. Schussler. 2001. "Toward a Theory of Plant Blindness." *Plant Science Bulletin* 41(1): 2-9.
Page 25 of 25.

Redeveloping the Science and Life Gallery at Melbourne Museum

KATHY FOX & KATE PHILLIPS

Melbourne Museum

Museum Victoria, Australia

At Melbourne Museum, Victoria, Australia we are in the midst of redeveloping four exhibitions within the Science and Life Gallery. This redevelopment provides an opportunity to use our current knowledge of visitors and of their concerns. It also allows us to combine new technology with traditional museum communication methods to create engaging and memorable experiences for our audiences.

The museum context

Museum Victoria is Australia's largest public museum organisation. As the State museum for Victoria we are responsible for looking after the State collection, conducting research and providing cultural and science programs for the people of Victoria and visitors from interstate and overseas.

Melbourne Museum is one of three museums run by Museum Victoria. It is a new building opened in October 2000 with exhibitions and other public spaces, work areas and collection stores and is located in Carlton Gardens, just north of the Melbourne's Central Business District. Melbourne Museum showcases Australian social history, indigenous cultures, medicine, science and technology and the environment.

Ten years on from opening we are redeveloping the *Science and Life Gallery* on the ground floor of the museum. The gallery has a total area of 2200m^2 of which 1600m^2 is being redeveloped. This involves replacing several of the original exhibitions with new ones. Since opening, visitor expectations, behaviour, programming and commercial

needs are better understood, and we are now in the position to work within the gallery spaces more effectively. Our charter as an institution aiming to increase scientific awareness and literacy in the Victorian community is also becoming better defined. In addition, there is an active need for Museum Victoria to continue to respond to areas of contemporary interest, reveal more of its collections and present original research, enhancing the marketing of Melbourne Museum as a place to "Come and see the real thing".

The development of these new exhibitions provides us with both opportunities and challenges. We have a great opportunity to strengthen existing themes, to use technology which has developed in the last 10 years and to draw on our collections that have not been on display for many years, such as geology and mineralogy collection and our extensive mounted animal collection. The suite of new exhibitions has given us a renewed ability to engage audiences in contemporary scientific issues with a focus on change – changing climates, changing landscapes, changing life forms.

In the last 10 years since the first exhibitions were created for Melbourne Museum, the ground has shifted in terms of awareness of human impact on the planet, such as biodiversity loss and the impact of climate change. This time we feel compelled to address these issues more overtly. We have also been more conscious about sustainability in the way we build the exhibitions, the materials and energy involved and what to do at the end of the exhibitions to genuinely take a life cycle approach to exhibition development.

The new exhibitions sit amongst existing exhibitions
– *Marine Life*, *Bugs Alive* and *Forest Gallery*, so need to work
with them and create a cohesive science-themed space.
The redeveloped exhibitions also must exceed audiences
expectations of the museum's science gallery – the traditional
displays of mounted specimens, dinosaurs, minerals and
dioramas – and create an more dramatic and engaging journey
of scientific discovery and imagination. As much as possible,
ideas about the Earth, landscapes, environments, fossils,
plants, animals and other living species are integrated in an
interdisciplinary approach to scientific fields. The revamped
gallery focuses on what is special about our part of the world
(Victoria in the south-east corner of Australia) within the
context of universal themes such as the evolution of life and
the processes that shape the earth and atmosphere.

The first of the four new exhibitions is a dramatic central
display – *Dinosaur Walk* (opened April 2009) and features
skeletons of dinosaurs and megafauna. The second, *Wild:
Amazing Animals in a Changing World*, (opened November 2009)
is a spectacular display of mounted mammals and birds from
the museum's collection of worldwide and local animals. The
third exhibition, *600 million years: Victoria Evolves*, (opened
June 2010) combines geology and paleontology to tell the story
the evolution of life and landforms with particular reference
to Victorian examples. The fourth exhibition, *Dynamic Earth*,
(open October 2010) is a highly visual, interactive exhibition
exploring the story of Earth's formation, structure, power and
ability to sustain life.

At the time of writing two exhibitions *Dinosaur Walk* and *Wild: Amazing Animals in a Changing World* are open to the public and so the examples from these exhibitions will be discussed in more detail.

Thinking about our audiences

Melbourne Museum had 1,010,336 visitors in 2009. The Museum's main audience markets are adults, families and schools – roughly in a ratio of 3:2:1. Visitors to Melbourne Museum tend to come in groups of two or three. About half come with children and half come with a spouse or partner. The average age of visiting children is 8 years old and the average age of adults is 42 years old. 90% of visitors speak English in the home.

Over half of independent visitors are from the Metropolitan Melbourne area, especially from Inner and Eastern Melbourne, 14% of visitors are from Regional Victoria, 16% are from interstate and almost 15% are from overseas. Most international visitors are from English speaking countries such as the UK, NZ and USA.

On average, nearly 1, 400 people visit the *Science and Life Gallery* at every day, but at peak times this can swell to 2,200.

To cater to this multiplicity of audiences we adopted a mosaic approach to match exhibition experiences and audiences. In this approach, different experiences with different target audiences are delivered across the many spaces both within and between exhibitions in the Gallery. This differs from the approach taken in some other exhibitions of

imagining one target audience, catering specifically for that audience and seeing any other audiences as secondary. We could not afford to do that in such as large, well used space, with themes of broad significance.

Designing for children

Forty-four percent of all visitors are children: 24% members of an intergenerational group and 20% students on a school visit. Given their significant presence at the museum, we responded to a need to cater more specifically for children across Melbourne Museum, not just in the designated Children's gallery. Exhibition experiences targeting the specific needs of children such as interaction, immersion and fun are included throughout the four new exhibitions.

Whilst a significant audience will be children (and their families/carers) visitors who do not attend with children will also expect to engage with the exhibition experiences and the content. The mosaic approach with exhibitions that are multi-layered and multi-faceted in their content and interpretation ensure that their needs are met. Interactive experiences, which by their nature are particularly appealing for children, are also designed with adults in mind. Intuitive to use, and physically appropriate for visitors of different sizes, they encourage adults to have a go too.

Learning

Museum Victoria takes a holistic view of learning, understanding that it encompasses changes in attitudes and

feelings, and the development of social and physical skills as well as the acquisition of knowledge and understanding. The redevelopment of the *Science and Life Gallery* provides an opportunity to further define Museum Victoria's role in influencing the public's attitudes to science and their understanding of scientific concepts. It is an opportunity to highlight to our stakeholders our charter as an institution aiming to increase scientific awareness and literacy in the Victorian community.

While acknowledging that visitors will engage with and learn from the experiences in *Science and Life* in a multiplicity of ways, the Gallery's redevelopment will be based on intended learning outcomes in three key areas: cognitive, affective and skills-based. Cognitive outcomes refer to information and understanding; affective outcomes refer to emotions, attitudes and values; and skill-based outcomes refer to a range of skills, in particular those which are important in science. For each exhibition we formulated intended learning outcomes which were cognitive, affective and skills-based to guide the development of exhibition content and experiences.

Ensuring a variety of experience
Based on evaluation and our desire to create exciting and coherent visitor experiences we put together a concept that allows visitors to easily navigate spaces and ideas, provides a diversity of highlights and offers changes of pace and depth of experience, and moments of rest.

The concept design for all four of the new exhibitions was developed concurrently. Whilst this was an enormous task, there was huge benefit in being able to develop a holistic sense of the space and pace of the entire gallery experience, rather than work in to individual exhibition corners. We were able to ensure that key ideas and content were promoted and reinforced across all of the exhibitions, and develop design and interactive solutions that created a consistent visual language but also ensured each exhibition offered its own set of unique experiences appropriate for our mosaic of audiences.

Front-end evaluation

At the concept stage of the redevelopment project (May 2008), we carried out front-end audience evaluation by conducting eight focus groups. Forty adults who were predisposed to visiting the museum came together in small groups of up to 6 people. They were presented with concepts and a broad notion of interpretive ideas and asked to respond to what they would expect to see and how interested they would be. The results highlighted some things we were aware of and raised some new issues to consider.

The participants strongly supported the idea of creating a journey or integrated approach to of the different experiences within the *Science and Life Gallery*. Based on the themes presented they said that they would expect to learn more about climate change in the gallery. People expressed a concern for the future and felt that it should be a part of

the exhibitions but at the same time were cautious about burdening children with problems and leaving them with a feeling of powerlessness. Positive stories and role models were suggested as an antidote.

Appreciation of the natural sciences varied a great deal amongst the participants. Many did not see exhibitions about the natural world (biology, palaeontology and geology) as science. This suggested that we need to be very explicit about the nature, processes and people involved in science. Focus group sessions also highlighted that most people have very little understanding of time beyond the spans associated with human lifetimes i.e. 50–100 years. The knowledge and interest people have about things which happened thousands or even millions of years ago varied enormously. Even people who are knowledgeable and interested in the past have few time landmarks to attach to their knowledge. Those who have little knowledge of past timelines and events have misconceptions about what happened e.g. dinosaurs and people coexisted. This informs our approach to communicating past events and times.

A constant theme of the discussions was the significance to humans of the topics presented. This was expressed on a personal scale (How does the skeleton relate to my skeleton?) and on a broader scale in terms of things like the human experience of natural disasters and the desire to know about the consequences of particular human actions. This influences the interpretation in all exhibitions.

Participants emphasised the desire for immersive experiences, the importance of touch and more generally the

senses. We know that touch is essential to engaging young children, and this was echoed by the parents during evaluation. What was more surprising was the value which young adults placed on immersive, atmospheric and "arty" experiences as an incentive to visit an exhibition on a subject which they might otherwise not be drawn to, such as past life on earth. While participants thought that multimedia and screen-based experiences could add something, they also wanted the real thing as they saw that as unique to the museum.

Insights from the evaluation influenced our approaches to a range of elements in the exhibitions.

More information please: integrated multimedia

A common tension in the development of any exhibition is the depth of information it is possible to include within the scope of graphic panels and object labels. It is not ideal to cover mass displays of objects with words, nor is it ideal to leave these objects only superficially interpreted. Labels located more than an easy shift of a visitor's gaze are problematic, as are object labels that number specimens into the hundreds.

The timing of this development means that we are perfectly placed to incorporate new techniques that offer the visitor an ability to access more information about objects and find the information of their choice.

Whilst touch screens have been considered clunky in the past, a contemporary version which creates a live graphic panel/object label now offers great potential. We were inspired by those at the Berlin Natural History Museum.

Our preliminary considerations were that three layers of information (including the top screen) would be sufficient and wherever possible, the additional layers of information would be highly visual such as animations, maps, animated diagrams and live footage.

The new exhibitions

The following description of elements in the first two exhibitions will illustrate how we resolved interpretive and design challenges and responded to visitor evaluation.

Dinosaur walk

This new exhibition on dinosaurs and other prehistoric creatures aims to excite visitors with the science which continues to discover what they were like as living breathing creatures. It illustrates ideas about evolution and the continuity of life over millions of years. It contributes to science literacy and an understanding of the place of humans in a bigger picture.

One of the criticisms of the original *Science and Life Gallery* was that on entry the visitor was confronted with nothing – a large open thoroughfare with a few couches – as all of the exhibitions were located off to the sides. By moving our collection of dinosaur skeletons to this area we have created a simple but dramatic entry that immediately tells visitors they have arrived in the *Science and Life Gallery*.

Visitors now see an impressive diversity of dinosaur skeletons heading towards them. Our ancestor, a mammal-

Dinosaur Walk is an exhibition that is built in, up and around skeletons of prehistoric animals.
Photo: Jon Augier, Museum Victoria.

like reptile, has greeted them at the entrance; a giant *Quetzalcoatlus* (flying reptile) is swooping towards them from the void overhead. Megafauna are seen in the distance.

Designed as two interconnected ramp-like structures – one for dinosaurs and one for visitors – the exhibition experience is elevated from one merely of a series of plinths and flat viewing, to one that weaves the visitor in to the skeletons' physical space – climbing under the giant *Mamenchisaurus's* rib cage and so on. Multimedia, interactives, touchable objects and graphics are integrated along this path. Key to the experience is the ability to get up close to the skeletons, to walk in amongst them and to get interesting views from different angles. The design also includes an overhead platform structure that allows visitors to walk into the void

Dinosaur Walk exhibition has sloping interpretive plinths with multimedia screens and touchable elements, such as dinosaur teeth, built in. Photo: Jon Augier, Museum Victoria

where they are surrounded by the skeletons of flying reptiles and can look down on the dinosaurs below.

Integrated interpretation

Along the ramp, interpretive plinths are located next to each skeleton. These plinths integrate text, images, touch objects and multimedia. This followed the principle of interpreting what you see in a very direct way so that it is easy for visitors to answer their first question: what is that? A seemingly simple, but often overlooked aspect of this is ensuring that the illustrations of the animals are shown in the same orientation and relative size as the skeletons viewed by the visitor. Having easily found out about the creature they are looking at, visitors are then able to see what it might have looked like alive and to learn about the process of scientific discovery.

Animated footage of dinosaurs and megafauna is the top layer of the multimedia which is integrated into the interpretive plinths. Interviews with museum experts are on the second layer which is activated when visitors press a button [these interviews are viewable on the Museum Victoria's website at http://museumvictoria.com.au/melbournemuseum/ discoverycentre/dinosaur-walk/videos/]. As the skeletons are "look but don't touch" we also included touchable elements such as dinosaur teeth on these plinths and this tied in well with the interpretation of diet, predator-prey interactions and behaviour. In this exhibition the plinths provided a clean contained way of interpreting the skeletons in a busy space, but perhaps most importantly, provide a satisfying experience for visitors of all ages.

Understanding time with time devices

As noted in the evaluation, large spans of time are not well understood by people, nor are the sequence of geological time periods. The dinosaurs and megafauna featured in *Dinosaur Walk* are all located within the very large timescale of approximately 230 million to 50,000 years ago. Whilst not a strict chronology – the dinosaurs are grouped by type, not date – the exhibit obviously moves from the time period of dinosaurs at one end; to the time period of megafauna at the other end. One of the key things to communicate for our general audience was that these two general groups lived at vastly different prehistoric times. As such both ends of the exhibition begin with a time device – each representative of

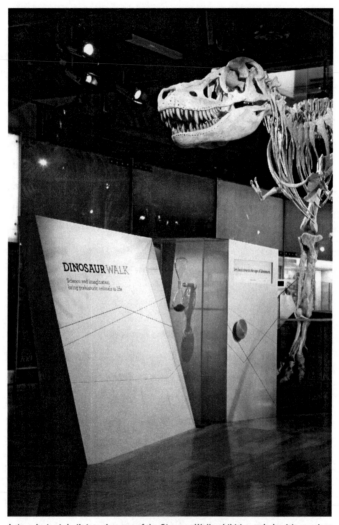

A time device is built into the start of the *Dinosaur Walk* exhibition to help visitors orient themselves in time. It is fun too! Photo: Rodney Start, Museum Victoria

the two different time periods.

This device combines a level of fun interaction, represents time visually within a stylized hour glass and provides numerical information about the detail of the how long ago the story occurred with respect to information about the timescale/millions of years.

The time devices invite visitors to "turn back time to the age of the dinosaurs" (or megafauna, at the other end). As a visitor turns the wheel, a large hour glass turns over and the sand starts to run through. Next to this, a display starts to go from the present to the past. The display includes an arrow moving along a timeline and a numerical readout of millions years ago. In addition, events flash up at the appropriate time in the past: *cities develop, first humans, mass extinction – dinosaurs die out, massive dinosaurs roam, first birds evolve*. The final readout says *230 million years ago the first dinosaurs evolved*. This stays on the screen for several seconds for the visitor to absorb. The exhibit then re-sets.

Bringing fossils to life with multimedia

Several other multimedia exhibits bring prehistoric animals to life in this exhibition. As well as featuring delightful animations, they are meaningful because they are specifically made for the place they sit in the exhibition and help visitors to visualize the living, breathing animals which the fossils represent.

Three sets of binocular-like viewers show custom-made animations which bring the skeletons to life. They start with

the skeleton as viewed in from that point in the exhibition, for example, a view of the massive head and fearsome jaw of the skeleton of *Tarbosaurus bataar*, a close relative of *Tyrannosaurus rex*. As you look into the viewer you see the skeleton's head, then you see it become covered by muscles, then skin, then it turns and roars at you. Other viewers bring to life *Pteranodon*, a flying reptile from the time of the dinosaurs and *Diprotodon*, a giant plant-eating marsupial from the time after the dinosaurs.

Fossil sauropod eggs from China are interpreted with an animation showing the hatching of the baby dinosaurs.

Under the belly of the largest sauropod in the exhibition, *Mamenchisaurus*, a touch-screen animation shows the stages in its digestion. In these ways visitors are able to see what we believe these animals and events looked like based on the understanding built up by scientific research.

Wild: amazing animals in a changing world

We are at a critical moment in history. As the human population expands rapidly, we are starting to see the impact of our species on global systems. The success or failure of our efforts to live sustainably will determine the future health of planet earth. Species extinction, the rapid loss of biodiversity, is a major concern of this exhibition.

The exhibition avoids the potential of an overwhelmingly gloomy ambience by celebrating and highlighting the richness and beauty of the animals and environments around us. It provides powerful examples of what can be done to restore environments and live with less impact.

Using Museum Victoria's wonderful collection, *Wild: Amazing animals in a changing world* aims to promote a holistic understanding of the competing pressures on animal diversity whilst inspiring people to value and nurture Victorian animals and environments. Visitors traverse between local Victorian issues and a larger global context as a way of making more general stories about climate change have a more direct and manageable meaning.

On entry visitors first encounter Museum Victoria's impressive diversity of Victorian animals (190 specimens). Showcased behind a huge glass wall, visitors can get up close to these remarkable creatures, seeing the subtle details of their markings, colours and features and exploring stories highlighting the diversity of Victoria. This display leads the visitor on to the worldwide animal display. Worldwide animals wrap the walls of the double height space and are complemented by large projections that extend messages about diversity, climate and change. Under the mezzanine, intriguing forms, multimedia and interactives entice visitors to explore environments further, with new perspectives on five Victorian environments (alps, mallee, coastal wetlands, grasslands, dry forest) giving local meaning to global concerns.

This exhibition had Museum Victoria's considerable historic collection at its disposal: Thousands of mounted birds, mammals and reptiles from around the world, and particularly rich collections of local species. The exhibition is in an architectural space, with sloping walls, a mezzanine

and a double height space 14 metres high. The exhibition designers used these features to great advantage to surround the visitor with animals from around the world – 620 of them to be precise.

Interpreting a mass display

When it came to answering the question *What is that?* traditional labels would not work, so we had to come up with a unique solution. It was essential to develop an interpretive device that could be used by young and old alike, short and tall, and people with varying degrees of enthusiasm for computer based technology. Adapted from a concept by Professor Jeffrey Shaw, Museum Victoria worked with a local display technology company, Megafun, to create a system that is simple and fun to use and provides visual and text based information every mounted specimen in the exhibition. We call the devices worldwide animal viewers.

There are three worldwide animal viewers in the exhibition, each providing a different perspective of the display and covering all the animals. A touchscreen greets visitors with an image of the display they see before them. The units can rotate horizontally and vertically to enable them to cover wall to wall and floor to ceiling of the animal mounts in the exhibition. Touching on an animal brings up information including: its name, distribution map, conservation status (i.e. secure; vulnerable; endangered; extinct) and interesting facts about the animal and what is changing in its environment. A high quality photograph or video of the animal in its natural

Worldwide animal viewers seen here in the *Wild* exhibition (centre floor and balcony) allow visitors to select any animal and bring up images, footage, maps and text about it. Photo: Heath Warwick, Museum Victoria.

habitat can be viewed and the museum created a 360° movie of the object can be rotated by the visitor and even downloaded to a Bluetooth™ compatible cell phone. This rotating movie was made by turning each of the mounted animals on a turntable and taking 36 photos. The images were combined into a movie.

The worldwide animal viewers have been a popular with our audiences since the exhibition opened. One visitor commented that she enjoyed contemplating the unlabelled animals in the exhibition first, just enjoying their diversity and detail, then when she was ready, seeking out the information she wanted. We think that this sense of being able to find as much information as you want, while not being bombarded with information, enhances visitor involvement

The *Wild* exhibition has interpretive plinths with graphics and a touch screen. Photo: Heath Warwick, Museum Victoria.

and control and works against museum fatigue. As the display is based on mounted animals we also felt it was important to bring them to life with photos or footage of the animal in its habitat and current information about their conservation.

In addition to the worldwide animal viewers we included five interpretive plinths with text and images about the bioregions of the animals on display, information about three key iconic species (such as the Giant Panda) and a touchscreen. The touchscreen has a photo of the display as its top layer. Visitors touch an animal to bring up its name, conservation status and photo of the living animal in its environment.

Interpreting local environments

As well as the worldwide animal display, the exhibition features five Victorian environments: the alps, mallee,

Visitors touch the mud to help Red-Necked Stints to find food. When the time is right and the birds have enough energy to fuel their journey, they set off from southern Australia to Siberia. Photo: Heath Warwick, Museum Victoria.

grasslands, dry forest and coastal wetlands. Each environment shows visitors aspects of past, current and future change. They include footage and interviews with people working in science and conservation who study, protect and restore biodiversity. The impact of climate change is one aspect which threatens biodiversity, but these interviews also provide suggestions and role models of action to enhance biodiversity (the interviews can be viewed at http://museumvictoria.com.au/melbournemuseum/discoverycentre/wild/victorian-environments/wild-science/).

One especially engaging exhibit in this area is a touch table interactive based on the journey of the Red-necked Stint, a tiny migratory shorebird. Visitors help the birds to find food such as worms and seeds in the wetlands. Then the birds

migrate from Melbourne to Siberia via Asia where rest-stops and hazards such as pollution are highlighted on their way. Visitors then help guide each bird to its mate then the birds produce young. When the young are hatched and fledged, the birds then fly back on their amazing journey across the globe. Many visitors stay to participate in the birds' next annual migration.

The Victorian Alps environment features a short film of the view from Mt Stirling. We created the film from a set of time-lapse sequences filmed all day and overnight at each season of the year from this scenic spot looking from the summit, over grass and boulders, to distant peaks. In six minutes visitors see winter snow, spring thaw, summer heat and autumn winds as seen from the mountain top. Information about the potential impact of climate change on alpine adapted animals and plants is displayed in the context the seasons.

Conclusion

Redeveloping four linked exhibitions within an existing gallery space has given us the opportunity to strengthen and connect science themes. We have make a fundamental leap forward in the way we use technology, both to engage the visitors and also to provide a greater depth of content. In the new exhibitions we have combined traditional museum displays of fossils, skeletons, dioramas and stuffed animals with newer technologies – interactive multimedia with animations, films, timelapse photography, soundscapes and graphics. To do this has taken a lot of work and thought, but

has produced experiences which are engaging, meaningful and bring the displays to life. All have been based on current scientific research and care has been taken to translate and interpret science in ways which interest the public. In some instances the dynamic process science has been made explicit; illustrating how ideas change as new evidence is discovered. Video interviews have been a powerful tool in presenting these complex science stories in a visually interesting way and making visible the Museum's researchers.

With a charter to increase science literacy and a sizable audience of young people, new media is an essential tool. It has helped us to link the global and local aspects of issues such as human population growth, wildlife conservation and climate change. The visualizations of change that we created for the exhibitions can be readily understood by a broad audience.

At this stage with two exhibitions open, we have had a very positive response from the public. When all exhibitions are complete we will have an opportunity to evaluate the impact of the suite of experiences to see if they do as we hoped; to create a memorable museum experience that stimulates curiosity, increases confidence in scientific concepts and gives people an increased understanding of the vital connections of life and the planet.

Chips for Everyone: Exploring Engineering Engagement through Practical Interactive Simulation

JANE MAGILL

University of Glasgow

Engineering and technology are all around us and permeate every facet of daily life. From medical applications in bone reconstruction and frame design for a winning the Olympic bike; through the design of energy infrastructure and utilities from wind turbines to nuclear power stations; to the brains inside every electronic device in our cars computers and mobile phones, engineering really is everywhere.[1] Despite the pervasiveness of the technology, and possibly as a result of this, engineering, particularly in the UK, is a widely misunderstood and often unrecognised discipline.[2] Recent research with pupils in their early teens reveals a very limited view of engineering careers and occupations.[3,4] Engineering is rarely a taught subject in most school curricula and instead appears as applied aspects within the science subjects. For electronics and semiconductor technology the problem is even greater because the products of the technology are usually physically hidden for their own protection. And yet it might be argued that the use of this hidden technology is increasing faster than any other. Semiconductor devices or silicon chips are tiny electronic circuits built onto pure crystals of the chemical element, silicon, that are the brains inside every computer. In modern western society most of the population young or old will be carrying at least one semiconductor device all the time, their mobile phone. Our cars now rely on onboard computers for both control and diagnostics of faults; domestic appliances from washing machines to microwave ovens offer more and more functions facilitated by computers and electronic sensors; options in

home entertainment are ever increasing – television and radio sets offer an often bewildering array of audio and video recording and playback devices including home computers; and in personal communication semiconductor technology provides us with the ability to communicate with almost anyone at any time wherever we are.

Chips for Everyone is an ongoing ten year project which aims to reveal semiconductor technology to a broad audience from young children to adults and in a wide range of locations from schools to shopping centres. This paper describes the development and evaluation of *Chips for Everyone* from small beginnings to reaching over 25,000 people across the UK and beyond by 2009.

A multifaceted approach

The public engagement project had several main aims:

- to reveal the hidden technology;
- to show that the technology, even though unrecognised, is widely used;
- to show that semiconductor devices are tiny electrical circuits;
- to demonstrate the importance of the microscopic size of semiconductor devices for both the speed of operation and the overall size of consumer products;
- to simulate some of the techniques used in semiconductor device fabrication;
- to show how the small size is achieved, in part, by

layering the components one on top of each other (vertical integration) instead of the side-by-side layout in a conventional circuit;

- to show why the microscopic circuits need to be protected;
- to show why high purity materials and clean environments are important.

The main emphasis of the project has been in learning by doing, a hands-on and interactive approach. There has been much debate in recent years about the value of practical work in science[5]; however, recent research supported by policy and the development of school curricula recognises the great importance of practical work in the learning process both in science and other disciplines.[6] Moreover the *Chips for Everyone* activities focus on practical simulations using familiar items to provide a realistic insight into a sophisticated and complex technology. This approach was chosen for two main reasons. First, from a science communication and public engagement perspective, practical and hands-on activities have been shown to be more effective in both educational and enjoyment terms.[7] Second, the use of practical simulations and familiar everyday items has enabled engagement which is not obscured by unfamiliar materials or equipment. This use of familiar items provides an opportunity for more rapid engagement with the audience as there is no barrier to be overcome associated with the materials or the equipment. This is particularly true when audiences are

either unfamiliar with science activities or have not engaged in science for many years. The use of familiar items was not limited to the physical items used in the activities but also to descriptions used in them. The descriptions made extensive use of carefully chosen analogies, especially to demonstrate the small scale of semiconductor devices in comparison with more conventional circuits, and also for such features as the purity of the materials used and the low level of imperfections that can tolerated. For example, if the whole population of Europe were pure white mice apart from one green one, then this would be a good approximation of the level of "purity" required in silicon used for semiconductor fabrication.

Small beginnings

The first *Chips for Everyone* activity was presented to a group of primary school pupils who were taking part in an engineering structures challenge. A short activity was needed to keep school classes busy while the equipment for the challenge was set up in the classroom. At that time the initial ideas and development plans for the *Chips for Everyone* workshops were being put in place and this event provided an opportunity to test some initial ideas. However, the informal nature of the engagement, lack of tabletop workspace and the uncertainty in time available made the need for agile interaction essential. The presenter had visual aids and the whole group sat on the floor or on school benches. First of all the presenter passed round a small tub of sand and asked the group what it was – everyone knew that. A simple digital watch was passed round

Figure 1: A selection of visual aids including a pure silicon wafer, a processed wafer containing about 100 silicon chips across the surface, an example of the mask or stencil used to make the circuit pattern and some examples of chips mounted inside their protective packages

and again the children were asked to identify the object – everyone knew that too. Then presenter posed a question to the group: "what is the connection between this bucket of sand and this digital watch?" As expected, no-one suggested that the silicon semiconductor device that is the "brain" inside a digital watch, started off as simple sand. The next phase was a simple explanation supported at each stage by visual aids, to explain how the sand was made into the silicon chip inside the digital watch. Visual aids included a pure silicon wafer (a thin circular slice of pure silicon on which the silicon chips are made), a processed wafer containing about 100 silicon chips across the surface, an example of the mask or stencil used to make the circuit pattern and some examples of chips mounted inside their protective packages. A selection of the

visual aids used is shown in Fig. 1. It was quite clear that the group were very engaged in the process: they asked questions throughout and later were able to explain in simple terms to their teacher what had happened.

Following this positive experience it was decided that the initial workshop idea was viable and that the scope of the public engagement activity could indeed be extended to different audiences and locations.

Strategy for development: Chips for Everyone

It was decided from the outset that there was potential benefit in developing a range of activities suitable for different age groups, different audience sizes, different locations and different dwell times at those locations. Therefore it was essential to develop a suite of multipurpose activities to be used in isolation or in combination to suit of wide range of public engagement opportunities. The collective title for these activities is *Chips for Everyone*. Three principal audience groups were identified:

- a drop-in audience to be found in non-science public venues such as shopping centres, galleries and libraries;
- a drop-in audience at public events at science centres, or science festivals;
- a captive workshop audience such as a small group or a school class either at a special science event or a school out-reach or in-reach activity.

The project was able to draw on a truly multidisciplinary team of collaborators and its success is in no small part due to the strength of this team. At the heart of the collaboration were both electrical engineers and engineering educators providing both technical and pedagogical expertise in the activity design. In addition to the academic group, artists, musicians and undergraduate student technology teachers were an integral part of the project development. The student group was able to provide initial ideas for practical simulations which were then developed and refined further in collaboration with the electrical engineering team. This group was also familiar with the content and level of school curricula and therefore was able to advise on appropriate activities for the school workshops. In addition the student group provided an audience for piloting and developing ideas as part of the iterative process. Musicians and artists were involved on the final development of the *Chips with Flair* exhibition bringing a completely different dimension to an essentially technical topic. The collaborative workshop development of both artworks and musical composition was a new experience for both groups, combining arts and engineering, which led to a well-received and quite unique exhibition. It is a testament to this success that the group continues to collaborate on new Science-Arts projects.

The following sections describe the activities developed under the *Chips for Everyone* umbrella.

Drop-in activity: Make a giant SIM card

This activity was based on the operation of a mobile phone and especially the importance of the SIM card in controlling its use. Each participant made a giant model SIM card, which if made correctly produced a ring tone when connected to the giant model mobile phone.

Under the centre square of the gold pattern on every SIM card there is small piece of silicon, without which the mobile phone will not work. This is where numbers and codes are stored which personalise and activate an individual's phone. When inserted into phone, the silicon chip is linked by gold connectors into the phone's electrical circuit enabling it to operate.

For the simulated activity, the SIM was made of card, about the size of the business card, which was pre-printed with patterns and codes similar to the real device. To complete the SIM card, a simple multilayer stencil pattern was added using a soft black pencil. The mobile phone was brick-sized, fitted with a ring tone generator. On the top surface of the phone, there were connections to the internal circuit. This was where the SIM card was needed to complete the circuit connections. The patterned SIM card was placed pattern side down and in the correct orientation on the phone. If the SIM card's stencil pattern was completed correctly then the phone would ring. Fig. 2 shows the model mobile phone and SIM card and the multilayer stencil pattern. To complete this activity the SIM card was placed into a standard conference badge holder for the participant to take away. If available a small

Figure 2: Model mobile phone and SIM card and multilayer stencil pattern.

Figure 3: Young participants make silicon chip badges in a busy Glasgow shopping centre.

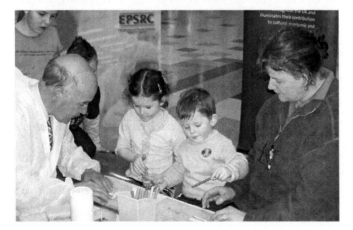

piece of silicon containing a chip pattern was stuck to the surface of the badge to further demonstrate the difference in scale. Other take-away items were provided: semiconductor technology information leaflets, engineering careers leaflets, bookmarks and various small gifts provided by sponsors and industrial collaborators. Fig. 3 shows some young participants making their silicon chip badges in a busy Glasgow shopping centre.

The workshops: Phase One – Chips for Everyone
Initial workshop ideas came from groups of students training as technology teachers. Working with this group of students has been mutually beneficial; students had an opportunity to develop their professional skills beyond normal classroom activities, and the workshop ideas they presented were generally well-matched to the target audiences. The student groups all presented their workshop ideas for assessment to an audience of fellow students, academic staff, science communicators, and the project mentor. A wealth of novel ideas were presented including:
- Firing ball bearings into jelly to simulate ion implantation; this was difficult to control and not good for a hot event space!
- Potato stamping and screen printing to demonstrate the layered structures in silicon chips.
- Salad spinner + ink or handmade spinner + glitter used to demonstrate the light sensitive coating on a silicon wafer with a layer which is the first stage of the

pattern making process.

- Cardboard box chamber and spray paint to demonstrate deposition of metals onto silicon wafers.
- Hand-made punch to demonstrate ion implantation at different depths into a wafer.

The initial ideas were then combined, refined or developed further and scaled to suit audiences and venues.

Simulation of the silicon chip fabrication processes: This main workshop was aimed mainly at the 10-15 years age group and offered at schools outreach and careers road shows. The workshop was designed to fit into a 15-20 minute time slot usually available at such events. The three main stages of the workshop were based on revealing the answers to a series of topics posed in a discussion style.

What is silicon; what are silicon chips; what do they do and why are they important? This section was a discussion with lots of visual aids, a question and answer session, and sometimes a short quiz for the participants (with prizes awarded at the end of the session). This part of the workshop was developed directly from the very first *Chips for Everyone* activity *What is the connection between a bucket of sand and a mobile phone.* The initial focus was a mobile phone or games console and thinking about what made it work. The group looked at what was inside the chip package and there were samples of wafers, chips, packages etc. The focus of this section was on tiny electrical circuits which are fast and can be portable.

ing

The importance of high purity, small scale on device speed:
Silicon chips are microscopic circuits and in order for them
to work, the materials used and the factories where they are
made need to be very clean and free from impurities. All the
presenters wore full cleanroom suits and this provided an
opportunity to focus on the small size of the devices and the
need for cleanroom conditions. Participants could also try on
the cleanroom clothing. Microscopes and magnifying glasses
were used to see the tiny circuits more clearly. Analogies and
high magnification images helped to explain the challenges,
for example: the wires are a thousand times thinner than
a human hair; a flake of skin on a chip looks like a huge
boulder has landed on it; and expecting a contaminated
circuit to work properly is like dropping a ship onto a busy
road junction and expecting the traffic to flow normally. So
both the materials and the air in the factories must be very
clean – in fact semiconductor factories are much cleaner than
hospital operating theatres.

Making tiny circuits: The final stage focussed on the
fabrication process itself and the audience worked in groups
to make a large model of a patterned wafer. The analogy of
photography (conventional not digital) was used to show
how silicon wafers are patterned using a technique called
photolithography. The model wafers were round sticky
labels usually used for CDs and especially modified with a
silicon chip pattern in place of the usual circle at the centre.
Coincidentally the CD labels are about the same size as silicon
wafer samples used both in the workshop and also in many

Figure 4: Making patterned wafers with the spinner system

fabrication plants. All participants wore hats and gloves when taking part in the activity to resemble the clean environment. The experiment involved making a very thin layer of a light-sensitive substance on the wafer surface. Instead of the using very high speed lab spinner (3600 rpm) and the photosensitive chemical (usually red) which would have required a special cabinet and fume extraction facilities, there was a modified kitchen blender with a flat disc in place of the blades and water based red ink for the chemical. Fig. 4 shows a class group making a model circuit during the Phase One workshop.

Finally, the groups studied their finished devices in comparison with some real ones, received quiz prizes, and other giveaways such as engineering careers leaflets and bookmarks.

The workshops: Phase Two – Chips with Relish

The Phase Two workshop developed directly from its predecessor and on the basis of the extensive evaluation that was conducted in Phase One (further details are given later in this chapter). The main changes were in response to two aspects of the evaluation:

1. the need for more interactive elements for the whole group rather than a few members, and

2. a workshop structure requiring less spoken information from presenters to facilitate delivery by those who were not electronic engineers.

This was achieved through a number of changes. The workshop group was divided into smaller groups of 3-5 participants and the whole session was presented as a team challenge. Teams represented semiconductor fabrication companies (e.g. Marvellous Microchips, Superior Semiconductors) with a challenge during the workshop of earning the most money by making the best products. The workshop was presented using a series of animated and narrated slide shows while the presenter was master of ceremonies making the link between the sections, managing the activities and awarding the competition points and prizes. The three workshop sections had a very interactive element with a team winner for each activity. Firstly the group had a timed challenge to remove as many "impurities" as possible (small rubber balls, marbles, ball bearings) from a large container of sand. The second activity was a quick-fire quiz following a video about

Figure 5: A team challenge in the Phase Two workshop.

how silicon wafers are made; and finally each team made a model SIM card and the first phone to ring won the round. This last activity was essentially the same as the drop-in activity described earlier. In the final stage, the scores were totalled and the prize awarded to the team with the best overall results from the three team challenges. As usual giveaways included sponsor gifts, careers information, *Chips for Everyone* information bookmarks, team badges and winners certificates. Fig. 5 shows a team activity in the Phase Two workshop.

The exhibition: Chips with Flair

Images of semiconductor devices fit the old saying small is beautiful. However, these images are rarely seen outside the

Research & Development environment where they are created. A collaboration between an artist/film-maker, a musician, an electronic engineer and an engineering educator, *Chips with Flair* presented annotated still and moving images and a musical interpretation of this almost hidden world. The aim for *Chips with Flair* was to take semiconductor images to a wide audience, especially a non-scientific one, not just to look at but to gain an insight into the underlying technology. A combination of media was used with the aim of engaging different audiences: static art work, video, music.

It was important for the artist to have an opportunity to be immersed in the technology so that the interpretation could be an artistic rather than a purely engineering one. To achieve this, a residency for the artist took place on three occasions during the project development phase. This allowed for image gathering and review as well as a collaboration with the music team. The artwork uses a style of annotated images borrowed from the notebooks of Leonardo da Vinci to interpret semiconductor images. The exhibition consists of nine large hanging panels (two metres high and one metre wide) each containing an image chosen by the team and animated by the artist. An additional panel shows one image and a brief description of the project and its collaborators. The panels are attractive and can be viewed in quite a superficial way but also studied in much more depth to draw out detailed information about the images, and the underlying technology. The short video (about ten minutes) provided a different dimension, showing engineers at work in the semiconductor cleanroom

Figure 6: The *Chips with Flair* exhibition.

research laboratories while talking to camera in a very informal way about what they do. This rarely seen insight surprised and captured the imagination of many visitors. Composition of the *Chips with Flair* music suite to accompany the exhibition took place in a workshop format where the engineers and the artist worked with musicians from Paragon Kaleidophone Ensemble[8] to develop a suite of music reflecting both the underlying principles and the fabrication of semiconductor devices. Three pieces form the *Chips with Flair* suite: *Silicon* which uses the letters of the element name to inform the music; *Diffusion*[9] which illustrates the process of adding electrically conducting elements into the pure silicon crystal; and *Integration* which explores the assembly of many

components to form the tiny electronic circuit. Fig. 6 shows some of the artwork in the *Chips with Flair* exhibition.

Evaluation

Several evaluation techniques have been used during the course of the *Chips for Everyone* project and each has been used to inform the development of next phase of the project. Some of these techniques were quite conventional while others were a little unorthodox and in this section a few examples are given. In the early stage of the project, during the *Bucket of Sand and Digital Watch* activity, a member of the team acted as an observer during the session. Particular features of interest were the attention and engagement of every member of the group, interest in the activity and in the visual aids shown, asking questions and, after the event, the ability to relate what had happened to their teacher who had not been present. The results of the observation showed quite clearly the importance of the interactive and hands-on nature of the activity. The pupils were particularly interested in handling the new materials and studying the patterns in the semiconductor devices.

The *SIM Card and Mobile Phone* drop-in activity has been run at shopping centres, science festivals and science centres. Sample participant surveys and observation were used for evaluation. During these events the presenters generally wore white cleanroom suits similar to those usually worn in semiconductor fabrication plants. Observation showed that the presenters' *uniforms* were likely to draw in younger

participants while older passers-by were less likely to engage. However, at family venues such as shopping centres, children often came forward and were later joined by other family members or the whole group returned later after the younger children had shown and talked about silicon chip badges or other giveaways. Whilst this technique might not be effective for all venues, the evaluation demonstrated that a feature, clothing in this case, that was initially off-putting to adults, but very attractive to children ultimately resulted in high quality interaction with family groups.

The Phase One workshop activity was initially run at Science Fairs but proved unworkable in practice. Audience numbers were often much larger than predicated making it almost impossible to provide an activity lasting for about ten minutes to the very large crowds. For subsequent events the mobile phone and badge activity was used. More recently, the longer workshop activities have been used either in schools or for school-age groups attending pre-booked workshops. During the first series of these events a major evaluation survey and interviews were conducted with over 1500 pupils and their teachers. Apart from event evaluation and suggestions for the workshop development, the evaluation was intended to gain an insight into the perceptions and aspirations of the participants in relationsto engineering. The main outcomes of the evaluation are presented below. For the Phase One workshop:

- 95% enjoyed the workshop;
- 98% learned something new;

- 90% enjoyed the hand-on/interactive activities most and would have liked more;
- presenters felt it was necessary to have specialist expertise in semiconductor technology to deliver the workshop effectively.

These results informed the Phase Two workshop development and especially the use of video sequences to enable non-expert presenters to deliver the workshop. For the perceptions and careers aspects of engineering:

- 76% identified engineering with manual work;
- 50% identified engineering as a profession;
- 70% enjoyed science, engineering and technology at school but had no career aspiration in these areas;
- 27% of all pupils (49% male and 6% of female) were considering a career in science, engineering or technology.

Evaluation of the Phase Two workshop was more limited and intended to ascertain whether the developments from Phase One had been effective. For example, did participants notice the greater range of interactive activities and were non-expert presenters comfortable in delivering the events? Positive feedback was given in both cases, and in particular the groups enjoyed the team competition element introduced in Phase Two. Presenters were very positive about the new format and whilst all felt that a science/engineering background was important, it was no longer essential for the workshop

to be delivered solely by electronic engineering academics. Therefore the scope and delivery of the workshop increased dramatically resulting in audience numbers of almost 10,000 in one year.

Evaluation of the *Chips with Flair* exhibition was through a visitor's book left in the gallery space. All responses were positive and included the following comments: "There should be more like this!"; "A really good way to understand what our phones and credit cards are made of!"; "Really good pictures!"; "Informative in an interesting way"; "I love the ideas behind the music!"; "I would recommend to friends".

In summary

Chips for everyone has used an integrated and multi-faceted approach to public engagement in the discipline of electronic engineering. Practical simulations, careful analogy, music and art have all been used to reveal the hidden technology in semiconductor devices to great effect. Audience feedback has provided a clear indication that this approach is both welcome and effective for reaching a wide range of audiences and in particular, those who might not normally engage with a science or engineering topic. A principal strength of the project has been in the diverse and multi-talented team of project developers and presenters – from artists and musicians to engineering researchers and technology teachers. The approach is quite generic and could be applied to many topics in a public engagement context.

Acknowledgements

The author wishes to acknowledge the collaboration of Dr Scott Roy of the Department of Electrical Engineering in the University of Glasgow and also the following organisations who have provided to financial or in-kind support for the work: The Engineering and Physical Sciences Research Council (EPSRC), British Science Association, Royal Academy of Engineering, Glasgow Science Centre, Freescale Semiconductor UK[10] and Stempoint West Scotland[11].

Notes

1. Magill, J., Gadd, K., Johnson, B. & Windale, M. (2008) Engineering Everywhere: A resource for 14-16 Science, 4 science. Accessed 6 October 2010, http://engineeringeverywhere.org.uk

2. MacBride, G., Hayward, E. L., Hayward, G., Spencer, E., Ekevall, E., Magill, J., Bryce, A. C. and Stimpson, B. (2010) Engineering the Future: Embedding Engineering Permanently Across the School-University Interface, IEEE Transactions on Education, 53 (1) 120 - 127. Accessed 29 September 2009, http://ieeexplore.ieee.org/stamp/stamp.jsp?tp=&arnumber=5238640

3. Ekevall, E., Hayward, E.L., Hayward, G., MacBride, G., Magill, J. and Spencer, E. (2009) Engineering - What's that?, Proceedings of SEFI (European Society for Engineering Education) annual conference, Attracting Young People in Engineering, Rotterdam, NL. Accessed 6 October 2010, http://www.sefi.be/wp-content/abstracts2009/Ekevall.pdf

4. Canavan, B., Magill, J. and Love, D. (2002) A Study of The Factors Affecting Perception Of Science, Engineering And Technology (Set) In Young People, International Conference on Engineering Education August 18-21, 2002, Manchester, U.K. Accessed 6 October 2010, http://www.ineer.org/Events/ICEE2002/Proceedings/Papers/Index/Posters/P32.pdf

5. Millar, R. (1998) Rhetoric and reality: What practical work in science

education is really for. In Practical Work in School Science: Which Way Now? ed. J. Wellington. London: Routledge, pp., 16-31.

6. SCORE (2009) Practical work in science: a report and proposal for a strategic framework. London: DCSF. Accessed 8 February 2010, http://www.score-education.org/downloads/practical_work/report.pdf

7. Bultitude, K. (2010) Presenting Science. In Brake, Mark L. & Weitkamp, E. Introducing Science Communication: a Practical Guide. Basingstoke: Palgrave MacMillan, pp.128-153.

8. Paragon Kaleidophone Ensemble. Accessed 8 February 2010, http://www. paragon-music.org/

9. Chips with Flair (2008) "Diffusion" Paragon Kaleidophone Ensemble and University of Glasgow. Accessed 8 February 2010, http://www.paragon-music. org/index.php?page=mp3-player

10. Freescale Semiconductor UK, http://www.freescale.com/

11. STEMPOINT West Scotland, Science Connects, http://www.scienceconnects. org.uk/

Dealing with Darwin

HENRY MCGHIE,

PETE BROWN & JEFF HORSLEY

The Manchester Museum

2009 was in many ways the year of Charles Darwin, with not one but two significant anniversaries: the 200th anniversary of his birth on 12 February and the 150th anniversary of the publication of his most important book, *On the Origin of Species*, on 24 November. A large number of organisations commemorated these events, including (amongst others) museums, libraries, art galleries, zoos and botanical gardens, scientific societies, research councils and funders, the BBC and the Royal Mint. The Darwin year saw more organisations interpret and address a single subject than has been the case for many years, certainly in terms of museum exhibitions and programmes. Presenting and interpreting Darwin's life, work and impact involves dealing with some complex and potentially controversial issues. This article outlines why it was important to confront these complexities and discusses the ways in which The Manchester Museum dealt with them during the development and delivery of its Darwin programme.

The Manchester Museum is one of the largest non-national museums in the UK. It is particularly distinctive for two reasons: firstly, it is part of The University of Manchester and is the largest university museum in the UK; secondly, the museum combines curatorial disciplines and collections in both natural history/sciences and humanities subjects, again unusual for a university museum. It has close links with academics throughout the University of Manchester and in academia more generally. The museum is extensively used in the teaching of students in The University of Manchester

and as a social venue for university staff and students. It is also widely regarded as Manchester's civic museum in the traditional model. The museum welcomes around 250,000 visitors each year including approximately 30,000 organised visits from schools and colleges. The museum serves a diverse local and regional audience and has a history of working in partnership with community members and groups on a wide range of projects. Taken together, these features make the museum a particularly dynamic place where people are engaged with different disciplines and perspectives.

Developing a Darwin-themed programme
The fundamental objective of the work of the museum is to enable its parent institution, The University of Manchester, to achieve its strategic goals. The museum has particular responsibility for delivering part of the university's ambitions in public and academic engagement – at all levels – through its wide range of programmes. The museum's mission is underwritten by two main goals: promoting understanding between cultures and promoting the development of a sustainable world. Developing a programme on Darwin, which has obvious links with big ideas (the currency of a university), evolution and biodiversity, would clearly contribute to a range of internal and external objectives. The museum is well placed to deliver these through its resources – its people, places and collections. Consequently, the Manchester Museum committed itself to a Darwin-themed programme two years prior to the anniversary year.

Internal factors

- Darwin – and evolution-themed programmes fit with Museum Mission Statement
- Relevant curatorial expertise, especially in natural sciences subjects
- Relevant staff expertise (curatorial and learning staff) in science communication, education and interpretation
- Very large, relevant collections available for use in exhibitions and related programmes
- Darwin – and evolution-themed programme enhance and reinvigorate existing gallery displays
- Museum has historical connections with Darwin through T H Huxley and specimens in the collection

Institutional factors

- Darwin – and evolution-themed programmes fit well with University Mission Statement
- Access to academics from a wide range of disciplines relevant to interpretation of Darwin's life, science and evolution throughout the University of Manchester
- Cross-disciplinary theme presents opportunities for engaging students from different disciplines with one another

External factors

- The museum is the only natural history museum in Manchester

- There is a large audience for natural history and science themed topics and the museum is well-known for its programming of these topics
- A programme on Darwin was likely to be able to attract external funding

Darwin and science in contemporary society

In a 2002 BBC poll that attracted more than a million votes, Charles Darwin was voted the fourth most popular choice as *Greatest Briton of all time*, behind only Winston Churchill, Isambard Kingdom Brunel and Diana, Princess of Wales, and ahead of William Shakespeare and Isaac Newton[1]. Nevertheless, he is undoubtedly one of the most persistently misunderstood and misrepresented figures in modern history. His science and its supposed impact on society is similarly often misunderstood and misrepresented. The relationship between Darwin's original ideas and scientists' current understanding of evolution is, for many people, shrouded in mystery.

There is strong evidence that anti-evolution sentiment is growing in the UK (Spencer in Pharoah, Hale and Rowe 2009: 8). A programme of surveys and reports by the think-tank Theos, entitled *Rescuing Darwin*, has investigated the public understanding of evolution with particular reference to its relation to faith[2]. A survey of 2,060 UK adults found that over half considered that evolution cannot explain the full complexity of life on earth and that a "designer" was required. A similar proportion considered evolution to be either

unproven or wrong. A third of those surveyed accepted that the earth was created by God in the past 10,000 years. Only a minority – 10% – considered that science and religious belief were completely incompatible (Lawes 2009).

The general public is faced with a barrage of stories for and against positions relating to evolution, to Creationism and to Intelligent Design. High profile attacks waged by both sides tend to pit science, evolution and Darwin on one side against Creationism and religion on the other. These over-simplified versions of the relationship between science and religion are all too common in the media and, although they may make for good viewing, listening and reading, being based on tabloid-style headlines, they generate a poor quality of debate.

The importance of running a Darwin programme was reinforced by evidence that confusion around the public understanding of evolution is mirrored by that of other science-related issues of greater practical relevance to museum visitors. These issues include vaccination (notably MMR), genetic modification, human-induced global warming and climate change.

Funding for the Darwin programme

The museum has a relatively modest internal budget for developing exhibitions and other programmes. This means that securing external funding is vitally important in enabling us to deliver large scale programmes. We were very fortunate in receiving significant funding (£150,000) from the Northwest Development Agency (NWDA) for the Darwin

programme. This grant came with relatively few strings attached, beyond the aim of attracting an increased number of visitors to the city from outside the region.

The museum's Darwin programme expanded in response to a high level of public interest in Darwin-related activities that developed through 2008-9 and as a result of the heightened ambitions of the NWDA and the museum generally. In 2007, when we began developing the Darwin programme, the exhibition was to be a relatively low-key intervention on the existing Mammal Gallery. The location for the exhibition moved to one relatively small gallery and then, following the award from the NWDA, to our largest temporary exhibition gallery. With increased funding we decided to feature more than one exhibition in our programme to accommodate the range of interests and abilities of our mixed audience. We then had to plan the shared allocation of financial resources between exhibitions and other programmes. A generous grant from the Wellcome Trust for £30,000 enabled us to develop and deliver tailor-made programmes for schools, public events and outreach activities, together with marketing. Further grants from the Edina Trust and the British Ecological Society supported learning programmes and public events.

Working in partnership – Darwin200
Partnership working is a foundation of The Manchester Museum's practice of programme development. Partners are recruited from across The University of Manchester, from academia and the cultural sector generally, from local

schools and colleges and from local community groups, notably through the Community Advisory Panel (now the Community Network). The museum became a member of Darwin200, an advocacy and networking group established to maximise the opportunities presented by the Darwin year[3]. Around 150 organisations joined the partnership, from the public, private, academic, cultural and voluntary sectors[4]. Darwin200 hosted a number of partner meetings through 2008-9 and a monthly e-newsletter was sent out to partners by the organisers. Partners contributed information on their individual programmes that was broadcast from a searchable website. The Manchester Museum aimed to provide leadership and advice to organisations running Darwin- and evolution-themed programme across Manchester and the region.

The development of the Darwin programme
The museum has a commitment to collaborative working and practically all of the museum's staff were involved in some way in the development of the Darwin programme. Programmes are developed in an holistic manner, with exhibitions being developed as part of a menu of activities alongside web outputs, public events, learning programmes for schools and colleges, community outreach and volunteering, marketing and retail.

Two teams were established to develop the Darwin programme and to co-ordinate its delivery. The first of these was a project management team, consisting of people whose roles mean they have particular responsibility for delivering

areas of the museum's operation. The second team, the core content team, was responsible for developing the aims and themes of the programme and working up the content. This team consisted of Henry McGhie (Head of the Natural Environments Team and Curator of Zoology as lead), Jeff Horsley (Head of Exhibitions and Presentation), Pete Brown (Head of Learning and Interpretation), Lauren Furness (Lead Educator for Secondary Science), Anna Bunney (Curator of Public Programmes) and Sue Bulleid (Curator of Learning, Primary Science).

For the purpose of this project, it was necessary to establish some terms of reference for how people would be involved with the project. *Consultation* and *collaboration* were defined, as there had been confusion as to what these terms meant. The importance of co-operation and co-ordination were re-emphasised at the same time. These definitions were provided to staff involved in developing programmes: "Collaboration doesn't mean everyone doing everyone else's job – we all have our own roles to deliver (let alone having different skills and expertise) – it means working together so that everyone can deliver their own role – whether by consulting on matters, collaborating to produce something together or co-ordinating with what one another are doing. As we are all working to the same ends – to make the Darwin festival fantastic, all of these are forms of collaboration."

Members of the core content team, together with a member of marketing staff, attended a development day at The Automatic – a training and facilitation laboratory at

John Moores University, Liverpool – to focus people on to the project and to understand one another's working styles[5]. A number of staff involved in developing exhibitions visited Down House (Kent) and a number of museums in Berlin; these trips were invaluable in engendering a sense of team spirit. A number of museum staff attended meetings held by Darwin200. This included a variety of curatorial, marketing and learning staff as well as those on the core content team. Participating in these meetings helped to engage staff who were less directly involved in the shaping of the programme. Ideas for exhibitions, storylines and objects for the programme were gathered through two brainstorming sessions at the museum with the Director, curatorial, learning and public programming staff. Additional ideas were gathered through one-to-one meetings with curators. This multi-faceted approach helped to augment the ideas that arose in meetings of the core content team and accommodated people's preferred styles of communication and information processing and engaged more people with the project. Fifty copies of the *Rough Guide to Evolution*[6] were distributed to staff involved in the development and delivery of programmes. This was intended to engender a common understanding of the concepts involved and serve as a "leveller" for staff, enabling them to converse on subjects that they might not otherwise have felt comfortable discussing with one another and accommodating the range of ways in which people take in and process information.

Updates on the developing Darwin programme were made

at weekly staff briefings and at monthly meetings of all staff. These presentations differed in style depending on the nature of participation that was required: some were straightforward information updates, whereas others involved more active audience participation. In one meeting people conferred in groups to answer quiz questions about the forthcoming Darwin programme. Presenting to staff throughout the process of development helped to prepare people for the final product and to avoid misunderstandings about the project. This was felt to be particularly important because there was a general perception that Darwin-related programmes could lead to difficult situations for people with non-scientific viewpoints (both visitors and staff).

Interpretation strategy for programming

Learning and enjoyment are the twin touchstones of the museum's approach to interpretation, with a focus on the quality of the visitor experience. We acknowledge that every visitor has distinct needs – both as an individual and as a member of a family or community group. All recent temporary exhibitions have been framed as part of a wider overall project that includes activities and resources for schools, colleges and university students as well as a wide range of public programmes, both in the museum and through outreach work aimed at harder to reach groups and individuals. This approach acknowledges that exhibitions have strengths and limitations and that some of our objectives are more effectively achieved through other means, such as

one-to-one discussion, lectures, debates, demonstrations, web resources or printed media. This is informed by the concept that every individual has a "learning identity"[7] and that this identity has at its core a blend of "multiple intelligences"[8]. This model, developed by Gardner, proposes that learners can be categorised as linguistic, logical-mathematical, musical, spatial, bodily-kinaesthetic, interpersonal, intrapersonal and naturalistic (Gardner has acknowledged that research may identify more). Gardner did not privilege one style over another. MLA's *Inspiring Learning for All* (ILfA) framework used this model as the basis for its understanding of how to measure the learning impact of museum experiences. We apply the principles of ILfA in the evaluation and development process. By acknowledging different motivations and preferred ways of learning we aim to create the conditions that facilitate "personal meaning making" and "flow". When used as tools for understanding the complexity of the learning process – what Wenger calls "the multidimensional problem of learning"[9] – knowledge of the variety of learning styles can help focus the design and presentation of exhibitions, programmes and on-line resources for the benefits to learners.

The core content team also developed a set of guiding principles based on the Falk and Dierking Contextual Model of Learning (see below). Information was provided in chunks – in exhibitions and in other programmes – to enable people to absorb and make sense of things, using relevant objects to grab people's attention and to illustrate, explain or demonstrate these key themes and concepts. We aimed to

provide a range of intellectual entry and exit points, making links to everyday life and experiences to take visitors from the familiar to the new. Information was presented using a range of media (texts and objects, audio, activities) to appeal to a wide range of ages, interests and abilities to allow people to choose what suits them.

We aimed to make the experience multi-sensory, bearing in mind physical issues such as the positioning of objects, lighting, readability of text and provision for people with hearing or visual impairment. Stories that related to people as individuals were chosen, employing surprise and humour. Opportunities for social interaction, either with fellow visitors or with museum staff and volunteers, were built in to programme development. Opportunities to extend learning were provided by promoting the various exhibitions, offering references and links to future activities beyond the museum.

Falk and Dierking Contextual Learning Model[10]

Personal context
- Motivation and expectations
- Prior knowledge, interests and beliefs
- Choice and control

Socio-cultural context
- Within-group socio-cultural mediation
- Facilitated mediation by others

Physical context
· Advance organisers and orientation
· Design
· Reinforcing events and experiences outside the museum

Following discussion in the core content team, we decided to work on the basis that the museum should not always aim to give visitors "the final word" or "the answer". We intended the exhibitions and programmes to act more like a catalyst, building on what people know already and aiming to ignite further interest in the subject that continues beyond their visit, either by showing them something stimulating and unexpected or involving them in a new experience as part of an event.

Dealing with difficult subjects

As a university museum, we see ourselves as having a particularly important role in engaging with contemporary debates. We have a good track record in this area, notably concerning debates about the retention and display of human remains and the representation of non-Western viewpoints. With a wealth of academic expertise on our doorstep, we are well placed to provide our audiences with opportunities to engage with difficult issues in an informed manner and in a safe environment. Dealing with the interpretation of Darwin presents some considerable challenges because he, his work and its wider meanings have been so continually

misunderstood and misrepresented. In all programming, we needed to be mindful of these sensitivities, while maintaining academic integrity. As ever, The Museums Association *Code of Ethics* was a useful guide[11].

During the early stages of the development of the Darwin project, it was decided that the museum would develop an institutional *Position Statement* on evolution[12]. There were a number of reasons for this decision. Internally, it helped explain to staff the academic understanding that they were expected to present during the course of their work; this was felt to be important as few staff are from scientific backgrounds. In terms of our institutional stakeholders, the statement was developed in consultation with the museum's academic advisory board and with a number of university colleagues, notably from the Faculty of Life Sciences. In terms of our community partners, the statement was presented to the Manchester Faith Leaders' Forum and to the museum's Community Advisory Panel, clarifying and explaining the position that the museum intended to take regarding integrity and sensitivity. For our visitors and other users, the position statement helped to clarify the museum's official acceptance of the science of evolution. It established a scientific "voice" that carried through the whole Darwin project.

The position statement also set out how we intended to work with our visitors, many of whom are not from scientific backgrounds and some of whom would be likely to have religious beliefs that conflict with scientific explanations of the mechanisms of evolution. During the Darwin programme,

we aimed to acknowledge controversy where it exists, to contextualise debates and to dispel misunderstanding. By publishing the position statement the museum was not intending to denigrate visitors' alternative viewpoints as one of the aims of the programme was to encourage public participation – some of which involved the airing of personal opinions. We aimed to promote informed discussion and debate around some of the contentious issues (real or perceived) surrounding Darwin and his work.

Aims and themes of the Darwin programme

The aims and themes of the Darwin programme were developed by the core content team; these were agreed and signed off institutionally by the museum's management team. Six themes were selected:

- to present information on Darwin's life and ideas;
- to present the evidence of evolution;
- to explain how science works;
- to look at evolutionary science since Darwin's time;
- to look at the difference between faith and fact;
- and to look at the use and abuse of Darwin's work.

Professor Steve Jones, a leading geneticist and promoter of the public understanding of evolution and biology, advocated that the Darwin year of 2009 should focus less on the historical figure of Charles Darwin and more on modern-day evolutionary science[13]. Notwithstanding such comments, many institutions – including our own – felt that

understanding Darwin as a person should be a key part of their exhibitions and programmes in the Darwin anniversary year. For many people, Darwin is closely associated with evolution, yet comparatively few people knew who he was or what he did: a survey by Theos established that although 70% of those questioned knew Darwin was associated with evolution, only 50% were aware that he wrote *On the Origin of Species* (Lawes 2009). We also felt that interpreting a real person would be a way into the subject for a greater range of people than an if we had only interpreted scientific topics related to evolution.

Accessibility of exhibitions and other programmes

At the Manchester Museum, we accept that there are many barriers to access and we are committed to working towards removing these. Our aim is to help visitors feel safe, welcomed and comfortable and to be able to find their way around independently. Visitors are given clear choices with realistic goals and opportunities for progression, in order to take their understanding further. We want them to feel involved and able to express themselves freely, within a context of mutual respect. The physical surroundings are designed to be comfortable and welcoming and staff and volunteers are trained to be approachable, knowledgeable and empathetic. When we employ them, interactives have to be meaningful (minds-on as well as hands-on) and interpretive information aims to provide a range of entry points and directions. On-line and other digital resources have to be both adaptable and

adaptive, tuning in to the distance learner's needs[14].

Putting a programme together

A table was devised for each of the six project themes, with the target audiences on one axis and columns for activity type, people to deliver, objects to use and places to do them on the other. The intended audiences were: families motivated by activities exclusively for children (kid's first families), families looking for intergenerational learning opportunities (learning families) and independent adults interested in increasing their knowledge and understanding (self-developers); the museum also has targets to increase the number and proportion of visitors from ethnic and minority groups and with disabilities. The core content team used these tables to assess the appropriateness of particular themes and activity types for each audience and drew up a programme of exhibitions, web-based media, public events and outreach activities. A great deal of thought in particular was given to the challenge of presenting complex ideas in straightforward ways accessible to different ages and abilities. The selected activities were then transferred to a programme diary that was used to deliver and monitor the events (Fig.1).

Through the period of the Darwin programme, family-friendly *Big Saturdays* on a Darwin theme were held in August, November, February and May. Additional events for adults were mainly held in evenings and during weekdays. Activities during school holidays attracted very large numbers of visitors. A large number of university academics

and their students, notably from the Faculty of Life Sciences, participated in public programmes and thus engaged large numbers of visitors with their work. The museum took the lead on Darwin-related activities for the Manchester Science Festival and museum staff gave introductions to films at the Manchester Cornerhouse Cinema.

The various exhibitions and public programmes were marketed together as *The Evolutionist: a Darwin extravaganza at The Manchester Museum*. The intention here was to emphasise the range of different activities that visitors could take part in, recognising that many visitors come in groups of people of mixed ages, abilities and interests and encouraging visitors to devise their own programme for their visit.

Darwin exhibitions

From initial audience research and evidence from surveys elsewhere (particularly that by Theos, quoted earlier) it soon became clear that people's knowledge and understanding of Charles Darwin and his work ranged from zero to substantial and that we would need a range of approaches to cater for such a wide range of starting points. We developed three separate exhibitions, each with a distinct purpose and with a different audience in mind. Each was complemented by a bespoke suite of activities and resources aimed at the target audiences, both in the exhibitions themselves and elsewhere in the museum. Interpretation in each of the exhibitions was developed and signed-off jointly by Henry McGhie and Pete Brown, as curatorial and interpretive leads respectively, with

Date	Event	Audience	Staff involved	Darwin theme
Big Saturday 26/9	'Ferns & Fossils' drawing and object handling	Family	Learning, public programming, curatorial, British Pteridological Society	Charles Darwin: his life, science and natural history
Thursday 15/10	Poetry reading by Ruth Padel	Adult	Public programming, visitor services	Charles Darwin: his life, science and natural history
Tuesday 20/10 Ideas Café	Darwin's Sacred Cause by James Moore	Adult	In partnership with Centre for History of Science, Technology and Medicine	Charles Darwin: his life, science and natural history Use and abuse of Darwin's work
Thursday 22/10 Evening event	Evolving Words poetry performance	Young people and adult	Public programming, visitor services. In partnership with Manchester Literature Festival	Charles Darwin: his life, science and natural history Use and abuse of Darwin's work How science works Evidence of evolution Science since Charles Darwin Faith and Fact
Monday 26 - Friday 30/10 (school holidays)	The Darwin Drawing Studio	Families	Public programming, curatorial, visitor services	Charles Darwin: his life, science and natural history How science works
Friday 30/10	The Beagle has landed comedy event	Adults and young people	Public programming, visitor services	Charles Darwin: his life, science and natural history

Figure 1: Examples of Darwin-related public programmes

input coming from many additional curatorial and learning staff.

Charles Darwin: evolution of a scientist

This exhibition was aimed at an 11+ audience of interested non-specialists. We had a number of particular objectives for this exhibition: to present the life of Charles Darwin and an unambiguous story about what he did; to explore and explain evolution and natural selection, and to engage visitors with the museum's collection. The museum took the role of presenter as we felt it was important to clarify who Darwin was and what he did, given the widespread confusion in this area.

The exhibition combined three elements: explorations of key events in the development of Darwin's career as a scientist through large scale colour illustrations in a graphic-novel style alongside selected objects; explorations of scientific concepts and topics, and a timeline of Darwin's life. The use of the graphic-novel style illustrations grew from our desire to use quotes from Charles Darwin's autobiography and *The Voyage of the Beagle*. The artist brought Darwin's words to life, revealing different phases in Darwin's development: the child naturalist, reluctant student, wide-eyed explorer, creative and ponderous thinker, meticulous researcher, energetic correspondent and prolific publisher and, finally, the quiet man who rarely went into society. These panels were developed through very close collaboration between artist Chrissie Morgan, Henry McGhie, Pete Brown and Jeff Horsley.

The illustrations aimed to be factually correct but were never intended to be any kind of reconstruction. Quotes from Darwin were presented as white words on a black background to differentiate them from museum-scripted text, which appears in black on a pale background. These panels were built around (and cut through) cases containing, for example, a child-like collection of natural objects; Darwin's first publication (a record of a moth); a first edition *On the Origin of Species* and a finch that Darwin collected on the Galapagos. Each construction (illustrated panel and accompanying case) related to a separate, discrete event in Darwin's career and could be read independently, although they could be followed in chronological order.

The reverse of these structures interpreted related topics including how science works, Darwin's evidence for evolution and natural selection. These were interpreted using large numbers of specimens from the museum's own collection and some borrowed objects (mostly from Darwin himself) from the Natural History Museum, Royal Geographical Society, British Geological Survey and John Rylands Library.

Around the walls of the exhibition space a time-line was presented in the style of Victorian playbills and posters, adding historical context to the scientific story. This incorporated both pre-Darwin and post-Darwin events in science and its impact on society, leading up to the present day. The time-line content was adapted into the form of a newspaper and offered free of charge to visitors as an exhibition souvenir. This included links to a large number of activities outside

the museum, mainly on the internet. An audio description guide was developed to enable visitors to engage with the exhibition's subject matter in a different way. There is also a library corner in the exhibition space with comfortable seating and books to browse.

Nature Discovery

Inspired by Darwin's belief that he was "born a naturalist" this space used fantasy and poetry to encourage open exploration of the natural world by younger children and their families. Natural objects were chosen and displayed in different settings designed to promote imaginative interaction: owlwood, flowermeadow and deepsea. A signpost with open and closed questions and a prompt sheet for adults were intended to encourage family learning. A small library included additional information about the specimens on show. Volunteers were trained to demonstrate and explain a range of handling specimens in the space.

In Darwin's Footsteps

We developed an exhibition including photographs by nature photographer, Ben Hall. Ben had travelled to some of the places Darwin saw on his five year voyage of discovery on the Beagle, recording the same landscapes and wildlife. Selected quotes from Darwin's journal were displayed alongside Ben's photographs and technical notes, together with displays of modern trekking maps, providing a unique double perspective on the wildlife and landscapes of South America.

Darwin for schools and colleges

The Manchester Museum's learning programmes for schools and colleges are connected wherever possible to academic research, encourage access (both physical and intellectual) to collections and support academic and community engagement. They are linked to the National Curriculum and embody the principles of a number of museum and government initiatives for learning[15]. Our sessions use familiar techniques and terminology in order to encourage teachers to incorporate museum learning in their overall planning, but the experience is very different to what goes on in the classroom. The emphasis is on free choice learning, by providing carefully managed opportunities for pupils to follow their own interests and enthusiasms within the structure of the session. Free choice learning acknowledges that we all build our understanding by incorporating or adapting prior knowledge and that motivation is the key to development.

For the Darwin programme a series of new activities for all age ranges from Early Years to Post-16 were developed and integrated into the learning programme. Examples include:

- (Early Years – KS2): *Voyage to the Galapagos* and *Animal Encounters* explorer sessions.
- (KS3): *Diversity of Life* and *Adapt* – interactive handling sessions allowing secondary aged pupils to explore concepts behind biodiversity.
- (KS4): *Clippy Island: An Investigation into Natural Selection*. New sessions aimed at helping students to

engage with the theory of evolution developed with museum curators and University academics and funded by BBSRC.

- (KS5): *Darwin's Legacy* (Post-16 Biology). A series of lectures, debates and activities utilising the museum's collection and offering the opportunity to meet museum curators and University researchers in an in-depth examination of natural selection, how it changed the way in which scientists interpret the natural world and how we currently understand it.
- (KS5): *The Great Debate: Darwin and Humanity* (Post-16 General Studies) facilitated debate days exploring the ethical issues surrounding Darwin's ideas involving museum curators and University researchers.

By creating partnerships between learning and curatorial staff in the museum, colleagues in University faculties and organisations such as STEMnet and Science Learning Centres in the region, the museum offered Continuing Professional Development (CPD) days for teachers in the use of evolution-themed resources developed by the Wellcome Trust, BBSRC and The Manchester Museum. The intention was to raise teachers' confidence in using these existing resources to encourage them to introduce innovative practices into their teaching, enabling them to present and teach evolution and natural selection with assurance and a high level of competence.

COMMUNICATION AND EVALUATION

Community engagement activities

Community outreach activities included visits to targeted local communities. For each visit, a member of curatorial staff, a museum volunteer and a science PhD student visited a local venue with a box of relevant objects selected to represent each of the six themes in the programme. These objects were chosen during training sessions at which participants were provided with information about Darwin, science and evolution. Twenty such visits were planned, with selections of venues being developed with the volunteers.

Museum staff also worked with a local STEPS group (Moston STEPS) of young adults to produce an off-site exhibition. The project involved visits to a range of local museums and Chester Zoo, along with youth workers. The group selected an animal to research (they chose to work on Tigers) and produced poems about these. An exhibition was staged in a local library, incorporating a stuffed tiger and the young peoples' poems. Holding an off-site exhibition in a library was relatively straightforward as the library already had a number of arrangements in place regarding security, eating and drinking.

The museum was also a partner in *Evolving Words*, a poetry project involving young people and funded by the Wellcome Trust. Henry McGhie worked as a science specialist with *Young Identity*, a group of poets based at the Contact Theatre and led by poet Shirley May. The young poets worked through 2009 and some of their work was presented in the museum as part of Manchester Literature Festival and at the Wellcome Trust

HENRY MCGHIE, PETE BROWN & JEFF HORSLEY · 437

in London. One of the poems was produced as a short film, shot in the museum.

Darwin for university students

Tutors of undergraduate students in life sciences, earth sciences and history subjects were provided with information of the content of exhibitions well in advance of the exhibitions opening, so that they could incorporate these into their programme of tutorials. Post-graduate students in Museum Studies were given presentations on the development of the programme. Final year undergraduate projects were offered to students from the Faculty of Life Sciences and Faculty of Human and Medical Sciences. Undergraduates in the School of Education and postgraduates in Art Gallery and Museum Studies were offered projects involving evaluation of programmes. Student ambassadors made very extensive use of *Charles Darwin: evolution of a scientist* as part of university tours to prospective undergraduate students and their families.

Evaluation of the programme

Exhibitions and programmes were evaluated using the following methods: comment cards collected within the exhibitions, assisted surveys conducted by Museum staff and MA students, accompanied visits, market research with identified attendees, evaluation forms given out at events, observation of visitors and recording in diaries by Visitor Services staff, discussion groups facilitated by and held

in the Museum.

Visitor figures and other quantitative data are routinely collected. A one day workshop intended to promote learning between institutions was organised for partners in Darwin200 who wished to share their experiences of the Darwin year. The outcomes of the day were to be disseminated to other organisations to promote similar partnerships for the future.

Discussion

The museum's Darwin programme was highly successful in some areas, less so in others. Being a member of the Darwin200 partnership was an excellent way of maximising the opportunity of the year and was very effective at sign-posting people to potential collaborators. The meetings provided an opportunity for partners to raise concerns and talk through issues that were potentially going to arise. This engendered a feeling of mutual support and goodwill that undoubtedly raised the quality of programmes, including our own.

From the beginning of our Darwin project we chose to focus on the later date in the anniversary year – the publication of *On the Origin of Species*. This had benefits as it allowed us to programme events that built on activities elsewhere and capitalise on Darwin stories in the media. The down side of this strategy was that by running a programme later in the year it proved difficult to maintain interest from journalists for marketing purposes.

Working in a Victorian building designed and structured in a way that effectively impedes collaboration – disciplinary boundaries, lots of locked doors, many people working in isolation – presents a considerable challenge to project-based working. Staff who are not members of the (necessarily small) development teams can feel that it is not "their" project and is therefore not their responsibility to resolve issues or to deliver activities. The solution to this required a highly focused approach from managers and team leaders, with people's contributions built into individual work plans. Regular information updates and motivational discussions helped to ensure continuing engagement with the project, but this again required managers and team leaders to take a share of the responsibility for engaging their own staff.

Looking to the future for our forthcoming exhibitions and programmes, the greatest lesson we have learned from the experience of the Darwin programme has been that focused team working is absolutely essential to delivering large programmes. With a joint commitment from managers and team leaders, a clear division of roles and a commitment to follow up on actions, responsibility can be shared across the workforce rather than resting on the shoulders of a handful of over-worked enthusiasts.

Notes

1. *http://news.bbc.co.uk/1/hi/entertainment/2509465.stm* [accessed 24th December 2009]

2 Lawes, C. 2009. *Faith and Darwin: Harmony, Conflict or Confusion?* London: Theos. Pharoah R., Hale T. and B. Rowe 2009. *Doubting Darwin: Creationism and evolution scepticism in Britain today.* London: Theos. Spencer N. and D. Alexander 2009. *Rescuing Darwin: God and evolution in Britain today.* London: Theos. Anon. 2009. *Discussing Darwin- an extended interview with Mary Midgley.* London: Theos.

3. *http://www.darwin200.org/* [accessed 31st December 2009]

4. *http://www.darwin200.org/utils/who-is-involved.jsp* [accessed 31st December 2009]

5. *http://www.ljmu.ac.uk/Business/93307.htm* [accessed 31st December 2009]

6. Pallen, M. 2009. *The Rough Guide to Evolution.* London: Rough Guides.

7. Kelly, L. 2007. *Visitors and Learning, Adult museum visitors' learning identities, in Museum Revolutions: How museums are changed* [Eds.] S. J. Knell, S. McLeod and S. Watson. London: Routledge, pp 276-291

8. Gardner, H. 1993. *Multiple intelligences: the theory in practice.* London: Basic Books.

9. Wenger, E. 2002. *A social theory of learning, Communities of Practice: Learning, Meaning and Identity.* Cambridge: Cambridge University Press, pp. 3-4.

10. J. H. Falk and L. D. Dierking 2000. *Learning From Museums: Visitor Experiences and the Making of Meaning.* London: Altamira Press.

11. *http://www.museumsassociation.org/publications/code-of-ethics* [accessed 31st December 2009], see especially sections 9.2, 9.6, 9.8 and 9.10.

12. *http://www.museum.manchester.ac.uk/whatson/exhibitions/theevolutionist/fileuploadmax10mb,150894,en.pdf* [accessed 31st December 2009]

13. *http://www.telegraph.co.uk/technology/4323051/Can-we-please-forget-*

about-Charles-Darwin.html [accessed 28th December 2009]

14. Hawkey, R. 2004. On-site learning, Learning with Digital Technologies in Museums, Science Centres and Galleries, NESTA Futurelab series, report 9. NESTA Futurelab, pp. 22-29

15. 'Every child matters' www.everychildmatters.gov.uk/ [accessed 6th Jan. 2010]; Learning Outside the Classroom Manifesto www.teachernet.gov.uk/ teachingandlearning/resourcematerials/outsideclassroom/ [accessed 31st Dec. 2009]; Philosophy for Children www.enquiring-minds.co.uk/ [accessed 31st Dec. 2009]; www.inspiringlearningforall.gov.uk [accessed 31st Dec. 2009]; Linking the Thinking in Family Learning www.niace.org.uk/Research/Family/ linkingbooklet.pdf [accessed 31st Dec. 2009].

Acknowledgments

We are very grateful to our colleagues who helped with the development and de-livery of our Darwin programme. We are especially grateful to Chrissie Morgan, Anna Bunney, Lauren Furness and Dr. Sue Bulleid. We take this opportunity to thank all of our collaborators and partners beyond the museum, notably Dr. Bob Bloomfield and Katie Edwards (NHM), Elizabeth Lynch (Evolving Words), Shirley May and Young Identity, Jo Cooper (NHM), Ed Potten, Jacqui Fortnum and Dr. Stella Butler (John Rylands Library, Manchester), Drs. Steve Judd and Clem Fisher (World Museum Liverpool), Randal Keynes OBE (Charles Darwin Trust) and Dr. John van Wyhe (Darwin Online).

ABOVE: *Charles Darwin: evolution of a scientist*: display of natural history objects that also served as an introduction to the main area of the exhibition.

BELOW: View into the exhibition *Charles Darwin: evolution of a scientist*.

ABOVE: Each key event in Darwin's career development was explored through a construction consisting of a large graphic panel built around, and cutting through, a case containing carefully selected objects, in this case a first edition of *On the Origin of Species*.

BELOW Graphic novel devices, in this case repetition of the image of Darwin's face, helped to build mood and atmosphere for each illustrated episode.

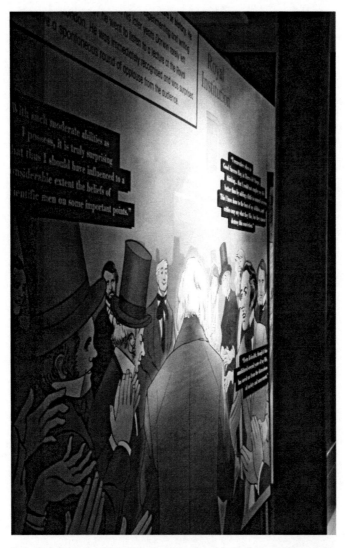

Quotes from Charles Darwin's writings formed the basis of the development of the storyline for each illustrated episode. Darwin's words were presented on black cut-outs to distinguish them from museum-authored explanations. This also gave the quotes weight.

Science in a Historic House: Presenting Charles Darwin's Work in his Home

JENNY COUSINS

English Heritage

In much of 2009, it seemed you could not turn on the radio or scan the TV listings, without coming across a programme contemplating some aspect of Charles Darwin's life and legacy. The bicentenary of his birth fell on February 12th, and the 150th anniversary of the publication of *On the Origin of Species* was on November 24th. Most British – and many international – cultural institutions were celebrating in some way. Rich and imaginative projects came in all shapes and sizes. In Barcelona, the complete text of *Origin* was read aloud publicly. In Stroud, the local knitting group created an extraordinary installation which included a life-sized woolly iguana. In Shrewsbury, British and American folk singers collaborated to make a Darwin-inspired CD.

English Heritage cares for the home of Charles Darwin, Down House in Bromley, Kent. Our bicentenary project centred on interpreting his life and work for modern-day visitors – no small challenge considering the scope of his influence. Over the three years leading up to 2009, we invested £1 million in making a range of improvements to visitor facilities and creating a new exhibition and handheld video guide.

The house

Down House was Darwin's home for 40 years, and the place he penned most of his works. After returning from his inspirational five-year voyage around the southern hemisphere on board *HMS Beagle* (1831–6), Darwin first lived in London. He worked on the material he had collected on his travels, building up a serious scientific reputation. He also

married his first cousin, Emma Wedgwood. With a third child on the way, they decided to move to the countryside, and chose Downe[1], a small village sufficiently far away from London to be peaceful, but close enough for convenience. It remained their home until Charles died in 1882.

Emma continued to spend the summers at Down House until she too died, 14 years later. After her death, the house was used as a school until the 1920s, when the pioneering doctor, Sir George Buckston Browne, purchased it and persuaded the Royal College of Surgeons to open it as a monument. At this time, Darwin's study was recreated and furnished with the help of his son Leonard.

The site came into the guardianship of English Heritage just over a decade ago, and the first presentation project of 1996–7 focused on conserving the fabric of the building and presenting the rooms on the ground floor of the house as they were in Darwin's time. An inventory dating to 1882 and several photographs taken by Leonard Darwin made it possible to be highly accurate, and Darwin's heirs lent or donated many original possessions and pieces of furniture.

Visitors often comment on how atmospheric it feels. The drawing room teems with books, including the romantic novels that Darwin so enjoyed; the study is full of intriguing clutter, tiny bottles labelled in faded ink, wooden string dispensers and fragile microscope slides. Walking through the rooms, one gets a real sense of how Darwin and his family inhabited the spaces.

The old presentation scheme included an exhibition on

Visitors use the new handheld video guides to take them on a tour of the garden.

the first floor of the house, which had reached the end of its life. The garden was open to visitors, but had almost no interpretation.

The visitors

We began our project in 2005 by commissioning visitor research to inform our interpretation plan. As well as market profiling, we undertook a specific exercise looking at how familiar our visitors were with Darwin and his work. From this, we split people broadly into four groups:

1. Pilgrims[2] – highly knowledgeable about Darwin, his work or both, who want to see the places he lived and worked.

2. The actively curious – those who are interested in Darwin, but know little about him or his work (this

was the largest category).

3. Day trippers – those who are primarily visiting to have a good day out, often as a companion of one of those in the first two categories.

4. School groups – generally at Key Stage 2 (8–11 year olds) studying the Victorians.

Some of what we learnt from the research came as a surprise. A typical visitor to Down tended to be highly educated, but in the arts rather than the sciences. There was a keen interest in Darwin, but knowledge of his work and ideas was quite low.

At many houses where celebrated books have been created, the works themselves receive short-shrift in the interpretation. There seems to be a not unreasonable assumption that visitors must already be familiar with the publications in question; they come rather to gain an affinity with the author's personality or almost as on a pilgrimage. While this is no doubt accurate in many cases, there are also a proportion of visitors who go to a site to understand the reasons behind an author's significance and reputation. From the visitor research it appeared that this is particularly true of Down House. Few people who we surveyed claimed to have read any of Darwin's books, but most were aware of his importance. They associated him with the theory of evolution, but few of them claimed any great familiarity with it. A persistent request that came up was that we should cover his ideas and discoveries in the displays at the house. In this light, it seemed that we were failing to fulfil an important function of the site in

the eyes of visitors; they saw Down as much as an information centre as a monument to Darwin or historic house. We needed to interpret Darwin's work.

For the purposes of designing the project, we used the "actively curious" category of visitors as a baseline – assuming that most visitors had no, or little, knowledge, but an interest in the subject matter and a desire to learn. However, we also agreed that it was important to go into some depth with the interpretation, so that more knowledgeable visitors would feel that they too were being catered for.

The exhibition

We decided to make replacing the aging exhibition on the first floor of the house a major priority of the bicentenary project. The new displays would concentrate on Darwin's most important work and how he came to publish it. We titled it *Uncovering Origin*. In seven rooms we told the story of Darwin's development as a scientist, beginning with his antecedents.

As Down is a historic house, we wanted to make sure that the design of the displays chimed with the spaces they were going into. Working with Designmap and MDM Props, we adopted a watercolour palette for the graphics, and a high-quality wooden look for the exhibition furniture and interactives. Rather than separating showcases and graphics, we tried to integrate objects into larger displays to contextualise them and aid visitors in understanding their significance. For example, we set Darwin's field notebooks

Darwin's study is a highlight of a visit to Down House.

from his formative journey on board *HMS Beagle* into a vast watercolour map tracing his route. These modest and slightly shabby leather-bound books contain Darwin's first impressions of the people he met and the things he saw. Historians of science have scanned them assiduously to piece together the genesis of Darwin's thought. By providing such a backdrop, we implied their function and emphasised their importance.

Similarly, we created a scale replica of Darwin's cabin to use as a giant showcase to display a rich collection of *Beagle*-related material. As well as putting the objects into context, it helps visitors imagine what the voyage was actually like for Darwin – a chronic seasickness sufferer in a tiny room. The ship's chart table would have taken up most of the space and the tiller ran underneath it, complete with ropes and

Objects from the collection are displayed in a new exhibition on the first floor.

pulleys to be dodged. While he was in his cabin, Darwin's life revolved around this table. He slept in a hammock above it at night, laid out his equipment and papers on it during the day, and, occasionally, lay on it to help ease a bad bout of seasickness. We displayed objects from the collection on our replica table.

We wanted visitors to have some sense of human scale within the cabin, especially because Darwin was a tall man who would have had to stoop to avoid banging his head. We created a Pepper's Ghost (a three-dimensional illusion) of Darwin sitting beneath his hammock contemplating a letter, looking at small rocks and even taking an occasional pinch of snuff. The sounds of the ship creaking, the sea lapping its sides and occasional footsteps overhead, help to give the impression of movement. Visitors often joke that they feel

The recreated *Beagle* cabin, with its Pepper's ghost illusion of Darwin, has proved very popular with visitors.

seasick themselves!

We included two rooms focusing on the *Origin*: one on its publication and reception, the other on its contents, amplifying its arguments for visitors using visual metaphors and interactivity. This section of the exhibition was potentially one of the most challenging to get right. The principle behind it was to answer visitors' requests to cover Darwin's theory. However, it is clearly difficult to translate several hundred pages of close reasoning – "one long argument" as Darwin himself described it – to three-dimensional space. Our solution was to create a rigidly hierarchical display, but to deliver as much as we could playfully. Each of the eight main graphic panels sets out a key principle of Darwin's argument. A supporting exhibit illustrates it. Thus, a panel on species is supported by an interactive on classifying cats, one on

geology by a model of a valley, and so on. Each display has its origins in a quotation from Darwin, reproduced alongside.

We thought that, given the arts education bias of our audience, an installation-led approach which made extensive use of metaphor would capture imaginations most successfully. It is also appropriate as Darwin uses metaphor to explain some of his arguments in *Origin*. Again, with Down as a historic house in mind, we decided to make use of Victorian technology, as in keeping with the space. Thus the evolution of a whale is shown using mutoscopes – end of the pier flickbook-like machines – and a simple camshaft mechanism demonstrates the interdependence of species. Using this kind of technology has the added benefit that it appeals to adults as well as children. Wooden Victorian parlour toys have a certain enduring appeal which helps to combat the problem of getting adults to feel less self-conscious about playing in a gallery.

A particularly popular interactive is our sheep island. Modelled on the Scottish island of Hirta, it illustrates that a habitat can only support so many individuals from a species. Numbers are held in check by many different factors including competition for resources. Visitors have to balance as many wooden sheep on the island as possible before it tilts, and a proportion of them fall off. It works well because it is fun and challenging, and the metaphor can be interrogated.

Early on, we agreed that, as Down is associated with a single figure, not a science centre with a broader remit, we should focus on Darwin's science, rather than on the ways his

ideas have been developed in the centuries since. We would not have the space or the resources to do justice to modern Darwinism and the debates that surround it. However, we made three short films looking at figures who have been inspired by Darwin. Professor Alan Hildrew of Queen Mary, University of London, explains his work on the biodiversity of woodland streams: Professor Geoff Boxshall of the Natural History Museum demonstrates some of the difficulties involved in classification of *copepods* (small crustaceans), and John Ross introduces us to modern pigeon breeding. These films help to give some awareness of how Darwin's ideas have continued to grow and change since his death, and how wide-reaching his influence has been.

Video guides in the garden

Over the last decade, the gardens had been restored to their appearance while the Darwin's lived at Down. Both Charles and Emma were enthusiastic gardeners, (though not known for their neatness). Many of the trees they planted still flourish and we have a lot of evidence for how the family used the garden, not least in Darwin's own publications. The garden and countryside around Down House was his living laboratory and just as important a destination for many of our "pilgrim" visitors as his study. The challenge for the bicentenary project was how to present and interpret the work that he undertook outside.

There were four main problems to overcome. Firstly, many of Darwin's experiments in the garden involved observing

The video guide includes animations and film which visitors can choose to access to learn more about Darwin's experiments in the garden.

plants as they grew or changed. Clearly visitors cannot see these processes in action on a single visit. In fact, depending on the time of year, several experiments might show no signs of life at all. Secondly, many of the experiments are not obviously recognisable as such. They appear to be empty patches of earth, or row upon row of plant pots filled with moss. They need interpreting, not just to bring them alive, but so they can be identified. Thirdly, some of the experiments are quite complex. Explaining what Darwin was trying to achieve could result in descriptions which are very long and complicated, especially in written form. Lastly, the garden is not large: it is a family garden. There was a danger of cluttering it and destroying the ambience if we introduced fixed interpretive elements like graphic panels.

We determined that the most successful way of addressing

these problems was to use PDA technology and create a handheld video guide. With animation and film we could show visitors how some of Darwin's experiments worked. It also allowed us to cater for the differing levels of interest that visitors had in the site.

Working with Centre Screen and Hypertag Ltd, we created a tour of the garden in 16 stops, each between 1–2 minutes long, narrated by Andrew Marr. At each stop (where relevant), we linked what Darwin was doing to one of his published works and explained how it supports his theory of evolution by natural selection. After the main stop content, you are presented with a menu of choices. You can choose to move on to the next stop straightaway, or to explore in further detail.

We filmed a series of interviews with experts on aspects of Darwin's life and science edited into a series of 1–3 minute films. Visitors can choose to access these to explore an experiment in more detail. Thus, in the greenhouse, one can listen to Professor David Kohn explaining Darwin's love of the sundew (*Drosera rotundifolia*) or to the former head gardener, Toby Beasley, explaining how plants are adapted to climb. We have 44 of these interviews, with 15 different experts and exponents. They present complex information in a digestible form and make it possible for us to give visitors access to in-depth perspectives. Darwin descendents recall family memories, and David Attenborough and Melvyn Bragg present their favourite aspects of the garden.

At some stops, other supporting material is available.

The "wormstone" – an experiment Darwin's son Horace set up with his father's guidance and continued to monitor long after his father's death – is explained using animation. We also incorporated poetry written by Darwin's great-great-granddaughter, Ruth Padel, to which visitors can listen as they pace Darwin's celebrated "thinking path", the Sandwalk. There is also a game to play at every stop.

Most importantly, having an individual video guide allows visitors to dictate the pace and depth of their own visit. It offers something of interest to everyone – even pilgrim visitors tend to find out something they did not already know. It was cited as the main reason that Down House won the 2009 British Guild of Travel Writers' *Best UK Tourism Project* award.

After some months working through the inevitable gremlins which arise when installing new technology, we undertook evaluation of the video guide. The response from visitors was extremely positive, especially in terms of their perception of how much it had added to their visit. They rated it very highly in improving their understanding of Darwin's life and work. Even of those who said their pre-visit knowledge of Darwin was high, over 80% still felt that their comprehension had been deepened.

Lessons learned

Generally the project went well and there is little that we would have changed in retrospect. There are two pieces of advice that I would give to anyone beginning a similar undertaking.

Get the right support from stakeholders: At the start of the project we sought the assistance of three distinguished Darwin scholars – the historian of science, Professor James Moore, Professor David Kohn of the Darwin Digital Library of Evolution, and biographer (and Darwin's great-great-grandson) Randal Keynes. Their assistance and support throughout the project helped us ensure that our presentation of Darwin and his work was as accurate, measured and serious as we could hope to achieve. It was especially important given that almost everyone on the internal project team had – like our visitors – an arts rather than science educational background. The support we received from our expert panel – and from those who featured on the video guide and in the exhibition films – was invaluable.

Define the range of material and answer visitors' questions as directly as you can: Darwinism is a vast and difficult subject and it was important for us to identify what we were going to cover early on in the project so that we could be clear in communicating to visitors. Space limitations meant that we could not cover everything, but we needed to answer the main questions that visitors came with – particularly those surrounding religion and controversy.

We chose to discuss Darwinism in its Victorian context, rather than focusing on its significance today. We discussed Darwin's own attitude to religion in some depth. We also looked at how the theory was received by Darwin's contemporaries and the objections that they raised. We felt that visitors would find this illuminating as the religious

perspectives on Darwin in the 21st century are not identical to those in the 19th century – "young earth creationism" (the belief that the world was created in literally six 24-hour days within the last 10,000 years) was arguably less of an issue then than it is now. By looking at the historical debates, we were able to recognise that there are alternative perspectives without dedicating lots of exhibition space to them.

The debate one can have on a graphic panel is limited. We wanted to leave a space for visitors' opinions. However it was also clearly important that we were not ambiguous in presenting the theory. Down House is a national monument because of the importance of Darwin's work – "the single best idea anyone has ever had" according to Daniel Dennett.[3] When in doubt about how to present a point, we always returned to the text, to Darwin's own words.

The huge amount of coverage Darwin was given in the national and international media led to unprecedented visitor numbers. Down House's nearly trebled to 75,000. Although this was challenging at times, it was rewarding to see the site being enjoyed by so many people. The media focus has moved on, the temporary exhibitions have closed and 2009 is over, but Down House remains a place where visitors can reflect on some of the most profound questions that we can ask ourselves. As the biologist Steve Jones says on our video guide, "It's actually Britain's Galapagos. Everybody's seen those islands, the lizards and the tortoises and the finches, but actually if they came to Bromley, they would see something much more interesting..."

Notes

1. The village of Down is now spelt 'Downe'. The 'e' was supposedly added by the postal services in order to differentiate the village from other places called Down in the 1850s. The Darwins retained the original spelling for their own house. This is probably the most common question asked by visitors to the site.

2. Despite the possible incongruity in referring to those who venerate Darwin as pilgrims, it is difficult to think of a more appropriate term.

3. Daniel Dennett, Darwin's Dangerous Idea: Evolution and the Meanings of Life (London: Allen Lane, 1995)

Between Environment and Science
An Exhibition about Butterflies

ANA DELICADO

University of Lisbon, Portugal

Scientific exhibitions have come a long way since the early days of static displays of scientific instruments or basic interactive devices demonstrating scientific laws. After decades of discussion on the public understanding of science (see, for instance, Gregory and Miller 1998, or Wynne 1995), it is no longer enough for exhibitions to "teach science" to dispel ignorance and irrationality. Generating interest and trust in science requires a more sophisticated approach, namely a greater awareness of the public's perceptions, concerns and expectations, but also a new outlook on science, more focused on the process of research, on contemporary objects of study, on still disputable or contentious knowledge, on the social relevance and implications of science and technology (Durant 2004, Farmelo 2004, Schiele 1998, Pedretti 2002, Field and Power 2001, Bettlestone et al 1998).

These new approaches have been tried and tested in the world's leading sciences centres and museums (Ward 1997, Durant 2004, Mazda 2004). But what happens when they are attempted in lesser-known institutions, with little tradition of producing their own exhibitions?

Butterflies throughout Time was groundbreaking, in a country where science museums and centres are quite a recent phenomenon and rely mainly on amateur handbuilt displays or on buying exhibitions from foreign institutions (Delicado 2009b). A temporary exhibition held at the Portuguese National Museum of Natural History, it was entirely home-grown and highly innovative. With bold museographical choices and a concern to blend nature conservation and

current research in the message conveyed to the public, the exhibition seemed the perfect example of recent trends in scientific museology. And yet, it fell short of its expected outcomes, especially in terms of its audience.

This essay presents a case study of that exhibition but also discusses the challenges of designing an exhibition that is both relevant and successful. It is based on an analysis of the exhibition and an interview with its curator, but also draws on data collected through extensive research on Portuguese scientific museums (Delicado 2009a).

The exhibition

Butterflies throughout Time was on show at the Portuguese Natural History Museum between March 2007 and May 2008. It was devised and mounted by Tagis, a small organisation within the Natural History Museum that is both an environmental NGO and a research group dedicated to butterflies. The exhibition and Tagis owe their existence mostly to Patricia Garcia-Pereira[1], a young researcher who decided to convey the knowledge acquired through her doctoral thesis on Portuguese daytime butterflies (the first academic research project dealing with this subject) to the general public and to continue research and conservation.

Thus the design of the exhibition reflected the scope and structure of the thesis and is indebted both to the data collected throughout the research project and also to contacts made with amateur lepidopterists, who acted as "privileged informants" (since in Portugal there is no research centre

working on this class of insects), loaned their collections and became involved in setting up Tagis.

The exhibition comprised five sections. The first contained a wall-to-wall 3D video animation depicting the evolution and presence of butterflies in the world from the Jurassic to the present day. It showed the increase in species during the Tertiary, caused by the appearance of plants with flowers, but also the decrease noticed since the Industrial Revolution, due to man-made threats to biodiversity.

The second room was dedicated to Iberian endangered butterflies. It contained an interactive map of the Iberian Peninsula on the floor with 14 species of butterflies. Upon stepping on each of the butterfly images, large-scale photos on the wall lit up, illustrating the main threats: forest fires, industrial pollution, water contamination, desertification, quarries, urbanisation, and intensive agriculture.

The third room was called the *museum room* and was dedicated to the work of four eminent early-20th century Iberian lepidopterists, three of them amateurs. According to Patricia Garcia-Pereira: "It's an homage to the historical study I did in my PhD research. We selected four characters in order to build a representation of the past, to highlight the importance of systematics and the work that is done in museums, which is still important. It's not a 19th century thing, it's not a thing of the past, the work of the museums is still important."

The room contained four mannequins with voice recordings summarizing their biographies and achievements,

surrounded by objects representing their social background and scientific activities. Also in the room were a table with microscopes for examining and drawing morphological details of butterflies and a large cabinet with drawers, containing collections of preserved butterflies, scientific illustrations, videos and some written information.

The *museum room* gave access to two small rooms, the final sections of the exhibition representing fieldwork and laboratory work. The first consisted of a short documentary showing the work being carried out by an amateur lepidopterist and a university student in a natural park in the north of the country, on the lifecycle and ecology of the rare blue butterfly. The second consisted of a life-size replica of a modern molecular biology laboratory in an American university, where research is being carried out to identify the genes responsible for the colours and patterns in butterfly wings.

Patricia Garcia-Pereira again: "I had to find a sequence, I was interested in biological evolution but also in the evolution of knowledge, so people would understand how the study of any animal group, or any biological group, has developed in the 20th century... So I needed something ultramodern, I needed a laboratory of molecular biology, which is the latest exponent of biology, the summit."

Exhibition curators travelled to the University of Buffalo (USA) to photograph the evolutionary developmental biology laboratory led by Professor Antonia Monteiro and interviewed its researchers. The exhibition display reproduced the

laboratory, through actual size photographs, showing scientists at work and their instruments, with a door opening into the chamber for raising butterflies. Videos depicting a scientific experiment and four touch-screen computers located on a workbench in the middle of the room provided detailed information on the research.

The exhibition was intended to end with a room with live butterflies. However, the curators decided it would be more useful in the long run to have a permanent structure in which to raise butterflies, something which would enable them to study their lifecycle, to devise a conservation strategy for their less visible stages (cocoons and larvae), and to show the live insects to the public. Thus, a butterfly house was built in the Botanic Garden adjacent to the Museum, and opened to the public a few months before the exhibition.

After the main rooms of the exhibition, there was also a display of butterfly photos and butterfly shaped objects (dishes, cushions, decorative items), loaned by a collector, representing the social appropriation and meaning of these insects.

The museographical choices of the exhibition were quite bold and innovative, jointly decided upon by the curators (biologists) and by a team of professional designers and architects. There was no written text since, according to the main curator: "What I see and know about scientific exhibitions, it bores me a lot to read stuff, I think that reading is for sitting down, it's not when you're walking through a place, you don't have the same ability, it's not comfortable,

it makes no sense to be reading text. So we went overboard, we had absolutely no text at all, except in the drawers and in the titles. What we wanted was to tell a story, which would be like a physical experience of seeing something different, with a strong visual impact. Afterwards, whoever wanted to know more would look it up in books... It was supposed to be fun... I don't know a lot about exhibitions but I had a feeling that it's not in a half-hour visit that I'd learn the main groups of butterflies or why they are endangered. I would like people to feel it, to be in that room of endangered species and to feel surrounded by those awful photos, and for it to be more sensory than informative. Why do people make exhibitions? What's the difference between writing a book and making an exhibition? There has to be a difference and that difference is to show people what you want to transmit."

Although the exhibition relied mainly on eye-catching multimedia and full-body interactivity, it still contained the typical preserved specimens of natural history exhibitions, artfully combining the old and the new to convey an historical perspective on science.

The exhibition was accompanied by the usual array of activities that have become almost mandatory: guided tours, workshops, holiday activities for children, a website (containing the detailed written information that was absent from the exhibition).

In sum, this exhibition managed to address many of the challenges of the modern museology of science. It explored the link between environmental protection and science,

highlighting the social relevance of research and the role of natural history museums in raising public awareness (Heim 2001, Nair 1996, Melber and Abraham 2002). Without neglecting the history of natural sciences, and lepidoptery in particular, it succeeded in presenting to the public contemporary research or "unfinished science" (Durant 2004, Fehlhammer 1997, Farmelo 2004). It even tentatively explored the ties between nature and culture/society, in the display of butterfly objects. On the whole, its purpose was not to teach science to the public, presuming their knowledge was insufficient, but rather to make a lasting impression, to raise interest in and motivation for both science and nature conservation, to stimulate visitors to search for further information. This exhibition also demonstrates the benefits of the close involvement of scientists in public understanding of science activities (Bell 2004, Wark 1997, Fehlhammer 2000), something that has become quite common in Portugal (Delicado 2009a) but is not so frequent in science exhibitions.

Institutional constraints

Although the end product seemed to have ticked all the boxes where the modern museology of science is concerned, the whole process of setting up the exhibition was mired with difficulties, which eventually had an impact on the (relative lack of) success of the exhibition.

Firstly, the institutional context in which the exhibition had taken place played a major role. The Portuguese Natural

History Museum is a 150 year-old institution that belongs to the University of Lisbon, together with the much more recent Science Museum (created in 1985) (for their recent history, see Delicado 2009a). Both museums occupy an imposing neoclassical building (still known by its 19th century name, Polytechnic School), in an historic quarter of Lisbon, that until the seventies housed the Faculty of Sciences. Just as the Natural History Museum had lost its teaching role and was redirecting its activities towards the general public, a catastrophic fire in 1978 destroyed most of the collections, especially the zoological ones, and eviscerated the building.

Recovery from this disaster has been a very slow process and has occurred at different speeds in the three sections of the Museum. The botanical section was the least affected and the Botanical Garden has remained open to the public almost uninterruptedly. The geological and mineralogical section did lose some specimens and its exhibition halls but thanks to the persistence of its long-time director and dedicated personnel, rose from the ashes with a much stronger commitment to bringing science to the public. Throughout the following 30 years, this section has organised dozens of exhibitions, conferences, activities for schools, mineral and gemstones fairs, with many of the events initially taking place in dilapidated rooms surrounded by scaffolding.

The zoological section was the worst affected by the fire. Almost all the collections were lost, including very rare and almost irreplaceable specimens (such as a dodo skeleton or all the colonial fauna). In this section a different policy

was followed. Work was directed towards reconstituting some of the collections (namely autochthonous fauna) and performing research, rather than carrying out activities aimed at the public. Exhibitions were few and far between and only mounted when enough funding was secured to produce high quality displays. The then director adamantly refused to hold exhibitions in "unplastered halls" (Delicado 2009a, 135). This situation somewhat changed when a new director was appointed in 2004, who decided to change this policy. Since then a few exhibitions have opened to the public, among them *Butterflies throughout Time.*

At the same time, the Natural History Museum was undergoing other institutional changes. After decades in which the three sections operated more or less separately, under the management of a director (always faculty members of the Faculty of Sciences), a change of statutes created the position of the Director of the Natural History Museum (who is also director of one of the sections), with the aim of implementing a common strategy and joint activities. A few years later, the Rector of the University decided to join the two Museums (Natural History and Science) under a single name (Polytechnic Museum) and single directorship (currently the Director of the Science Museum, a Professor of Physics), with the aim of creating synergies between the two institutions. The end result was to create three levels of authority, but without a clear-cut definition of roles and responsibilities.

The exhibition *Butterflies throughout Time* was organised during this period of upheaval and transformation within

the Museum. The timing and location of the exhibition had to be painstakingly negotiated with the directors of zoology and geology (who had exhibition plans of his own for the same space), and the directors of the Natural History Museum and Polytechnic Museum. "I think it was the appearance of the Director of the Polytechnic Museum that made possible the exhibition *Butterflies throughout Time*, because I was having a lot of trouble finding a space for the exhibition because of the *Earth Adventure* exhibition that was being planned at the same time. There was a huge fight for space. One day they would tell me one thing – and I already had the plans – and the architect would put his foot down saying they couldn't change anything. Then they'd tell me I couldn't use the great hall because it was meant for *Earth Adventure*... There was a bit of a conflict here and then came my angel Ana Eiro, with the skills of diplomacy and leadership, which I lack... and she made a decision."

Another obstacle was the lack of experience of the zoological team in organising exhibitions. "There were so few of us, I had to deal with everything. We didn't have a structure. How do we charge for tickets? How much will we charge?". This obstacle was overcome with the help of geology staff who were much more experienced in mounting exhibitions.

Although the Natural History Museum hosted the exhibition and the curator worked for Museum, it was in fact organised by Tagis, a non-profit organisation closely affiliated to the Museum. Tagis was created to fill a void in butterfly research and conservation and to bring together amateurs and

scientists, modelling itself on organisations such as Butterfly Conservation in the UK.

Funding the exhibition also represented a major challenge. A successful bid to the Government Agency in charge of public understanding of science, the Science Alive Agency[2], set in motion the organisation of the exhibition. However, between funding approval and funding delivery a long time elapsed, making it necessary to find other funding sources in order to open the exhibition on schedule. Since the Natural History Museum is wholly dependent on the University and operates on a very tight budget, it was necessary to search for outside sponsorship. And although the team was successful in attracting some small contributions, (the Luso-American Foundation for travelling to the US, and a corporate sponsor which recycled plastics and had a butterfly in its logo), several other deals fell through. Verbal promises were never translated into actual support and even the main sponsor, which had committed to a four-year deal, was bought by a foreign corporation which renounced the agreement after only two years.

These difficulties had two major implications. First, the exhibition only opened to the public thanks to a bank loan (which took a long time to be paid off) and by using up all the resources of Tagis (the association was on the verge of bankruptcy and had to dismiss all its staff). Second, substantial budget cuts had to be made, some of which affected anticipated sources of revenue: the publication of a catalogue, and the touring of the exhibition in Portugal and Spain.

So far, the exhibition has only been shown in two other locations in Portugal (Lagos and Abrantes) and in both cases changes had to be made, since the displays that were designed for the large rooms with high ceilings of the Natural History Museum do not adjust well to other kinds of spaces. Though a few other institutions have shown interest in renting at least some parts of the exhibition, this is far from the initial aim of the curators of having a travelling exhibition touring both countries and being seen by a large number of people.

These major setbacks had substantial implications not only in terms of the success of the exhibition but also on the survival of Tagis and in the development of further activities.

Public response

If visitor numbers are to be taken as the main measure of the success of an exhibition, then *Butterflies throughout Time* must be considered a relative failure. After more than a year on show at the Natural History Museum, it was visited by under 15,000 people. And although Portugal does have one of the lowest rates of science museum visitors – according to the latest Eurobarometer on Science and Technology (EC 2005), only 6% of Portuguese had visited a science museum in the past year[3] – this figure is considerably lower than other exhibitions of the same nature. For instance, the Pavilhao do Conhecimento (the main science centre in Lisbon) attracted almost 250,000 visitors in 2007, even though three of its exhibitions have been on show since 2000. The Gulbenkian Foundation has been

organising biennial temporary scientific exhibitions since 2002 and, although never on show for more than five months, all three had far more visitors: *Potencies of 10* had over 48,000, *In the light of Einstein* over 69,000 and the latest (2009), *The evolution of Darwin*, reached a record 161,000.

Several reasons may explain this lack of popularity. First of all, the Polytechnic Museums have a traditionally low visitation: barely 50,000 between July 2007 and June 2008. It is possibly the austere facade, the absence of welcoming facilities (a cafe, a museum shop with attractive products) and the lack of a positive communication strategy that keeps the public away. However, the geology department has been quite successful in attracting large numbers of visitors to its dinosaur exhibitions, starting in 1993 with a blockbuster from London's Natural History Museum, which received 360,000 visitors. Subsequent exhibitions, some loaned from foreign institutions, others created by the museum team and based on their own research, have also been quite successful, although there are substantial differences in visitor numbers between exhibitions with and without animatronics. Dinosaur exhibitions, of course, have outstanding appeal, fuelled by films, toys and merchandising. In the words of the curator of *Butterflies throughout Time*, butterflies, though undeniably more beautiful than fossilised skeletons, are far more commonplace and lack the appeal and mystery of the extinct.

According to Patricia Garcia-Pereira, one of the main reasons for low visitation was the misguided decision to

open the butterfly house a few months before the exhibition. This received extensive media coverage and attracted a large number of visitors (30,000 in one year), who could not be persuaded to come back to see the exhibition. And yet, once the exhibition opened, the greenhouse continued to receive more visitors and the majority showed no interest in buying the combined ticket to see both attractions.

In hindsight, however, Garcia-Pereira admits that the location of the exhibition may have put off some visitors: "This building... it's something people have a lot of difficulty with... The corridor wasn't finished. People would say, *Is this an exhibition or what?* They complained a lot. They had to cross an ocean of concrete... People were impressed that it was all made in Portugal, but they would say, *Why do you have it in this hole, why didn't you chose another place?*"

The exhibition design may also have proved too innovative for some members of the public: "I have the feeling that you must explain more to people, you have to make it more obvious... it was too indirect, we thought people would understand but they missed it completely. Of course there was a small group of people who loved the detail, but we want to reach the average person, and they missed it completely. We need to make things much more direct, clearer, make them do things. Because there was too much freedom, freedom not to open any of the drawers... We wanted people to see and half of them didn't see anything, like this woman who reached the end of the exhibition and asked: *So, where is the exhibition?* So I told her, *My God, come with me.* And so I showed her: *Look at*

this, now step on that other butterfly, see? She had gone right through and she didn't realise that the lights would go on, she didn't listen to the mannequins, she didn't open a single drawer, she didn't go through the curtains [into the rooms representing fieldwork and the laboratory], she didn't see anything, that's why she said *Where's the exhibition?"*

Nevertheless, the curators believe (though no summative evaluation or audience study was carried out) the majority of visitors did enjoy the exhibition and that the main problem was the inability to attract the public, rather than visitors' dissatisfaction with the visit.

The aftermath of the exhibition

Despite the lack of success in terms of visitors and the institutional constraints, not all the consequences of *Butterflies throughout Time* were negative. One the one hand, it did function as a learning ground for the team of very inexperienced curators, who derived valuable lessons from the mistakes made, which can be put into use in future exhibitions: in 2010 they organised an exhibition on the classification of insects, that attracted 3500 visitors in the first few months. The exhibition helped give a new dynamism to the zoological section of the museum, which is preparing new exhibitions, both single-handedly and together with the other sections of the Museum.

Additionally, even Tagis, which suffered greatly from the financial strain caused by the exhibition, gained public visibility and a track record of achievement that is important

for developing new projects, attracting more members and acquiring more stable sources of funding. It is currently embarking on an ambitious new project, which again combines research, conservation and communication with the public: a network of dozens of biodiversity stations scattered through the country, with pedestrian paths signalled by panels containing information on local flora and insects. This project is being funded by local authorities and the national Environmental Agency.

And despite the lack of a tour and a publication, the exhibition lives on thanks to its website, which contains a significant amount of information on butterflies, their research and conservation, and is still available to the public. The documentary shown at the exhibition was also bought by the public television network and has been broadcast several times.

Setting up a scientific exhibition is a very demanding process, probably more so than an art exhibition. The content must be scientifically accurate but at the same time accessible to a wide audience. The format must be appealing but without distracting the visitor from the message. And with the benefit of decades of research and discussion on scientific museology, many other aspects need to be considered: social relevance, engagement with contemporary science and research, minds-on interactivity, the representation of controversy, and involving the public in a debate rather than lecturing or teaching science.

But even if many of these issues are considered, this does

not guarantee the success of an exhibition. It may please greatly a more demanding audience, such as sociologists of science, but that does not mean that it will be understood or appreciated by the general public. Or it can be so simplified and dumbed down that it puts off all but children.

On the other hand, context does matter. The best laid out plans of exhibition curators can come up against all sorts of obstacles. From financial difficulties to spatial constraints, from institutional conflicts to broken partnerships, mounting an exhibition can be an uphill struggle. And the public's reception also depends on cultural context. In a country with a low levels of cultural consumption in general, and of scientific culture in particular, and where scientific exhibitions are still seen as difficult to understand, curators face an even harder task. In the end, hiring exhibitions from prestigious foreign museums still seems the easier option.

All the same, change can only be brought about by persisting in swimming against the tide. It is by developing challenging and innovative exhibitions that fusty museum institutions can rise from the ashes, that a greater connectedness between science and society can be engendered, and even that public taste can be educated. And though imported high-quality exhibitions are indispensable, museums need to also to produce their own, in order to show the public the research that is being conducted in Portuguese institutions and to involve more researchers in science communication.

Notes

1. *To whom I am indebted for a long and very informative interview. All the quotations in this chapter are derived from that interview.*

2. *The Science Alive Agency, created in 1996, though formally an association, is fully funded by the Ministry of Science (Delicado 2009b, Miller et al 2002). It runs a network of sixteen science centres scattered throughout the country and promotes a wide array of activities: science competitions for schools, summer activities in astronomy, biology, geology and engineering, S&T week, summer internships for high school students in research centres, international projects.*

3. *It must be said that the majority of visitors to science centres and museums in Portugal are school children, which are left out of Eurobarometer surveys. Furthermore, most of the exhibitions in these institutions are mainly aimed at children, which in turn helps to explain their lack of popularity among adults. Nevertheless, Portugal has low rates of public participation in all kinds of cultural activities (see, for instance, EC 2007), which is chiefly due to the relatively low average education level of the population.*

References

Beetlestone, John G. et al. 1998. The science centre movement: contexts, practice, next challenges. *Public Understanding of Science* 7: 5-26.

Bell, Larry. 2004. Collaboration and the public understanding of current research. In *Creating connections: Museums and the public understanding of current research*, D. Chittenden, G. Farmelo and B.V. Lewenstein, 163-182. Walnut Creek: Altamira Press.

Delicado, Ana. 2009a. *A musealização da ciência em Portugal.* Lisbon: FCT/Fundação Calouste Gulbenkian.

Delicado, Ana. 2009b. Scientific controversies in museums: Notes from a semi-peripheral country. *Public Understanding of Science*, 18 (6): 759-767.

Durant, John. 2004. The challenge and opportunity of presenting 'unfinished science'. In *Creating connections: Museums and the public understanding of research*, ed. D. Chittenden, G. Farmelo and B.V. Lewenstein, 47–60. Walnut Creek: AltaMira Press.

European Commission. 2005. *Eurobarometer 63.1: Europeans, Science and Technology.* Brussels: EC. URL: http://ec.europa.eu/public_opinion/archives/eb_special_en.htm (accessed January 2010).

European Commission. 2007. *Eurobarometer 278: European Cultural Values*, Brussels: EC. URL: http://ec.europa.eu/public_opinion/archives/eb_special_en.htm (accessed January 2010).

Farmelo, Graham. 2004. Only connect: linking the public

with current scientific research. In *Creating connections: museums and the public understanding of research*, ed. D. Chittenden, G. Farmelo and B.V. Lewenstein, 1-26. Walnut Creek, Altamira Press.

Fehlhammer, Wolf Peter. 1997. Contemporary science in science museums – a must. In *Here and now: contemporary science and technology in museums and science centres*, ed. G. Farmelo and J. Carding, 41-50. London: Science Museum.

Fehlhammer, Wolf Peter. 2000. Communication of science in the Deutsches Museum. In *Museums of modern science*, ed. S. Lindquist, 17-27. Canton: Watson Publishing International.

Field, Hyman and Patricia Powell. 2001. Public understanding of science versus public understanding of research. *Public Understanding of Science* 10: 421-426.

Gregory, Jane and Steve Mille. 1998. *Science in Public: Communication, Culture and Credibility*. New York: Plenum Trade.

Heim, Roger. 2001. Protection de la nature et musées de l'histoire naturelle. *Museum International*, 212, 53 (4): 30-32.

Mazda, Xerxes. 2004. Dangerous ground? Public engagement with scientific controversy. In *Creating connections: Museums and the public understanding of research*, ed. D. Chittenden, G. Farmelo and B.V. Lewenstein, 127–44. Walnut Creek: AltaMira Press.

Miller, Steve et al. 2002. *Report from the Expert Group Benchmarking the Promotion of RTD Culture and Public*

Understanding of Science. Brussels: European Commission. URL: ftp://ftp.cordis.europa.eu/pub/era/docs/bench_pus_0702.pdf (accessed January 2010).

Melber, Leah M. and Linda M. Abraham. 2002. Science education in U. S. Natural History Museums: A historical perspective. *Science & Education* 11: 45-54.

Nair, S. M. 1996. L'écologie entre au musée. *Museum International* 190, 48 (2): 8-13.

Pedretti, Emilia. 2002. T. Kuhn meets T. Rex: Critical conversations and new directions in science centres and science museums. *Studies in Science Education* 37: 1-42.

Schiele, Bernard. 1998. Les sciences de la muséologie scientifique?. In *La révolution de la muséologie des sciences*, ed. B. Schiele and E. Koster, 353-378. Lyon: Presses Universitaires de Lyon.

Ward, Lorraine. 1997. Lessons of Science Box. In *Here and now: Contemporary science and technology in museums and science centres*, G. Farmelo and J. Carding (eds), 83-90. London: Science Museum.

Wark, David. 1997. Neutrinos in a science centre, part II – view from a scientist in a laboratory. In *Here and now: contemporary science and technology in museums and science centres*, ed. G. Farmelo and J. Carding, 73-76. London: Science Museum.

Wynne, Brian. 1995. *Public Understanding of Science*. In Handbook of Science and Technology Studies, ed. S. Jasanoff, G. Markle, J. Petersen and T. Pinch, 361-88. London: Sage.

Critical Listening: An Essential Element in Exhibit Design

CARY SNEIDER

Portland State University, USA

Creative ideas and federal funds provide a good starting point, but they are by no means the most important ingredients in successful exhibit design. The most important part of the process comes after grant funds are received, and you start contacting the people whose story you want to tell, the experts whose input is essential but often contradictory, and the many individuals who have a stake in the outcome. Blending these ideas together into a coherent and entertaining venue for visitors of different ages and interests requires critical listening to all points of view.

This paper discusses three personal experiences to illustrate the importance of critical listening and to define what it means. The first two concern major exhibit projects at the Lawrence Hall of Science in Berkeley, California. The third is a long-term exhibit at the Museum of Science in Boston.

Experience #1:
The Wayfinding Art: Ocean Voyaging in Polynesia

The Wayfinding Art was a joint project of the Lawrence Hall of Science in Berkeley, California and the Bishop Museum in Honolulu, Hawaii with support from the National Endowment for the Humanities (NEH). My personal interest in the project began when I saw a planetarium program from the Bishop Museum about how the ancient Polynesians used the stars for navigating between islands. When our exhibit team learned about the idea they saw an opportunity for an exhibit in the area near our planetarium. Staff at the Bishop Museum had a similar need for exhibits near their planetarium, so the plan

snowballed into a major grant from NEH.

As it turned out I had a lot to learn about how the Polynesians navigated and how they viewed their own history. Prior to this project my major source of information about Polynesian ocean voyaging was *Kon Tiki*, a book by anthropologist Thor Hyerdahl, which I had read in high school. Hyerdahl believed that the Polynesians descended from American Indians whose fishing canoes were blown off course and drifted with the prevailing trade winds to Hawaii, Tahiti, and the other Pacific Islands. They were not able to return home because the winds in those latitudes blew from East to West and very rarely reversed direction.

Our primary informant was Ben Finney, an anthropologist and sailor who took an interest in Polynesian culture and disagreed strongly with Hyerdahl. To demonstrate that the Polynesians purposefully explored the Pacific in sailing canoes he built a replica of the kind of canoe described in the Polynesians' legends and depicted on petroglyphs. Later he co-founded the Polynesian Voyaging Society and helped to build a full-size ocean voyaging canoe called the *Hokule'a*. The many voyages of *Hokule'a*, and other large ocean-going canoes later built by Polynesians from other islands, demonstrated that such canoes could sail into the wind, tack, and perform in other ways much like modern sailboats, and that they could be navigated from island to island across the Pacific ocean.

In many ways the navigational aspect of the project was more challenging that the sailing part. Native Hawaiian Nainoa Thompson reconstructed the ancient skill of

navigation out of sight of land using the stars and waves with the help of Micronesian traditional navigator Mau Piailug. While the exhibit was being planned, *Hokule'a* was sailing throughout the Pacific, demonstrating that the ancient voyages were indeed possible, and creating a renaissance of Polynesian culture in the process.

I gained first-hand knowledge of the Polynesian sailing tradition during an unforgettable voyage on *Hokule'a* from Tahiti to the Tuamotu islands. While waiting for the right sailing weather I stayed at the home of a Tahitian family with Ben Finney and other members of the crew. Ben spoke French and Tahitian, so it was a great opportunity to learn what the Tahitians thought of the project. They recognized the Hawaiians as long-lost brothers and sisters, and did all in their power to support the *Hokule'a* projet and reunite these two branches of the Polynesian community. Although Hawaiians had travelled to Tahiti during modern times, this was the first time in hundreds of years that they had come on an ocean voyaging canoe.

At sea I learned that stars were not always reliable indicators of direction since it often rained. Mau's lifetime of experience taught him to feel the canoe move on waves that maintained their direction over hundreds of miles for many days at a time. All he needed to reset his mental compass was to see the stars for a short time, and then to stay oriented by feeling the rocking of the canoe until he could again glimpse the stars. During this voyage Mau was there as a coach, and his student Nainoa acted as navigator and sailmaster.

When I returned to Berkeley I challenged our planetarium engineer to design a projector that would show the prow of our double-hulled canoe rocking on the waves. The projector had a "rudder" which could be turned to show how the rocking changed as the direction changed. During the participatory planetarium show that was eventually presented for several years running in Berkeley and at the Bishop Museum in Hawaii, the visitors would watch the prow of our canoe and the stars for a while before a thunderstorm disrupted our peaceful voyage. A volunteer from the audience then used the "rudder" to reset our direction by remembering how the canoe moved before the storm. At the end of the program we would test the visitors' navigation skills by seeing the volcanoes of Hawaii's Big Island ahead, or a bleak featureless horizon. Luckily we never lost an audience.

Nainoa Thompson, the remarkable young man who reconstructed methods of non-instrument navigation and inspired a generation of Polynesians throughout the Pacific, was generous with his time and committed to helping us portray the wayfinding tradition accurately and meaningfully. Nainoa was present at a test-run of the planetarium program, and afterwards he commented that while the program was not wrong it did not explain what happens when you cannot see the stars and there are no waves.

As a science educator I had been pleased with the way the show was developing, as it was a good way to communicate to public audiences some basic ideas about astronomy and ocean waves. What Nainoa was communicating went beyond

science. As he later explained on tape in a segment that we added to the planetarium program, after hours on a cold glassy sea, with no break in the clouds, and no waves to guide the way, the wind came up, and he suddenly "knew" which way to go.

Although my science teaching sensibilities initially resisted the idea of knowledge with no obvious source, clearly Nainoa was speaking from experience. Will Kyselka, a planetarium colleague who had helped Nainoa familiarize himself with the sky over hundreds of hours in the Bishop Museum's planetarium, helped me put aside my agenda as a science teacher, and really listen to what Nainoa had to teach me. It was a turning point. By adding a segment in Nainoa's voice the program was greatly enriched. The audience had a more authentic experience recognizing that ocean voyaging was a treacherous undertaking for the ancient Polynesians, and that the skill of wayfinding required full engagement of a navigator's physical and intellectual resources, including some abilities that could not be explained by modern science.

The focus of the floor exhibits also reflected the centrality of ocean voyaging in the settlement of Pacific islands and the spread and maintenance of Polynesian culture. The introductory exhibit at the entrance to the museum featured a model of Captain Cook's ship, the *Endeavor*, and a Polynesian voyaging canoe, with the following signage, based on reports of Cook and his crew:

Did you know that Polynesian ocean-going canoes:

- *Could carry as many people as Captain Cook's Ship?*
- *Could sail faster than Cook's Ship?*
- *Could sail rings around Cook's Ship?*

To find out what the Polynesians did with these remarkable canoes, visit The Wayfinding Art: Ocean Voyaging in Polynesia.

The remainder of the exhibit was developed with the help of many more anthropologists, oceanographers, ship builders, sailors, curators from the Bishop Museum, scholars from the University of Hawaii, science educators, and the warm and thoughtful support of the Polynesian people. It included a diorama of an excavation of an ancient settlement with fragments of an ocean voyaging canoe, and an interactive exhibit on linguistics showing the close relationship of Polynesian vocabulary to languages spoken in Asia (not South America). The Bishop Museum also made available replicas of pottery and stone tools from many islands from which it was possible to infer a timeline showing the order in which the various islands were settled, starting with islands close to the Asian mainland. Another exhibit showed evidence of plants and animals that must have been carried on canoes to equip new settlements with the materials needed for food, shelter, and maintenance of culture. In cases where the anthropologists disagreed we presented both viewpoints with an invitation for audience members to consider the evidence.

And what of Thor Hyerdahl's theory that the Polynesians drifted on a raft from off the South American coast? We did

not want to support his theory since it was contradicted by virtually all the archaeological evidence, the linguistic evidence, Polynesian oral history, and the reconstruction of Polynesian canoes and sailing methods. However, we could not ignore it either since formative evaluation of the first exhibit mock-ups showed that many visitors asked, "What about *Kon Tiki*? I thought it proved the Polynesians came from the Americas."

Eventually we solved the problem by including a panel with four theories: Pedro Fernandez de Quiros (1595) who thought the Polynesians came from a hypothesized Southern Continent. Jacob Roggeveen (1722) who said, "Only Europeans could sail across the ocean, so either they brought the Polynesians to their islands or God put them there." M. Crozet (1771) who thought the Polynesians once lived on a large continent that sank into the sea, and that the islands we see today are the mountaintops of the sunken continent. And finally Heyerdahl (1950) who believed they drifted with the prevailing winds. Visitors could open the panel by pulling a handle to see the evidence for and against that idea.

We also learned an important lesson from our colleagues at the Bishop Museum – that different types of museums use different methods, and there are advantages and drawbacks to each. As a science-technology center the Lawrence Hall of Science valued interactive exhibits in which visitors learned science. Formative evaluation using exhibit mock-ups with typical visitors was the name of the game. We were science educators, not curators. As a natural history museum with a

focus on the Pacific Basin the Bishop Museum had extensive collections. People came from around the world to see its beautifully designed exhibitions of authentic artifacts. Curators at the Bishop museum used detailed scale models to design elegant exhibits, and worked with teams of exhibit designers, builders, curators and scientists.

The development of *The Wayfinding Art* required that we work together to design and build exhibits and develop a planetarium program that worked well in both settings. David Kemble, Chairman of the Exhibits Department at the Bishop Museum, presented a paper on this collaboration at the American Association of Museums in 1986. His paper concluded that there has to be a balance among different methods: model building is necessary to envision the spatial elements of an exhibition, including the flow, pacing and sequence of experiences. Teamwork is essential to efficient design, and periodic review by the entire team can nip a lot of problems in the bud. But neither models nor teamwork can accurately predict public response, which is why formative evaluation of mockups with visitors is important, especially for interactive exhibits.

In summary, lessons learned about critical listening from this project included the importance of:

- Setting aside our own biases so that we can hear with what people have to say about the story we wish to tell.
- Listening to conflicting points of view, and developing ways of telling the story that do not sweep conflicts

under the rug, but instead uses conflicts to engage visitors in thinking about the issues.

- Getting feedback from typical museum visitors early and often, and listening to the ideas they have about the exhibit topic, rather than just paying attention to whether or not they understand what we want them to learn.

- Using opportunities to collaborate with colleagues from other organizations by working towards a common goal, and paying special attention when uncovering differences about goals, methods, and values.

Experience #2: 1492 Two Worlds of Science.
Anticipating the 500th anniversary of Columbus's famous voyage in 1492, we received complementary grant awards from the National Science Foundation (NSF) and National Endowment for the Humanities (NEH) for a travelling exhibition called *Columbus's Great Experiment*.

The idea for the exhibit arose from a conversation with Giuseppe Gambardella, a professor at the University of Genoa, in the city where Columbus was born and learned about sailing, navigation, and the business of international trade and finance. Thanks to Professor Gambardella's extensive knowledge and contacts we were able to dispense with many myths about Columbus, such as the erroneous belief that he "proved" the Earth was round. In fact, the argument was not about the shape of the Earth but rather its size.

When Columbus requested funds from the monarchs of Spain to travel across the "ocean sea" to the Far East, King Ferdinand and Queen Isabella deferred the question to the most learned men in their kingdom. The councillors were aware that Eratosthenes had measured Earth's diameter around 240BC. Various attempts had been made in the intervening centuries to improve on the measurement, but all of the findings indicated that any attempt to reach the Far East by sailing west from Europe would have to traverse a vast and unknown ocean. Given the size of ships and the amount of food and fresh water they could carry, it was likely that Columbus and his crew would die of hunger and thirst before reaching their goal.

Columbus countered by citing references to the smallest estimates of Earth's diameter that he could find, as well as arguments that the extent of the Eurasian landmass was greater that most thought it to be, so that the ocean sea was not so large after all. He also emphasized the economic imperative for making the voyage. Prior to 1492 European merchant seamen had developed a thriving trade at ports in the Mediterranean, where they obtained goods that had been transported overland from the Far East. Around the middle of the 15th century the rise of the Ottoman Empire blocked many of these ports, leading Spanish and Portuguese sailors to compete in finding a sea route to the Far East. When the Portuguese explorer Bartolomeu Dias rounded the Horn of Africa in 1488, Columbus's bold proposal suddenly seemed more attractive to the Spaniards.

The above account was one of three themes that supported our successful bid to the NSF and the NEH to fund the project. A second theme was the phenomenal growth of technology and science in Renaissance Europe, and the spirit of discovery exemplified by Columbus's voyage. The third theme was to be the enormous changes brought about by the European exploration and eventual settlement of the Americans.

We had done our homework that enabled us to write successful proposals. In developing the proposals we listened carefully to historians, museum curators, marine archaeologists, and a great many other scholars in Italy, Spain, and at our home base, the University of California. UC Professor Emeritus Woodrow Borah was especially helpful in understanding the enormous impact of early European voyages on populations of Native Americans.

After we received the funds for the project, the real work began. During the early phases of planning, an exhibit opened in another state concerning the interaction between European explorers and American Indians starting in 1492. It was met with national media coverage of protests by American Indian groups who felt that the exhibition failed to faithfully represent the enslavement of Native peoples by the European explorers. We didn't want that to happen when our exhibit opened in California. Consequently we reached out to American Indians in Northern California.

Some of the American Indians we contacted were both influential and hostile to our ideas. They wanted to know what was so "great" about an experiment that resulted in the

annihilation of entire tribes of American Indians, a process that continued for centuries as Europeans established and expanded settlements. And they wanted to know how Columbus could "discover" a land where people had lived for thousands of years.

Clearly we had a problem on our hands. We did not want to offend American Indians, nor did we wish to offend our local Italian and Hispanic populations. The problem was compounded because funding was dependent on the agreement of other museums to share in the costs of development in exchange for a venue. No museum would sign on if it meant protests at their sites. It was time for us to listen critically, and ask some of our critics to help us figure a way out.

One of the first groups we invited to preview the exhibit mockups we had developed so far was the local chapter of Resistance 500, a vociferous national political group organized to protest activities surrounding the Columbian quincentennial. Eleven members of the organization met with project staff for several hours. They enumerated objections to specific points in the exhibit as well as their overall philosophy. Project staff listened carefully, acknowledged the validity of many of their points and expressed willingness to seriously consider changes. In the days that followed we examined what we had developed so far, and recognized several ways to modify the exhibits to take their input into account.

Had we stopped at that point we might have avoided some

serious blunders. However, we decided to look further for other points of view. That was when our real breakthrough occurred, thanks to Jim Lamenti, Director of the Intertribal Friendship House in our local community. He put us in touch with a number of people who had deep knowledge of Indian technologies in medicine, transportation, housing, and astronomy. We contacted these individuals and began to realize that we had only been thinking of the negative impacts of Europeans on Native Americans. But we had neglected the positive side – that in 1492 American Indians were at least as advanced as Europeans in many respects.

The next few weeks were exciting as we developed entirely new exhibits. These included interactive exhibits on Incan number systems, the Mayan calendar, metallurgy in Peru, pre-contact cities and trade routes, sophisticated methods of agriculture, fishing, and astronomy. We visited the Hupa Indians in northern California who had a tradition of astronomical observations to calibrate a solar-lunar calendar to set dates for hunting, fishing, agriculture, child-bearing, and the various ceremonies that wove these activities into the spiritual life of the tribe. We based a planetarium program on the Hupa system of the universe, and when it was completed we presented it to children on the Hupa reservation. And finally we changed the name of the exhibition from *Columbus's Great Experiment* to *1492: Two Worlds of Science*.

It was also tremendously helpful to have on our team Lee Sprague, an Ottawa Indian, who brought his youthful energy and sensitivity to every aspect of the project. Sometimes Lee

heard comments that we missed, and that made a world of difference in the outcome.

On opening day there were no protests. Although we had included all of the exhibits originally planned to illustrate Columbus's real intent, the arguments over the size of the Earth, the technology of ocean voyaging, and the challenges faced by the sailors on board Columbus's ship, we also had an equally grand exhibition about the Native American capabilities during the same period of time. Many of our visitors were American Indians who came to learn and appreciate more about their own heritage.

But there was one element of the exhibition that was the hardest to solve, and that was the exhibit about what happened on the island of Hispaniola, where Columbus and his crew first landed. Our expert, Woodrow Borah, and many other sources described the terrible fate of nearly the entire population on the island. We decided that an interactive computer exhibit would be inappropriate, so we simply developed an informative panel. The introductory text for the panel read as follows:

> In his journal Christopher Columbus remarked on the peaceful and gentle ways and generosity of the first people he encountered.
>
> The Taino, also called the Arawaks or Lucayos, had a well-defined system of regional government with men and women leaders. Their spiritual life was rich and interwoven with all aspects of their lives. Their mixed planting system was ecologically wise. They also had large dugout canoes, including

some that could carry hundreds of people. Our word "canoe"
comes from the Taino language, as do the words "potato,"
"maize," "barbeque," "manatee," and "hurricane".

The graph on the next page illustrates the decline and
destruction of the Taino people on the island of Hispaniola,
which is known today as the Dominican Republic and Haiti. As
the graph shows scientists have different opinions about how
many people lived in Hispaniola before the Spanish came. But
most modern scholars believe that the population was in the
millions. By 1570 only 125 Taino people were counted.

Although the Taino people and their culture were virtually
destroyed, there is a strong Taino tradition that exists today
on many Caribbean islands. There are also people alive today
who identify themselves as Taino.

Other sections of the large panel show census results of the
Taino population taken by the Spanish, showing a steep
decline through the 1490s, and continuing until well into
the 16th century. There is also information about disease and
slavery as reported by Bartolomé de Las Casas, a Dominican
Friar who came to the Caribbean in 1502.

When we sent our interim report to the National
Endowment for the Humanities, we received a stern letter
from a program officer who objected to the contents of the
panel. The officer pointed out that we were judging the
Spaniards by modern standards. At that time in history
slavery was common throughout Europe. We were warned
against "Conquistador bashing", which was becoming more

common around the time of the quincentennial.

We thought about it for several days. Our facts were well corroborated, but the NEH officer had a good point. It is inappropriate for people from one time and culture to judge others from a different time and culture. The letter noted that we used the term "genocide" to describe what occurred on the island, which certainly constituted a judgment. Then someone on our team suggested that rather than stating that it was genocide, we ask the visitors to consider the question. So we revised the text of the panel to ask: *Was it Genocide?* and we added the United Nation's definition of genocide. That seemed to solve the problem as we explained our solution in a response to our program officer and heard no more about it.

But we were still not satisfied with the panel as the only expression of what occurred when the two cultures met. We wanted to communicate the hardship, but also the surviving spirit of the Taino people. The solution was a play called *The Story of Itiba*, which is about a modern girl of Taino descent who has a dream that she is living back in the time when her people were enslaved by the Spaniards, but still maintained many elements of their culture. The play was based on anthropological and archaeological data as well as Spanish first person accounts. It was presented to many audiences, and was very well received by children, parents, and teachers.

The project also included a second planetarium program entitled *Who Discovered America?* that began by asking the audience who they thought discovered America. Typically, some answered that Columbus discovered America, but

others pointed out he could not have done so since people were already living here at the time. The goal of that part of the program was to engage the visitors in listening to each others' points of view about what it means to "discover" something. Other portions of the program concerned European explorers who may have landed in the Americas prior to 1492, the events that actually led to Columbus's ocean crossing in 1492, and an activity, based on actual events, in which visitors are "shipwrecked" with Columbus and his men for a year.

We also developed a 1492 *School Kit* that upper elementary and middle school teachers can use around Columbus Day.

After opening in Berkeley, California in 1992, *1492: Two Worlds of Science* travelled to Charlotte, North Carolina, Chicago, Illinois, Columbus Ohio, Corona, New York, Durham North Carolina, Flint Michigan, Greensboro North Carolina, Louisville, Kentucky, Lubbock, Texas, Omaha Nebraska, Portland, Oregon, Washington, D.C., and Wichta, Kansas. So far as we know there were no protests at any of these sites.

In summary, lessons learned about critical listening from this project included the importance of:

- Doing your homework by gathering information and advice from experts prior to writing a grant proposal in order to increase the likelihood of funding, and to provide a creative and solid starting point after funds are received.
- Staying abreast of national and international developments and sensibilities both within and beyond the museum field is important so as to avoid

potential missteps and political fallout.

- Confronting potential resistors can be a valuable experience provided museum staff are active listeners and avoid being defensive.
- Presenting controversial issues and positions can sometimes be more acceptable if presented in the form of a question for visitors to consider, rather as factual statements.
- Planetarium programs, plays, school kits, and other supplementary materials in addition to exhibits can extend the experience and expand the audience of museum exhibitions.
- For any given project there are likely to be many people within the local community who have knowledge, skills, and a positive attitude about the role of museums in society. Seeking out and engaging those people can be an important factor in success.

Experience #3: WeatherWise

Robert van de Graaff's high voltage static electricity generator has been an iconic exhibit at the Museum of Science in Boston for 30 years. Created as a research instrument by Professor Van de Graaff from MIT in the 1930s this three-story-tall instrument is used daily in live programs that demonstrate the tremendous power of lightning to the Museum's 1.2 million exhibit hall visitors each year. Many people come back to the Museum just to see this source of artificial lightning one more time.

Although the lightning program continued to attract many visitors, most left the dark cavernous space that housed the generator immediately after the program. It was time to figure out how to better use the space and the opportunity afforded by the lightning program to bring several audiences into the hall each day.

As we thought about ways to better use the darkened hall, we kept returning to the idea of weather. Prior efforts to use the generator to teach about the nature of electricity met with limited success. People loved seeing 20-foot lightning bolts accompanied by a loud *Crack!* of thunder. Visitors sat on the edge of their chairs as the presenter's cage was lifted upwards toward the menacing silver spheres. Only after lightning struck did the presenter explain that the cage served as protection, as would an automobile in a lightning storm.

There was so much more that people could and should learn about weather, we started to brainstorm ideas for an exhibit that would invite people to stay after the show and learn more on their own at interactive exhibits. We knew that the subject of weather in New England had a lot of potential. Given the variability and occasional severity of weather in the region people frequently checked the forecast on radio or TV. Major television stations competed with each other and the Weather Channel to have the best weather report since many viewers tuned in to plan their days' activities.

In addition to listening to ideas from our creative staff in the Programs and Exhibits Divisions we invited local experts – meteorologists from television stations, climate researchers,

and educators from TERC, the organization that pioneered educational uses of computers in science and mathematics.

Among our small group of experts, who volunteered their time to help us develop key ideas for a proposal, was Mish Michaels, an experienced and energetic meteorologist from Channel 4, and one of relatively few women of color who was both a scientist and well-known personality in the greater Boston area. Mish's description during one of the meetings of how she puts together a weather forecast was riveting, starting with her early morning drive to the station as she observed clouds, to her work in the studio, checking on satellite images and computer models of regional weather patterns, before developing a forecast.

Mish had also been instrumental in working with teachers and school children in the region who had weather stations installed at their schools. Data from the stations helped Mish develop an accurate forecast, and each day a different school was featured on the morning weather report. Mish agreed to be the exhibition's "anchor." She would work with the production crew at her station to develop a series of videos to orient people to the exhibit.

The core idea for the exhibit came from Dan Barstow, then a Director of TERC's Center for Earth and Space Science Education. Weather was Dan's avocation, and he had taught himself how to do a *nowcast*, which was a short-term prediction of the weather at a specific location a few hours in advance.

The idea to develop an exhibit that would teach people

to make a nowcast was very appealing since it had obvious practical value. Television forecasts could only predict the weather for a region, not a specific location. But people needed to know what to wear when the left the house. Do they need an umbrella or a winter coat? Should they go on that bike ride or go to the gym? A forecast of 50% chance of rain is not as helpful as knowing that it will start raining at your house at about 2:30pm. By checking a Doppler radar map it is possible to make that kind of detailed prediction.

We sent in a proposal to NSF's Informal Science Education program a few weeks later. It included funds to design and build a series of interactive exhibits surrounding the Van de Graaff lighting generator. It also included a subcontract for Channel 4 TV to make videos for use in the exhibit and for broadcast TV, providing both useful weather information and telling people about the exhibit. TERC also received a contract to develop a website that would teach anyone in the greater Boston region how to predict the weather for a particular place and time a few hours in advance. It was to be a portal that would connect people directly with the data that they needed and show them how to use that data. We were sure we had a winner.

We were awarded funding by NSF a few months later. Reflecting on previous internal difficulties in communication we started with a meeting between key personnel from the Exhibits and Programs Divisions to set guidelines for our work. It was especially important to keep channels of communication open since major programs and exhibits

needed to coexist and support each other. We cast the net broadly within the museum for specific ideas, and the project began to take shape.

Over the years program officers at NSF had grown to respect the value of independent evaluations. In contrast to the two projects reported above, where formative evaluation was performed by staff and consultants, it was required that we have an independent evaluator. So in addition to formative testing with exhibit mockups, accomplished by our staff, we contracted with Selinda Research Associates to serve as independent evaluator.

The evaluator assigned to the project, Eric Gyllenhaal, was conscientious and thorough. His assignment was to conduct front end, formative, and summative evaluation studies. We held a number of telephone conferences and he made a number of trips to our site to discuss the project. Eventually he interviewed visitors who visited our second-generation mockups, and came back again to evaluate the final exhibit designs.

Front-end evaluation is a study of typical visitors before detailed exhibit components are developed. By interviewing our visitors on the museum floor, Eric found that nearly all visitors said they paid attention to weather and weather forecasts daily, usually by checking a forecast on TV. But the pattern changed dramatically when visitors needed a short-term forecast. For that purpose the most popular choice was the Internet. The visitors seemed to know and at least partially understand some of the "facts" about weather but they had

difficulties coordinating them into an appropriate explanation of what was happening, and why. Children and adults expressed a remarkable variety of alternative understandings [misconceptions] about basic weather processes on all scales, from micro-processes of evaporation and condensation, through the shape of raindrops, to the genesis of lightening and thunder, through the ultimate causes of rain. Finally, visitors had a special interest in extreme weather events, but little understanding of why they occur.

Exhibit planners interpreted these findings as support for the idea that visitors needed some explanations of weather phenomena, such as warm and cold fronts, so they could better understand what they heard on TV broadcasts. But also that people do have a need for short-term weather forecasts (nowcasts). As we listed the various concepts that people would need to understand basic issues and make their own nowcasts we realized that some of the issues were global, some regional and some local. We developed icons to orient people to these three levels of weather phenomena.

We then proceeded to develop and refine a set of exhibits. Some were designed to teach nowcasting explicitly, while others provided a broader context. *The Weather Corridor*, for example, was an immersive exhibit in which people walked through a simulated cold front, so they could feel the different air masses as they walked along a map of terrain, and viewed simple diagrams to explain what was happening. *The Storm Watch Living Room* explained how severe storms developed by placing people on a comfortable couch in front of a TV,

with explanatory information as a severe storm could be seen developing through a window. *The Video Den* provided information from Channel 4 on TV monitors in a comfortable seating area for older visitor, and a section on Global Weather with spectacular globes provided the broader context. The website developed by TERC also became one of the exhibits with assistance in using the web to learn how to do nowcasting.

We thought that we had covered all the bases, and we thoroughly tested all of the components with visitors. Eric Gyllenhaal, our evaluator came back to interview visitors for the summative evaluation. Here were his overall findings, dated October, 2006:

Visitors seemed engaged with the WeatherWise exhibition physically, socially, emotionally, and intellectually. Many visitors spent minutes at computer interactives, the immersive Storm Watch Living Room, and the Video Den. Many visitors walked through the Weather Corridor twice. Social engagements were also strong, as visitors sat side-by-side at the computers, explored Global Weather as a group, and narrated their immersive experiences as they sat through the thunderstorm in the living room or walked through the Weather Corridor. We also noted a wide range of emotional engagements in WeatherWise, including enjoyment of the exhibits, just the right amount of fear in the immersive exhibits, and frustration with several exhibits that malfunctioned or were difficult to use and understand. Visitors' intellectual engagements took place on many levels. Many respondents told us about things they had learned, or been reminded of, in the exhibits, and visitors

practiced higher-level thinking skills at the Winds computer and Fog Tornado. Looking at the range of visitor engagements, the WeatherWise exhibition seemed to provide a satisfying experience for most Museum visitors.

There were smiles on our faces when we read the above. But then we read on to see if the major point of the exhibit had been accomplished:

Most visitors thought WeatherWise was a general exhibition about weather. Some respondents zeroed in on one particular aspect of the exhibition that had particularly impressed them, such as extreme weather, weather prediction, advances in weather technology, or the scales of weather discussed throughout the exhibition. These perceptions reflect the goals of the WeatherWise project, with one exception; none of our respondents specifically said the exhibition was about nowcasting. In fact, many respondents had completely missed the term "nowcasting," despite the fact that the word appeared at least once at almost every exhibit.

Eric analyzed the reasons that people did not grasp the term *nowcasting*. He noted that "nowcasting was an unfamiliar concept and a somewhat confusing term for most visitors." He made a number of specific recommendations and concluded that, "With appropriate remediation, many more visitors could leave the exhibition thinking of WeatherWise as the place where they discovered nowcasting and started to learn how to make their own nowcasts at home."

Given prior experiences in exhibit development we reserved some of our funds for remediation, and a final-final evaluation. Over the next ten months we made many improvements. We were determined to communicate the idea of nowcasting, as we had promised in our grant proposal. Here is the final post-remediation findings dated August, 2007, ten months after the previous report:

> Working with limited funds and staff time, the remediation was somewhat successful at focusing visitors' attention on the concepts and skills of nowcasting. More visitors learned about nowcasting in the exhibition than during the previous evaluation, largely because the staffed activity carts and some of the remediated exhibits effectively introduced them to the term nowcasting and exposed them to nowcasting skills. That said, some visitors still showed limited understanding of nowcasting. Few visitors spent enough time-on-task to develop their nowcasting skills to any great extent. However, some visitors recognized that they had already been practicing nowcasting skills at home without calling them by that name.

Reflecting on the overall effectiveness of our effort, we had accomplished nearly all of our goals. We had transformed a dark uninviting space into an engaging exhibit about a topic that nearly everyone cared about. It was a solid museum experience, and visitors learned a lot about weather. Thanks to the contributions of Mish Michaels and the Weather Team at Channel 4, the exhibit was anchored by a scientist and a woman of color. Our friends at TERC created an excellent interactive

website[2] after also receiving several rounds of critical reviews. And thanks to improvements we made during the last year of the project many more people learned about nowcasting.

However, in hindsight I realize that as the Principal Investigator of the project I failed to listen critically to a sentence in the summative evaluation report that others had mentioned before: "nowcasting was an unfamiliar concept and a somewhat confusing term for most visitors." At other points Eric had said that the visitors understood the idea of a "short-term weather forecast," but I was blinded by what I had written in the grant proposal. Had we eliminated the term "nowcasting" and substituted "short-term weather forecast," I believe that we would have been successful on all fronts.

In summary, lessons learned about critical listening from this project included the importance of:

- Deciding whether or not it is necessary to introduce a new term or concept in order to communicate the most important ideas in an exhibit.
- Hiring an independent evaluator to bring an objective lens to a project.
- Conducting front end evaluations to learn about visitors' needs and interests and to frame the major challenges of a project.
- Conducting formative evaluation alone isn't enough, nor is a combination of formative and summative evaluations. It is helpful to allow for additional rounds of modification and evaluation for exhibits to reach their full potential.

The first two examples in this chapter – *The Wayfinding Art* and *1492: Two Worlds of Science* – concern exhibitions that tell stories about different cultural systems. As museum educators we knew that visitors were interested in the cultures of indigenous peoples and we saw these efforts as a means to satisfy our visitors' interests as well as teach some basic scientific concepts and methods. It is not surprising that we encountered conflicting messages. Looking back, I would say the exhibitions were better as a result of our efforts to listen critically to different points of view, and develop solutions that illustrated all sides of an issue, and engaged visitors in thinking about these issues rather than trying to resolve them neatly.

The third example, *WeatherWise*, would appear to present a simpler case since it had the single goal of communicating about weather in New England at a personal level, so that individuals would feel empowered to make their own more specific weather forecasts. And although we listened carefully and thoughtfully to our visitors and our independent evaluator we did not accomplish all of our goals because we tried to do something that was very difficult – introduce a new term. I'm convinced that had we simply used the term "short-term forecast" we would have accomplished all of our goals. That final case illustrates another element of critical listening – processing what we hear at a sufficiently deep level to cut through our expectations and biases, and make the changes necessary to reach the full potential of our exhibits.

Notes

1. *Except where otherwise specified, references to "we" in the text refer to my colleagues at these two institutions, and especially my mentors Jennifer White, Director of Exhibits at the Lawrence Hall of Science and Larry Bell, Vice President for Exhibits at the Museum of Science in Boston.*

2. *http://www.mos.org/weatherwise/*

References

Wayfinding Art: Ocean Voyaging in Polynesia

Finney, Ben (1976). *Hokule'a: The Way to Tahiti*. New York: Dodd, Mead, and Company.

Finney, Ben (1976). *Pacific Navigation and Voyaging*. Wellington, New Zealand: Polynesian Voyaging Society, Inc.

Gladwin, Thomas (1970, 1974). *East is a Big Bird*. Cambridge, MA: Harvard University Press.

Golson, J. (1962, 1963). *Polynesian Navigation: A Symposium on Andrew Sharp's Theory of Accidental Voyages*. Wellington and Sydney: A.H. & A.W. Reed.

Holmes, Tommy (1981). *The Hawaiian Canoe*. Hanalei, Kaui, Hawaii: Editions Limited.

Heyerdahl, Thor (1950, 1990). *Kon Tiki*. New York, Simon and Schuster.

Jennings, Jesse D. (1979). *The Prehistory of Polynesia*, Cambridge, MA: Harvard University Press.

Kane, Herb Kawainui (1976). *Voyage*. Honolulu, Hawaii: Island Heritage Ltd.

Kirch, Patrick Vinton (1985). *Feathered Gods and Fishooks*. Honolulu, HI: The University of Hawaii Press.

Kyselka, Will (1987). *An Ocean in Mind*. Honolulu, HI: The University of Hawaii Press.

Kyselka, Will (1987). *North Star to Southern Cross*. Honolulu, HI: The University of Hawaii Press.

Lewis, David (1972, 1975). *We, The Navigators*. Honolulu, HI: The University of Hawaii Press.

Lindo, Cecelia Kapua (1976). *A Resource Curriculum Guide on Polynesian Voyaging.* Honolulu, HI: Polynesian Voyaging Society.

Parkinson, Sydney (1984). *Journal of a Voyage to the South Seas.* Hampstead, London: Caliban Books.

Sneider, C. and Kyselka, W. (1986). *The Wayfinding Art: Ocean Voyaging in Polynesia, A Collection of Essays.* Lawrence Hall of Science, University of California, Berkeley.

1492: Two Worlds of Science

Bakeless, J. (1961). *America as Seen by its First Explorers: The Eyes of Discovery.* New York: Dover Publications, Inc.

Boorstein, D.J. (1983, 1985). *The Discoverers: A History of Man's Search to Know His World and Himself.* New York: Vintage Books.

Brown, L.A. (1949, 1977). *The Story of Maps.* New York: Dover Publications, Inc.

Morley, S.G. (1975). *An Introduction to the Study of the Maya Hieroglyphics.* New York: Dover Publications, Inc.

Millanich, J.T., and Milbrath, S. (1989). *First Encounters: Spanish Explorations in the Caribbean and the United States, 1492-1570.* Gainsville, FL: University of Florida Press.

Morison, S.E. (1978). *The Great Explorers: The European discovery of America.* New York: Oxford University Press.

Morison, S.E. (1942). *Admiral of the Ocean Sea.* Boston: Little, Brown and Company

Nabhan, G.P. (2002). *Enduring Seeds: Native American Agriculture and Wild Plant Conservation.* Tucson, AZ: University of

Arizona Press.

Pike, R. (1966). *Enterprise and Adventure: The Genoese in Seville and the Opening of the New World*. Ithaca, NY: Cornell University Press.

Sale, K. (1990). *The Conquest of Paradise: Christopher Columbus and the Columbian Legacy*. New York: Alfred A. Knopf.

Sharp, S. (1963). *Ancient Voyages in Polynesia*. Auckland, New Zealand: Longman Paul Ltd.

Shimada, I., and Merkel, J.F. (1991). Copper-Alloy Metallurgy in Ancient Peru, *Scientific American*, July, 1991, pp. 80-86.

Stuart, G.S. (1995). *America's Ancient Cities*. Washington, D.C.:National Geographic Society.

Wilford, J.N. (1981). *The Mapmakers: The Story of the Great Pioneers in Cartography from Antiquity to the Space Age*. New York: Vintage Books.

WeatherWise

Editors of the Boston Globe (2007). *Great New England Storms of the 20th Century*. Boston: Boston Globe.

Gyllenhaal, E. (2007). *Post-Remedial Evaluation of WEATHERWISE for The Museum of Science, Boston*. Selinda Research Associates, Inc. August 2007.

Gyllenhaal, E. (2006). *Remedial/Summative Evaluation of WEATHERWISE for The Museum of Science, Boston*. Selinda Research Associates, Inc. October, 2006.

Gyllenhaal, E. (2004). *Annotated Bibliography for the Front-End Evaluation of Predicting the Future Exhibit*. Selinda Research Associates, Inc. October, 2006.

Henriques, L. (2000). *Children's misconceptions about weather: A review of the literature.* Paper presented at the annual meeting of the National Association of Research in Science Teaching, New Orleans, LA, April 29, 2000. Online at: http://www.csulb.edu/~lhenriqu/NARST2000.htm

Meteorologist Mish Michaels http://mishmichaelsweather. com/

WeatherWise at the Museum of Science, Boston http://www. mos.org/weatherwise/

WBZ Weather Almanac http://wbztv.com/almanac/WBZ. Weather.Almanac.2.576347.html

Zielinski, Gregory A. (2005). *New England Weather,* New England Climate. University Press of New England.

Forming a Museum of Mathematics

GEORGE W HART, CINDY LAWRENCE,

TIM NISSEN & GLEN WHITNEY

Museum of Mathematics

New York, USA

Mathematics is the foundation for all the sciences, yet science museums contain relatively few exhibits that highlight mathematical topics. Currently, only a handful of traveling exhibits focus on mathematics, and there is no museum in North America dedicated to math. We believe there is a great need for more math content in the museum sphere. With this in mind, we are creating an innovative Museum of Mathematics.[1]

The first piece of our strategy was to create an overall structure for the museum development process. Our founder, Glen Whitney, spearheaded the project by shifting from the field of quantitative finance to working full-time on the creation of the Museum. He assembled a core of energetic volunteers, began the process of recruiting a diverse and talented board of trustees, and obtained private funding in the millions of dollars. Consultants helped us gauge the resources needed to establish a permanent site in a variety of possible locations, ranging from suburban academic spaces to Manhattan. A volunteer advisory council including math educators and researchers was established to provide guidance, write a mission statement, suggest possible content, and perform countless organizational tasks.

We adopted a strategy to gain design experience by creating a high quality traveling exhibition before moving into a permanent site. We sent a Request for Proposal (RFP) to several design firms and hired Ralph Appelbaum Associates (RAA) as lead designer. Our advisory council provided a rich database of ideas that served as an excellent starting point.

Figure 1: Overview of Math Midway at World Science Festival, June 14, 2009.

After extensive brainstorming about how to transform mathematical ideas into exhibits, we settled on the theme of a *Math Midway*. This exhibition provides a colorful and visually engaging carnival atmosphere while conveying the idea that math is fun. It also serves as a tangible illustration of what a math museum might be like. We struggled with the details of how to disseminate significant math content in hands-on interactive exhibits that provide *Aha!* moments in novel ways. A wide selection of content was included, targeting audiences from preschool to adult. We requested bids and hired fabricators in New York, Philadelphia, and Boston to do the detailed design and construction of over twenty major exhibits.

An offer to participate in the World Science Festival gave us the impetus to initiate an intense construction phase. This

culminated in the *Math Midway's* highly successful premiere at the World Science Festival street fair in Manhattan. (Fig. 1) Excellent press from the *New York Times*, *The New Yorker*, and other media outlets helped spread the word of our effort, attract additional volunteers, and secure several bookings for the *Midway*.

With this focused year-long experience, we are poised to move beyond the *Midway* and take the next steps toward creating The Museum of Mathematics: selecting a permanent site, advertising for professional museum staff, and developing additional exhibits. However, much can be learned by reviewing the past year's experience as the *Math Midway* moved from conception to reality.

Goals and objectives

It is helpful to consider the objectives of the *Math Midway* exhibit within the larger context of the establishment of the country's only museum centered on mathematics. We will design the Museum of Mathematics to enhance public understanding and perception of mathematics; to stimulate inquiry, spark curiosity, and reveal the wonders of mathematics; and to demonstrate the evolving, creative, human, and aesthetic nature of mathematics. In creating the *Math Midway*, we wanted the exhibit to reinforce these same goals while stimulating support for creation of a national museum of mathematics. Therefore our goals were two-fold: first, to include exciting, dynamic, engaging content to have a significant impact on the visitor's view of mathematics,

Figure 2: Visitors have fun with giant puzzles at the Math Midway.

and second, to demonstrate what a hands-on museum of mathematics could be like and generate ample support for creation of the Museum itself.

In generating appropriate content, there were several hurdles to overcome. Perhaps the primary difficulty we faced was that there are many commonly held misconceptions about math. We wanted to demonstrate that mathematics goes well beyond the mundane, repetitive calculation methods that the word *math* often brings to mind, and we wanted to overcome preconceived notions that math is difficult, boring, or static.

Another difficulty we faced was that mathematics involves a certain level of abstraction. We wanted our exhibits to celebrate mathematics by highlighting its inherent beauty. This involved bringing somewhat abstract concepts within

reach of visitors of all ages and backgrounds. We wanted the exhibit to showcase mathematics as a primary field of study, not simply as a tool for supporting or explaining other areas of science. Therefore our exhibits needed to be about mathematical concepts themselves, rather than simply providing mathematical explanations of physical phenomena.

Overcoming these hurdles involved several subgoals: specifically, we wanted the exhibit to convey the notion that *Math is cool!* and to demonstrate that math is found all around us. A key objective was finding ways for visitors to experience the Aha! moment of discovery that mathematicians find so compelling, albeit on a level that was attainable to a wide range of visitors. Often, this involved taking something familiar and presenting it in an unusual light. Our goal was for visitors to experience math as playful and engaging rather than rote and mundane. (Fig. 2)

Several of our exhibits demonstrate the mathematical ideas underlying real world experiences. Too often, people conceive of mathematics as something found in a school textbook, never to be used again once one graduates. The *Math Midway* exhibit tries to turn this notion around by showing how mathematical concepts surround us in everyday life.

Although creating excellent content was a primary goal, a second but equally important goal was to create positive momentum for the creation of America's only museum centered on mathematics. When the opportunity to participate in the World Science Festival arose, we seized it despite the

short timeframe involved. The entire team was driven to create a top-notch, hands-on exhibit in just a few months, and we worked hard to make this happen. Our efforts paid off when, at the World Science Festival street fair, the *Math Midway* drew over 4,000 visitors in one day. In addition, the exposure generated that day created a wealth of connections that served as stepping stones and resulted in a groundswell of support for creation of the Museum of Mathematics. The success of the *Math Midway* at the World Science Festival also served to enhance our credibility in the world of science and technology centers, demonstrating that we have both the intent and the capability to create a world-class museum. Our success that day also significantly improved our ability to attract capital investment. Finally, creation of the exhibit proved to be a valuable learning experience on which we will be able to draw when creating a permanent museum.

Organization

Turning from the motives and objectives of the *Math Midway* project, it is helpful to consider the way in which the effort was organized and the people who were involved. A brief history of the Museum of Mathematics will aid in setting this context. The initial idea to create America's only museum dedicated to the wonders of math originated with Glen Whitney. A hedge-fund analyst who formerly taught mathematics at the University of Michigan, Whitney had visited the Goudreau Museum, a "small hands-on" mathematics museum in Herricks, New York, years earlier.

While coaching an elementary school math club, he learned that the Goudreau had closed. Over the following months, he gradually resolved to turn this disappointment into an opportunity, embarking on an ambitious project to create a new museum of mathematics—one which could ultimately be not only self-sustaining but have a broad and lasting impact.

Clearly for such a project to succeed, it would need the involvement and input of many people. That sense of collaboration has become a guiding principle for both the Museum and for the *Math Midway* exhibition in particular. Whitney reached out to those who had been involved with the Goudreau Museum as well as friends and colleagues interested in math education. In particular, he made an early connection with Cindy Lawrence, a CPA and director of the Gifted Mathematics Program at Brookhaven National Laboratory. She put him in touch with Bruce Waldner, president of the Nassau County Association of Math Supervisors, who had operated a Pi Day celebration in conjunction with the Goudreau Museum. They were able to gather a number of math educators and former volunteers from the Goudreau Museum to create an informal Working Group tasked with creating the new mathematics museum.

To facilitate communication among members of the Working Group, Whitney created a simple website[2] that helped foster an informal, collaborative style of working and allowed individuals to contribute at varying levels of involvement and intensity. This site has been instrumental in the development

of both the Museum and the *Midway* exhibition. There are currently hundreds of members, and the website helped us organize Working Group meetings, coordinate volunteers for *Midway* events, write explanatory text for *Midway* exhibits, and most importantly, collect hundreds of exhibit concepts for the Museum. This latter collection proved to be one of the most valuable assets in getting the museum project off the ground.

Shortly after the organizational meeting, Glen Whitney also reached out to George Hart, a mathematical sculptor and research professor in the Computer Science department at Stony Brook University. Hart and Whitney found they shared a vision of creating an interactive immersive mathematical environment to help convey the beauty and elegance of mathematics. Hart quickly became an integral part of the organizational team and a key content advisor for the Museum.

With the seed of the organization in place, the group began to reach out to many people from different backgrounds, seeking advice and input. Whitney and Hart discussed the museum project with mathematicians in both university and industry settings, K-12 math educators, museum professionals, politicians, etc. They hoped to gain access to expertise in informal education, math enrichment programs, museum operations, curriculum development, fund raising, and many other pertinent topics.

Gradually through this outreach, a more articulated structure developed. The Working Group remained the core

body of volunteers executing the nascent museum's activities. The Museum began to acquire a Board of Trustees from a variety of industry and philanthropic backgrounds to help govern and garner support. The Museum also assembled an Advisory Council consisting of mathematics professionals from various fields to oversee and guide intellectual content.

Amidst this formative activity, the Museum was invited to provide math programming for the June 2009 World Science Festival. That opportunity helped to coalesce previously vague plans to create a traveling exhibition, and Cindy Lawrence stepped up in December 2008 to chair a committee of the Working Group to create the exhibition. Realizing that the Museum did not have sufficient in-house expertise to design and build such an exhibition, Lawrence quickly put together a Request For Proposal for designing a traveling math exhibition. The RFP went out in mid-January 2009, and Lawrence quickly became another integral member of the Museum's organizational team. Acting as chief of operations, Lawrence helped oversee all logistical aspects of the project, including design and development, marketing and public relations, and internal communications. Together, the core team guided the Museum from its initial conceptual stage toward the realization of a physical location.

After careful review by the Working Group and Trustees, the Museum of Mathematics chose Ralph Appelbaum Associates as the design partner for the math exhibition. The RAA team assigned to the project was headed up by Tim

Nissen, an architect and former lead exhibition designer at the American Museum of Natural History. Tim and his crew dove into the project, and soon Tim was himself a key part of the intensive design process for the *Math Midway*, which stretched from the beginning of February nearly to the date of the World Science Festival itself. Nissen became an integral member of the team that brought the *Math Midway* to life.

The organization had to adapt to the needs of the *Math Midway* after its debut at the World Science Festival, and needed someone to oversee the *Math Midway*: to contact potential venues, manage the bookings, arrange the logistics of packing and trucking, supervise installation and take-down, order consumables, and provide a contact point for assistance to museum personnel. The Museum also needed someone to write curriculum material related to each exhibit and provide a facilitator for class visits. Malia Jackson, who has both museum and classroom experience, agreed to take on this important role.

Design constraints and principles

The design process had to occur under a number of unusual constraints, and was guided by a number of principles key to the approach and philosophy of the Museum of Mathematics. On the constraint side, the exhibition was being created by a nascent organization lacking any existing building, facility, or even regular meeting place. It had no shop to create prototypes and no visitor flow to test concepts. Moreover, there was an incredible crush on time: the design contract

was awarded February 6, 2009, and the exhibition was to be on the street on June 14. Given that the World Science Festival street fair was a one-day event, the *Math Midway* could not under any circumstances be delivered late.

On the other hand, we had many assets to bring to bear in the design process. We had a wealth of experience among the educators in the core group and advisors. Worthy of particular mention in this regard is Ken Fan, a math Ph.D. and organizer of *Girls' Angle*, a math club for girls. Fan provided insight as to how students, especially girls, would react to the exhibits. We also had a good mixture of math specialists (Whitney, Hart, and Fan) and non-specialists (Lawrence, Nissen) in the core group of content designers. This mixture allowed us to balance deep mathematical content with accessibility to the general public.

The enormous database of exhibit concepts accumulated on mathfactory.org also played a huge role in our design process. We were able to focus on filtering and selecting the optimal combination of exhibits from a strong supply, rather than scrambling to find enough material to fill an exhibition hall. Selection of appropriate math content was driven by an evaluation of the extent to which each exhibit idea was engaging, feasible, robust, and cost-effective, as well as how it fit into the overall midway theme. RAA reported that it was uncommon for the client to be so closely involved with the content aspects of the exhibition, and this helped speed development. Throughout the design process, the mathfactory.org website also allowed us to solicit additional

content assistance from the Working Group when necessary.

Designing a math exhibit forced us to grapple with a number of issues, some of which pertain to science exhibits in general, and some of which are unique to mathematics. Each abstract concept we hoped to convey to visitors needed to have a realization that would turn it into an engaging, physical, tactile interaction, but then had to be presented in a way that the abstract concept would be appreciated by visitors. We could not rely on a working familiarity with many of the concepts, since they came out of branches of mathematics outside the standard curriculum. For example, in an exhibit on soap films in a physics exhibition, designers can draw on visitors' previous experiences with soap bubbles. Not so with an exhibit on group theory. In addition, since math may suffer from pre-existing negative attitudes, there was a premium on making the individual exhibits particularly inviting and immediately engaging. We wanted visitors to play first and ask questions later. Fortunately, mathematics lends itself to visualization and is often spatial, graphic, or sculptural, so we were able to capitalize on this to draw in visitors.

In designing the *Midway*, we also were faced with some pedagogical decisions. Should we have a historical perspective? Who should be our target audience? Should the individual exhibits have a sequential narrative or should they be independent? How deep should the mathematical content be? Should we try to cover specific topics such as algebra or probability? Should we be tied to any standardized curriculum goals, and if so, which ones? In the end, we decided to focus primarily on math content that ties

to exciting or insightful activities.

We also needed to consider the physical aspects of the exhibition. Since the *Midway* was intended to travel, the planning and design were informed by the general requirements of traveling exhibits, as opposed to permanent exhibits designed for a particular space. This offered a level of freedom in planning: there was no particular overall footprint configuration, no specified entry and exit, and no physically defined square footage requirement. Given the tight schedule, the initial plans called for a 1200 square foot exhibit, which was small for a typical traveling exhibit, but also provided a reassuringly limited scope. In addition, it allowed the budgeted resources to be more highly concentrated on a per square foot basis, which permitted us to be more imaginative in our initial design. The footprint that was initially proposed ultimately grew to occupy 4500 square feet. This considerable increase resulted from a number of factors, including the incorporation of appropriate circulation space around the exhibits and the creation of several physically expansive exhibits.

Traveling exhibits benefit from being as adaptable and reconfigurable as possible. The layout flexibility of an exhibit is enhanced if it is composed of a non-hierarchical set of experiences, with no preferred sequence. In contrast with historical exhibits, which have a temporal sequence, or exhibits which need a set of prerequisite presentations to build to a conclusion, the *Midway* is, by and large, a set of independent exhibits. While this approach was taken

because it fitted the pedagogical approach for the content and the anticipated behavior of the visitors, it was clear that a free-form, node-based exhibit would also pay dividends in terms of its layout flexibility. Furthermore, it was particularly appropriate in the circumstance of the premiere venue at the World Science Festival, an event with multiple uncontrolled points of entry. It should also be noted that it was not considered essential to include every math concept presented, so venues with smaller halls could exclude exhibits without losing essential content or clipping an overall narrative.

We also needed to consider cost constraints. The *Midway* was initially designed to comprise six carnival booths, but cost overruns led to a reduction to four. We redesigned many exhibits to clamp onto booth frames instead of being freestanding, as a way to save money. We made hard decisions about which exhibits to cut, and we revised designs to be more cost-effective. A team of Working Group volunteers helped with some fabrication tasks.

Math Midway exhibit

After considering the initial design constraints, it was time to focus on a specific theme. Three organizing motifs were considered: *A Journey Through the Dimensions*, *Giant Puzzles*, and the *Math Midway*. *Journey Through the Dimensions* was rejected as too restrictive, and there was concern that *Giant Puzzles* would not be universally appealing, so the *Math Midway* was selected. As an existing mode of exhibition, a midway is a recognizable delivery system of experiences. It

was hoped that the midway metaphor, by virtue of its deep pedigree, would be easily separable in the visitor's mind from the mathematical concepts being put forth. In addition, using a theme that was eclectic by design allowed us to incorporate aspects of the Dimensions and Puzzles themes within the midway framework.

The midway concept was especially appropriate for the World Science Festival. With most of the exhibitors under tents provided by the festival, as well as performances and demonstrations in the open air, a midway concept was a natural fit. The tents, each of which were only 10 feet by 10 feet in plan, could contain individually themed booths, complete with signage, perhaps even hawkers. Acceptance for the festival required a presentation to the organizers, and it was thought that a midway theme would be attractive to them. The concept was met with enthusiasm; however, due to space constraints, we were initially limited to three tents. As the design concepts developed and the need for more space became evident, a series of open-air exhibits developed, and a promenade exhibit area emerged for the street frontage addressed by the tents.

Besides the comfortable fit within an outdoor festival, a midway presents several advantages independent of the nature of the hosting venue. A midway is a place for events, action, participation, wonder, fun, and social engagement. It has appeal across generations. A midway is naturally eclectic and can absorb concepts with relative ease. Indeed, the team felt the midway concept was sufficiently elastic to incorporate

elements suggesting the circus as well as amusement park rides. The theme of each booth takes its cue from traditional midway genres and park rides: a gypsy's booth (*Mysterious Harmonograph*), a booth with games of chance (*House Takes All*), a hall of mirrors (*Fun House*), and physical adventure (*Daredevil Alley*). The use of booths allowed for creation of small themed worlds containing related concepts within compelling and spatially efficient environments. An aluminum framework provided a handy support structure for intermediate fabric walls, exhibit components, graphic panels, and overhead lighting.

The brash and engaging graphics of circuses and midways evolved to entice all ages. A circus poster presents itself as news, with bold headlines in splashy colors. These attributes seemed perfectly matched to the need to attract and engage visitors with presentations about mathematics. And if mathematics could first be framed and then experienced as a delightful adventure, one of our major goals would be achieved. We incorporated this motif in developing signboards that were used to relate visitors' fun experiences to the underlying math. A carnival-like *Step Right Up* graphic provided instructions, while *Here's the Math* text added explanations of the underlying mathematical concepts.

The *Math Midway* exhibition itself consists of over twenty exhibits, distributed among four booths and a promenade area. Space does not permit a detailed description of the entire exhibition,[3] but selected exhibits are highlighted below.

The iconic exhibit of the *Math Midway* is *Pedal on the Petals*

Figure 3: Pedal on the Petals Exhibit: Take a circular ride on square wheels.

(Figure 3). This wildly popular exhibit showcases the fact that math can be used to design a perfectly mated road for any shaped wheel, or in more general terms, a gear system that meshes together fluidly. Visitors pedal two tricycles made with square wheels: a large trike for adults and teenagers and a small trike for young children. The steering is set so the two trikes move in opposite directions around the circular track. Surprisingly, the ride is perfectly smooth because the special track is contoured to compensate mathematically for the square shape of the wheels. Creating the custom trikes and track was a significant project, since every aspect of the design required research and experimentation. As we gain experience in various venues, we are learning more about the degree of maintenance and adjustment required, e.g., how the custom tires wear.

The *Roller Graphicoaster* demonstrates how mathematical concepts can be used in roller coaster design. It allows the user to configure a custom roller coaster and then time how long it takes a car to roll from start to finish. This exhibit brings up an important problem in mathematical optimization – how to choose the fastest possible trajectory between two given points – which engages visitors as they enjoy the downhill dynamics. This is a technically ambitious exhibit, as it works like a piece of laboratory equipment with hundredth-of-a-second timing and extreme configurability, yet it must be robust and intuitive to use. We repeatedly redesigned and rebuilt many aspects of this exhibit to address initial design flaws. However, the problems we worked to correct were apparently significant only to us, not to visitors, who enjoyed using it in each stage of its evolution.

The *Ring of Fire* (Fig. 4) presents the user with an eye-safe plane of laser light into which large plastic polyhedra can be positioned. The lasers illuminate a visible cross section of each 3D form. This intuitive exhibit is hugely popular for the Aha! effects it creates. Visitors are typically surprised, then delighted, to discover that one can cut a cube to find a regular hexagon as its cross section, or find a square slice in a triangular pyramid. The exhibit encourages open-ended discovery by providing an assortment of shapes to slice and also a plastic human model in which to create CAT-scan-like cross sections. Keeping the lasers exactly aligned in a common plane requires a precision adjustment mechanism, which originally was not sufficiently stable, but was corrected with a

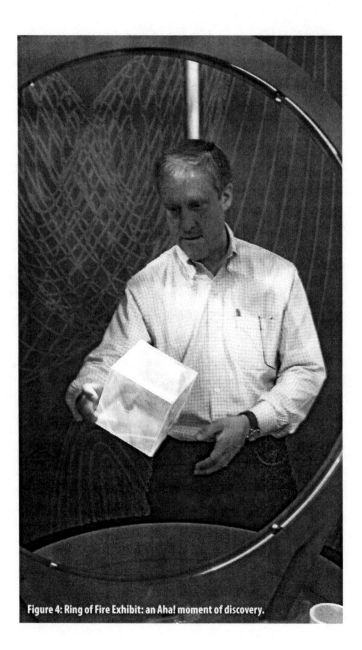

Figure 4: Ring of Fire Exhibit: an Aha! moment of discovery.

redesign. A maintenance problem is that the acrylic polyhedra can crack if abused. We chose low cost models based on an analysis that it would be less expensive to sometimes replace cracked polyhedra than to incur the expense of making them highly robust.

Funny Face is a software-based video transformation exhibit. Images of the visitor from a video camera are distorted in real time according to mathematical operations with user-selected parameters. Visitors interact with the distorted face on a screen and then can take home a color printout of their face labeled with the mathematical transformations they chose: *This is your face. This is your face on $y=y+a\ sin(x)$.* The natural interactivity and the take-home photo make this very popular, but color printing supplies can be costly. To address this issue, we enhanced the software so the hosting museum can select between free printouts at the exhibit or printing via the network at the museum store, where a fee can be charged. As a high-tech exhibit, it had some typical problems with software updates and equipment compatibility, but they were quickly resolved because we had close access to our software designers.

The *Organ Function Grinder* (Fig. 5) is extremely engaging because of its musical content. It behaves like a calculator, with inputs transformed into outputs via mathematical operations. In addition, as the user turns the crank, an internal algorithm generates original pieces of calliope music specific to the calculation. Because of its high complexity – an optical reader for the inputs, a printer for the outputs, an internal paper roll,

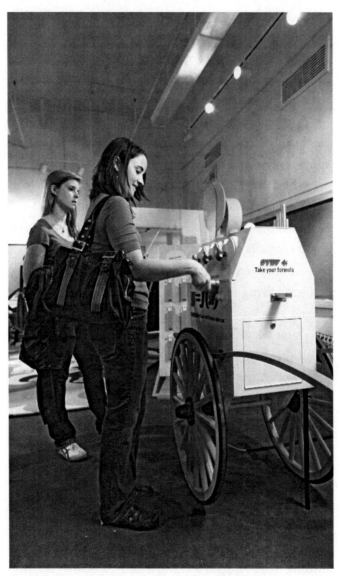

Figure 5: Visitors enjoy the sights and sounds of the Organ Function Grinder

function dials, an organ crank, lights, a music synthesizer, and an internal computer – there are many ways it might fail. An enormous amount of equipment and wiring are packaged inside the exhibit, so it is important to have easy access to technical support experts if problems arise.

A pleasant surprise for us was the great success of *A-Maze-ing Math*. This is a large walk-through maze with an unusual *no left turn* rule that gets visitors thinking in new ways. We discovered that visitors enjoy the social dynamics of having a crowd around the outside, cheering on the maze walker. It becomes a collaborative spectator sport of sorts, in which the crowd excitedly shouts suggestions to help find the solution route. Educationally, it is an opportunity for identifying problem-solving strategies, such as working backwards from the end.

A large magnetic tile board called *Miles of Tiles* is a big hit for all ages (Fig. 6). It is appropriate for visitors as young as preschool age, yet even adults love it. In addition to familiar regular polygon shapes, we fabricated custom magnets of tessellating monkeys, and rhombuses that make a chaotic Penrose tiling. There are many magnets available and the activities are open-ended, so visitors can be engaged for long periods.

One thorny exhibit is the *Universal Wheel of Chance*, a large wheel of fortune which visitors can spin. It clicks loudly, slows, and then stops in one of 100 positions. Such a wheel is an iconic midway object and people are immediately drawn to it. They love to spin it and see where it lands, but we haven't yet

Figure 6: Miles of Tiles: Open-ended exploration for adults and kids alike.

come up with an ideal math application. We worry that trying to teach about probability can backfire because sometimes low-probability events happen, and we don't want to give a false lesson in those rare situations. However, it was designed with a magnetically replaceable panel for its graphics, so new activities will be easy to implement. What exactly they will be remains an open problem for us.

On the road

Since its June 2009 debut, the *Math Midway* exhibit has traveled to a variety of locations, in part due to connections made during the World Science Festival. For example, an enterprising teacher from a New York City alternative high school saw the exhibit and immediately contacted us about bringing the exhibit to her school. In addition, the Director and Chief Content Officer of the New York Hall of Science

was impressed enough by the exhibit that he invited us to display it in his institution. The *Midway's* one-day debut was instrumental in generating interest, support, credibility, and opportunity.

After leaving the World Science Festival, the exhibit was installed at the Urban Academy, an alternative high school on Manhattan's upper east side. Here was the first real proving ground for the exhibit. Many school groups, ranging in age from kindergarteners to high school seniors and even adults, came to experience the exhibition. Museum staff learned why it is important that exhibits be robust, as well as which concepts worked well and which did not. Firsthand observation allowed us to refine some of the exhibits, to create an appropriate user guide for each exhibit, to experiment with related curriculum, and to make real-world observations of the way in which visitors interacted with the exhibition. The heavy demand for school group visitation reinforced our belief that there is a need for innovative math programming, and demonstrated that teachers and students alike are enthusiastic about experiencing mathematics in a new way. We also learned about traveling the exhibit, including the trade-offs between crating and blanket-wrapping (protection vs. cost) and the need to carefully evaluate potential venues (the size of doorways, existence of a loading dock, and ceiling heights all proved critical in the installation and de-installation of the exhibit). In addition, the museum made useful connections from the variety of visitors that were able to stop by the exhibition because of its convenient Manhattan location.

The *Math Midway* next traveled to Allentown, Pennsylvania, where it made its science center debut at the Da Vinci Center. Here for the first time the exhibition was on its own, and we learned about the ability of the exhibits to stand independently without constant oversight from Museum of Mathematics personnel. We also learned about which exhibit experiences suffered without a docent nearby, and identified additional robustness and wear-and-tear issues with increased use. The need for troubleshooting from a distance, and the occasional unexpected need for a site visit, were learning experiences that further underscored the need for robust exhibit design. Despite occasional performance glitches, venue personnel remained tremendously enthusiastic about the exhibit. We also learned about issues that are important to venues, such as the ability to more tightly control the cost of consumables. Heavy school group demand further supported the idea that the Museum of Mathematics is an idea whose time has come.

In the midst of the run at Da Vinci, we extracted a few key exhibits to accompany us to the annual ASTC (Association of Science-Technology Centers) convention in Fort Worth, Texas. We also brought the popular *Pedal on the Petals* exhibit to a museum in Dallas, creating a two-pronged approach to increase exposure. Museum personnel in Dallas completely installed the *Pedals* exhibit even before they received the installation guide, a testament to its user-friendly design. And in Fort Worth, hundreds of delegates from U.S. and international science and technology centers visited our

booth, dozens asked for information about renting the traveling exhibition, and some even expressed interest in buying copies of specific exhibits.

As we go to press, we are poised to begin a run at the New York Hall of Science (NYSCI). This venue, being much larger than the Da Vinci Center, will surely provide new feedback about the exhibit and how we might improve it. Curriculum will be expanded, and we will host several events and private tours to raise awareness of the exhibit, the Museum, and their shared goals. With this venue being in the backyard of our desired Manhattan location for the permanent museum, publicity generated will likely prove critical in moving our mission ahead.

Evaluation and conclusion

Overall, our assessment of the exhibit is very encouraging, though of course as the designers we are biased. It is too soon for any formal assessment as we are still refining the exhibition. We have no museum infrastructure yet to do any scientific evaluation of what visitors learn or remember, so we can only present informal evidence of its reception. Our favorable assessment is founded on observing the positive reactions of visitors. We have many photos of happy faces. Visitors are engaged and asking us mathematical questions. They tell us they are having fun, and we've watched them enjoy solving puzzles and explaining their thought processes.

One independent measure of quality is the good press that the exhibition has received. *The New Yorker* understood what

we are about when it said, "The idea behind the museum, which doesn't yet have a home, is that math is ubiquitous, [and] supercool..." [4] Reporting on the World Science Festival, the *New York Times* said the *Math Midway* "turned the common conception of mathematics into a circus of square-wheeled tricycles, giant blocks and simulated roller coasters... combining the mobility of a state-fair swath of carny booths with the slick execution of an educational theme park." [5] And *MAA Focus*, the news magazine of the Mathematical Association of America, ran a beautiful color article highlighting many aspects of the exhibit. [6]

Another quantifiable measure is the demand from teachers wanting to schedule school visits to the exhibit. When we set up the exhibit temporarily at the Urban Academy in Manhattan, we emailed area teachers that they could sign up to bring their classes for field trips. We ran an open house evening for them to experience the exhibit themselves. The response was overwhelming. Beyond filling all the available class slots in the six-week period, we collected a waiting list of over 250 teachers who wanted to bring classes but were turned down because there were no more open slots. Similarly, while the exhibit was housed at the Da Vinci Science Center, attendance increased 33% over the comparable period of the previous year.

Yet another measure of quality is the reception we received from the museum community at the ASTC conference in Fort Worth, Texas. We were delighted to find demand for our exhibit exists not just on the east coast, but also around

the country and even beyond. Interest from venues in Texas, California, Canada, the Netherlands, Belgium, and Israel proved further just what a scarcity of math exhibits there is, and solidified our desire to create America's only museum centered on mathematics.

Another component of our evaluation is to assess the technical robustness of the exhibition. We learned that every exhibit is an experiment, and the *Math Midway* is a testing ground for each of its component exhibits. Working with our consultants, designers, and fabricators, we had intended that each exhibit be robust enough to withstand years of heavy public use. But in the field, we quickly learned that some needed refinement, strengthening, or redesign. We also learned that different fabricators had different strengths, particularly in regard to engineering design choices that affected robustness. And we learned two things about the design of high-tech exhibits: first, that it is ideal to negotiate for ownership of the software, so that there is greater flexibility in later troubleshooting, and second, that having the fabricator hire the software staff is a good idea so that there is only one point of contact when troubles arise. Fortunately, the free-flowing nature of the *Math Midway* allowed any part to be removed and sent back to the shop for reworking without adversely affecting the overall experience. Budgets must be planned with these contingencies in mind.

One measure of an exhibition's usability is how well it presents itself to visitors in the absence of any museum docents. At the World Science Festival, roughly 4,000 visitors

attended in one day, and we had dozens of expert volunteer docents on hand to guide them. Docents were also able to distribute special math coins that we designed as prizes. With a traveling exhibition, trained docents may not be available near each exhibit. To address this concern, we made the exhibits as self-explanatory as possible, using signboards to convey key information to visitors. The nature of the docent-free experience is something that we wonder about and would like to address with a formal study in the future.

As an assessment exercise, we have reflected on each exhibit to assess its particular strengths. In terms of our visitor experience criteria – Aha! experiences, learning that math is everywhere, realizing that math is fun, and seeing math in new ways – we rank the *Pedal on the Petals* and the *Ring of Fire* as very successful in every category. We look to them as models of what we wish to embody as we start to design the permanent museum that is to follow.

In sum, we see many ways in which the *Math Midway* is working very well. We also have seen some exhibit robustness and maintenance issues that have challenged us to redesign and rebuild a few pieces after they were in the field. Overall, the positive reception the *Midway* has received encourages us to forge ahead with our mission. Our experiences in designing the *Math Midway* will serve as an important reference for us as we continue the process of creating America's only museum centered on mathematics.

Notes

1. http://momath.org

2. http://www.mathfactory.org

3. http://mathmidway.org

4. Nick Paumgarten, "Math-hattan," The New Yorker, Aug. 3, 2009.

5. Dominick Tao, "The Math Midway Takes Shape. Go Figure," NY Times, City Room, http://cityroom.blogs.nytimes.com/2009/06/15/the-math-midway-takes-shape-go-figure/, June 15, 2009.

6. Tim Chartier, "A Mathematical Circus," MAA Focus, December 2009/January 2010.

COMMUNICATION AND EVALUATION

Market Simulation at the Interactive Museum of Economics

SILVIA SINGER & CARMEN VILLASENOR

MIDE (Museo Interactivo de Economía)

Mexico City

MIDE, the Museo Interactivo de Economía, (Interactive Museum of Economics) was created at the behest of the Banco de México (Central Bank of Mexico) to encourage a culture of economics in Mexico. It invites visitors to discover new ways of understanding economics, to realize that their everyday lives are closely linked to economic processes, and to appreciate how access to information can allow them to better deal with current and future personal and social economic challenges.

MIDE's commitment is to help citizens understand economic processes and has four main objectives:

- To provide a place that revolves around visitors' needs and interests.
- To offer an educational model that addresses the different forms of learning and levels of knowledge of its visitors.
- To present diverse groups of people with alternative ways of relating to economics.
- To be a place for meeting, discussion and reflection while promoting cultural diversity.

The project began nine years ago, and the museum was opened five years later. We have not heard of any other museum dedicated solely to the understanding of economics. We had no point of reference in establishing the message the museum intended to convey nor in developing our exhibits. We therefore relied on the science museum model to create the MIDE experience.

The two biggest challenges we faced were the architecture (museography) and the exhibition theme (economics). The museum is located in the old Bethlehemite Convent. An 18th century building, it is a part of Mexico City's historic center. We focused on:

- Respecting the building's value as part of Mexico's architectural and historical heritage.
- Incorporating the old with new technology.
- Designing exhibits around the history of the building.

The exhibition theme

Economics is a topic surrounded by preconceptions, most of which are negative. Therefore, we sought to confront the complexity of the subject matter by establishing our credibility. We aimed to create a place that introduced basic economic concepts without offering opinions. We wanted to allow people to enhance their knowledge and form their own opinions. Our slogan is: *We are all a part of the economy.*

The project began with contributions from a range of specialists: the Central Bank's economic research division, industrial and graphic designers, museum and exhibit design professionals, educators, communicators, lawyers and administrators. This professional perspective was complemented by another group we believe is vital: visitors. Using an ongoing evaluation program and beginning with front-end evaluation, we learned about potential visitors' interests, preconceived ideas, misconceptions and attitudes –

which all influenced the design of the museum as we adapted it to the needs of the public.

Without a collection to determine the design of the museum, our starting point was the visitor's experience. The next step was to draw up a master plan for the disposition of the themes and to establish the type of experience we wanted to create in each location. The exhibit designs, and the proposals for their implementation, were assessed using formative evaluation to create and correct both equipment and content.

MIDE presents a series of everyday situations in which visitors embark on a fun trip through the science of economics, using visual, auditory and tactile experiences that are divided into themes:

1. The Basic Principles of Economics
2. Institutions and Economics
3. Growth and Wellbeing
4. Money and the Numismatic Collection
5. Voices of the Building: The History of the Building
6. We will soon have a new area on Sustainability.

The museum exhibits use cutting-edge technology which allows for visitor interaction. In addition to stimulating discovery, dialogue and reflection, this means of communication encourages group interaction. This technological approach transcends the recreational experience and is complemented by other museum techniques: exhibits, total immersion experiences in thought-provoking environments, laboratories and other hands-on exhibits.

The Market Simulator experience

The *Market Simulator* exhibit is an economic experiment that fulfils the key requirements of today's science museums:

- It allows visitors to fashion their own experiences and build on prior knowledge.
- Technology enhances the visitor experience, but the real interaction lies in person-to-person communication (guides-visitors-guides and visitor-visitor).
- It is focused on visitors and was developed through a thorough evaluation process.
- It is a hands-on experience since it depends on visitor input; it is a minds-on experience because it requires the use of cognitive skills; and it is a hearts-on experience because, prompted by our guides, visitors yell, get wound up, excited and emotionally involved.

The public has hailed the *Market Simulator* as one of the prime attractions in the museum. It was awarded the 2007 *Gold Muse Award* of the American Association of Museums in recognition of the highest standards of excellence in the use of media and technology for interpretive interactive installations.

Description

The *Market Simulator* is a group experience within the *Basic Principles* exhibition area. Twenty visitors – ten buyers and ten sellers – participate in an imaginary market, each carrying a

PDA device that assigns a maximum sale or purchase price and registers each transaction. For easy identification, sellers wear blue vests and buyers, orange. The PDAs are attached to each vest and both the vest and the PDA have a seller or buyer identification number.

Based on the dynamics of the exercise, the goal is for each participant to obtain the largest possible profit. The PDA shows buyers the minimum sale price, while sellers are shown the maximum purchase price. Profits are obtained for what the sellers are able to sell above the minimum price and what buyers can buy below the maximum price.

The exhibit is located in a specially-built room with screens that show the trend in prices determined in the transactions,

the price of the last transaction performed (in real time), the time remaining for each round, the good or service that is being exchanged and the price range for each transaction. A bell rings each time a transaction is finalized. The room has an area for other visitors to watch the progress of the game.

Dynamics

Once all the particpants have their vests and PDAs, they vote on the goods or service to be traded on the market (apples, trips, chocolate, movies, spaceships or shoes). Two guide-mediators are available to help. Further details on how to use the PDAs are given on screens.

Three 3-minute rounds are played. In each round, buyers and sellers negotiate a sale or purchase and agree on the price of the transaction. During the rounds, visitors usually shout and jump up and down to obtain the best prices.

Every finalized transaction between the participants is recorded on their digital devices, which calculate the earnings or losses on the trade. The PDA makes a record, changes the players' maximum and minimum prices and sends the transaction price to a central processor, which in turn charts the price changes on two screens in the exhibit.

When the simulation is completed, the guide-mediator reviews the results on the screens with the visitors and together they interpret the results, thereby reinforcing the significance of the exhibit, and explaining how interaction between buyers and sellers can determine prices. Finally, they applaud the two sellers and buyers with the largest profits.

In the design and evaluation process, we initially found the instructions for the exercise long and complicated because many variables needed an explanation (for example, how to interpret the data on the PDA device, how to reach a compromise and finally how to record a transaction.) After close observation, we realized that the dynamics were better understood if players first watched another group doing the exercise. This resulted in redesigning the room to allow the group waiting their turn to observe players from a raised walkway encircling the exhibition room.

The results have been positive. We have observed and assessed the process and a single simulator session takes approximately 30 minutes. However, if one group first observes another, we can complete two sessions in 45 minutes.

In addition to streamlining the flow of visitors, the groups begin their rounds with much more confidence in terms both of the dynamics of the exercise and the use of the PDAs, which can be complicated, especially for older people and those not already familiar with them.

Objectives and messages

Objective: To experience the fact that in one market-type mechanism, the prices of goods and services are determined by supply and demand.

Message: The market is an exchange system in which people who want a good or service (buyers) interact with people that can supply the desired items (sellers). The price allows both buyers and sellers to negotiate the terms of the exchange.

Educational objectives: Visitors negotiate between themselves, carry out transactions and learn that supply is characterized by the act of sellers offering goods and services; and that demand is the act carried out by buyers. This experience is then translated into familiar situations to understand that the market is basically the interaction between buyers and sellers.

Mental abilities used: mental arithmetic, comparison, identification.

Making it possible for people to choose the goods or service to be exchanged allows us to reinforce the idea that the market is any interaction between buyers and sellers and not a physical place.

Context

The exhibit leading into the *Market Simulator* is *The Advantages of Exchange* which focuses on the concept of absolute advantage: how some people are better at certain activities than others and that, from an economic standpoint, it is better for us to do the activity we are good at and to satisfy our other needs by the exchange of goods and services. This exhibit is located in the hall where visitor groups wait to enter the *Simulator* and it shows images of different kinds of markets: the currency market, the market for goods and services, the metals market, the land market, the job market, the stock market and the securities market. This hall also features graphics showing the history of bartering and the use of money, as well as the benefits which the use of currency brought to exchanges.

The exhibit found on leaving the *Market Simulator* is *What Mexico Exports*, which presents exports as Mexico's comparative

advantage over other countries. In other words, Mexico is more efficient at producing certain goods and services because of the resources we have, which is why Mexico produces these goods and services to exchange with other countries.

This entire area helps visitors become familiar with exchange-related concepts (specialization, comparative advantage and absolute advantage) and with the predominant market system in Mexico (supply, demand, price and medium of exchange).

Each exhibit is self-contained and can be relatead to most of the other exhibits. For example, the *Market Simulator* can be linked to the *Numismatics, Minting Money* or *Future of Money* halls in the *Money* area to explore the evolution of money as a means of exchange. It also is related to *Price Movement* and *How Inflation is Measured* in the *Institutions and the Economy* area to explain how to measure inflation. The exhibits can also be visited in order since MIDE also offers a linear approach for those who want to follow it. This way, we can satisfy the needs of visitors with different interests.

Visitor experience

The exhibit enhances visitor experience because:

- It is a collective exhibit with many people participating at the same time.
- Sometimes, people who do not know each other participate and still need to interact. This builds collective knowledge and leads to discussion from different points of view.

- Interaction is reinforced by means of person-to-person dialogue using technology as a means to open the lines of communication.

The exhibit also allows us to explain part of the market system and the law of supply and demand in simple terms and to relate it directly to people's everyday lives:

- We have all been buyers at at some time and many of us have been sellers.
- A sales transaction familiar to everyone is carried out.
- All buyers try to get the best possible price so as not to spend all their money.
- All sellers try to obtain the largest possible profit from their sales.

By using these everyday situations, visitors can experience the way the prices of goods and services are determined.

The exhibit is just one of many experiences that reinforce the principal message the museum aims to communicate: We are all a part of the economy. We want visitors to realize that, perhaps unwittingly, they are already part of the economy. And the museum tries to make that clear.

Challenges

The *Market Simulator* is based on an experimental economic simulation game created by Michael Watts. The *Market Simulator* experiment originally used cards which assigned buyers a maximum, and sellers a minimum, price. Visitors recorded prices on their cards – the price of the transaction and the profit – and there was a board to record the transactions and later create a convergence graph. The excercise is used in universities and in research. Our challenge was to transform it into an interesting, lively exhibit – and keep it simple.

We worked with consultants and used ongoing evaluation to find the best way of adapting the experiment and to develop software that would simplify the activity.

This experiment normally uses some kind of incentive or prize to ensure that players avoid losses, calculate potential profits before deciding to finalize a transaction, or look for ways to obtain the highest possible profit. If this behavior becomes the norm, three rounds are enough to clearly establish the equilibrium price within the price range. In our first evaluations, we found that groups do not necessarily

reach the equilibrium price (which is the objective of this experiment and an indicator of whether the activity is being done properly). Two theories were given to explain this. The first was that we were not incentivizing visitors to make decisions as they would in real life. The second was that since recording depends on visitors' ability to do mental arithmetic, they can make mistakes.

We ran an evaluation to test both theories. People are more accurate when there is an incentive and the activity requires that participants pay close attention to several variables. This last aspect was solved with the use of a PDA that automatically calculates and records the transaction. As to an incentive, we opted for a round of applause for the two best buyers and sellers at the end of the activity. Both strategies worked in most cases, but not in all. In other words, we do not come to an equilibrium price in every simulation session. However, this does not affect the explanation of the concepts being explored.

The use of technology has allowed 10 to 13-year-olds – who found it difficult using cards – to play because it lowers the level of difficulty. Children under ten can play with the help of an adult.

The challenge lay in taking all the components of the exercise, the enormous number of variables involved in the original experiment, and recreating it in such a way that it preserved the most important elements of the game and gave visitors a meaningful experience within a 30-minute period.

Evaluation

The process of evaluation followed for this, and for most, exhibits was as follows.

Front-End Evaluation: In the early days of the project, several surveys were taken to discover people's preconceived ideas, misconceptions and interests on the topic of the economy. The content of elementary level textbooks was studied to see how key economic topics were presented.

Formative Evaluation: Evaluation was undertaken in four phases (three using the card version and one with the physical exhibit) which gave us guidelines for designing the software, the activity itself, the space needed, and the visuals.

The first phase evaluated the prototype with 257 students divided into 13 groups in Grades 4 to 6, middle school and high school. The activity was carried out at their schools because our building was still under restoration and was deemed unsafe for groups. The material needed for the activity (cards) was taken to the schools. During these sessions, we used an observation checklist and a questionnaire with open and closed questions. We also interviewed a sample of the participants from each group. Incentives or prizes were not used and the buyers and sellers were identified by yellow and blue caps.

The results showed us that:

- Participants thought the activity was fun, especially because it is lively. It promoted interaction and communication, although we were unable to see how groups of strangers would come together.

566 · MARKET SIMULATION

- The instructions were much more difficult than the game itself. During the first round, participants were very confused, but felt more confident from the second round on.
- Participants did not look at the board showing the prices of the transactions. This information would have helped them in their negotiations.
- Four-minute rounds gave better results than three-minute rounds.
- Participants would whisper to each other in an attempt to finalize transactions between each round to get ahead and win.
- Using mental arithmetic made it difficult for them to record the profits gained in the transactions.
- In most cases, the concept of price performance was understood.
- The terms *supply* and *demand* were unknown to them.
- A distinguishing emblem is indispensable to streamline the game.
- Some participants, especially younger ones, often confused losses with profits.

In the second phase, we also visited schools. Sixteen groups with a total of 406 elementary, middle, high school and now university students were evaluated. In this phase, changes were made to the game based on the results of the previous evaluation. We used an observation guide and a combined

questionnaire to gather information. The evaluation was also modified and new objectives were added. We wanted to see whether the variables of the experiment were met in order to understand when an equilibrium price was reached and when it was not, such as whether visitors carried out a larger number of transactions. The good or service was changed to an imaginary one: "chicuilines". We replaced the caps with buttons to identify buyers and sellers.

The results showed us that:

- Younger participants were more enthusiastic, but still had difficulty in understanding the instructions and calculating profits.
- Participants thought it was a stimulating activity. Older participants were initially indifferent, but steadily got involved and by the second round were fully immersed, yelling at and negotiating with each other.
- The instructions were simplified, but it was necessary to begin by giving an example. The game was much easier in practice than in theory.
- Price information posted on the board was not used.
- Using buttons to identify the players made the game more difficult because they are too small.
- An equilibrium price was not reached in half the cases.
- The message was clear, but the concepts were not. The mediators should have closed the session by reviewing the important concepts with the group.

The third phase consisted mainly of trying out different kinds of instructions. One model would be tested and changes would be made immediately for the next group and so on. From this phase, we obtained the final version of the instructions, to be modified only for PDAs and screens.

This evaluation was carried out with the participation of three groups of adults at the museum, 15 schools (elementary, middle, high and university) in their classrooms and a mixed group composed of families (with ages ranging from 10 to 68) in the museum.

We used incentives (movie tickets) for the three best buyers and sellers and the equilibrium price was reached in most cases. We also made a few observations to add the finishing touches to the design.

During the entire evaluation process, information was gathered which was directly reflected in the exhibit:

- A raised walkway allows waiting participants to watch the game underway to simplify the mechanics of the activity.
- A bell which rings every time a transaction is finalized and a price appears on the screen draws attention to information participants will find useful.
- PDAs give a profit statement each time a transaction is finalized, thus avoiding confusion due to mistakes in calculation.
- The PDAs are automatically blocked between each round, until the guide-mediator unblocks them at the beginning of the following round, thus preventing

visitors from playing outside time limits and enabling them to use the time between rounds for questions.

- Age-appropriate scripts were developed to reinforce the message and present the main concepts.

The last phase was carried out with groups using the physical exhibit. These tests helped us put the finishing touches to the instructions and the activity. They also helped us determine the kind of visuals needed, the relevance of the screens and the appropriate age group for the exhibit, as well as make minor adjustments to the length of the rounds and the activity in general.

This observation also allowed us to discover that vests were the best and easiest way of identifying buyers and sellers. We also found out that a lot of time was wasted in handing out PDAs that corresponded to the number on the vest, so we decided to attach the PDAs to the vests. We adjusted the timeframe for each round to three minutes because the devices reduced the time needed to finalize a transaction. This also allowed us to anticipate certain aspects of the flow of visitors and to manage the exhibit within the context of the museum as a whole.

Throughout the time the museum has been open, we have strived to improve the exhibit continuously through feedback from our guides on the comments overheard and visitors' opinions. As a result, we have adjusted the activity, the instructions, and other elements. This experience has taught us that evaluation can turn a good idea into a great exhibit.

Conclusions

The *Market Simulator* satisfactorily meets the museum's objectives:

- It has been created around the needs and interests of visitors, who have significantly contributed to its creation.
- It addresses different forms of learning and that is why it contains varied visual, aural and especially social stimuli.
- It helps us explain our current economic model, which we believe leads to enhanced critical reasoning skills in our visitors.

For the team, the *Market Simulator* and the development of the museum in general has been an experience that has enriched us as communicators, brought us closer to our visitors, reasserted the role of technology in interactive activities and allowed us to grow as a team that promotes awareness about the economy.

4.
AN EPISODE
FROM THE PAST

"…Collected in one view" Some Early Concerns with Staging Science in the 1876 London Exhibition of the Special Loan Collection of Scientific Apparatus

ANASTASIA FILIPPOUPOLITI

Democritus University of Thrace, Greece

The opening of this Exhibition may prove an epoch in the science of Great Britain. We find here collected, for the first time within the walls of one building, a large number of the most remarkable instruments. Gathered from all parts of the civilized world, and from almost every period of scientific research. The instruments, it must be remembered, are not merely masterpieces of constructive skill, but are the visible expression of the penetrative thought, the mechanical equivalent of the intellectual processes of the great minds whose outcome they are.[1]

On May 16 1876, William H. Spottiswoode (1825-1883), mathematician and physicist – later to become President of the Royal Society of London – had argued among other things for the intellectual connection between scientific instruments and processes at the opening lecture in the Physics section of the conferences held in connection with the Special Loan Collection of Scientific Apparatus, an international exhibition held in London the same year. He then continued to add another vivid comment:

There have been in former years, both in this country and elsewhere, exhibitions including some of the then newest inventions of the day; but none have been so exclusively devoted to scientific objects; nor so extensive in their range as this. There exist in most seats of learning in museums of instruments accumulated from the laboratories in which the professors have worked; but these are, by their very nature, confined to local traditions. The present one is, I believe, the first serious,

or at all events the first successful, attempt at a cosmopolitan collection.[2]

These two statements capture the rationale behind the making of the Special Loan Collection of Scientific Apparatus. Studying this historic episode offers an opportunity to map the main attributes of a 19th-century science exhibition; thus it gradually allows us to start a typology of display techniques applied to narrate science to the public. From the perspective of the study of museum histories, it echoes the development of a national science museum and the surrounding ideologies for national science education and the public. In an address delivered at the British Association for the Advancement of Science meeting in Glasgow in 1876, the President, Thomas Andrews, noted that:

this exhibition [the Special Loan Collection] will be, it is to be hoped, the precursor of a permanent museum of scientific objects, which like the present exhibition, shall be a record of old, as well as a representation of new, inventions.["3]

What had changed dramatically since the early decades of the 19th century was the fact that science had been displaced from being the leisure activity of gentlemen to a necessary benefit to be passed down to the lower classes in the form of scientific and technical instruction. And that included large-scale exhibitions too. This episode clearly places the materiality of science as a historic episode in the understanding of artefact/ idea interrelationships. In addition, re-reading an international

exhibition from the past unveils the trajectories that scientific objects follow across a variety of locations and reflects links between people, institutions and ideas that are not necessarily otherwise explicit. Science collecting and the museum have been the subject of substantial research in historiography and have given rise to significant publications in the field of the history of science as well as museum studies.[4] Underpinning this activity is the idea that material culture contributes essentially to the processes of knowledge construction and also illuminates the evolution of particular ideas and practices. Yet, the emergence of histories of science on display has been rather less explored by these two fields of research.

In the 1870s, most of the once-contemporary material culture of science was redefined as national heritage in order to argue for the founding of a national museum for the physical sciences. In 1874, the Fourth Report of the Royal Commission on Scientific Instruction and the Advancement of Science considered the museums of London and some university colleges.[5] It pointed out that the physical sciences had achieved satisfying results and that it was desirable that the national collections "should be extended in this direction, so as to meet a great scientific requirement which cannot be provided for in any other way."[6] The taxonomies that were used to separate the different types of collections touched upon the need for a national collection of scientific instruments and mechanical artefacts, united and placed under State authority. The conceptualisation of specialised museums was contemporaneous with the idea of thematic international

exhibitions. Up to that time, only natural history, with its geological, zoological and botanical collections, was pursued in provincial museums and field clubs. Natural history was illustrated in the British Museum, but there was no national collection of the instruments used in the investigation of mechanical, chemical, or physical laws.[7] Scientific apparatus were still to a large extent in private hands and in the scientific institutions that used them, a situation that permitted many of them to slip into obsolescence.

By then, the South Kensington site comprised of art and science schools, the Department of Science and Art, the National Art Library, the Royal Horticultural Society and Gardens, the Royal Albert Hall for Arts and Sciences, the National Portrait Gallery, the East India Museum and the museum of naval architecture. The South Kensington Museum was founded in 1857 as a different kind of pedagogical tool. It was part of a plan for improving science and art education that had been started by the Royal Commission for the 1851 Great Exhibition. Contemporary descriptions distinguished this museum from other, older establishments:

> Other museums may find their ultimate purpose in collecting and thus preserving from ruin antiquities, curious relics, illustrations of the habits and history of nations...but [the South Kensington Museum] has ever in view the supply of known intellectual wants, the supplementing [of] the incompleteness of popular education.[8]

The area was ideal as it permitted visitors to escape the

overcrowded city centre. Effective manipulation of the physical space was related to the plan of classifying collections.[9] That is to say that, while the British Museum with its natural history collections could serve as a research resource, the South Kensington complex intended to be more public. Although it was established far from the city centre, one visitor to the South Kensington Museum remarked that it was "a wonderful favourite of the public, considering its remote and far from central situation... it is the 'attraction' not the 'site' that regulates the number of visitors."[10] Surrounded by spacious parks, "whole families need not any more be cooped up for the day in the building, but avail themselves of the fresh air and its accessories at the same time as they profit by the collection."[11] In contrast, the British Museum had the city-centre disadvantages of crowded streets, pollution and poor lighting.[12]

The science collections were displayed in the education gallery, which also contained an extensive range of other collections: the building materials collection, models of machinery, ships and naval appliances, collections of economic entomology and forestry, collections of fish appliances, the educational library and the Patent Museum.[13] The arrangement of the space suggested that it was laid out as a classroom: "there are maps, diagrams, models, and apparatus; and object lessons are also conspicuous (Fig. 1). The curiosities and luxuries even of the schoolroom are not absent."[14] It was not only instruments but books too that were displayed for consultation by students and teachers, or sent

Figure 1: The education gallery at the South Kensington Museum.
(Source: The Leisure Hour, vol. 380, 1859).

out as loans to schools.

As instruments and apparatus were too expensive for schools to purchase (unlike a natural history collection that could be cheaply made-up), a museum loan collection was often a substitute for school teaching.[15] Popular textbooks described experiments, but performing the process could make abstract ideas take form. The catalogue of the education gallery records the layout of the space as it was in 1859. Models of school buildings showed the interior, while on the walls were hung associated plans from schools in Germany and France. Glass cases displayed examples of natural production from the colonies. Another section displayed appliances for educating students with disabilities, and examples of household economy. The division of Natural History was mainly enriched by models and diagrams made by professors who also showed

their private collections of botany, geology and mineralogy. The catalogue notes that the sections for astronomy and geography were the best represented, with atlases, maps, astronomical diagrams, globes and orreries, glass cases with physical and chemical apparatus from London makers, microscopes and electric apparatus. In consequence, the simple arrangement of the South Kensington education gallery had located scientific instruments within the "museum class of education objects" rather than according to their scientific typologies.

In this context, in January 1875, the Science and Art Department of the Committee of the Council on Education proposed organising a Loan Collection of Scientific Apparatus at the South Kensington site.[16] This proposal was then followed by the formation of a scientific committee – mostly Presidents of learned Societies – that would compose the Special Loan Collection.[17] Political speculation about the role of science in relation to museums and collections had mainly been expressed by the Royal Commission on Scientific Instruction and the Advancement of Science, under the chairmanship of the Duke of Devonshire. The Special Loan Collection committee had confirmed that interest with regard to the creation of a Science Museum along the lines of the Conservatoire des Arts et Metiers in Paris.

The collection would not be a mere gazing place[18]

The exhibition of the Special Loan Collection was inaugurated in May 1876 in the western galleries of the Royal Horticultural Gardens of that site (i.e. not in the galleries of the Museum).

The objectives set in the introduction to the exhibition catalogue emphasised that "the collection would not be a mere gazing place where nothing but feelings of wonder and pride would be excited by the past triumphs of science, but that much instruction would be gained from it."[19] The exhibition site eventually contained more than 6,000 items of scientific apparatus "so as to afford men of science and those interested in education an opportunity of seeing what was being done by other countries than their own in the production of apparatus, both for research and for instruction an opportunity which it was hoped would be of advantage also to the makers of instruments."[20] The event was defined as an international exhibition.

International exhibitions since 1850 were all about the industrial arts, a celebration of iron and the steam engine and, in consequence, the growing mechanisation of nature and man. World exhibitions mingled a wealth of products from both European countries and the colonies. In Europe these exhibitions took place mainly in Sydenham Park in London (1851; 1862; 1871-74; 1883-90; 1895; 1896) and in Paris (1855; 1862; 1867; 1878; 1889; 1900).[21] Paul Greenhalgh has called them serial exhibitions and notes that this type of exhibition multiplied from the Special Loan Exhibition onwards.[22] Jeffrey Auerbach, in his study of the 1851 Great Exhibition, noted that the exhibited British scientific instruments clearly had a commercial character.[23] Yet the Exhibition would not be similar in its character and arrangements to the numerous industrial exhibitions that allotted a certain amount of

space to each country for the arrangement of the products: "it was desired to obtain not only apparatus and objects from manufacturers [i.e. instrument makers] but also of historic interest from museums and private cabinets, where they are treasured as sacred relics as well as apparatus in present use in the laboratories of professors."[24] Participant institutions included leading museums with instrument collections: the Edinburgh Museum of Science and Art, the Oxford University Museum, the Geological Museum of Jermyn Street, as well as the Royal Institution of Great Britain, the Royal Astronomical Society of London and the King George III Museum of King's College London.

A series of devices was introduced to strengthen the role of the Special Loan Exhibition as a non-gazing, educational event. As the Director of the South Kensington Museum put it to the Secretary of the Royal Astronomical Society of London: "the exhibition in question should illustrate not only the history of science and its recent progress, but also the various methods of teaching science."[25] The Catalogue listed the object entries and detailed descriptions and manufacturing information and a handbook contained lectures on the current state of scientific research. As noted in the journal *Nature*:

> [...] *something more was required to show the purpose and import and historical place of the multitude of separate instruments in the various sections. This want is supplied in the admirable Handbook consisting of a series of descriptive and historical articles on the various sections by some of the most eminent living British men of science.*[26]

A central room hosted the conferences relating to the classes of exhibits which were run by eminent men of science to discuss the current state of the sciences and, particularly, the state of laboratory-based science. The handbook describing the history and function of the exhibits had entries by scientists such as Thomas H. Huxley (1825-1895), James C. Maxwell (1831-1879) and J. Norman Lockyer (1836-1920). These were, also, leading the reform of national science education at that time. During opening hours, there were demonstrations explaining the instruments and showing them in action. In many cases the demonstrations took the form of short lectures. Some months before the opening, the press had emphasised that the exhibition should have a non-commercial character, as opposed to the industrial world exhibitions that flourished at that time, and that it should disseminate as widely as possible "the knowledge of the different methods of science."[27] The exhibition's spatial layout arranged the objects in a thematic way by placing all the branches of sciences in series and grouping together instruments of every branch: mechanics (pure and applied mathematics), physics, chemistry (including metallurgy), geology, mineralogy, geography, and biology (Fig. 2).

The intended dissociation from the geographical arrangement of industrial prototype of exhibitions was explained in the introduction to the exhibition catalogue.[28] Instead, the sections of the Exhibition were created with subsections that included collections of portraits of scientific men, books, magazines, drawings and photographs of a

Figure 2: Plan of the Special Loan Collection exhibition. (Source: Catalogue of the Special Loan Collection of Scientific Apparatus at the South Kensington Museum)

scientific nature classified under the category "miscellaneous". A group of heterogeneous artefacts was made to define the notion of what a science exhibition would be and how it would disseminate scientific methods and their history. Portraits and notebooks added a personalised view of science in that they were attributed to a particular individual's scientific practices. A science exhibition followed a pattern of arrangement based on scientific principles. Such an event would provide, as James Prescott Joule (1818-1889), physicist, had commented in his parliamentary report: "seeing an instrument enables you to form a judgement to a certain extent as to what you may require for other purposes, perhaps, than those for which the instrument was intended."[29]

In terms of attendance figures, *The Times* newspaper stated that judging from its very specialised subject, the exhibition was a success: "the numbers attending have been about 3,000 on Saturdays and Mondays – more frequently above than under that number – and rather less on Tuesdays."[30] A correspondent to the journal *Nature* explained that the exhibition was not "of the merely curious, who would attend as at an entertainment in natural magic, but of those deeply interested in the topics discussed."[31] Mere gazing suggested a cheap spectacle that aimed only at causing wonder in the uneducated mass. After the 1860s there was a dichotomy between educational exhibitions and mass spectacle. The stipulations introduced by the Exhibition were part of a wider cultural effort to distinguish between educational events and public amusements. The Reform Act of 1867 and the Education Act of 1870 broadened museum audiences and encouraged a strong educational role for museums. As Alfred Russell Wallace put it:

> *The schools, the museums, the galleries, the gardens, must all alike be popular (that is adapted for and capable of being fully used and enjoyed by the people at large), and must be developed by means of public money to such an extent only as is needful for the highest attainable popular instruction and benefit.*[32]

Tony Bennett has shown that the intercourse of various social classes in such events posed issues relating to social conduct that the government was anxious to control.[33] International exhibitions were conceived as instruments for social order. National achievements moralised lay audiences by distracting

them with the use of great displays.

The educational potential was found in the fact that the exhibition presented the history of science through the use of historic objects. The oldest object was an astrolabe from 1345, but the collection also included original instruments once belonging to Tycho Brahe, Galileo Galilei, Robert Boyle, Robert Hooke, Isaac Newton, Joseph Black, Henry Cavendish, Antoine Lavoisier and William Herschel. Partnerships with collectors and institutions that held historic artefacts were formed. Collectors, in particular, were called on to contribute. The journal *Nature* commented that, "the various museums and private collections in this country and on the Continent have been ransacked for some of their choicest contents to be sent to these South Kensington Galleries."[84] Both antiquarians and men of science were involved, such as Joseph Bonomi of Sir Hans Soane's Museum, Frank Crisp, the antiquarian and historian of science, Lewis Evans (1853-1930), collector of scientific instruments, and also relatives of deceased scientists.

Objects from institutional repositories were the sources out of which objects of the past were to be displayed as pieces of unique mastery:

> The Royal Society contributes a most important collection, including some of Newton's apparatus. The Royal Institution contributes historical apparatus used by Faraday and others, and some of Tyndall's instruments. The Astronomical Society contributes Baily's apparatus for the Cavendish's experiments, and Herschel's telescope. The Geography Society contributes maps and instruments. The Microscopical Society has promised

to organise a collection of microscopes, which Mr Sorby has especially in charge; the Horological Institute a collection of clock escapements &c., and the Royal College of Surgeons has promised an interesting collection. King's College has promised to contribute the collection of the late Sir C. Wheatstone.[35]

A large number of instruments was gathered together, relics of the past, sanctified as having belonged to the pioneers of science, together with objects from modern times (Fig. 3).

The past would be there to speak through the original object: "the early instruments of observation, the 'first still small voice' of experiment, and the full chorus of modern work, both observational and experimental, are all brought before us in the collection."[36] The original object was there to stand for the past rather than to commemorate it. This period also coincided with the death of Michael Faraday, whose name was linked with the Royal Institution's scientific achievements, an event that provides further testimony to the growing interest in historic scientific objects. For example, the Royal Institution lent Humphry Davy's and Michael Faraday's laboratory notebooks.[37]

Narratives for a history of science display

It would be impossible, we imagine, to walk through those corridors and inspect the various objects encased on either hand, without soon beginning to marvel at the multiplicity and complexity of the tools which science had come to construct for herself in the progress of her inquiries.[38]

Figure 3: Scientific apparatus displayed at the exhibition of the Special Loan Collection.
(Source: The Illustrated London News, vol. 69, 1876)

Up until then, the past was commemorated through modern objects that had been designed intentionally to recall the past, mainly through their stylistic patterns. Chris Hopkins has suggested that this is very characteristic of Victorian modernity: "If innovation was to be admired, it was only perfected by being dressed in a tasteful style from the past."[39] A history of technology was important too. As an essayist discussing how to bridge the past with the future of technology suggested:

> A trade museum should include the past history. It would not be difficult to show that as much is to be learnt from failures as from successes, and that the unsuccessful projects of manufacturers are often as valuable and instructive to others as their most successful improvements... If well carried out it would form a vast storehouse of industrial knowledge of the greatest practical use.[40]

By the time of the exhibition of the Special Loan Collection, science was to be presented through a linear or thematic placement of objects that stood for science as a process in contrast to science performed as in the lecture theatre. The latter corresponded to a live process, whereas instruments on exhibitions stood as facts. In his inaugural address in the series of conferences for the Exhibition, William Spottiswoode commented that "by bringing together in one place such a progressive collection as they had there they were enabled to afford the scientific man a comprehensive and vivid picture of the history of science."[41] Creating historical narratives

from earlier periods to the present time would indicate the present state of technology. The exhibition strategy followed the way ethnographic material was displayed as a model for showing the evolutionary progress from primitive tool to the mechanical artefact.[42]

In contrast to the way instruments were presented in other spaces, where the interpretation came from a process of demonstration, in big exhibitions, whenever the intention was to express the antiquity of man, instruments followed the prevalent scientific discourse of the period, the narrative of progress. Visitors to the Special Loan Collection could view the objects as having advanced up to that time: "from the less perfect to the most perfect, from the rough and clumsy to the finished and refined, in the construction of her [i.e. science] instruments."[43] Participant institutions had noted such a progressive development in their own collections. No instrument was repudiated or replaced by another as "accretion, rather than substitution, has been the rule."[44]

In this context, Augustus Henry Lane Fox (Pitt-Rivers, 1827-1900) had suggested that the arrangement of material arts demonstrated the succession of ideas by which the mind of man developed. As it is recorded in *The Proceedings of the Royal Institution*, Lane Fox explained:

> *From the simple to the complex, and from the homogeneous to the heterogeneous; to work out step by step, by the use of such symbols as the arts afford, that law of contiguity by which the mind has passed from simple cohesion of states of consciousness to the association of ideas, and so on to broader generalisations.*[45]

Classification enabled two types of museums, according to Lane Fox: reference and educational. The first arranged the objects geographically, the latter in an evolutionary way.[46] William Whewell (1794-1866), the natural philosopher, had noted that the discoveries of the past have an effect on the intellectual education of the succeeding periods, and that induction is the prominent method of education.[47] Thus, an exhibition in order to be memorable would represent all the stages of development but, for the sake of physical space, according to Lane Fox, would exhibit only representative objects from each stage.

The progressive narrative that underpinned the exhibition was the same one used to explain the positivist field of the history of science. Looking at the representation of history, the value of these objects relied upon their association with well-known scientific figures rather than their actual age. In galleries, portraits of past discoverers were put on display as linear presentiments of former scientific periods. The man of science, as much as being a hero, was also a labourer; being described with metaphors was inherent in the process of making a man of science look like a national hero.[48] The National Portrait Gallery had had possession of the portraits of Charles Babbage, Francis Bacon, Charles Darwin, Michael Faraday and James Clerk Maxwell since 1859.

Towards a national science museum

A museum of only the past, venerable though it might be, would be also grey with the melancholy of departing life.[49]

The exhibition of the Special Loan Collection closed on 30 December 1876. Most of the objects, especially those of historic interest, were returned to their owners. The Royal Astronomical Society of London, among other institutions, was asked to deposit the historic objects from its collection as permanent loans at South Kensington Museum. However, as there was no official policy on collecting historic relics, nor a particular conservation policy, objects were placed in the museum as evidence of a history of science. The Royal Institution of Great Britain, on the other hand had, by the 1860s, formed "a museum containing scientific apparatus of historical interest, mineral specimens and other collections."[50] Objects from the travels of wealthy Fellows and all sorts of non-western curiosities found a place in the library and the glass cases of its museum. However, along with that event grew an awareness of questions surrounding the future role of science museums. William Spottiswoode suggested that instruments that were of no practical use, but simply of historical interest, might be left at South Kensington on permanent loan. The voices in favour of the creation of a national science museum coincided, also, with a wealth of publications that discussed the role of the museum as the last and only safeguard of heritage and authenticity. Museums were invested with the project of retaining the authenticity of objects; yet, the main argument surrounding such exhibitions as the Special Loan Collection, was whether a science museum should be about the history of sciences or illustrate current scientific practice.

Museums and learned societies in the late nineteenth century were increasingly concerned with preserving the past but, as most were concerned with the natural sciences, they were, like the vision of a national physical sciences museum, concerned with the present and the future of society.[51] Between 1870 and the First World War the sciences emphasised the importance of laboratory work rather than collection-based research, which eventually pushed science museums into repositories and attractions concerned with the history of sciences.[52] This occurred gradually as universities became the main places for generating knowledge. During the 1880s the science museum was formulated in a more systematic way and found itself becoming a matter of national supremacy and pride rather than merely a tool for instructing the public. From 1885 the science collections at South Kensington were broadly known as the *Science Museum*. The instruments of men such as Michael Faraday and James C. Maxwell began a new life as historic pieces in the collections of museums like the National Museum of Science and Industry in London. Representing the great men of science that epitomised the heroic histories of the time, these objects reified the values of the scientific elite.

Notes

1. *South Kensington Museum. 1876. Conferences Held in Connection with the Special Loan Collection of Scientific Apparatus. Physics and Mechanics, p. 1. London: Chapman and Hall.*

2. *Conferences Held in Connection with the Special Loan Collection of Scientific Apparatus, op. cit. (1) p. 1.*

3. *T. Andrews. 1877. Address of the President. In Reports of the 46th Meeting of the British Association for the Advancement of Science, pp. lxviii-xxxvi (p. lxviii).*

4. *See mainly S. Alberti. 2002. "Placing Nature: Natural History Collections and their Owners in Provincial Nineteenth-Century England". British Journal for the History of Science. 35 (3) pp. 291-312; S. Alberti. 2005. "Objects and the museum". Isis 96, pp. 559-571; K. Arnold. 2006. Cabinets for the Curious. Looking back at Early English Museums. Ashgate; P. Findlen. 1994. Possessing Nature: Museums, Collecting and Scientific Culture in Early Italy. University of California Press; S. Forgan. 1994. "The architecture of display: museums, universities and objects in the nineteenth-century Britain". History of Science. 32, pp. 139-62; S. Forgan. 1998. "Museum and university: spaces for learning and the shape of disciplines". In Scholarship in Victorian Britain, M. Hewitt (ed), pp. 66-77. Leeds: Leeds Centre for Victorian Studies; S. J. Knell. 2000. The Culture of English Geology, 1815-1851. A Science Revealed through its Collecting. Ashgate.*

5. *British Parliamentary Papers. 1969. Third and Fourth Report of the Royal Commission on Scientific Instruction and the Advancement of Science with Minutes of Evidence, Appendices, and Correspondence together with a supplementary Report and Memorial (1873-4), vol. 3, Shannon. Ireland: Irish University Press Series.*

6. *British Parliamentary Papers, op. cit. (5), appendix I. Para 81, p. 3. Proposed*

additions to the Scientific Collections of the South Kensington Museum.

7. British Parliamentary Papers, op. cit. (5), appendix I. Para 81, p. 13.

8. Anon. 1862. "The South Kensington Museum. Its educational resources". The Museum. 1, pp. 66-72 (p. 67).

9. Anon. 1889. "The Estate of her Majesty's Commissioners of 1851". Nature. 40, pp. 25-6 (p. 26). On the effects of the Great Exhibition of 1851 to the development of industrial education, see J. G. Crowther. 1965. Statesmen of Science, pp. 196-202. London: The Cresset Press. Also Anon. "The Great Exhibition of 1851". Times (27 May 1876), p. 11.

10. Anon. "South Kensington Museum, Report and Blue Books on the Science and Art Department". Times (14 June 1858), p. 9.

11. Anon. 1868. "Museums as aids to education". Leisure Hour, pp. 687-8 (p. 688).

12. Museums as aids to education, op. cit. (11) p. 688.

13. The South Kensington Museum. Its educational resources, op. cit. (8) p. 68.

14. Anon. 1859. "The South Kensington Museum". Leisure Hour, pp. 232-6 (p. 232).

15. Anon. "The need of a science museum". Times. 29 July 1887, p. 4.

16. The Science and Art Department was established in 1853 as a development of the Department of Practical Art and it was placed under the Committee of Council on Education in 1856.

17. Some of the members of that committee were the Astronomer Royal George B. Airy (1801-1892), Henry Cole (1808-1882), civil servant and inventor, Colonel Lane Fox President of the Anthropological Society, James C. Maxwell (1831-1879), Charles Wheatstone (1802-1876), the politician J. P. Kay-Shuttleworth (1804-1877), founder of the English system of popular education, Thomas H. Huxley (1825-1895), then President of the Royal Society, George. G. Stokes (1819-1903), 1st Baronet, mathematician and physicist, and Henry J. S. Smith

(1826-1883), mathematician.

18. *Conferences Held in Connection with the Special Loan Collection of Scientific Apparatus, op. cit.* (1) *p. ix-x.*

19. *South Kensington Museum. Handbook to the Special Loan Collection of Scientific Apparatus, pp. ix-x. Chapman & Hall, Piccadilly.*

20. *Handbook of the Special Loan Collection of Scientific Apparatus, op. cit.* (19) *p. x.*

21. A. C. T. Geppert, Coffey J. and T. Lau. 2000. "International exhibitions, expositions universelles, 1851-1951: A bibliography". Wolkenkuckucksheim: Internationale Zeitschirft fur Theorie und Wissenschaft und Architektur; P. Greenhalgh. 1987. "Education, entertainment and politics: lessons from the Great International Exhibitions". In The New Museology, P. Vergo (ed) pp. 74-98. London: Reaktion Books; P. Greenhalgh. 1988. Ephemeral Vistas: the Expositions Universelles, Great Exhibitions and World Fairs, 1851-1939. Manchester: Manchester University Press.

22. *Greenhalgh, op. cit.* (21) *p. 75.*

23. J. A. Auerbach. 1999. The Great Exhibition of 1851. A Nation on Display, p. 124. New Haven and London: Yale University Press; Prof. Westmacott. 1865. "On art-education, and how works of art should be viewed". Proceedings of the Royal Institution of Great Britain. 4 (41) pp. 381-5 (p. 381).

24. *Handbook of the Special Loan Collection of Scientific Apparatus, op. cit.* (19) *p. xii.*

25. *Royal Astronomical Society of London Archives: RAS Letters 1876, Letter from F. P. Cunliffe-Owen, Director of South Kensington Museum to Secretary of Royal Astronomical Society, dated 2nd February 1876; RAS Papers 2.7, Council Meetings Minutes, vol. 7, 4 February 1876, f. 219.*

26. Anon. 1876. "Notes on the Special Loan Collection". Nature. 14, pp. 21-4.

27. Anon. 1876. "The loan exhibition of scientific apparatus at the South

Kensington". Nature. 13, pp. 231-2.

28. *Science and Art Department of the Committee of Council on Education.
1876. Catalogue of the Special Loan Collection of Scientific Apparatus at the
South Kensington Museum, p. xiii. London: Eyre & Spottiswoode.*

29. *J. P. Joule. "Report on the Royal Commission on Scientific Instruction.
Minutes of Evidence", British Parliamentary Papers, op. cit. (5), Para 10, p.
586.*

30. *Anon. "The museum of scientific instruments". Times.* 1 September 1876, p. 4.

31. *W. Gee. 1876. "Letter to the Journal giving feedback on the exhibition".
Nature.* 14, p. 231.

32. *A. R. Wallace. 1870. "Government aid to science". Nature.* 1, pp. 279-80 (p.
279).

33. *T. Bennett. 1995. The Birth of the Museum. London and New York: Routledge;
T. Bennett. 1998. "Speaking to the eyes: Museums, legibility and the social
order". In The Politics of Display. Museums, Science, Culture, S. MacDonald
(ed) pp. 25-35. London and New York: Routledge; T. Bennett. 1999. "The
exhibitionary complex". In Representing the Nation: A Reader. Histories,
Heritage and Museums, D. Boswell and J. Evans (eds) pp. 332-61. London and
New York: Routledge. Also R. D. Altick. 1978. The Shows of London, p. 499.
Cambridge: Harvard University Press.*

34. *Anon. 1876. "The progress of the Loan Collection". Nature.* 13, pp. 503-5
(p. 505). *Also Catalogue, op. cit. (28) p. xiii.*

35. *Anon. 1876. "Notes on the Special Loan Collection". Nature.* 13, pp. 349-50.

36. *Anon. "Special Loan Collection". Times.* 19 May 1876, p. 10.

37. *Royal Institution of Great Britain Archives: RI MM, Meetings Minutes, 5
June 1876, vol. 13, f. 86.*

38. *Anon. 1876. "The progress of the Loan Collection". Nature.* 13, pp. 503-5
(p. 504).

39. C. Hopkins. 1998. "Victorian modernity? Writing the Great Exhibition". In *Varieties of Victorianism. The Uses of the Past*, G. Day (ed) pp. 40-62 (p. 59). London: MacMillan Press.

40. E. Solly. 1853. *Trade Museums, their Nature and Uses: Considered in a Letter Addressed, by Permission, to HRH the Prince Albert*, pp. 12-14. London: Longman.

41. Anon. "Science at South Kensington. President's inaugural address". Times. 17 May 1876, p. 7.

42. A. Lane Fox. 1878. "The arrangement of museums". Nature. 17, pp. 484-5.

43. The progress of the Loan Collection, op. cit. (38) p. 504.

44. Anon. 1876. "The Loan Collection of scientific apparatus". Illustrated London News. (69) pp. 69-70 (p. 270).

45. A. Lane Fox. 1875. "On the evolution of culture". Proceedings of the Royal Institution of Great Britain. 7 (63), pp. 498-520 (p. 503).

46. Lane Fox, op. cit. (42) p. 485.

47. W. Whewell. 1855. "On the influence of the history of science upon intellectual education: a lecture delivered at the Royal Institution of Great Britain". *Lectures on Education delivered at the Royal Institution of Great Britain*, pp. 5-31. London: Parker.

48. C. L. Brightwell. 1859. *Heroes of the Laboratory and the Workshop*. London: Routledge.

49. *Conferences Held in Connection with the Special Loan Collection of Scientific Apparatus*, op. cit. (1) p. 13. Extract from William Spottiswoode's speech to the Conference.

50. Royal Astronomical Society of London Archives: RAS Letters 1876, Letter from Norman MacLeod to the Secretary of Royal Astronomical Society, dated 30th December 1876; RAS Papers 2.7, (1866-77) Council Meetings Minutes, 7, ff. 245-246. Royal Institution of Great Britain Archives: RI MS, Guard Book 3, f. 31.

Prospectus of the Nature and Objects of the Royal Institution, December 1863. On the use of the collections of the Royal Institution, see also Filippoupoliti A. 2009. "Aspects of a public science: the uses of the collections of the Royal Institution of Great Britain". Early Popular Visual Culture Journal. 7 (1) pp. 45-61.

51. R. Hoberman. 2003. *"In quest of a museal aura: turn of the century narratives about museum-displayed objects". Victorian Literature and Culture. 31 (2) pp. 467-82.*

52. K. Arnold. 1996. *"Presenting science as product or as process: Museums and the making of science". In Exploring Science in Museums, S. M. Pearce (ed) pp. 57-78 (p. 60). London: Athlone Press; S. Forgan. 1994. "The architecture of display: museums, universities and objects in the nineteenth-century Britain". History of Science. 32, pp. 139-62 (p. 155); J. Golinski. 1998. Making Natural Knowledge: Constructivism and the History of Science, p. 99. Cambridge: Cambridge University Press; J. V. Pickstone. 1993. "Ways of knowing: Towards a historical sociology of science of science, technology and medicine". British Journal for the History of Science. 26, pp. 433-58 (p. 450).*

Acknowledgements

I must thank the staff of the Royal Institution of Great Britain and the Royal Astronomical Society of London that facilitated access to the material used in the article. The Alexander S. Onassis Public Benefit Foundation funded research on the subject.

Index

About the Authors

Glykeria Anyfandi is Head of Communication at the Eugenides Foundation (Athens), and also works on the development of research projects with a focus on non-formal learning. She holds a PhD in the Pedagogic Analysis of Science Exhibits from the University of Peloponnese. Glykeria has worked for various national and European research projects on science communication, non-formal learning, and on applying participatory methodology in science decision processes. She has been advisor to the Alternate Minister of the Exterior and the Minister of the Aegean Sea on issues of political communication.

Pete Brown is Head of Learning and Interpretation at The Manchester Museum, The University of Manchester. Pete trained as a teacher and copy editor and has worked in museums since 1988. Since beginning work at the California Academy of Sciences and the Steinhart Aquarium he has maintained an interest in, and enthusiasm for, science. The two halves of his current job are closely connected, leading a talented team of educators who develop and deliver a wide range of workshops and sessions for schools and colleges, from Early Years right through to University level. The rest of the time he works with colleagues from all parts of the museum to develop the interpretation for temporary exhibitions, galleries and public programmes. He has recently completed an MA in Interpretive Studies at the University of Leicester, exploring the potential of museums as free-choice learning environments within the broad context of leisure, heritage and culture.

Clare Buckland is a plankton analyst and the education officer for Sir Alister Hardy Foundation for Ocean Science and is a Science (STEM) Ambassador. As education and outreach officer she co-ordinates, designs and carries out scientific events for schools and the general public. She also writes the content of the foundations education web pages and curates SAHFOS's collection of Sir Alister Hardy paintings.

Silvia Casini is a researcher at Observa – Science in Society and a freelance curator for several private art galleries in the Venetian area. For Observa, Silvia works on the evaluation and monitoring of a number of EU-funded projects dealing with public engagement with science. In 2007 she curated the art exhibition *Surfaces: Gabriele Leidloff and Marc Didou* (Naughton Gallery at Queen's). In 2009 she curated the exhibition *Movimenti Urbani (Urban Movements)* with artworks by painter Angelo Accardi, photographer Ruggero Ruggeri and internationally-acclaimed video-maker Jean-Claude Mocik. Among her research interests there are art and science cross-fertilizations and visitor studies. Silvia holds an AHRC-funded PhD in Film and Visual Studies at Queen's University of Belfast (UK). She has also worked at the Venice International Film Festival as coordinator of the Horizons section. www.silviacasini.net

Kitty Connolly is Associate Director of Education at the Huntington Library, Art Collections, and Botanical Gardens in San Marino, California, where she has been since 1999.

A major focus of her work is interpreting the Huntington's collections through exhibitions. She was the Co-PI and project manager for *Plants are up to Something* in the Rose Hills Foundation Conservatory for Botanical Science, which was the 2007 winner of the American Association of Museum's Grand Prize in *Excellence in Exhibition*. She has also been co-curator and coordinator of exhibitions at the Huntington and Smithsonian Institution. Kitty has served as a Director-at-Large for the American Public Gardens Association and holds a BS in environmental zoology from Ohio University and an MA in geography from UCLA.

Jenny Cousins is the Interpretation Manager for English Heritage's sites in London and the south-east of England, including the home of Charles Darwin, Down House. Prior to joining English Heritage, she worked for exhibition design firm Event Communications. She studied at Balliol College, Oxford University and Birkbeck, University of London.

Ana Delicado is a sociologist, currently working at the Social Sciences Institute of the University of Lisbon (ICS-UL). She was awarded a PhD by the same institution in 2006, for her thesis on scientific museums in Portugal. Previously, she was a research fellow at the Observatory of Sciences and Technologies and at ICS-UL, then a Post-Doctoral Fellow at the Institute for Prospective Technological Studies (JRC – European Commission, Seville) and at ICS-UL. Ana is currently coordinating research projects on scientific societies and on

the interplay between science, policy and the public regarding climate change. She has published a book and several articles on science in museums in Portuguese and international journals.

Kostas Dimopoulos is Associate Professor of Learning Materials in the Department of Social and Educational Policy, at the University of the Peloponnese, Athens. He also teaches Didactics of Science at the Hellenic Open University. He has participated in many national and European R&D projects related to science communication and science education and has written many articles, conference papers, and recently two books on these issues.

Elaine Fileman is a plankton ecologist and schools liaison officer at Plymouth Marine Laboratory. She coordinates PML's science education activities with local primary and secondary schools and is a Science (STEM) ambassador.

Anastasia Filippoupoliti is a lecturer in museum education at the School of Education Sciences, Democritus University of Thrace (Greece). She also lectures at the Hellenic Open University. She undertook research in the fields of museology and science communication while she was a postdoctoral fellow at the Austrian Academy of Sciences, and focused on exhibition design and museum planning issues while working as a museologist at the Piraeus Bank Group Cultural Foundation (Greece). She holds PhD and MA degrees in museum studies (University of Leicester, UK) and a BA in history and

philosophy of science (University of Athens). She writes regularly on exhibitions, collections and science museums.

Jodie Fisher is the Schools Liaison Officer for Science and Technology at the University of Plymouth. Working with secondary and primary schools, Jodie puts together and runs workshops and events for students giving them a taster for where science and technology can take them. Specialising in geology, schools can get the chance to take part in field excursions and practical sessions to both support and enhance their curriculum.

Kathy Fox has worked with Museum Victoria as an exhibition producer for ten years. She has a BSc (physiology and biochemistry) from the University of Melbourne; a BA (industrial design) from RMIT University and an MA in design from RMIT University. Kathy's role as team leader, manager and ideas generator uses her many skills to bring an exhibition from paper to reality. She is currently coordinating a team of 40 people on the redevelopment of the Science and Life Gallery.

Helen Fothergill is the Collections Manager at Plymouth City Museum and Art Gallery. She set up the Wild about Plymouth group in partnership with the University of Plymouth, which is a monthly natural history group encouraging local people to visit and explore wildlife on their doorstep.

Jan Freedman is the Keeper of Natural History at Plymouth City Museum and Art Gallery. He is involved with science education events with primary and secondary schools, and is working closely with a secondary school science club supporting students to be involved in creating small museum displays in their science department.

Warwick Frost teaches Tourism and the Environment at La Trobe University. His research focuses on interpretation and visitor attraction development and he has published in major journals including *Annals of Tourism Research, Tourism Management* and *International Journal of Heritage Studies*. He is the editor of *Tourism and National Parks: International perspectives on development, histories and change* (with C.M. Hall, Routledge 2009) and *Zoos and Tourism: Conservation, Education, Entertainment?* (Channel View 2011). He is one of the founding organisers of the biennial International Tourism and Media Conferences, the 4th being held in Prato, Italy in 2010.

George W. Hart is Chief Content Advisor at the Museum of Mathematics. A research professor in the computer science department at Stony Brook University, NY, he holds a B.S. in Mathematics and a Ph.D. in Electrical Engineering and Computer Science, both from MIT. George is the author of a linear algebra monograph, *Multidimensional Analysis*, and a geometry text, *Zome Geometry*. He is a sculptor developing innovative ways to use computer technology in the design and fabrication of his artwork.

His sculpture has been exhibited around the world and can be seen at www.georgehart.com. He is also very active in developing novel hands-on workshops as ways to communicate the richness and excitement of mathematics.

Franz Klingender has curated Canadian science and technology collections for over the past twenty-five years. Currently he is Curator, Renewable Resources with the Canada Science and Technology Museum Corporation.

Vasilis Koulaidis is Professor of Education and Communication in the Department of Social and Educational Policy at the University of Peloponnese in Athens. He is also head of the module of Science Education and Communication at the Hellenic Open University. Vasilis has written a considerable number of books, articles and conference papers and has participated in a large number of national and European R&D projects, most of which are related to science education and communication. Currently, he leads a team responsible for the production of audio-visual materials and programmes for popularizing science and technology.

Cindy Lawrence is Chief of Operations at the Museum of Mathematics. She holds a B.S. in business administration from the University of Buffalo and an MBA from Hofstra University. Cindy began her professional career as a CPA with Price Waterhouse, and more recently worked as an instructor for a national professional review program. In addition to

teaching, she fielded questions from around the world, wrote course curricula, edited textbooks, ran marketing programs, hired and supervised staff, and was actively involved with software development and testing. She has also created and runs an extracurricular mathematics program for gifted middle school and high school students, run through a joint venture with Brookhaven National Laboratory.

Rob Longworth is an Education Officer at Plymouth City Museum and Art Gallery. His outreach work includes the Museum in Transit, which brings museum specimens to schools where the students set up a temporary mini-museum display in their school.

Jane Magill s the Director of the Robert Clark Centre for Technological Education and Deputy Director of the STEM Education Centre at the University of Glasgow. In 1982, she was awarded a PhD degree in Physical Chemistry from the University of Manchester for a study of atomic diffusion using photon correlation laser spectroscopy. Since graduating, she worked for National Research Council Canada and Northern Telecom Electronics in Canada before taking up her current post at the University of Glasgow. Jane has been involved in teaching and research in electrical engineering, more recently in STEM education and is also lecturer in a degree programme for future technology teachers. She has a strong interest in inter-disciplinary education and public engagement, particularly using new technologies such as virtual worlds and

COMMUNICATION AND EVALUATION

electronic voting to improve interactivity and engagement. She is currently leading projects linking art and music with science and technology. Across Glasgow University she is also leading projects to establish undergraduate and postgraduate public engagement teams which allow students to develop a broader skill set enhancing their choices and employability.

Henry McGhie is Head of the Natural Environments Team and Curator of Zoology at The Manchester Museum, The University of Manchester. He has worked at the Museum for nine years in a range of different roles and now leads a team of natural sciences curators who contribute to lifelong learning through public events and exhibitions, schools teaching, university student teaching and facilitating access to the enormous collections (almost four million specimens), with assistance from curatorial assistants and volunteers. Henry teaches on undergraduate courses in Animal Evolution and the Geography of Life. He is also a participant in the project *Animals as Symbols and as Signs*, funded by the Norwegian Research Council. Through 2008-9, Henry led the development of content of the museum's year-long Darwin programme, titled *The Evolutionist: a Darwin extravaganza at The Manchester Museum*. He is now leading the development of content to redisplay the museum's current Mammals Gallery to engage with contemporary attitudes to nature and humans' place in nature, due for completion in 2011.

Tim Nissen is Chief of Design for the Museum of Mathematics. He holds a B.A. in architecture from Carnegie Mellon

ABOUT THE AUTHORS · 643

University. Tim's previous experience includes working as a Project Director for RAA and serving as the associate director of exhibition design at the American Museum of Natural History (AMNH). At AMNH, his responsibilities included art direction, technical direction, and management of the in-house design studio. He was also involved in project development from concept to execution, and collaborated with other institutions to support worldwide exhibition travel programs. Prior to work at AMNH, Tim was an associate at the Rockwell Group.

Kate Phillips is Senior Curator, Science Communication at Museum Victoria. She has a BSc Honours (genetics and ecology) from Macquarie University, a Graduate Certificate in Science Communication from the Australian National University and an MSc Science Education from Curtin University. Kate worked in interactive science centres in the UK and Australia before joining Museum Victoria. She has been the curator on ten exhibitions on diverse topics including cell science, sewerage treatment, toys, sport science and the now is the lead curator on the Science and Life Gallery redevelopment.

Annette Scheersoi is a researcher and lecturer at Frankfurt University. Her research on biology learning focuses on interest development in out-of-school learning environments. Her doctorate was on museum exhibition concepts and the use of different media for communicating biological knowledge.

Eric Siegel is Director and Chief Content Officer at the New York Hall of Science. He leads the education, programs, exhibition development, science, and technology functions at the Hall of Science and is responsible for strategic planning and partnerships. He led the planning and institutional fundraising for the $92 million expansion completed in 2004, as well as directing the development of four major exhibitions. Eric has been in senior roles in art and science museums for 25 years and has consulted and published extensively in the museum field. He is President of the National Association for Museum Exhibitions; a member of the graduate faculty of the New York University Museums Studies program; Board Member of SolarOne, an urban environmental organization in NYC; and past Chairman of the Museums Council of New York City. Eric graduated from the CORO Leadership New York program, and holds an MBA in arts administration from SUNY Binghamton.

Silvia Singer is Director General of MIDE, Museo Interactivo de Economía. For more than 25 years Silvia has worked in museums, and has extensive experience of creating new museums having managed three new museum projects. Silvia has been President of ICOM Mexico for the last six years, International Secretary of CECA (the International Committee for Educational and Cultural Action) within ICOM, and ASTC Latin American Representative on the Conference Organizing Committee. She comes from a scientific background as a biologist and holds a PhD in Ecology.

Peter Smithers is a biologist at the University of Plymouth where he is part of the Faculty of Sciences and Technology outreach team. He regularly visits local schools to enthuse pupils about science, works closely with the city museum to organise family-friendly events and exhibitions, and works with local artists and theatre groups to bring science to a wider audience.

Cary Sneider is currently Associate Research Professor at Portland State University in Portland, Oregon, where he teaches courses in research methodology for teachers in Master's Degree programs. He also serves as a consultant on diverse issues in STEM education, such as youth programs at science centers, state and national standards, and assessments. Dr. Sneider served as Vice President for Educator Programs at the Museum of Science in Boston, and prior to that he served as Director of Astronomy and Physics Education at the Lawrence Hall of Science at the University of California. Cary's curriculum development and research interests have focused on helping students unravel their misconceptions in science and on new ways to link science centers and schools to promote student inquiry. In 1997 he received the Distinguished Informal Science Education award from NSTA and in 2003 was named National Associate of the National Academy of Sciences.

Gillian Thomas has over 20 years' experience in developing

and directing major projects for science centers, museums and children's museums. As President/CEO of Miami Science Museum, she is leading the development of the new MiaSci Museum in Museum Park, a 250,000 square foot museum to open on a four acre site in 2014. Previously the CEO of at-Bristol, UK, she led the team developing of this award-winning $150m waterfront Millennium project which opened in 2000. She was also the Director of Eureka! The Museum for Children, in Halifax, UK, for its development and opening, and subsequently Assistant Director at the National Museum of Science and Industry, London, with responsibility for new building projects, galleries and facilities. Her first exhibition experience was a part of the development team for the Cite des Sciences and de L'Industrie, at la Villette, Paris, the largest science center in Europe. She has also acted as an international consultant on science center and museum projects for trusts, foundations and government agencies, including Ireland, Egypt, Trinidad and Qatar as well as the US and the UK.

Sue Dale Tunnicliffe is a zoologist specializing in education with many years of school teaching at all ages and museum and zoo education research. Sue's doctorate, from King's College, London was *Talking about animals* and she devised a means of analyzing conversations and obtaining statistical results. She is part-time lecturer at the Institute of Education, University of London and has published and spoken widely on learning biology at all ages in and out of the classroom, especially at natural history exhibits.

Dhikshana Turakhia is a Schools and Community Outreach Officer at the Science Museum in London. She graduated from the University of Aberdeen in 2007 with a joint honours degree in History and Art History, following which her love of spending time in museums and galleries pushed her to pursue a career in museum education. She completed her masters in Museum and Gallery Education in 2008 at the Institute of Education in London, and it was while studying for this that she wrote the paper presented in this book. Over the last four years Dhikshana has interned, volunteered and worked in a variety of museums and galleries, as well as mentoring children in primary schools. In her work at the Science Museum, Dhikshana develops and presents interactive science shows and workshops, as well as focusing on a strategy that will see the Outreach Team build and sustain relationships with communities in and around London.

Stephen Uzzo is VP, Technology for the New York Hall of Science. Aside from planning and developing the information infrastructure for the museum, he applies his research skills for developing projects and programs related to topics such as complex networks, media, scientific visualization and the environment. Before coming to the Hall of Science, he spent nearly 20 years in formal education developing STEM projects, curriculum, and professional development programs, and currently teaches Math, Science, and Technology Integration for the New York Institute of Technology Graduate School

of Education. Dr. Uzzo holds a terminal degree in Network Theory and Environmental Studies from Union Institute and speaks and organizes for various conferences. Most recently, he was invited to speak for the Gordon Research Conference on Scientific Visualization and Education at Oxford. His current research interests include complex network theory, media studies, linguistics, and sustainability.

Carmen Villaseñor is Head of Educational Communication at MIDE, Museo Interactivo de Economía. Carmen began work at MIDE three years before its opening in the Evaluation Department, and so has been in touch with its potential audience from the start. Since 2006 she has been Head of Educational Communication, working on visitor activities and on strategies to communicate economic and financial concepts. She is a Social Anthropologist with an MA in Museum and Gallery Education and the first non-American museum member of the American Association of Museums' Executive Board.

Karina White led exhibition development and design teams on two major projects at The Huntington Library, Art Collections, and Botanical Gardens, in San Marino, CA, winning both the 2007 and 2009 American Association of Museums' grand prizes in their annual *Excellence in Exhibition* award. She holds a Master's degree in Architecture from UCLA.

Glen Whitney is Executive Director of the Museum of Mathematics. He received an undergraduate math degree from Harvard University and a PhD in mathematical logic from UCLA. Glen began his career on the academic, theoretical side, teaching at the University of Michigan, then added the applied point-of-view as a hedge-fund quantitative analyst. He discovered the spirit of hands-on exploration as an elementary school math club coach. And he's seen the value of math as a tool to give back to society, helping to design the data collection systems used by the Simons Foundation Autism Research Initiative.

Also from MuseumsEtc

Science Exhibitions: Curation and Design

ISBN: 978-0-9561943-5-0 [paperback]
ISBN: 978-1-907697-03-6 [hardback]
Order online from www.museumsetc.com

*Edited by Dr Anastasia Filippoupoliti,
Lecturer in Museum Education,
Democritus University of Thrace,
Greece*

This important new book is the
companion volume to Science
Exhibitions: Communication
and Evaluation and examines
how best to disseminate science
to the public through a variety
of new and traditional media.
With some 20 essays from leading
practitioners in the field, and
over 500 pages, it provides an
authoritative, stimulating overview
of new, innovative and successful
initiatives.

The essays draw on cutting-edge
experience throughout the world,
and include contributions from
Australia, Brazil, France, Germany,
Singapore and New Zealand – as
well as the UK and USA.

Rethinking Learning: Museums and Young People

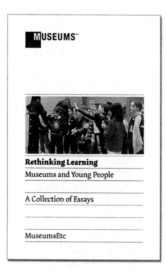

MUSEUMS

Rethinking Learning
Museums and Young People

A Collection of Essays

MuseumsEtc

ISBN: 978-0-9561943-0-5 [paperback]
Order online from www.museumsetc.com

Practical, inspirational case studies from senior museum and gallery professionals from Europe and the USA clearly demonstrate the way in which imaginative, responsive services for children and young people can have a transformational effect on the museum and its visitor profile as a whole.

Authors recount how, for example – as a direct result of their focus on young people – attendance has increased by 60% in three years; membership has reached record levels; and repeat visits have grown from 30% to 50%. Many of the environments in which these services operate are particularly challenging: city areas where 160 different languages are spoken; a remote location whose typical visitor has to travel 80 miles.

This is an essential book not only for those working with children and young people, but for those in any way concerned with museum and gallery policy, strategy, marketing and growth.

The Power of the Object: Museums and World War II

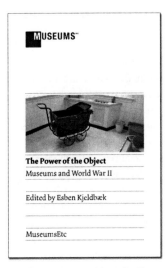

The Power of the Object
Museums and World War II

Edited by Esben Kjeldbæk

MuseumsEtc

ISBN: 978-0-9561943-4-3 [paperback]
Order online from www.museumsetc.com

Edited by Esben Kjeldbæk, Head of the Museum of the Danish Resistance 1940-1945, National Museum of Denmark

In this important new book, based on a conference held by the National Museum of Denmark, international museum professionals deal with the key issues affecting all history museums, using as the basis for their insights the interpretation by museums of World War II.

Among the many issues the contributors address are: How best can abstractions like cause, effect and other ideas be interpreted through objects? Just how is the role of objects within museums changing? How should we respond when increasingly visitors no longer accept the curator's choice of objects and their interpretation? How can museums deal effectively with controversial historical issues?

These essays explore how history museums can help explain and interpret the thinking of past generations, as well as their material culture.

Narratives of Community: Museums and Ethnicity

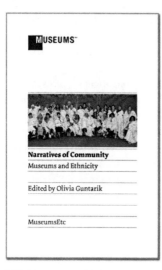

ISBN: 978-1-907697-05-0 [paperback]
ISBN: 978-1-907697-06-7 [hardback]
Order online from www.museumsetc.com

Edited by Dr Olivia Guntarik, RMIT University, Melbourne, Australia

In this groundbreaking book, cultural theorist and historian Olivia Guntarik brings together a collection of essays on the revolutionary roles museums across the world perform to represent communities. She highlights a fundamental shift taking place in 21st century museums: how they confront existing assumptions about people, and the pioneering ways they work with communities to narrate oral histories, tell ancestral stories and keep memories from the past alive.

The philosophical thread woven through each essay expresses a rejection of popular claims that minority people are necessarily silent, neglected and ignorant of the processes of representation. This book showcases new ways of thinking about contemporary museums as spaces of dialogue, collaboration and storytelling. It acknowledges the radical efforts many museums and communities make to actively engage with and overthrow existing misconceptions on the important subject of race and ethnicity.

New Thinking: Rules for the (R)evolution of Museums

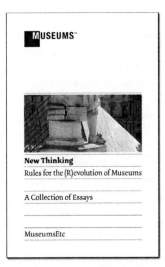

New Thinking
Rules for the (R)evolution of Museums

A Collection of Essays

MuseumsEtc

ISBN: 978-0-9561943-9-8 [paperback]
ISBN: 978-1-907697-04-3 [hardback]
Order online from www.museumsetc.com

This new collection of essays by leading international museum practitioners focuses on the across-the-board innovations taking place in some of the world's most forward-thinking museums – and charts the new directions museums will need to take in today's increasingly challenging and competitive environment.

Among the twenty world-class organisations sharing their innovative experiences are:

- Canada Agriculture Museum
- Canadian Museum for Human Rights
- Conner Prairie Interactive History Park
- Cooper-Hewitt National Design Museum
- Imperial War Museum
- Liberty Science Center
- Miami Science Museum
- Museum of London
- National Museum of Denmark
- Royal Collection Enterprises
- Smithsonian American Art Museum
- Victoria & Albert Museum
- Wellcome Collection

The New Museum Community

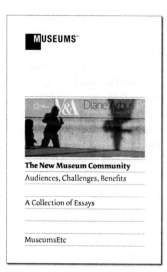

The New Museum Community
Audiences, Challenges, Benefits

A Collection of Essays

MuseumsEtc

ISBN: 978-0-9561943-7-4 [paperback]
ISBN: 978-1-907697-02-9 [hardback]
Order online from www.museumsetc.com

In a series of authoritative essays, this important new book examines in depth how museums globally are succeeding – in many different ways – in reaching and involving social groups traditionally overlooked or excluded from the museum experience. The New Museum Community is an invaluable and inspiring guide for any museum, gallery or cultural organisation intent on engaging with the broadest possible audience.

Among the world-class organisations sharing their practical experience are:

- British Museum
- Manchester Museum
- Miami Science Centre
- Museum of London
- Museum Victoria
- Museo Nazionale della Scienza, Milan
- Penn State University
- Tate Britain
- University of Brighton
- University of Edinburgh
- University of Newcastle

Creating Bonds: Marketing Museums

MUSEUMS

Creating Bonds
Successful Marketing in Museums

A Collection of Essays

MuseumsEtc

ISBN: 978-0-9561943-1-2 [paperback]
Order online from www.museumsetc.com

Marketing professionals working in and with museums and galleries throughout the UK, USA and beyond, share their latest insights and experiences of involving and speaking to a wide range of constituencies. Their practical, insightful essays span the development and management of the museum brand; successful marketing initiatives within both the small museum and the large national museum environment; and the ways in which specific market sectors – both young and old – can be effectively targeted.

Contributors include: Amy Nelson, University of Kentucky Art Museum; Aundrea Hollington, Historic Scotland; Adam Lumb, Museums Sheffield; Bruno Bahunek, Museum of Contemporary Art, Zagreb; Claire Ingham, London Transport Museum; Kate Knowles, Dulwich Picture Gallery; Danielle Chidlow, National Gallery; Margot Wallace, Columbia College; Rachel Collins, Wellcome Collection; Sian Walters, National Museum Wales; Gina Koutsika, Tate; Alex Gates, North Berrien Historical Museum.

Colophon